the *How to Identify* series

How to Identify
OLD PRINTS

How to Identify
OLD PRINTS

by
F. L. WILDER

Editor of
PRINT PRICES CURRENT (1918–1939)
PICTURE PRICES CURRENT (1935–1937)

LONDON
G. BELL AND SONS LTD

Published by
G. Bell and Sons, Ltd
York House, Portugal St.
London, W.C.2

SBN 7135 1534 1

Printed in Great Britain by
The Camelot Press Ltd., London and Southampton

Contents

The Plates

74. Henry Meyer: *Lady Hamilton*, after G. Romney; mezzotint
75. J. R. Smith: *Love in her Eyes sits playing*, after Peters; mezzotint
76. Richard Earlom: *The Life School at the Royal Academy*, after Zoffany; mezzotint
77. Richard Earlom: *An Iron Forge*, after Wright of Derby; mezzotint
78. William Ward: *The Anglers' Repast*, after George Morland; mezzotint
79. William Ward: *The Citizen's Retreat*, after James Ward; mezzotint
80. G. Demarteau: *Grande Pastorale*, after J. B. Huet; crayon manner and aquatint
81. F. Bartolozzi: detail of *Napoleon*, after Appiani; stipple
82. F. D. Soiron: *The Promenade in St. James's Park*, after Dayes; stipple
83. M. Dubourg: *George III hunting in Windsor Park*, after Pollard; detail showing aquatint ground
84. Francisco Goya: *Los Caprichos*, plate 32; aquatint
85. H. Daumier: *Le Ventre Législatif*; lithograph
86. Toulouse-Lautrec: *La Grande Loge*; lithograph in colours
87. F. Janinet: *L'Indiscretion*, after Lavreince; aquatint, printed in colours
88. F. Janinet: *Marie-Antoinette*, after Gautier-D'Agoty; aquatint, printed in colours
89. P. L. Debucourt: *Les Deux Baisers*; aquatint, printed in colours
90. L. M. Bonnet: *Tête de Flore*, after Boucher; imitation of pastel
91. R. & D. Havell: *Oxford*, after W. Havell; coloured aquatint
92. J. J. Biedermann: *View of Geneva*; coloured etching
93. G. Lory: *Swiss Costumes*; coloured aquatint
94. James Gillray: *Carlo Khan's Triumphal Entry into Leadenhall Street*; coloured etching
95. R. Pollard and F. Jukes: *Vaux-Hall*, after Rowlandson; etching and aquatint
96. I. R. Cruikshank: *Monstrosities*; coloured etching with aquatint
97. G. Cruikshank: *The Piccadilly Nuisance*; coloured etching
98. Clark and Merke: *Partridge Shooting*, after S. Howitt; coloured aquatint
99. H. Alken: *Going out of Kennel*, after W. P. Hodges; coloured aquatint,
100. F. C. Lewis: *The Meet*, after H. Alken; coloured aquatint
101. T. Sutherland: *Barefoot*, after J. F. Herring; coloured aquatint
102. G. Hunt: *Approach to Christmas*, after Pollard; coloured aquatint
103. D. Wolstenholme Jnr: *Whitewell near Welwyn*, after D. Wolstenholme Snr.; coloured aquatint
104. R. G. Reeve: *Ascot Heath Races*, after F. C. Turner; coloured aquatint
105. Francisco Goya: *El Coloso* (*The Giant*)

Preface

Is it an *old* print?

Is it a reprint? That is to say, an impression taken from the original plate or wood-block, some years after the first edition.

Is it a copy?

Is it a reproduction?

These are questions which even the most experienced expert cannot always decide off-hand, but there are certain signs he has learnt to look for, which can be an infallible guide.

It is this knowledge, often the result of years of comparison, that this book has tried to impart, whilst also giving a brief and elementary history of the printed picture.

Thus it starts with some of these hints, before going into a history and description of the various processes, in the order of their invention. In some respects it could be regarded as a replacement for some earlier elementary guides, now out of print, such as Alfred Whitman's *Print Collector's Handbook*, whilst being more in keeping with changing fashions.

No attempt, however, has been made to cover the more modern prints, now a vast subject, already dealt with in many recent publications.

It is hoped the hints on differences in old and modern paper, watermarks, plate-marks, etc., plus the charts of copies after Dürer and Rembrandt, will point the way to beginners, and give a short-cut to matters which might otherwise take years of experience to discover.

Following these hints, and after dealing with each process, some emphasis has been given to prints specifically designed for hand-colouring.

This embraces the beautiful Swiss prints of the 18th and early 19th centuries; landscapes and marine subjects; the many caricatures by Rowlandson, Gillray and Cruikshank, and the British sporting print.

Here again some attempt has been made to describe means of telling if the colour has been added later, and how to distinguish the many reprints of sporting prints.

When prices are mentioned it should be remembered that these are subject to constant fluctuations.

Acknowledgments are due to Messrs. Sotheby & Co. for the loan of photographs from their records.

1. Some Hints to Collectors

SUMMARY of ORIGIN and PROCESSES

The word *Print*, when used in its pictorial sense, embraces any form of printed picture. Various methods of holding ink on a block or plate, and transferring it to paper, have been invented from time to time, and prints are often referred to by the name of the process by which they are produced, such as 'etching', or 'lithograph', but they all come under the generic heading of 'prints'.

These processes are usually divided into three categories:

Relief prints (where the lines are raised, as in woodcuts).
Intaglio prints (where the lines are below the surface, the word *Intaglio* being Italian for engraving). *line engraving*
Surface, or planographic, prints (lithography).

It is generally agreed that the earliest prints produced in Europe were made about A.D. 1400, and were both playing-cards and coloured religious prints, a large number of the latter being issued by the monasteries and given or sold to pilgrims, after Pope Boniface IX (1389–1404) had granted indulgencies to places of pilgrimage other than the churches of Rome.

The first prints were made from wood-blocks, a development of a much older process of printing patterns on materials. It was only at the end of the 14th century that paper was manufactured in sufficient quantity in Europe to make possible the production of cheap prints on paper.

About 1430 another system of printing was tried: the first of the intaglio (engraving) processes, known as *line-engraving*. This was a goldsmith's art, developed from the engraving of designs in metal, the lines often being filled with another metal, such as gold, or a dark substance to show up the design. Printing from plates engraved in this way was first practised north of the Alps, although it may have developed independently in Italy, from the engraving of pictures on small silver plates, filling the lines with a black 'nigellum': an art known as *niello engraving*.

Etching was the next system to be invented, shortly after 1500. In this method the lines were bitten into the plate by a mordant, such as acid, instead of being engraved by hand. The first etchings were made on iron plates, because it was a development of the armourer's art of etching designs on weapons.

Next in order of discovery was the process known as *mezzotint*. This was invented about 1640, to imitate tones instead of lines. A burr was raised on the plate with a

toothed wheel or rocker, which enabled a cloth coat, for instance, to be imitated in a rich, velvety black, whilst less burr on the plate meant lighter tones for flesh and other tints, graduating to no burr at all for the highlights.

Aquatint was first used about 1650, though patented in the latter half of the 18th century. Its purpose was the imitation of a water-colour wash.

Lithography was perfected by Alois Senefelder in 1798. He intended it to be a cheap means of duplicating parts of plays for actors and cheap musical scores for orchestras. It was soon used as an effective means of reproducing drawings.

PRICES and FASHIONS

Western artists have been making prints for nearly 600 years, and merchants, for most of this time, have been adding to the total by breaking up illustrated books to sell the plates separately, thus increasing the already formidable amount of prints, and adding the necessity of knowing which came out of books and which were published singly.

The subject is, therefore, so vast that few collectors will have time to do more than specialise in one branch or period, and it is, in fact, the specialist who stands most chance of recognising something that may pass unnoticed by others. Many an amateur, by devoting his activities to one section, has acquired a greater knowledge of his subject than professionals, trying to cover a wider field.

On the other hand, it would be useless choosing a type or period that might prove too barren. In some cases so much has been absorbed by museums that supplies have almost, if not quite, dried up, leaving little opportunity of forming a collection at all.

This is true of the always scarce early Italian prints of the 15th century, which now hardly ever appear in sales, and of Northern pre-Dürer prints, many of the earliest, in any case being known in only one or two examples.

The earliest 15th century wood- and metal-cuts are also of extreme rarity, existing in only one or two prints of each of the 3,000 or so catalogued by Schreiber in his *Handbuch der Holz- und Metallschnitte des XV. Jahrhunderts*. Little care seems to have been taken of them, and the survival of most was due to their being bound in manuscripts, or stuck in the lids of bible- and breviary-boxes, to assist priests in administering the last rites. Others were used in worship, or as protection against the plague; also, in common with paintings, to teach those who could not read.

Periodical outbursts of the sacking of cities, or of iconoclasm, have decimated the ranks of art, although Pope St. Gregory said such instructional things should not have been destroyed. No doubt, in 1498, when Savonarola's fanatical followers lit their bonfire of 'Vanities' in front of the Palazzo Vecchio in Florence, prints went the way of books, illuminated manuscripts, paintings, false hair and rouge pots.

It is known that most of the paintings, sculpture and stained glass in the churches of the Netherlands were destroyed by the Protestants in the brief but destructive 'Beeldstorm' of 1566. Engravings may also have succumbed, 'for the churches had been enriched generation after generation by wealthy penitence'. Antwerp suffered in 1576 from the 'Spanish Fury', the revolt of the unpaid Spanish troops, and many

'estampes galantes' must have perished under the 'tree of Liberty' in the French revolution.

Britain also had her fair share of these bouts of destruction, such as the Reformation, when the contents of the monasteries were dispersed or destroyed, and again as a result of the Parliamentary decrees of 1642–5, that all pictures with the representation of the Second Person of the Trinity or the Virgin Mary 'shall be forthwith burnt'.

One of the fanatics appointed by the Cromwellian government to carry out this task – William Dowsing – left an account of how he worked 'godly thorough reformation' on the Cambridge colleges and elsewhere. 'We broke down about one hundred superstitious pictures; and seven Fryars hugging a Nunn' (St Joachim embracing St. Ann?). 'We broke down 1,000 Pictures superstitious, I broke down 200 . . .' He was described as going about the country 'like a Bedlam, breaking glasse windows, having battered and beaten downe all our painted glasse, not only in our Chaples, but (contrary to order) in our publique schooles, Colledge Halls, Libraryes and Chambers, mistaking perhaps the liberall Arts for Saints . . .'

Other kinds of prints, such as Elizabethan portraits, are seldom seen now, but Rembrandts are still a feature of the auctions, though it would probably be impossible to form anything like a collection of examples printed on Japanese paper only, as was done a generation ago, or, as Eugène Dutuit advised in the 19th century, examples on different kinds of paper and with different effects of inking.

Enormous increases in values have occurred in recent years of things fashionable. The steadiest holders of favour have always been the established old masters. Inflation, taxation and legislation have also played their parts.

Quoting from some of Sotheby's recent sales: Goya's *The Giant* realised £20,500 in 1964. *The Women's Bath* by the early Flemish 'Master P.M.' £32,000 in 1966. *The Letter M*, composed of grotesque figures, by the 'Master E.S.' £13,000 in 1966. These prints would have been worth little more than a thousand pounds each before the war. In 1966 Rembrandt's *Hundred Guilder Print*, on Japanese paper, made £26,000, a similar one having realised £1,000 just after the war, and the *Three Crosses* £30,000.

Astonishment was expressed ten years ago when a set of Canaletto's etchings made £1,000, but recently a set sold for £5,000, and another set, in Consul Smith's binding, for £10,000. It seems strange now to read in a book on Piranesi, published a generation ago, that his values 'have risen so much that a collection of the best of his plates could hardly be made for less than two hundred pounds', when recently a set of 135 plates of the *Vedute di Roma* alone fetched £2,000, and the sixteen plates of the *Carceri*, in the volume *Opere Variae*, £3,400 in 1965, and £11,500 in 1969 for first states.

In more modern fields the set of ten lithographs 'Elles' by Toulouse-Lautrec realised £8,000 in 1966 and *La Grande Loge* £5,500: each would have been worth less than £1,000 a few years ago. The lithographs of Odilon Redon reached nearly £2,000 but those of Fantin-Latour, who taught him the crayon and transfer process, go for next to nothing.

Fashion is perhaps the strongest influence on prices, every generation having its

favourites. Consequently some prints have gone down in value, the most notable instance being 18th century mezzotints. In the 1920s proofs of the portraits of ladies after Sir Joshua Reynolds, Gainsborough and Romney were selling for more than a thousand pounds each, and acclamation was heard in the saleroom when *The Ladies Waldegrave* made £3,045 in 1923; now these prints would be worth no more than a tenth of those prices.

Eighteenth-century colour-prints have suffered too, though not quite so badly as the 'black and white'. But no one now would pay £5,000 for Debucourt's *Les Deux Baisers*, or £1,000 for Lawrence's *Miss Farren*. Seventeenth-century line-engraved portraits by, for instance, Nanteuil, Masson and Delff have also fallen very badly.

Some of these changes, such as the demise of 'artist's proofs' beloved of the Victorians and Edwardians, are hardly surprising and not to be lamented, but it would seem, in certain cases, the pendulum has swung too far. Some etchings done since the revival in 1850, though over-priced after the first war, were almost entirely obliterated by the slump of 1930, and might be worth investigating again: Bone, Cameron, McBey and Griggs perhaps, and some of the Barbizon school. Others – Meryon, Whistler and Felix Buhot – are already reviving, but Seymour Haden, Whistler's brother-in-law, is still to be bought for a trifle. He was a great etcher of trees and his best plates, like *Sunset in Ireland* and *By-Road in Tipperary*, once worth up to £200 each, are now to be bought for a quarter of this, whilst many others can be bought for a few pounds.

It should not be forgotten that fine impressions of 18th century mezzotints, and colour-prints, with other prints, like coloured sporting prints and Swiss views and costumes, are also extremely rare, and may quite possibly disappear from the markets when this is realised, and the few available specimens are absorbed by museums.

Really fine impressions of colour-prints are in fact far rarer than many of the Old Masters, because hardly any museums, librarians or collectors bought them at the time of their publication.

REFERENCE BOOKS

Catalogues of individual artists' works are essential. These are available in places like the Print Room of the British Museum, but it is, of course, far better and more convenient to have one's own books, in which to make notes. Books with good illustrations are always useful, in fact, some otherwise admirable catalogues issued recently have illustrations too small to be much help.

The work of single artists – those who had large outputs – can be a very considerable study by themselves, Rembrandt, for instance, being credited with over 300 plates. Over eighty of these copperplates are still in existence, most of them in America and not in the Bibliothèque Nationale, as stated in some recent catalogues. Previous owners of these plates reprinted them from time to time, throughout the 18th and even into the 20th century.

The same thing happened to other etchers, like Ostade, Bega, Claude and Hollar,

because, until the 19th century, it was not the custom to destroy or cancel plates after printing a limited number.

REPRINTS and COPIES

With the aid of good illustrations it is possible, not only to compare them with copies, but to understand the information given in the catalogues, and distinguish early impressions from late or bad.

For example, Rembrandt's work is usually reinforced by drypoint touches, which wore down quickly, and late, worn impressions can be told by the absence of this work. Early woodcuts, like Dürer's, were cut with a surrounding borderline: pieces would break away as they became used, or in the finer lines in the blocks themselves, leaving gaps.

Very late impressions of wood-blocks often show cracks, some starting from quite early impressions as thin lines and gradually widening and lengthening. Frequently, in course of time, wood-blocks became worm-eaten, the wormholes showing white in the inked parts of a print. But it must not be forgotten that the wormholes, the cracks and the gaps in the borderlines have often been filled in on the paper with indian ink.

Weak impressions of etchings and drypoints are sometimes reinforced in the shadows with a wash of indian ink, needing exceptionally good eyesight to detect. To make sure a print is free from all these touches a good magnifying glass is necessary.

Many of the best-known woodcuts and etchings have been copied, even the lesser-known ones by important artists, and those copies made during or soon after the time of the original can be very difficult to detect. As instances, a copy of the 'Little Polander' by Rembrandt was reproduced as an original in an authoritative catalogue, and another catalogue, in its first edition, inadvertently reproduced three, because, to avoid expense, the publishers had hired the plates already used for a book on the subject.

The copying of etchings did not always have a fraudulent intention, as it was a general practice, at least in former times, for an art student to be given a well-known etching to copy as his first lesson in the art, the closer he could get to the original the more commendable his performance.

Similarly, reproductions made by photogravure dating from the 1870s are among the most deceptive copies. Although made as honest artistic records, unscrupulous opportunists, with other ideas, have removed the marks purposely put on by the makers.

Armand-Durand (1831–1905) used a red-seal stamp, on the back of the prints (Fig. 1).

Fig. 1: Armand-Durand mark on backs of reproductions.

He called his process 'heliogravure', and commenced in 1869 with a long series of 401 reproductions of etchings and engravings by old masters, following with the engravings of Schongauer, Dürer, Mantegna and van Leyden, and the etchings of Rembrandt, Van Dyck, Ostade, Potter, Claude and Ruisdael. Any text accompanying the prints was by Georges Duplessis, Keeper of Prints at the Bibliothèque Nationale.

Some foreign reproductions have words stamped on the backs saying they are facsimile reproductions, and the Autotype Company, working before 1900, printed their name in the margin. Some reproductions of modern prints favour a stamp, sometimes a blind stamp, in the margin.

The trouble with these precautionary names and stamps in the margins is that they can be cut off. The stamps on the back are more difficult to remove, unless the prints are stuck down on another sheet of paper. If scraped away they leave a thinned spot and the red Armand-Durand stamp has been known to come through to the front in a very faint red spot.

An example was once seen where the paper of one of these reproductions had been 'split' (thinned) and ironed down on to a piece of old paper of the period; then a frame obtained having the label on the back of a famous firm of dealers in old master prints, the result appearing to be an old print on paper of the right period, coming from an unimpeachable source.

Some of these reproductions, such as Armand-Durand's, were in fact printed on specially-made paper, an excellent imitation of old paper, and sometimes on Japan paper. The ink used was of a slightly browner tone than the black used north of the Alps, and they were often printed with 'retroussage', giving them a rather watery appearance (see Printing, page 151).

Another form of deception is the print in a frame with a glass dirtied on the inside. In the 1920s Pears Soap reproduced for advertisement the two prints after Wheatley, *The School Door* and *The Cottage Door*, the name of the firm appearing in a small circle at the foot of the prints. These could be bought for twopence a pair, so someone acquired a number of pairs, framed them with dirty glasses, and employed a squad of people to sell them to printsellers just at dusk, with some success. Similarly, about the same time, a *View of Fort George, New York*, had several successes, even in the salerooms, because the 'offset' method was used, enabling a photographic reproduction to be transferred to a rubber cylinder and printed on the comparatively uneven surface of 18th century paper. In both these cases buyers were caught because they were unaware at the time that these particular reproductions had been made.

PAPER and WATERMARKS

Some study of paper cannot be omitted, in order to know that prints are on the right kind of paper for the period, although it must not be overlooked that unused sheets of old paper are still procurable, nor that good imitations of old, hand-made paper can still be manufactured.

Paper is of two main types, 'laid' and 'wove', and prints up to the end of the 18th century will be on 'laid' for all practical purposes. It is so called because the bottom

of the mould in which the sheets are made consists of fine wires laid closely together lengthwise (Fig. 2), crossed at about every inch to inch and a half by other wires (laid- and chain-lines): the lines of these wires can be seen when held up to the light, and in paper say about 200 years old a darkening shadow will often be visible on either side of the broader-spaced chain-lines. The surface of this paper will be covered with hair-marks, from the felt layers between which the sheets were pressed. It is still manufactured and used to print reproductions of old prints.

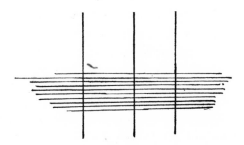

Fig. 2: Wiremarks.

In 'wove' paper the bed is woven into a fine mesh, or a finely pierced sheet of metal used, so that no wire-marks show. 'Wove' paper in Europe was not made generally till about 1800, and nearly all prints of the 19th century that were intended for hand-colouring, such as Sporting Prints, are on 'wove' paper.

Other kinds of paper used are India paper – a very thin, semi-transparent paper, usually backed by a thicker sheet when printed, so that it becomes laid down (French: *chine collé* or *chine appliqué*) – and Japanese paper, generally of yellowish tone and with a soft 'silky surface', showing fine, gossamer-like hairs under a magnifying glass.

One sees the term 'China' paper applied to a whiter type of Oriental, but this can be a too literal translation of the French *papier de chine*, which means India paper. The thick Japanese paper, used by Rembrandt for some of his best impressions, was called by the French *papier des Indes*, as well as *Japon*. A modern thick Japanese paper is known as Japanese vellum (French *vélin*). The French in fact misuse the word vellum for other papers with a smooth surface.

In the mid- and later 18th century, many English prints, such as those after Hogarth and Morland, were printed on a soft, pliant paper, which, if a large whole sheet were bent over, would rest edge to edge without springing back. This was used for Piranesi's plates when printed in Paris, and was especially suitable for mezzotints, as its softness was considered less harmful to the delicate plates. A disadvantage was that it had lumps in it, visible on the back and aptly likened to porridge. Connoisseurs have been known to remove these lumps with sandpaper, because, they were not only liable to rub on the top into bare spots, but, in a pile of prints, also to have an adverse rubbing effect on those underneath. Prints, most of all delicate mezzotints, should never be allowed to rub anyway.

This paper, as sometimes in other makes, had two different watermarks to the sheet, so that when folded once, a different watermark would appear on each half-sheet. The first carried the name of the maker and the town in two lines of capital letters: the top line T. DUPUY FIN (fin being the quality of the paper), the second line AUVERGNE 1742. The date never varied, even after 1800, because it referred to regulations regarding manufacture. The beginning of the maker's name incorporated a picture of a bell. The second watermark, to appear on the lower half of the folded sheet, was a double-eagle.

When it came to prints of the 19th century, which were intended for hand-colouring, such as Sporting Prints and views, these were nearly always printed on Whatman paper. This was at the time a 'wove' paper, so was without any lines except the watermark J. WHATMAN and the date changed each year (TURKEY MILL was sometimes below the name, usually on a thick variety). Paper of a similar type, used at the beginning of the 19th century, had the watermarks S. & C. WISE, or E. & P., with the date. No doubt paper of the fine smooth surface of these makes was chosen because the prints were intended for hand-colouring and would take the water-colour wash of a skilled colourist without blemish.

Watermarks only occur once to a good-sized sheet and will not be visible on every one of a set of small prints. Sometimes, of course, the watermark or part of it has been cut off.

These watermarks, the devices used by proprietary makes, are quite a study, books having been devoted to them, and many catalogues of the works of early masters have sections and reproductions of watermarks, Rembrandt being a notable exception. It is important to know at least those associated with the best impressions of any artists being collected, though unfortunately they cannot be studied in museums, where, for safety's sake, the prints are fixed to the mounts and cannot be looked at through the light. A few watermarks have been mentioned in the chapters on the leading engravers.

Watermarks can be forged by scraping and thinning the paper, so that they will show when held to the light; they can also be erased by sandpapering. In the latter case the whole area of the rubbed place will show thinned when held up. Paper made by Whatman in the first half of the 19th century bore a watermarked date on each sheet, which should correspond to the date, if any, appearing in the publication line of a print.

The reproductions of Rembrandt and other old-master prints made by the firm of Armand-Durand dating from the 1870s (see p. 17) are usually on a good imitation of old 'laid' paper, with the broader wiremarks one and three-sixteenths inches apart. The watermark is a figure of Fortune on a globe, holding a scarf over her head. Other very good reproductions were made at this period by The Autotype Company, etc., and Van Gelder paper was often used, with the watermark of a shield incorporating a fleur-de-lis and surmounted by a crown, with the name Van Gelder Zonen or the letters V.G.Z. *Arches* paper was also used, a laid paper having this name as a watermark, or a shield with the letters A.M., surmounted by a crown.

REPAIRED PRINTS

Damages and repairs are very common, the corners suffering most, especially in old-master prints. It was a frequent practice of early collectors and librarians to mount their prints in large volumes, stuck at the corners, and careless handling or removal may have damaged or torn them off. Sometimes they have been replaced, and often when missing they are facsimiled in pen and ink.

Damage can usually be noticed when the print is held up to the light, but it is worth knowing that there are restorers who can repair a clean tear so that it cannot be seen, even when held up to the light. A hand-coloured print is more difficult to repair, where a wash is disturbed.

When a print is laid down, the purpose, more often than not, has been to reinforce repairs or prevent them being so easily seen. There are, however, occasions when it may be necessary to strengthen a print in this way. Prints have been seen, after some years spent in New York, to be in an extraordinarily brittle condition: Sporting Prints, on Whatman paper, and even Dürers, on their fine, handmade rag paper. The colouring of the Sporting Prints has been still perfect, and all may have spent many years in frames. This brittle effect may be due to the atmosphere aided by excessive central heating.

PLATEMARKS

The platemark is the indentation made by an engraved metal plate in the damp paper when printed. Rough edges, with some ink on them, and very sharp corners, are often indicative of early states: after a few impressions the edges would be smoothed, so that they did not hold any ink, and the corners rounded, to prevent the plate cutting the paper.

Purists will say that the platemark should be well indented in the paper, because this will show the print has never been subjected to a wet-cleaning or repairing process and subsequently ironed down.

It will show also that it was not too heavily pressed after printing. Seymour Haden said that a print should be left to dry and not pressed immediately, so that the raised lines of ink had time to harden: then it could be lightly dampened again and pressed, so that the lines would not be flattened out. Pictures of printers at work often show prints drying over strings, like clothes on a clothes line (see Printing, p. 152).

Old-master prints rarely have margins, but the platemark should be visible, as it shows the extent of the print. From the earliest times some prints were issued with a title or inscription below, or even, as in the case of several Rembrandts, with a blank space. This is part of the print, so, if the platemark cannot be seen, a check should be made to ensure that nothing is missing.

A very narrow bevel is sometimes to be seen on 18th century prints, from the filing and smoothing down of the edge, not more than about a sixteenth of an inch: but the practice of putting a broad bevel on the edges of plates did not occur until the 19th century. This is like the bevel put on plate-glass or mirrors, giving the effect of two

lines up to as much as a quarter-inch apart, and did not come into general use until the 1840s, although it has been seen occasionally on earlier 19th century prints about 1820. For the many issues of Goya's works, the plates were bevelled about 1850 (Fig. 3).

Reproductions can often be spotted by their bevelled platemarks, though it must be borne in mind that cunning fakers would know this and cut them off. The plate-marks of reproductions are often well beyond the prints, whereas, in the originals, they are usually close up to the work, at least at the top and sides.

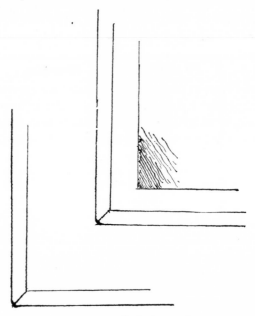

Fig. 3: Bevelled platemark.

The platemark of a copy or reproduction can be smaller, as well as larger, than the original plate, although the actual picture may be the same size. Some of these smaller plates appear at first glance to be proofs before the titles, but a second look will show, from the platemark, that there is no room on the plates for the titles.

Such a reproduction is one of *Miss Farren*, afterwards *Countess of Derby*, from the large full-length stipple engraving by Bartolozzi after Sir Thomas Lawrence: the re-production has no title because there is no room on the space below the picture. Other deceptive reproductions were made of the line-engravings known as the *Monument du Costume*, after Moreau le jeune: here again, though the names of the artist and engraver are printed below the pictures, there is no room for the titles, the plates thus at first glance appearing to be proofs.

Reprints from old plates can also sometimes be told by the plates having been bevelled for the new issue, the first issue being printed before the practice came into vogue. For instance, 18th century mezzotints, such as portraits after Reynolds and subjects after Morland, were mostly grounded and worked right up to the edges of

the plates at the tops and sides whilst in later reprints the bevelling cleared a space at the edges.

BORDERLINES

Many prints had borderlines: in early prints, just inside the platemarks at the top and sides, sometimes with, at the bottom, a space between the borderline and the plate-mark, if a title or inscription were intended.★

In the case of woodcuts, these nearly always had borderlines to enclose the work, which can be a useful means of indicating whether an impression is an early or a late one. In the course of time and wear these borderlines broke in places (Fig. 4). Joseph

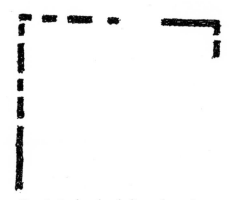

Fig. 4: Broken borderline of woodcut.

Meder, in the *Dürer Katalog*, has been able to list these breaks as they grew larger and more numerous, forming useful indications of early or late impressions, but it must be pointed out again that these gaps are often cleverly inked in by hand, with brush and ink, to feign earlier impressions.

Some etchings were also made with borderlines, the lines in early impressions often being thin and not always continuous, and strengthened evenly all round in later impressions. This is particularly the case with the etchings of Claude le Lorrain (1600–82) the French artist who worked in Rome, and Adriaen van Ostade (1601–85), the Dutch painter-etcher of peasant scenes, where the borderlines were strengthened and made even with a burin after the earliest states.

When a broad borderline, say about a sixteenth to an eighth of an inch wide, sur-rounds an engraving, it is sometimes composed of a series of parallel lines so close together that it looks like a continuous band (Plate 1). It is made of these lines to hold the ink which would otherwise be wiped out of a very broad single line, and here and there a white space of paper will show between the lines.

Such borderlines were often used on French colour-prints and crayon-manner prints of the 18th century, and, if the borderline appears to be engraved in some other manner (unless it be aquatint), then it needs checking. It might be one of the exceptional cases

★ Versions with spaces at top and sides larger than 3 to 4 mm. should be viewed with suspicion.

where the borderline is engraved with the roulette or some other means, but it would certainly be worth a careful examination (Plates 2 and 3).

Some of the very deceptive reproductions of French colour-prints done about 1900 have the borderlines made up of parallel lines, but often they are weak and spidery, not giving the effect of a continuous band of black as in the originals.

MARGINS *and* INSCRIPTIONS

The 'margins' are the paper beyond the platemark. They are rarely found on old-master prints and not often on etchings made in the 17th century, leading to the supposition that they were cut off when published. The term 'thread margins' means that a print shows its platemark, with just a fraction of margin beyond. 'Small margins' means an eighth to a quarter of an inch. 'Wide margins' could mean, on an old-master print, from a half-inch to an inch. 'Full margins' means that the sheet of paper is virtually untrimmed, the edges sometimes being referred to as 'deckle edges', i.e. with uneven edges, as made.

Whistler, except for his early French and Thames etchings, cut the margins off his Venice and later etchings, leaving only a tab for the signature, arguing that you did not have margins on an oil-painting, so why on prints? Some of his followers, like Theodore Roussel, followed his example. A leading London dealer, some years ago, sent a set of Whistler's Venice etchings to a famous Continental restorer to be cleaned. They all came back with full margins. Amusedly he had to take a pair of scissors and cut them off again.

This remargining has been practised very cleverly by restorers, many an old-master print having a missing platemark grafted on to it. Titles and inscriptions below prints were frequently cut off and pasted on the backs of frames by misguided framers, who thought the prints looked neater without them, and are quite often replaced, with an 'invisible mend'. When entirely missing, these titles and inscriptions are occasionally found to have been replaced by clever pen and ink facsimiles.

All prints published in England in the 18th century after 1735 should have a publication line (see Hogarth, p. 87). If missing it may have been cut off or the print may be a reprint.

MEASUREMENTS

It will be found that prints do not always measure exactly the same as the sizes given in the text books, in fact few prints measure exactly the same, although from the same plate: in small prints the differences may be very slight, but in large prints they may be astonishingly great. This is because the paper was dampened for printing and the shrinkage not alike in every case.

Some of the prints may also have been 'drummed', that is stuck at the edges on a board to dry. This renders prints less liable to cockle, and may have been done at the time of printing, or by a framer, who, if a print had wide margins, would dampen it, turn the edges over a stretcher and stick them, so that the print would contract and dry like a drum.

Again, when prints have been through a wet cleaning or restoring process they will expand and contract again when dry, almost certainly to a different size.

It is on record that a Rembrandt etching,* printed on vellum, had shrunk to such an extent that Adam Bartsch, the great cataloguer of old-master prints, could not believe it was from the same plate and recorded it as a second and smaller version.

STATES

A print is often referred to as being in the first or second state, or even perhaps in the tenth state: this means that alterations have been made during printing. Sometimes there is only one impression known in the first state, which may indicate that the artist or engraver saw something needing improvement, after the taking of one print.

Any alteration constitutes a 'state'. States are often caused by rework due to wear: such rework was done to many plates after the lapse of more than a hundred years and is ignored by some authorities, though those reprinted in the 18th century from Rembrandt's plates have lately been fetching astonishing prices in the salerooms.

A state may be due to an accident, like the printer's young son playfully smiting Woollett's plate of the *Death of Wolfe* with a hammer, saying 'I could soon be the death of Wolfe'.

Extensive alterations can be made to a metal plate by scraping away the lines, then, taking a pair of calipers, placing the point of one arm on the erased place and marking the place on the back of the plate with the other arm. This place is then hammered from the back on an anvil, until the hollowed-out place on the front is flat again, and level with the rest of the surface. It is then burnished until all scratches are removed and the new work can be carried out.

Some compilers of lists have made states out of scratches appearing and disappearing, though the partly-starched muslin used for wiping the ink off the surface of plates can sometimes scratch the soft copper.

In cases where lettering was engraved at the foot of a plate, such as artists' names and the title, this was done by specialists in that work, and states may read as 'proofs before all letters'; 'proofs before letters' (where some but not all of the words have been engraved); 'scratched (or etched) letter proofs' (where the lettering has been thus indicated for the letter-engraver); 'open-letter proofs' (where the letters are in outline and not filled in); finally any alteration in the lettering or publication line will constitute a state.

In the late 18th and particularly in the 19th century, it was customary deliberately to make states to cater for the whims of collectors. There were 'remarque proofs' where a little 'remarque' was engraved at the foot of the plate (to be later removed); 'artist's proofs', 'lettered proofs', 'India paper proofs', and so on.

As examples:

1806, by Jules Jacquet after Meissonier, was published in 200 'remarque artist's proofs on vellum'; 100 artist's proofs on vellum; 150 artist's proofs on Japan; and 400 lettered proofs.

* *Old Bearded Man* (Bartsch 300).

The Monarch of the Glen, by Thomas Landseer after his brother Sir Edwin Landseer: 300 artist's proofs at £10 10s. each; 200 proofs before letters at £8 8s.; 100 lettered proofs at £5 5s.; and an unlimited number in the 'print state' at £3 3s.

The Horse Fair, by Thomas Landseer after Rosa Bonheur: 1,000 artist's proofs at £12 12s.; 1,000 proofs before letters at £10 10s.; 1,000 lettered proofs at £7 7s.; and prints *ad lib.* at £4 4s.

The Railway Station, by Francis Holl after W. P. Frith: 1,000 artist's proofs at £15 15s.; 1,000 proofs before letters at £12 12s.; 1,000 lettered proofs at £8 8s.; and prints unspecified.

Derby Day, by Auguste Blanchard after Frith: 1,000 artist's proofs at £15 15s.; 1,000 proofs before letters at £12 12s.; 1,000 lettered proofs at £8 8s.; and 2,000 in print state at £5 5s.

Even Rembrandt has been thought to have taken advantage of the dawning demand for 'states'.

Alterations to a wood-block can be made by cutting out a section and fitting in a new one. There are woodcuts by followers of Dürer which, in late states, have the more famous Dürer monogram added in this way. A surprising number of alterations were found to have been made in the Maximilian blocks, when discovered in the 18th century.

A lithograph can also be altered if necessary by grinding down and reconstituting the surface.

FALSIFICATION of STATES

A print may sometimes appear to be a proof before the lettering, when, in reality, the lettered space has been wiped clear of ink before printing, or a strip of paper placed over it. In the former case traces of the indentations of the letters can often be seen, especially if deeply engraved. In the latter case, known as 'masked proofs', the indentation made by the edge of the strip of paper is usually visible, especially when it is carried over the margins at the sides.

The 'masked proof' was often a genuine proof with an uncleared inscription space, showing unsightly scratches and work that would be cleared away before the lettering was engraved, covered up by the printer for neatness, but it was also a method of faking a proof before letters.

A much more subtle and complicated form of falsification was done by over-printing, or double-printing, combined with masking. The earliest of engravers, the 'Master of the Playing Cards', did this double-printing by printing his suit-signs in the corners of prints already made. Later printers took plates by Rembrandt and Van Dyck and treated them in this way to make false states.

An impression of *Rembrandt and Saskia* is known with his mother's portrait instead of his wife's. This was done by wiping or masking out the portion containing Saskia, printing an impression with that part blank, then putting the paper through the press a second time and printing the portrait of his mother in the space left blank the first time. The *View of Amsterdam* is known with a hare in the fields, printed afterwards to create a false state. Adam Bartsch, the great cataloguer of old prints, was

deceived by a falsification of Rembrandt's *Christ Preaching* (*La petite Tombe*) into describing it as a first state.

In Van Dyck's case, equally, if not more deceptive things are known. An impression of *Jan de Wael* sold before the last war was extremely puzzling, until the mystery was elucidated by Mr. Osbert Barnard in an article in *The Print Collector's Quarterly*: it transpired that it was the only impression in its particular state which had not been falsified. The left arm had been erased from the plate, so that it left a blank space. In all other impressions, with this arm-space blank, another arm had been inserted as re-etched in a later state: i.e., in the second printing only the arm had been inked and printed in the blank space.

The chief evidence of this was in the scratches appearing both on the plate in the earlier state, with the arm space blank, and in the later state with the arm re-etched: these scratches had printed twice in the falsified impressions, indicating that the print had been through the press twice. Had it been a case of the paper slipping on the plate and thus double-printing (a thing that happens sometimes) the other lines near the scratches would also have double-printed. The registering of the plate for the second printing was extremely good, otherwise there would have been a second platemark.

In some of the plates of Van Dyck's *Iconography*, the name of the first publisher, Martin van den Enden, was inserted on late impressions by having it engraved on a second plate, which was made larger than the old one, so that the new platemark came outside it and could be cut off.

On plates where Van Dyck had etched only the head – as in his self-portrait (Plate 4) – and the plate had been finished by other engravers, cases have been known where the valuable early states have been falsified by masking out all the bodywork, and the scratches and blemishes, which appeared on the blank paper in the early states, imitated with a pen and indian ink.

ABBREVIATIONS

When the names of engravers and artists appear on prints, usually at the foot, a Latin word, generally abbreviated, will be found to follow them.

The words employed for 'engraved it' are:

Incidit (often abbreviated to inc.), or intaglio.
Sculpsit (often abbreviated to sc.); exsculpsit for re-engraved.
Caelavit.
Fecit, usually applied to 'etched it' and often abbreviated to fec. or f.

For 'painted it':

Pinxit.
Invenit (designed it).

For 'drew it':

Delineavit (generally abbreviated to del.), or disegno.

For 'published it':

Excudit, or Excudebat (sometimes abbreviated to ex., or exc.).

Three names may appear if more than one engraver or artist was employed, for instance: Painted (or Drawn) by . . . Aquatinta by . . . Engraved by . . .

Another case where three names may occur is when an intermediary artist was employed to make an 'engraver's drawing' of a picture (mostly on a smaller scale), from which the engraver could work: so the inscription may read: . . . pinxit., . . . del., . . . sc.

COLLECTORS

To make a fine collection of works of art is one of the easiest ways to fame, and many collectors of prints have achieved this through the 'marks' with which they have stamped or inscribed their possessions.

Thousands of these marks exist, so occur frequently on prints of all ages, some being a guarantee of quality, whilst others, such as that of Sir Joshua Reynolds, were stamped by executors on everything and give no indication of the value set on the objects by the owners. These marks have been recorded by Frits Lugt in *Marques de Collections.*

Sir Peter Lely's mark (his initials P.L.) is a good one, and it is said that his sale of 1688 first aroused the general taste for collecting prints and drawings. The signature of the dealers and collectors Mariette always adds to the value of a print; on the other hand the name of Storck of Milan, or of Naudet, is usually indicative of a late impression.

Some of them are a warning, if not of the cupidity, at least of the avidity into which a collector may easily fall. The initials of P. H. Lankrink, very like the P.L. of his master Lely, should be a reminder that he borrowed money for his passion, which he never succeeded in repaying.

The Chevalier Joseph de Claussin (1766–1844), who compiled a catalogue of Rembrandt etchings, had an admirable collection of them, which he kept in a small portfolio. This he placed under his pillow, and would rise in the night to examine some new perfection which had passed before his eyes in a dream.

At the Pole Carew sale in 1835, he bid up to £200 for the extremely rare portrait of *Arnold Tholinx*, then, observing it going beyond his reach, made a speech explaining who he was and how he had waited all his life for an impression of this print. If this one escaped him, he was never likely to see another at his time of life. He begged the other buyers with tears in his eyes for a little generosity, and to consider the service which his catalogue had rendered to collectors and the sacrifices which he had imposed on himself.

Such a speech at a staid sale of prints caused quite a sensation and some of those present were moved with pity. Others smiled when they did indeed recall often seeing this collector, who could push an etching up from ten pounds to two hundred, seeking in the mornings two sous' worth of milk in a little jug. After a moment of silence the auctioneer resumed the sale and the hammer fell at £220, the buyer being Baron Verstolk van Soelen, Foreign Minister in Holland.

Verstolk had in fact two impressions of this print, of which only about six examples

are recorded, now described by Nowell-Usticke as unobtainable and valued at $125,000.

Any collector will sympathise with de Claussin, and, perhaps, with Cardinal Mazarin, who, when he should have been finding excuses to place before his Maker for the possession of his vast quantity of worldly goods, was pausing in front of each treasure in turn and bemoaning that he had to leave them behind.

Sir Thomas Lawrence, President of the Royal Academy, who had been a brilliant infant prodigy and studied Marcantonio at the age of fourteen, possessed, not only prints, but one of the finest collections of old-master drawings ever formed, buying whole collections for thousands of pounds at a time, so that he owed his agents nearly £20,000 at his death.

The refusal of the nation to purchase this collection is an example of the other extreme of indifference, in spite of Talleyrand urging 'if you do not buy those things you are barbarians'.

Lest this thrust should rankle, there is the parallel case of Cardinal de Fleury refusing for Louis XV the chance of buying the famous Crozat collection, saying 'the King has got enough rubbish as it is'.

2. Woodcut (xylography)

EARLY WOODCUTS

As stated in the Summary, the earliest prints were produced from wood-blocks, the lines being left in relief, while the surrounding surface was cut away.

The usual procedure was for an artist to draw a picture on a wood-block, the surface of which had been smoothed with moistened bath-brick and then covered with a coating of white. Sometimes he would cover the back of a drawing with red or black chalk and transfer it by placing the drawing on the block and indenting the lines with a hard point. He could also lightly prick through the lines with a needle and then draw the design on the block, with the needle marks as a guide.

The earliest prints produced in Europe were both playing-cards and religious subjects, coloured by hand. It is not impossible that cards were first. An incident in the life of St. Bernardino of Siena is thought to bear this theory out, although it occurred in 1423, long after the introduction of printed pictures.

It is related that the Saint preached so eloquently against gambling with cards that his congregation destroyed them, causing a manufacturer to ask, 'How shall I earn my living?' The Saint replied by drawing the Sacred Monogram on a piece of paper, saying, 'Make pictures like this'. No playing-cards, however, printed from wood-blocks (as distinct from engraving), have survived of earlier date than about 1460.

Religious prints were issued by the monasteries from about 1400. The date 1384 appears on one, but refers to a miracle, the woodcut being made after 1450. Other dates, such as 1418 and 1423, which occur up to the middle of the 15th century, are mostly disputed, or merely record earlier events.

There is, however, a highly accomplished Chinese woodcut in the British Museum dated A.D. 868, proving that the art must even then have been very old in the Far East.

This form of printing, in Europe, is considered to have descended directly from the ancient art of printing patterns on textiles, the pattern being repeated over the surface from one or from several blocks, the German *Zeugdrucke*.

In the Lessing Rosenwald collection, Washington, is a lectern cloth of printed linen, with a picture of the *Marriage at Cana*, claimed to be about 1400, printed in black and coloured by hand with red and brown. Some dozen other examples of printing on fabrics are in Basle, Vienna, Nuremberg, and elsewhere, regarded as links between the pattern-printers and the earliest prints on paper. Many are only fragments and none is dated by Schreiber before the 15th century. This includes a wood-block of

the *Crucifixion*, known as the *Bois Protat* from its ownership, which, it has been suggested, dates from 1370.

It was, in fact, the advent of cheap paper that made the production of these prints possible in Europe. The Chinese claim to have invented paper at the commencement of the 2nd century A.D., but it was not till the middle of the 12th century that the first European factory was set up by the Moors in Spain. The Moors, no doubt, acquired the secret from the Arabs, who are traditionally supposed to have captured some Chinese paper-makers in the battle for Samarkand in 751, and to have been ordered by Harun al-Raschid in 974 to use paper for official documents.

Paper factories were gradually established in other European countries, but only at the end of the 14th century did the supply allow the production of cheap prints.

Some 3,000 of these early woodcuts, printed in the 15th century, have been traced and catalogued; they were produced both in Italy and north of the Alps, though by far the greater number are northern. They exist mostly in only one or two examples, and nearly all the European countries were sources of origin. It is thought they may have been issued in the towns on the trade routes, and at, or on the roads to the places of pilgrimage (Plate 5).

Professor Hind in *The History of Woodcut* pointed out that little profit comes from speculation as to which locality led in the field of woodcut. Sometimes prints depicting a known relic may have been made and distributed at places en route to the destination.

Woodcuts of the *Madonna in the Dress with the Ears of Corn* (*Madonna mit Aehrenkleide*), produced in South Germany, relate to a painting which hung in Milan Cathedral, commemorating the vision of a merchant in the city.

In this connection one can visualise Luther's later complaint against the Pope about the empty convent in charge of a lone monk whose principal duty was to sell pictures to pilgrims, for the financial benefit of a favoured cardinal.

THE MAXIMILIAN WOODCUTS

At the end of the 15th century Nuremberg and Augsburg had become two of the chief centres of woodcut production: Nuremberg with the Koberger printing press and the studio of Dürer, and Augsburg with the Schonsperger press and studio of Hans Burgkmair.

Shortly after 1500 the Emperor Maximilian I 'the last of the knights', thought of commemorating his reign and the House of Hapsburg with woodcut works of incredible magnificence (Plate 6).

Konrad Peutinger, town clerk of Augsburg, was put in charge of the works. He was a scholar and on terms of friendship with the Emperor.

The first work to be started was a Genealogy of the Emperor, in book form, for which ninety woodcuts were made, but never published.

In another unfinished work the Emperor appeared as 'Freydal', a young knight journeying to sixty-four Courts and jousting before the princesses. Although it was meant to contain 256 woodcuts (225 miniatures prepared as guides to the artists are

still preserved), only five were actually cut on the blocks. Known as the 'Freydal cuts' they are attributed to Dürer, 1516, consisting of four tournament scenes and a masquerade, or torch-dance, at Augsburg. Freydal is there and his future bride, Mary of Burgundy, is on the balcony with ladies and a jester.

The first series in book form to be actually published was *Theuerdank* (translated by Wilhelm Waetzoldt as 'one who thinks of adventure'), in 1517, consisting of 118 woodcuts, where Maximilian, in the character of Theuerdank, romantically re-capitulates his adventures in war, jousting, hunting, defeating his enemies and gaining his bride, Mary of Burgundy (Princess Ehrenreich in the book).

Hans Leonhard Schäufelein (*c.* 1490–1540), a pupil of Dürer, designed the woodcuts, which were given literary form, from the ideas of the Emperor, by the Prior of Nuremberg, Melchior Pfinzing, and the Emperor's secretary, the notary Marcus or Max Treitzsaurwein.

Another work, intended for publication in book form, but never finished, was the *Weisskunig*. This related in pictorial manner his own life and the life of his parents. His father, Frederick III, was the Old White King, he the Young White King, so named because of his silver armour; the Archduke Sigismund the Merry White King; the King of France the Blue King; the King of Flowers or White Roses is Edward IV; the Red King, Richard III; the White and Red King, Henry VII and the King of the Wild People, the King of Scotland.

The scenes for the *Weisskunig* were dictated by the Emperor to his secretary, or arranged from a Latin autobiography and, from these descriptions, sketched by different artists, the chief of whom were Hans Burgkmair and Leonhard Beck, who drew the scenes on the blocks.

Only a few proofs of the *Weisskunig*, printed at the time, exist. It was not till 238 of the blocks were discovered in the 18th century that an edition was published in 1775.

Another work, in which both Augsburg and Nuremberg combined, was the *Triumphal Procession*. In this again the programme was dictated by Maximilian. The blocks were cut between 1516 and 1518, but not published till 1526, after the Emperor's death. When joined together the 138 blocks measured over 60 yards long: 135 of them were discovered in the 18th century.

The *Great Triumphal Arch* was produced at Nuremberg, Dürer being the artist in charge. One hundred and ninety-two separate blocks were designed and cut, prints from which, when joined together, formed an arch of elaborate design, measuring about 11 by 10 feet.

THE WOODCUTTER

The wood used was generally of a soft type, such as pear or beech, easily cut with a knife or scoop, but the harder boxwood was also known.

The earliest cutters of the religious subjects were probably monks, working in monasteries, but professional cutters, such as those accustomed to cutting blocks for printing textiles, appear to have been employed. They were members of the car-penters' guilds (broadly like the modern unions, but with a religious, sociable and

charitable basis), with the carvers of butter-moulds, etc. Professor Hind quotes a record of work done in 1393, for the Chartreuse of Dijon, by one Jehan Baudet, carpenter.

These woodcutters (German: *formschneider*) had, by the middle of the 15th century, become craftsmen of importance, capable of dictating that only members of their guilds should be allowed to cut illustrations to the books then being printed with movable type. An often quoted document of 1452 records that the guild of carpenters at Louvain caused a cutter named Jan van den Berghe to be officially ordered by the Town Council to join their guild, with other 'printers of letters and pictures'. In 1468, at Augsburg, the work of a printer was held up until he agreed to the cutting of his illustrations being done solely by the members of the guild.

By the end of the 15th century the woodcutter was sufficiently important to hand his name down to posterity by printing it on the block. The names of others working at the beginning of the 16th century were revealed by the discovery, mentioned before, of a large number of the blocks made for the works commissioned by Maximilian I, which are still preserved, a few having the names of the cutters on the backs.

Dürer's chief cutters at Nuremberg were Hieronymous Andreae and Wolfgang Resch. The head of the cutters working at Augsburg on the Maximilian projects

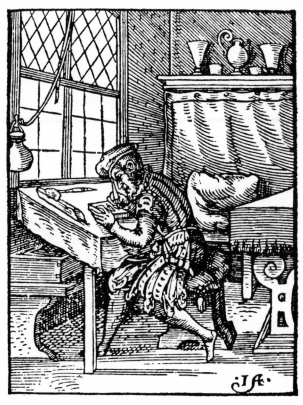

The Woodcutter, by Jost Amman (1539–91); woodcut.

was Jost de Negker, a native of Antwerp, who worked at Augsburg from 1508 to 1544. Among the cutters working under him was Hans Franck, who, it is believed, may be the same as Hans Lützelburger, who cut blocks for Holbein at Basle from 1522 to 1526.

The cutters of this period had, in fact, become so skilful that artists like Dürer took little account of any limitations to their craft, drawing on the blocks in a free and natural manner, with crosshatching, 'parallel' lines which ran into one another, complicated foliage and all the usual curved lines of the Dürer style, some extremely thin and tapering.

Jost de Negker was important enough to print his name, as well as the artist Hans Burgkmair, on the equestrian portrait of Maximilian, and Campbell Dodgson in his catalogue of German woodcuts in the British Museum thought him the inventor of the chiaroscuro woodcut.

Dürer's head cutter Hieronymus Andreae hung on to the blocks he had cut for the *Triumphal Arch* until he was paid in 1526, when he handed them over to the Nuremberg Council, to be sent to Augsburg and then to Vienna.

METAL-CUTS

The metal-cut, dating from about 1430, is classed as a branch of woodcutting, although it appears to have been an art or craft practised by the goldsmiths, whose guilds were considered to be in a class above the 'carpenters' (Plate 7).

In this process a plate of soft metal, possibly copper or pewter, was used instead of wood. Lines were in relief, as in woodcutting, but sections of the surface were left uncut, such as, it might be, a Madonna's robe: these uncut surfaces would thus have printed black, but punches were used to imitate patterns on them. The commonest was a round punch to produce dots on a black ground, and this accounts for the prints being known as 'Dotted Prints' (in German *Schrotblätter*, in French *Manière criblée*). The punches were sometimes shaped to produce patterns such as little flowers or stars. Lines were also often cut into the surface that would otherwise have printed black, producing white lines on a black surface, the prints being sometimes described as white-line engravings.

For printing purposes these metal plates were attached to a block of wood and inked on the surface with a dabber, like woodcuts. After the invention of movable type, about 1450, they were, like woodcuts, extensively used for illustrations to books, the thickness of the wood to which they were attached being the same depth as the type, about the diameter of a shilling.

WHITE-LINE WOODCUTS

Just as white lines could be made in the black-printing surface of metal, so could they be cut into a wood-block. This was a method known as white-line woodcutting and was practised at the end of the 15th century. One of its chief exponents was the Swiss artist Urs Graf (d. 1529), and Dürer also did his 'knots', after the designs of Leonardo, in this manner (Plate 8).

WOOD-ENGRAVING

The principle, therefore, of cutting lines, both in wood and in metal, to print white on a black surface, was used in the 15th and 16th centuries, and was the forerunner of a craft later known as wood-engraving.

The woodcutter worked on a 'plank' of wood, sawn lengthwise from the tree. In the 18th century experiments were made in cutting across the grain, on a block of wood cut as a section of the tree.

Hard boxwood was eventually found suitable, the finer lines being engraved as in metal, with a burin, instead of cut out V-shaped with a knife. As this was still a surface-printing process, these lines printed white on black as in metal-cuts; crosshatching and other complications could be done, the larger highlights, such as white clouds, being scooped out of the block as in woodcuts.

This system of cutting or engraving across the grain was further developed by Thomas Bewick of Newcastle (1753–1828), who, trained as a metal-engraver, was able to get a much closer and more detailed effect than his progenitors. One of his most famous prints was *The Chillingham Bull*, dated 1789 (Plate 9), which developed a crack during the printing.

Only about twelve perfect impressions (six on parchment and six on paper) were printed before the crack developed, but it has been denied that the damage was due to the printers getting tipsy. Bewick himself inadvertently left the block in the sun during a weekend. He succeeded in closing the crack, cut his name in the bottom left corner, and printed a few more impressions before the crack opened again. Later it was screwed together and backed with iron, but impressions taken in this state are without the border.

Cracks of this sort were not always due to a defect in the wood, but to the fact that a complete block could be made up of small sections bolted together, sometimes allowing slight gaps to develop.

Boxwood was slow-growing and the idea that a block could be composed of small pieces was used commercially in the 19th century, when papers like the *Illustrated London News* employed a team of wood-engravers, all trained to work in the same style, so that post-haste results could be obtained by sending an artist to sketch a scene or event, the result being given to the team, each of whom engraved a small block, all finally bolted together to form the complete picture to be printed.

William Blake used Bewick's methods when he was commissioned by Dr. Thornton to engrave seventeen small blocks as illustrations to Ambrose Phillips' *Imitations of Virgil's First Eclogue*. Three other cuts designed by Blake make the set up to twenty.

Unfortunately, Dr. Thornton (mostly celebrated for his publication of a set of large and fine flower prints, known as 'The Temple of Flora') appears scarcely to have appreciated the cuts and might not have used them at all but for the praise of artists like Sir Thomas Lawrence and James Ward. As it was, the blocks were all cut down in size, so that, although already very small, they lost some height and about half an inch in length. Only two or three impressions exist of eight of the blocks before they

were cut. They were printed in the book with an apology: 'The illustrations of this English pastoral are by the famous Blake, the illustrator of Young's "Night Thoughts" and "Blair's Grave", who designed and engraved them himself. This is mentioned as they display less of art than of genius and are much admired by some eminent painters' (Plate 10).

BLOCK-BOOKS

A block-book consisted of a series of pictures cut on wood, with explanatory text cut in the same blocks and known as xylographic. The subjects chosen were religious, a favourite being the *Biblia Pauperum*, or Bible of the Poor, with up to fifty scenes from the Old and New Testaments. Another set was called *Ars Moriendi*, the art of Dying, ten or twelve blocks where the devil and his assistants tempted the dying man with riches and other inducements to win his soul. In the early books only one side of the paper was printed on and mostly coloured, the prints being sometimes pasted back to back, and stitched or bound together. Later on they were printed on both sides of the paper. Those printed on both sides were known as opisthographic, and on one side anopisthographic.

Modern book authorities do not think they had anything to do with the invention of printing from movable type, which was a matter for the metal-workers, and recent research has indicated that the earliest date that can be assigned to them is in the 1460s.

This disposes of a number of interesting theories, and the legend that block-books were inspired by Chinese books brought back by Marco Polo to Venice about 1295. The existence of a block-book printed by Laurens Coster of Haarlem, in which the lettering is partly xylographic and partly in movable type, formerly led to the theory that he not only invented movable type, but also that his type was cut out of wood. This theory was supported by a Latin extract from Johannes Trechsel, about 1487, which Professor Hind, in his *History of Woodcut*, translated as follows: 'The beginning of printing, when the letters were cut in boxwood, caused little injury to the good scribes' activities; but when Germany cut and cast movable type, and made frequent use of it, the scribes in a body lost their old employment through the new methods.'

It is said that Gutenberg first carved each letter in hardwood and then cast it. The Chinese claim the invention of movable type long before Gutenberg.

BOOK-ILLUSTRATION

It is possible that the honour of printing the first pictures from wood-blocks set up with movable type should go to Albrecht Pfister of Bamberg, who, using type acquired from the bankrupt Gutenberg, was printing illustrated books about 1460.

Woodcuts and metal-cuts were eminently suitable for this purpose, as they could be set up with the type, inked with the dabber and printed on the same sheet, the metal-cuts being attached to blocks of wood to give them the same depth as the type.

There are examples before 1460 of books with elaborate initial letters, which might rank as illustrations, but there is a suggestion that these might have been printed from

metal cast in a wooden mould, and perhaps printed on the sheets in spaces left after the printing of the type.

Woodcuts had been used before this to illustrate manuscripts when spaces were left for the prints to be stuck on the pages after the writing had been done.

PRINTING of WOODCUTS

It is thought, though not always accepted, that the method of printing the earliest woodcuts on paper was to press or hammer the block on the back, as in pattern printing, or to lay the block face upwards and rub the paper on the back, in the Oriental fashion. According to authorities holding this theory, it was not till about the middle of the 15th century that the screw-down and lever presses were used for printing wood-blocks, after these presses had been adapted for printing books.

The screw-down and lever press, however, was originally derived from wine and olive presses, known to have been used by the ancient Greeks and Romans, and also used by bookbinders more than a hundred years before the first woodcuts on paper, so it seems quite possible these were printed in similar presses, as well as by the tapping and rubbing means.

CHIAROSCURO WOODCUTS

Chiaroscuro is the name given to woodcuts imitating drawings made on tinted paper, heightened with white, or, in early German examples, with gold. It is a combination of the two Italian words *chiaro oscuro*, and is, of course, applied also to paintings.

Early German chiaroscuro prints were made from two or three blocks, one printing the ground, usually green, blue, or brown, with the white high-lights cut out; a second block printing the black outline, and a third sometimes a stronger tint, or a white paste to which gold-dust could be applied while it was still damp. These cuts imitated the style of drawing used by Dürer and other Northern masters at the commencement of the 16th century (Plate 11).

The Italians used three or four blocks to print in grades of the same colour, to imitate drawings made in the grisaille or cameo manner, a style practised by Raphael, Parmigiano and others.

The invention of the process was either by Lucas Cranach, working for Frederick the Wise, Elector of Saxony, at Wittenberg, or by Jost de Negker, a native of Antwerp, chief woodcutter at Augsburg, working under Peutinger, for the Emperor Maximilian I.

There is a record that the Elector's Chamberlain had sent to Peutinger in 1507 'Knights in armour, of gold and silver', made with a press. This is taken to refer to Cranach's *St. George*, printed with two outline blocks, a black one and a white one (which was originally a paste-like substance, intended to have gold-dust sifted on it while still wet). The ground of this *St. George* was not printed but coloured by hand, thus not a full chiaroscuro.

Peutinger accepted the challenge in the Chamberlain's letter, to produce anything

comparable, and, in 1508, sent the Elector his 'Knights in gold and silver on vellum'. This is believed to refer to the equestrian portrait of the Emperor Maximilian I, by Jost de Negker, dated 1508, done from a drawing by Hans Burgkmair, but, as the earliest examples of the print do not have a printed ground, it is possible the tone-block was added to a later edition. Examples exist with the '0' removed from the date, also with the date altered to 1518.

Lucas Cranach produced two other chiaroscuro prints with an even earlier date, 1506, both with printed grounds, but here again it is said the date must really be later (probably 1509), because they show, as part of Cranach's signature, the winged serpent, the device on his coat-of-arms, not granted to him till 1508.

It was quite common for a woodcut to be produced and published as an ordinary black-and-white line-block, and later to have another edition issued with tone-blocks added. This was done in the case of a few of Dürer's woodcuts.

In Venice, Ugo da Carpi (*c.* 1455–1523) obtained a *privilegium* (a patent or copyright) from the Signoria to work the chiaroscuro process, and Vasari said he was the inventor, but his earliest dated print is 1518. Bartsch, in his *Peintre-Graveur*, vol. XII, was inclined to give the invention of chiaroscuro from two blocks to the North, and from three or more to Ugo da Carpi (Plate 12).

The idea of printing in tones, or on a ground on to which a tone had been printed, was probably inspired by Mair von Landshut (fl. *c.* 1492–1514) who before 1500 had printed both woodcuts and line-engravings on paper previously tinted with water-colour.

The chiaroscuro method was often combined in later years with engraving: the black or key-plate being printed from an engraving, or etching, instead of wood, and the tints and colours applied from wood-blocks. This method was used in their imitations of drawings by Elisha Kirkall (*c.* 1695–*c.* 1750), Knapton, Pond and Skippe, in the 18th century, a somewhat similar means being adopted by George Baxter in the 19th century, his patent providing for key-plates and colours applied from both metal and wood.

John Baptist Jackson (1701–*c.* 1780), an English artist and pupil of Elisha Kirkall, claimed to have rediscovered the lost art of chiaroscuro with wood-blocks, although it had been revived from time to time, generally with etched or engraved outline plates.

He worked both in Paris and in Venice, where, in 1745, he published a series of twenty-four woodcuts in chiaroscuro after Titian and other Italian masters. He also made six interesting and very rare landscapes in colours after Marco Ricci, using several blocks. By designing his blocks to print more than one colour at a time, he could produce ten tints from four printings.

In all his prints he obtained an embossed effect, by deeply impressing his line-blocks, an effect not unknown as early as the 16th century. It has been suggested that in these cases metal outline blocks may have been used.

Embossing was practised by the wall-paper printers, and Jackson did indeed open a factory for making 'oyl printed papers' after his return to his native Battersea in 1746, where he produced some large sheets.

In 1754 he published a book entitled *An Essay on the Invention of Engraving and Printing in Chiaro Oscuro, as practised by Albert Dürer, Hugo da Carpi, etc., and the Applications of it to the Making Paper-hangings of Taste, Duration, and Elegance. By Mr. Jackson of Battersea. Illustrated with Prints in proper Colours.* (N.B. Dürer did not himself produce chiaroscuro woodcuts.)

Papillon, in his *Traité de la Gravure en Bois*, 1766, disputed Jackson's claim to have invented wall-paper printed in the chiaroscuro manner, saying that his father had made and sold 'tapestry' paper in Paris in 1688. He substantiates it by complaining that his boyhood's task was hanging these papers.

It seems to be thought that Jackson intended some of his prints after Italian masters to be used as wall-papers. This would not be surprising, bearing in mind there was a vogue in his time for papering rooms with prints. Horace Walpole used some of Jackson's prints in this way at Strawberry Hill, writing in 1753, 'Now you shall walk into the house. The bow-window below leads into a little parlour hung with a stone-colour Gothic paper and Jackson's Venetian prints, which I never could endure while they pretended, infamous as they are, to be after Titian, etc., but when I gave them this air of barbarous bas-reliefs they succeeded to a miracle. . . .' Examples of walls covered with prints still exist in houses such as Rokeby and Strathfieldsaye, where one of the prints is Rembrandt's *Three Trees*!

Jackson's process eventually succumbed to the more fashionable Chinese papers, where 'lions leaped from bough to bough like cats', as he scornfully expressed it.

DÜRER'S WOODCUTS

Albrecht Dürer, of Nuremberg (1471–1528), was the first major producer of woodcuts, his work showing an enormous advance on anything previously done and his arrival coming at a time when the woodcut was beginning to stand as a black and white picture, without colouring.

He must have been something of a child prodigy, judging from a drawing of himself at the age of thirteen, and it was then that he was apprenticed to Michael Wolgemut (1434–1519), the leading Nuremberg painter and woodcut designer. He had already served under his father, a Nuremberg goldsmith.

He gained his first knowledge of designing and cutting under Wolgemut, who was one of the artists employed to illustrate the important books known as the *Schatzbehalter* and the *Nuremberg Chronicle*. Although Dürer had left his apprenticeship in 1490, and the two books were not published till 1491 and 1493, Professor Erwin Panofsky, in *The Life and Art of Albrecht Dürer*, has pointed out that preparations for them were commenced long before that, and Dürer may well have had a hand in the illustrations.

On leaving Wolgemuth in 1490 he travelled extensively, his *Wanderjahre* lasting till 1494. He may have visited the Netherlands and is known to have been in Colmar in 1492, too late to see the great engraver and painter Martin Schongauer, who had died in 1491, but visiting Schongauer's brothers, themselves engravers, who no doubt gave him the opportunity of studying the master's work, and recommended him to

another brother in Basle, where he made a woodcut of St. Jerome and possibly other book illustrations.

Returning to Nuremberg in the spring of 1494, he married Agnes Frey, but there seems to be indisputable evidence that he visited Venice in the autumn.

It has been said, possibly unjustly, that his first visit to Italy in 1494–5 was either to escape the plague* or his wife, who in later life earned the reputation of a shrew. The second visit in 1505 was to paint an altarpiece for the German church in Venice, and, incidentally, to try to stop the piracy of his designs by engravers like Marcantonio and Giulio Campagnola by appealing to the Signoria.

Altogether, taking into account that he visited the Netherlands, possibly for the second time, in 1520–1, he was well travelled in the civilised world of his day, and able to incorporate into the strong, angular Gothic style, some of the rounder, softer Italian style, descended from ancient Greece and Rome.

When he returned to Nuremberg in 1495, work was commenced on the first large set of woodcuts, the *Apocalypse*, consisting of sixteen blocks, the letterpress printed on the backs, facing the next block to which it was relevant. The set was first issued in 1498, with alternative text in either Latin or German, a second issue being made in 1511 with Latin text only and a cut of St. John added to the title (Plate 13).

The designs of the *Apocalypse* were not entirely original, being based on illustrations to the Quentell Bible published about 1479, but they had an immense effect on the history of woodcut, and were in keeping with the magnificent books being produced at that time, one of the presses being in Nuremberg, that of Koberger, a maternal uncle of the artist.

Panofsky thinks that Dürer cut many of the blocks himself, and other blocks before 1500, although most authorities hold that a successful painter would not have had the time. Eventually it is known that he had his own staff of cutters, the names of two Hieronymus Andreae and Wolfgang Resch, mentioned before, being recorded.

These woodcuts travelled widely over Europe, and must have had a great impact on all artists whose business was to compose pictures in line.

Italian prints of the period had the advantage of the grace and beauty imparted by artists like Mantegna and Botticelli, but line work south of the Alps was only just beginning to emerge from the system of first outlining the figures and objects, and then shading with diagonal strokes. Jacopo de' Barbari had begun to shade with curved lines following contours, but the rhythmical, organised lines, coupled with the power of draughtsmanship, were a great advance.

The *Apocalypse* was soon followed by a *Large Passion* of twelve blocks, and a *Life of the Virgin* of twenty blocks, all, in the published editions, with printing on the backs. Dürer referred to these as his 'Large Books' and, on very rare occasions, they are to be found bound together. In such examples the *Life of the Virgin* has wide margins, to make the leaves of the three sets of uniform size. They were printed in 1511, in his own press.

The influence of these large sets on the outside world was shown by the speed with

* In 1494 the plague in Nuremberg claimed 10,000 victims.

which they were copied. In 1502 Hieronymus Greff had cut a set of the *Apocalypse* of the same size as the originals, but easily distinguished because they bore Greff's monogram at the bottom, looking like an M and an F, but actually being IVF (Johann von Frankfurt). In 1505 Marcantonio, in Venice, had copied the first seventeen of the *Life of the Virgin*, engraved, however, in copper and with numbers at the foot, not to be seen on the original woodcuts.

The set of thirty-six smaller woodcuts which Dürer made of the Passion, known therefore as the *Little Passion*, published in 1511, were very exactly copied in woodcut by Johann Mommard in 1587. The title to these copies reads *Figurae Passionis . . .*, or *Historia Passionis . . .* (according to the edition, the first edition having also the date MDLXXXVII), whereas in the original by Dürer the title commences *Passio Christi ab Alberto Durer*. If a set should turn up with the title missing, they would need very careful comparison, preferably with the aid of Joseph Meder's *Dürer Katalog*, where sections of both sets are shown, with the differences described. Marcantonio also copied this set, in line on copper, but with a tablet instead of Dürer's monogram. Dürer's blocks for this set were reprinted several times, one late edition having Italian text on the backs instead of Latin.

The most desirable impressions of these sets are the proofs before the letterpress was printed on the backs, and they can generally be told by the watermarks,[*] the usual ones being:

> *The Apocalypse:* large Reichsapfel.
>
> *Large Passion:* large and small Reichsapfel or Monogram of Mary.
>
> *Life of the Virgin:* Bull's-head; High-Crown; or Scales in Circle.
>
> *Little Passion:* portions of the Bull's-head.

In the case of the *Little Passion*, the prints are on small pieces of paper cut from a larger sheet, so that only portions of the watermarks will appear here and there, on only a few prints in a set of thirty-six: on most no watermarks will be visible.

The large high-crown watermark measures 55 mm. ($2\frac{1}{8}$ ins.) wide at its widest point, and is not to be confused with the small high-crown only 35 mm. ($1\frac{3}{8}$ ins.) wide, used for later impressions.

After the proofs, editions of these sets were then printed for publication, with the letterpress on the backs, the usual watermarks being:

> *The Apocalypse:* for the 1498 edition, either no watermarks, or small Reichsapfel; for 1511 edition, Tower and Crown; or Flower and Triangle.
>
> *Large Passion:* 1511 edition, Flower and Triangle, Tower and Crown, or Monogram of Mary.
>
> *Life of the Virgin:* 1511 edition, Flower and Triangle, or Tower and Crown.
>
> *Little Passion:* 1511 edition, High-Crown.

Impressions were later printed without the letterpress on the backs, thus resembling proofs and to be wary of. The commoner watermarks of these late prints are:

[*] Between pages 42 and 46.

The Apocalypse: Nuremberg Arms.

Large Passion: Augsburg Arms and others.

Life of the Virgin: Wittenberg Arms, Fish Bladder, or small High-Crown.

Little Passion: medium Reichsapfel, small High-Crown.

In addition to the watermarks, the breaks in the borderlines and in the fine lines are another guide to the earliness or lateness of the impressions, as mentioned before. In the *Dürer Katalog*, Meder has minutely described these breaks. Careful examination is needed to see that they have not been filled in with ink by a pen or brush.

Authorities vary in the number of woodcuts attributed to Dürer. Some have included in their catalogues several which they say he did in Basle, in addition to the St. Jerome, which has been authenticated. Counting these and his share in the Maximilian woodcuts Dr. Willi Kurth catalogues 346. Some wood-blocks by his pupils had pieces cut out and the famous Dürer monogram inserted in later states. This happened to some by the famous Hans Baldung called Grien (*c.* 1476–1545), who was one of Dürer's apprentices from 1500 to 1506.

In the large works commissioned by Maximilian (see under Woodcut) Dürer and other artists were called in to co-ordinate the work and make practical drawings on the blocks from the ideas of scholars and sometimes the basic designs of other artists. When the Emperor thought of the *Triumphal Arch* he called in Johann Stabius, his historian and astronomer, and Kölderer, the Innsbruck architect and painter, while Dürer, with the assistance of others, including perhaps his brother Hans, made the drawings on the 192 blocks for the cutters. The towers were the work of Albrecht Altdorfer, the Ratisbon (Regensburg) artist and architect, whose hand is also thought to be seen in the miniatures first prepared for the *Triumphal Procession*, the blocks for this being drawn by Dürer and four or five other artists. The names of eleven cutters were revealed by the discovery of the blocks in the 18th century, when both the *Arch* and the *Procession* were reprinted.

Dürer's arms (an open door, from the derivation of the name *Turer*) appear on the steps of the *Triumphal Arch*, beside those of Stabius and Kölderer, the three coats-of-arms appearing in progressive sizes: Stabius, Kölderer and Dürer, the smallest.

Another work of a similar character was the *Great Triumphal Car*, printed from eight blocks. This was not published till 1522, after the Emperor's death, although it was first designed to be part of the *Procession*. It was published with the permission of Maximilian's successor, but in the artist's mind, very possibly, was the memory of the difficulty he had experienced in recovering his considerable monetary outlay, which the Nuremberg Council were eventually ordered to pay.

ALTDORFER, CRANACH, LUCAS VAN LEYDEN

Albrecht Altdorfer (*c.* 1480–1538), whose name has been mentioned as the designer of the towers on Maximilian's *Triumphal Arch*, was the Regensburg architect. As a painter he is referred to as 'the father of German landscape'. He was also an engraver and woodcut designer, his work in these fields usually being on a very small scale, so

Large Reichsapfel
actual size

Small
Reichsapfel

Monogram of
Mary

Scales in
circle

Bull's head

Large
high crown

Tower &
crown

Flower &
triangle

Little jug

Arms of
Nuremberg

Arms of Augsburg

Arms of
Wittenberg

Gothic P

Fish bladder

Small
high crown

that he is classed as one of the German 'Little Masters', with Hans Sebald Beham, Barthel Beham, etc. (see p. 59).

One of Altdorfer's principal woodcut works was a set of forty Biblical scenes, *The Fall and Rise of Man*, all no bigger than large postage stamps. An exception to this very small scale was *The Beautiful Virgin of Ratisbon* (Regensburg), measuring 340 by 247 mm., printed from a black outline block and five colour blocks: seven colour blocks have been counted by some experts, but Campell Dodgson does not see more than five.

This woodcut is usually catalogued as a chiaroscuro, but as there is no ground block, it would seem to be more a colour-print and one of the first examples of so many colours being used (Plate 14).

The subject of the *Beautiful Virgin* was an old carved wooden figure of the Virgin and Child, erected in 1519 on the site of the destroyed Synagogue, where the Protestant Church now stands. The figure was immediately credited with miraculous power and immense pilgrimages took place in the next few years.

Lucas Cranach the Elder (b. Kronach 1472, d. Weimar 1553) has already been mentioned in connection with the first chiaroscuro print. He settled at Wittenberg in 1505 as Court painter to the Elector Frederick III of Saxony and his two successors John and John Frederick, becoming burgomaster of the town in 1537.

When John Frederick was defeated and captured by the Emperor Charles V at the Battle of Mühlberg, in 1547, Cranach accompanied his patron into captivity at Augsburg and Innsbruck, and when they were freed in 1552 he still went with the former Elector to Weimar. Here he is spoken of as having a 'large workshop for the manufacture of pictures', assisted by his two sons, Hans and Lucas Cranach the Second.

In 1508 he had been granted a coat-of-arms, with the device of a winged serpent, and this he subsequently used to sign his pictures and prints.

A feature of his woodcuts is the Ducal and Electoral Shields of Saxony which he introduced into them, hanging as it were haphazardly from trees and elsewhere. The Electoral shield has two crossed swords, with, in its earlier form, the lower half sable, the upper argent, the two 'fields' being reversed in 1507 or 1508 (Plate 15).

The winged serpent used by Cranach the Elder in his woodcuts had, up to 1523, a bat's wing, the webbed spines sticking upwards. Lucas Cranach the Younger used a bird's wing.

Lucas van Leyden (1489 or 1494–1533) has been treated at greater length under the section on line-engraving. Over 100 woodcuts are attributed to him, more than half being illustrations to books. The single woodcuts are very uncommon, which seems to be one reason why reference is seldom made to his work in this medium. The influence of Dürer is very strong.

DECLINE of WOODCUT

The decline of woodcut began towards the end of the 16th century, when publishers resumed the practice of binding copperplate illustrations into their books. In some cases, such as De Bry's *Voyages*, the plates were printed on sheets with wide margins

and the letterpress printed afterwards. This was a clumsy method compared with the beautiful productions of a hundred years before, but doubtless cheaper, and, in the case of small plates, more expeditious. Portraits, which many of these books contained, could be rendered more effectively in line-engraving.

In the 19th century the famous 'presses', such as the Kelmscott Press of William Morris, revived the design and printing of fine books with woodcut illustrations, though in many cases the actual printing was done from electrotypes.

3. Line-engraving

ORIGIN

Line-engraving is the ploughing of lines in a metal plate by means of a burin, or graver (Fig. 5), shaped like a bradawl, with a triangular or lozenge-shaped point, the handle being pushed forward with the palm of the hand, the point guided by the fingers and thumb, the plate resting on a round cushion, filled with sand, to allow it to be turned. Any ridges of metal raised are scraped away, so that, when printing, the ink is held only in the lines.

Fig. 5: Graver or burin

The engraving of designs and pictures by means of lines was, perhaps, the most primitive of all arts, and, when done in metal, had become, in the Middle Ages, a goldsmith's craft. It was customary to fill these lines with some other metal or substance, and it was not till about 1430 that it was discovered the lines could be filled with thick ink and printed on paper.

Giorgio Vasari (1511–74), the Italian artist and art historian attributed the discovery of printing from engraved plates to a Florentine goldsmith, Maso Finiguerra (1426–64), but there is proof that it was first practised north of the Alps, though Finiguerra may well have made his discovery independently.

In Florence the discovery was an off-shoot of the engraving of small silver plates, known as nielli. These plates were filled with a black substance (nigellum) and polished, so that the design showed black on a bright silver ground, and, before it was found they could be printed from, it had been the practice to take casts from them in clay, and, from the clay, another cast in sulphur. According to Vasari, Finiguerra's first prints on paper were from these sulphur casts, examples of which are to be seen in the British Museum.

A legendary story of the discovery of printing from these silver nielli says that one evening a goldsmith, having filled the lines of a plate with nigellum, left it to dry overnight, first covering it with a sheet of paper to protect it from dust. Later a washerwoman unwittingly placed a bundle of damp clothes on it, so that, in the morning, it

was found to have dampened the paper and pushed it into the lines, thus making a print.

Although the Chinese were centuries ahead of Europe in the printing of woodcuts, their first intaglio prints from copper plates appear to be a large set of twenty engravings, *The European Buildings in the Yuan Ming Yuan*, showing the palaces and gardens designed and built in the Italian rococo style, to the order of the Emperor Ch'ien Lung, by the Jesuit missionaries Fathers Giuseppe Castiglione and Benoit; no traces of the buildings now remain. The engravings were made by Chinese artists, under the instructions of Father Benoit, about 1783, and are extremely rare (Plate 16).

LINE-ENGRAVING. *North of the Alps*

Modern research is continually upsetting old traditions and theories, and some new discovery may transpose an engraver's birthplace overnight from North to South Europe, or even add to or subtract a few years from his date. As things stand at the moment, the earliest known engraver is thought to have been Swiss or South German, working from about 1430 to about 1450, known as the 'Master of the Playing Cards' (Plate 17), because, besides religious subjects, he did a set of playing cards in five suits (or 'colours'). An engraving by him of St. Bernardino of Siena, canonised in 1450, proves that he was still working after this date.

Confirmation of the region in which he worked is thought to be his portrayal of the Alpine violet, a flower to be found in the mountains around Lake Constance. His style of work seems to indicate that he was a painter rather than a goldsmith, like most of the earlier engravers, but authorities no longer believe he was actually the famous Basle painter Conrad Witz.

The earliest dated print north of the Alps, 1446, disproves Vasari's claim that printing from engraved plates was first practised in 1460. The engraver, known as the 'Master of the Year 1446', was thought by Max Lehrs to have been a pupil of the 'Master of the Playing Cards.'

Another anonymous early engraver of importance is known as the 'Master of the Housebook' or the 'Master of the Amsterdam Cabinet': the first title because there are drawings attributed to him in a 'housebook' belonging to the Duke of Waldburg-Wolfegg, the second because by far the largest collection of his works is in the Rijksmuseum, bought by King Louis Bonaparte in 1808. He is noted as the first engraver to use the drypoint technique, and, if there be any truth in the suggestion that he may have used lead, it would certainly account for only one impression existing of most of his engravings, as the soft metal would flatten out after even one passing through the heavy pressure of a roller press (see chapter on Etching).

The most important of the anonymous early Northern engravers, and those known only by their initials, was the 'Master E.S.' who worked from 1450 to 1467. A follower or pupil of the 'Master of the Playing Cards', he is thought to have worked in the neighbourhood of Lake Constance and may have been Swiss. Impressions from 317 of his plates have survived (95 of them being unique, i.e. known by only one impression).

D

The appearance of the date 1466 on some of his plates led to his being known as the 'Master of the Year 1466'. In this year he did his large *Madonna of Einsiedeln*, and also made two smaller engravings of the subject, only a few now existing, though commissioned at the time possibly for issue to the vast number of pilgrims visiting the black wooden statue of the Virgin known as the 'Madonna of Einsiedeln'.

The Master E.S. also engraved a series of eleven plates illustrating the *Ars Moriendi*, which were once considered to be the originals which inspired the block-books, but a return has now been made to an earlier theory that both the E.S. engravings and the block-books were copied from or based upon earlier illuminated manuscripts.

The most important anonymous early engravers north of the Alps were:

Master of the Playing Cards (fl. *c.* 1440–50).

Master of the Year 1446.

Master of the Gardens of Love (fl. *c.* 1440–50).

Master I. A. of Zwolle (b. *c.* 1440 at Zwolle, d. 1504 at Zwolle); Hollstein says identified as Jan van den Mijnnesten, a citizen of Zwolle from 1462. His initials (sometimes I.A.M.) are followed by a weaver's shuttle and the word Zwott appears on the prints (Plate 18).

Master of the Berlin Passion (fl. *c.* 1450–66), now identified as Israhel van Meckenem the Elder.

Master of the Banderolles (fl. *c.* 1455–70); has been called Master of the Year 1464.

Master ᙍ ⚑ (W.A., or W. with a key) (fl. *c.* 1465–85) (Plate 19).

Master F.V.B. (fl. 1475–1500). At one time thought to have been a Frans von Bocholt; now said to be Frans van Brugge, working under the influence of Dirk Bouts, Hans Memling and Martin Schongauer.

Master of the Housebook (fl. *c.* 1480); also known as the Master of the Amsterdam Cabinet, and Master of the Year 1480.

Master E.S. (fl. 1450–67). Sometimes known as the Master of the Year 1466.

Many prints by the earliest of these artists are unique (i.e. known only in one impression). Those that are obviously goldsmiths' designs are especially beautiful.

Martin Schongauer (*c.* 1430–91) was the first of the early Northern engravers to be known by name. He was a painter as well as an engraver, as, no doubt, some of the other goldsmith-engravers may have been. He is thought to have been a pupil or follower of the 'Master E.S.' and a son of Caspar Schongauer, a goldsmith working in Colmar in 1440.

Professor Singer tells us he was known as Handsome Martin (Martin Schoen), and that Hans Burgkmair painted a copy of Schongauer's self-portrait, pasting a slip of paper on the back of the panel, on which he wrote 'Master Martin Schongauer, painter, called beautiful Martin on account of his craft'. Vasari says that the engravings of 'Martin of Antwerp' were introduced into Italy in great numbers. He tells us how the young Michelangelo was impressed by the *St. Anthony tormented by Demons* and by the fearsome Gothic devils 'the most variegated and strangest shapes, which delighted Michelangelo in his youth to such an extent that he illuminated them'.

Condivi said that he copied the engraving in oils, making careful studies of fish-scales in the fish market in order to get the colour correct for those devils having a fish-like origin. A painting of this subject passed through the salerooms recently.

Three of Martin's brothers were engravers, two at his studio in Colmar and one in Basle (Plate 20).

Israhel van Meckenem (*c.* 1450–1503) 'the younger', was probably a pupil of his father, the 'Master of the Berlin Passion'. He was by far the most prolific of the early engravers, but is described as being unscrupulous in copying other artists' works, a considerable number of his 624 plates being copies. He assisted the Master E.S. and inherited his plates. He also acquired those of other engravers, such as the 'Master F.V.B.', reworking them, with those of his father, and becoming, as Professor Hind points out, one of the first to rework and reprint worn-out plates.

His work shows that he must have been above all a goldsmith, his ornamental designs earning great praise (Plate 21).

Max Geisberg selected a number of prints by Israhel van Meckenem and said they were by the father, Israhel van Meckenem the Elder, the 'Master of the Berlin Passion'.

The Master M.Z., sometimes called Matthaus Zasinger (fl. 1500), showed goldsmith tendencies in his engravings, some of which portray interesting scenes and costumes of the time (Plate 22).

DÜRER'S LINE-ENGRAVINGS

Albrecht Dürer was the third of the eighteen children of Albrecht Dürer the elder, a goldsmith of Hungarian origin who had settled in Nuremberg. It is reasonable to suppose that his father taught him the goldsmith's craft of line-engraving, and that he improved his knowledge during his wander-years from 1490 to 1494.

It has been suggested that an arrangement had been made for him to work under Martin Schongauer at Colmar after his apprenticeship to Wolgemut, but when he eventually reached there the great engraver was already dead. In Colmar and Basle he met Schongauer's surviving brothers.

In 1494–5 he visited Venice for the first time, where he met Jacopo de' Barbari, 'The Master of the Caduceus', and was much impressed by his theories on the possibilities of preparing a canon for the proportions of the human body. Subsequent meetings, after Barbari had gone to Nuremberg to work as a portrait painter and illuminist for the Emperor Maximilian, seem to have temporarily cooled his ardour, but he still made an attempt to obtain a sketch-book by Barbari, from the Regent of the Netherlands, after his death, only to be told that it had been promised to another artist. There is some controversy as to which of these artists exercised the greater influence on the other, but, if Professor Hind's theory is correct, that Barbari did all his thirty engravings in Venice, before he went north in 1500, then most of the credit must surely go to him.

It is possible that regulations, based on religious principles, hampered Dürer in his studies of the nude, although he made a woodcut of the Nuremberg public *Men's Bath* and some drawings such as the *Women's Bath*. It was this lack of regular models

perhaps that led to Vasari's criticism: 'I believe that Albert could not have done better, considering that he did not have proper advantages, and was compelled to draw his own pupils when he did nudes. These formed bad models, like most Germans, though they appear fine men enough when clothed.'

Jacopo de' Barbari preserved his secret, so Dürer had to follow the proportions laid down by Vitruvius, culminating in his book on Proportion, with woodcut illustrations, published just after his death in 1528.

It has been thought that several of his nude subjects were done in this way, particularly the famous *Adam and Eve*, some bearing a resemblance to, or being actually copied from Barbari, who had also begun to shade with lines following the contours, instead of the straight diagonal lines generally used in the Italian school up to that time.

Dürer perfected the translation of pictures into line, using this contour method to follow curves and indentations of objects and figures, already used to some extent by Schongauer. Through his admiration of the Venetian artists and others such as Mantegna, he also softened his engraved work into an amalgamation of the strong, angular Gothic with the neo-classical renaissance style of the great Italian painter-engravers.

Dürer's subjects embraced Turks, Soldiers, Witches, Devils, and sometimes other things, the importance of which is lost to us. Perhaps some attention should be paid to the times: the fear of armed conflict, on a large or small scale, which necessitated the fortification of any town, like Nuremberg; the fall of Otranto in 1480 and the fear of invasion by the Turks; the Peasants' Revolt; the Reformation, which he strongly embraced.

The Devil was a very real menace, and, according to the authorities, could be expected to look like the fearsome representations conjured up by Northern artists like Schongauer and Dürer.

Demons had difficulty in assuming a correct 'likeness of God' in human shape. The Devil in human form could be distinguished by his hollow back, his claw-like hands, his hoarse voice, his excessive thinness and his lack of any shadow. 'The Demons condense for themselves a body out of some Matter and assume the Shape of various living Things; and at times even take a Human Shape; but of a Low and Depraved Countenance, and always with their Hands and Feet hooked and bent like Birds of Prey. Their Speech is a hoarse muffled Murmur. Their Appearance is always accompanied by a Loathsome Stench.'

The long winter darkness was not easily dispelled by the flick of a switch, nor even by the striking of a match. The worthy yeoman, or the housewife, tried to kindle a light with flint and tinder, to repel the 'evil things of the night', beset by a thousand misshapen fiends, with difficulty kept at bay with Aves and Pater Nosters. 'The air is not so full of flies in summer,' says Burton, 'as it is at all times of invisible devils.' Storms were raised by witchcraft; witches and demons shrieked to their nocturnal assemblies in the howling gale. Lightning was the devil striking in his anger – were not the marks of his claws visible? 'That which is struck by Lightning is often seen to be Marked and Scored as it were by Claws.' Church bells were rung to frighten

away these angry devils. 'The sound of Bells, because they call Men to Holy Prayer, is odious and baleful to Demons, and it is not without Cause that Bells are often rung when Hailstorms and other Tempests, in which Witches' work is suspected, are brooding and threatening.'

The first engravings attributed to Dürer are placed as early as 1494, and *The Four Witches* is the first actually to bear a date: 1497 (Plate 23). A hundred and seven engravings are listed in Campbell Dodgson's 'Albrecht Dürer'.

Sixty-six of these are religious, their meaning easily understood, and one cannot imagine the artist's intention to be otherwise, especially as his wife and mother sold them in the market places. Some of the allegorical subjects, however, are obscure and a great deal of theories and different interpretations have been advanced.

Three of his engravings are sometimes referred to as his 'master prints'. These are *The Knight, Death and the Devil* (Plate 24), *St. Jerome* (Plate 25) and *Melencolia* (Plate 26). The meaning of the first seems clear enough – the Christian knight on his journey through life, unafraid of death and the devil – but the fact that a parcel of Dürer's prints was pillaged from a carrier's waggon by the unemployed robber-baron Kunz Schott von Hellingen has led at least one writer to suggest a connection between the knight and the villain who cut off a Nuremberger's hand for writing to him some protesting letters.

The three 'master-prints' have been classified as representing moral, scholastic and intellectual virtues: the 'Knight' the moral virtue and *St. Jerome in his Study* the theological and scholastic.

The third, intellectual virtue is *Melencolia I*. Dr. Erwin Panofsky in his 'The Life and Art of Albrecht Dürer' has brought a great deal of erudite research to this print, which contains a number of symbols relating to the Aristotelian theory that all superior men are subject to melancholy. The figure of Geometry is accompanied by magic squares and other symbols bearing on the subject. The figure 1 means it is either the highest form of 'intellectual melancholy' or the first of the four humours or temperaments, associated with the four winds, four seasons, four directions, etc.

Panofsky thinks it reflects the whole of Dürer's personality – scholar, thinker and writer. Erasmus was astonished at his ability to hold his own when in debate or conversation with friends such as Willibald Pirckheimer, one of the leading scholars of the day, educated at Pavia university and consulted by Maximilian I on the allegories involved in his woodcut 'Triumphs'.

Dürer's engravings, like almost everything else of value, have been copied and reproduced extensively. For hints on how to tell the reproductions see p. 17.

Old engraved copies are often difficult to detect. Sometimes they are in reverse, so easily recognised; at other times it is necessary to note small differences.

The watermarks most commonly to be seen on the best impressions are the bull's-head and high-crown, with occasionally the Gothic P and Little Jug, etc., see p. 43. The high-crown should measure 55 mm. at its widest part.

The platemarks are mostly sharp and square at the corners, with the exception of some of the etchings, where the corners are well rounded.

A number of the engravings were copied by Jan Wierix, at a precociously early age, but fortunately he put his name and age on most of them, sometimes cut off if close to the edge.

The list given below, followed by illustrations of many of the examples in it, notes some of the most deceptive copies, leaving out any done in reverse and others, such as those by Wierix, which are distinguishable by the copyists' initials.

The Nativity (Bartsch 2). The little flag on the right-hand pillar of the well slopes upwards in the original (B. 2).

Christ on the Mount of Olives (B. 4). There is a copy in which the figure 8 in the date comes just over the left end of the cross-piece, instead of over the left upright stroke of the A.

Christ before Pilate (B. 7). There is a copy in which the right down-stroke of the A is farther from the right edge (B. 7).

Christ shown to the People (B. 10). There is a copy in which the cross-beam of the leaning cross touches the cross-beam of the nearest cross (B. 10).

Christ on the Cross (small plate) (B. 13). Copy in which the down strokes of the A in the monogram are straight: in the original the left stroke curves distinctly (B. 13).

The Resurrection of Christ (B. 17). Copy in which the figures 1 and 2 in the date just touch the A of the monogram.

The Man of Sorrows, hands tied (B. 21). Copies with difference in the boat in distance on left (B. 21).

Christ on the Cross (small round plate) (B. 23). Copy A described by Bartsch is now accepted as the original.

Christ on the Cross (large plate) (B. 24). Copy in which three stones on the white path halfway up the print on the left are of almost equal size, instead of the left one of the lower two being very small (B 24).

The Prodigal Son (B. 28). Copy in which the three windows in the large gable to the right are on the same level (B. 28). There is no flag on the vane nearest the right edge, as in the original, but instead one on the farther vane.

The Virgin on the Crescent, with long hair (B. 30). Copy in which the D in the monogram is very small (B. 30).

The Virgin with a starry Crown (B. 31). Copy with only six long rays slanting downwards to the right of the Child's head, instead of seven in the original (B. 31).

The Virgin seated on a grassy Bank (B. 34). Copy published by Visscher, with his monogram at bottom right and dated 1566 instead of 1503 in the original.

The Virgin suckling the Child (B. 36). Copy with difference in the reeds on the right.

The Virgin crowned by one Angel (B. 37). Copy with a difference in the nail-hole in the farther plank of the bench on the left (B. 37).

The Virgin crowned by two Angels (B. 39). Copy in which the 8 in the date is slightly higher than the other figures, and the slab more rounded at the base.

The Virgin seated by a Wall (B. 40). Copy with a difference in the 4 of the date and a smaller D in the monogram (B. 40).

The Virgin with a Monkey (B. 42). Copy with ornamental hinges to the door high in the house, instead of plain as in the original (B. 42).

St. Christopher, facing to the left (B. 51). The path in the distance on the right, running down from the Saint's right hand, is curved in the copy and straight in the original (B. 51).

St. George on horseback (B. 54). Copy with much smaller monogram (B. 54).

St. Sebastian bound to a tree (B. 55). Copy without the two dots or flicks either side of the monogram (B. 55).

St. Anthony (B. 58). Copy A, without the chimney at the side of the sloping roof of the large house in distance left (B. 58).

St. Jerome in his Study (B. 60). Copy in which the D of the monogram is on the same level as the ends of the A, instead of being slightly higher, as in the original (B. 60).

Melencolia (B. 74). Poor copy in which the I is much farther from the edge of the scroll instead of nearly touching it. B: copy by Wierix omitting the 'S' between the name and the I. C: the ward of the key hanging at the side of 'Geometry' is in the form of a cross (B. 74).

Fortune (B. 78). Copy with differences in the thistle, the hair etc.

Justice (B. 79). Copy with difference in lion's whiskers (B. 79).

The Lady riding and the Landsknecht (B. 82). Copy in which the curved lines on the right turn upwards instead of downwards (B. 82).

The Peasant and his Wife (B. 83). Copy with differences in the hair of the man; the hair hanging down the woman's back meets the curved seam (B. 83).

The Three Peasants (B. 86). Copy in which the slit in the cuff above the left hand of the peasant on the right is more open than in the original (B. 86).

The Standard Bearer (B. 87). Copy with a difference in the stone at the bottom left (B. 87).

Peasants at Market (B. 89). Copy with a difference in the sticks rising over the woman's right shoulder (B. 89).

The Little Horse (B. 96). Copy with a difference in the tuft growing from the corner of a stone against the sky space below the shaft of the battleaxe (B. 96).

The Great Horse (B. 97). Copy which omits the dots either side of the date, and has a tuft of three flicks on the right corner of the dark stone above the horse's head, whereas the original has a tuft only on the left corner (B. 97).

The Knight, Death and the Devil (B. 98). Not very deceptive copy which omits the date on the tablet, above the monogram.

The Coat-of-arms with a skull (B. 101). Deceptive copy with a difference in the monogram.

Cardinal Albert of Brandenburg (small plate) (B. 102). There is a copy with the 'S' before Anno reversed (B. 102).

Frederick the Wise, Elector of Saxony (B. 104). Copy with the sword-guards not so round (B. 104).

Willibald Pirckheimer (B. 106). Copy in which two hairs on the top of the head cross (B. 106).

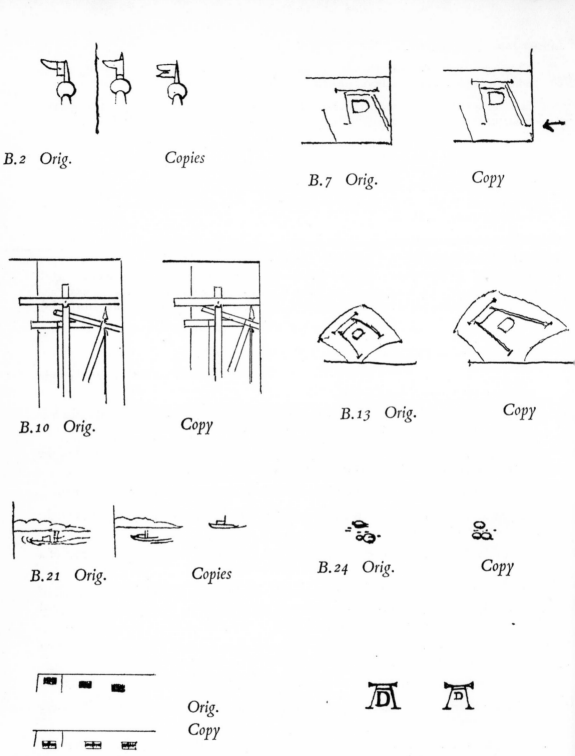

B.2 *Orig.* *Copies*

B.7 *Orig.* *Copy*

B.10 *Orig.* *Copy*

B.13 *Orig.* *Copy*

B.21 *Orig.* *Copies*

B.24 *Orig.* *Copy*

Orig.
Copy

B.30 *Orig.* *Copy*

B.28

B.31 *Orig.* *Copy*

B.37 *Orig.* *Copy*

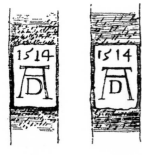

B.40 *Orig.* *Copy*

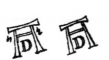

B.42 *Orig.* *Copy*

B.51 *Orig.* *Copy*

B.54 *Orig.* *Copy*

B.55 *Orig.* *Copy*

B.58 *Orig.*

B.60 *Orig.* *Copy*

Orig.

Copie

B.74 *Copy*

Orig. *Copie.*

B.79 *Orig.* *Copy*

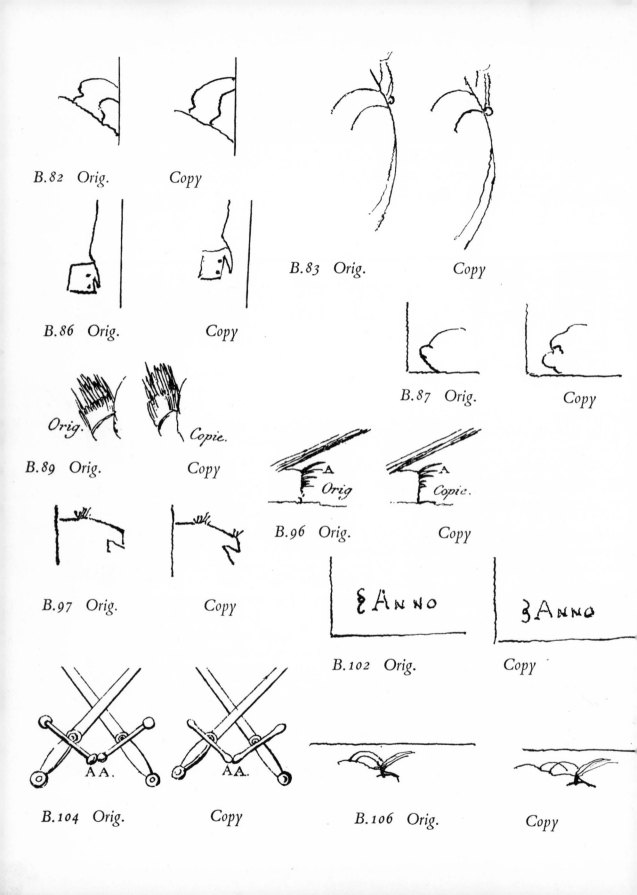

B.82 Orig. Copy

B.83 Orig. Copy

B.86 Orig. Copy

B.87 Orig. Copy

B.89 Orig. Copy

B.96 Orig. Copy

B.97 Orig. Copy

B.102 Orig. Copy

B.104 Orig. Copy

B.106 Orig. Copy

GERMAN LITTLE MASTERS

Some painter-engravers of the early 16th century in Germany made woodcuts and engravings of such small size that they have been grouped together as the 'German Little Masters', the best known being:

Heinrich Aldegrever (1502– after 1555)
Albrecht Altdorfer (*c.* 1480–1538)
Hans Sebald Beham (1500–50)
Barthel Beham (1502–40)
Jacob Binck (d. 1569)
Hans Brosamer (fl. 1537–52)
The Master I.B.
Georg Pencz (*c.* 1500–50)
Virgil Solis (1514–62)

Three of these – the two Beham brothers and Georg Pencz – were pupils of Dürer, and were denounced by him as 'Godless men' for the extreme views on religion they professed, subsequent to the Reformation movement. At a trial in Nuremberg in January 1525 they testified to believing neither in God nor Christ, and were lucky to suffer only temporary banishment from the city.

The two Behams settled elsewhere, a charge being later brought in Frankfurt against H. S. Beham for plagiarising unpublished material from Dürer's work on Proportion.

Georg Pencz returned to Nuremberg and is thought possibly to have been the 'Jorg' who married Dürer's maid. He may also have been the 'Master I.B.'

LUCAS VAN LEYDEN

Lucas [Huygensz] van Leyden (1489 or 1494–1533) was a pupil of his father and Cornelis Engelbrechtsen, both painters, and as a painter he is regarded as the father of the Dutch School. The Emperor Rudolph II was so impressed by his immense triptych of *The Last Judgment* in the Leyden town hall (fortunately hidden during the iconoclastic Beeldstorm of 1566) that he offered to cover it with gold as a price.

He is almost better known as an engraver and woodcut designer, but his teacher of these arts seems to be unknown. He was another infant prodigy and proficient in the crafts as a boy. Van Mander said he was a master from the cradle, with painters' and engravers' tools as toys. It is supposed that he picked up engraving by watching a goldsmith and an armourer at their craft of inlaying.

The influence of Dürer is very strong, and, in his short life he made 177 engravings, some quite large, as well as designing over 100 woodcuts. The first dated engraving, 1508, was sufficiently noticeable for Marcantonio to 'lift' the background for his 'climbers', after Michelangelo.

The subject of this early engraving, *Mahomet and the Monk Sergius*, seems an unusual one, at least for a boy who may have been only fourteen. It illustrates an Eastern story from the life of Mahomet, explaining why he forbade the use of wine. The

prophet is shown drunk and made the scapegoat for his servants' murder of a friendly monk: they placed his bloody sword beside him, so that, when he awoke he thought the crime was his.

Another subject that he rendered both in line and in woodcut was *Virgil suspended in a Basket*. Virgil had boasted to his friends of his conquest of the daughter of the Emperor Augustus, disclosing to them that she had agreed to lower a basket and draw him up to her room during the night. Word of this got to the lady's ears, so that she left him suspended half-way up the wall, to be ridiculed next morning by his friends and the whole populace. The poet, however, had learned magic from a large devil he had released from a very small hole, where he had been confined till the Day of Judgment, and exacted revenge by extinguishing all the fires in the city, making everyone go to the lady for a light.

Among his other plates are the large oblong *Ecce Homo*, *Conversion of St. Paul*, and *The Dance of the Magdalen*, perhaps his most famous plate, almost a Watteau-like composition in a woodland setting, where, in a gay party, St. Mary Magdalen 'delivers herself up to the pleasures of the world,' with a solemn pas-de-deux. He also did a set of *The Passion* on circular plates, now extremely rare, using the same separate circular border for each plate.

The smaller, upright *Passion*, a set of fourteen, measures 115 by 74–76 mm., the second states having the name of Petri. This small upright *Passion* was deceptively copied by Jan Muller, the same size, with Lucas's initials and the date. The first plate of these copies, *The Last Supper*, has, in the first state, the name I. Muller ex.; in the second state this first plate has the name C. Danckerts ex.

When Dürer went to Antwerp to obtain the confirmation of his annual pension of 100 guilders from the new Emperor Charles V, he described in his journal how he met 'Master Lucas, the engraver on copper, a little manlet', and exchanged all Lucas's engravings for eight florins' worth of his own art. Van Mander tells us Dürer embraced him, his breath and speech failing with emotion, surprised to find a man with so great a reputation had so small a figure.

Lucas married the daughter of a noble family and regretted the time he was obliged to spend at banquets and festivities. He also went on a journey with Jan Gossaert (Mabuse) to Zeeland, Flanders and Brabant, and, possibly as a result, was taken ill in 1527, although there was even a legend that he was poisoned by a jealous artist. His last six years seem to have been spent mostly in bed, painting and engraving with specially made tools, and the suggestion that he was consumptive may well be correct, in addition to overworking.

The lightness of Lucas's touch with the graver, however, is visible throughout his work, so can scarcely be attributed to his bedridden state, but does account for the fact that good impressions from his plates are rare (Plate 27).

HIERONYMUS COCK, BOSCH *and* BRUEGHEL

Following the success of Il Baviero in publishing Marcantonio's engravings after Raphael (see Marcantonio), a number of publishers established similar businesses.

Worn and reworked impressions of plates by Marcantonio, also some of those newly done by his pupils, are often to be seen with the words *Ant. Sal ex.*, meaning Antonio Salamanca excudit (published it) (d. *c.* 1562). Another name in Rome, sometimes also on plates of Marcantonio's school, was Lafreri, i.e. Antonio Lafreri, d. 1577 at Rome, who also published several engravings by Cornelis Cort.

In Holland and Flanders, as perhaps elsewhere, these publishers were often engravers themselves, one of the most important being Hieronymus Cock of Antwerp (1510–70).

Cock had first observed the success of the print publishers at Rome, where he had himself published a series of landscapes engraved from his own work and that of his brother Mathys. Returning to Antwerp in 1550, he established a famous publishing and printselling business at the sign of 'The Four Winds', employing a number of engravers and artists: Frans Huys, Pieter van der Heyden, Theodore Coornhert (the master of Goltzius), Herman Muller (father of the more famous Jan), and Philip Galle, who himself became an engraver-publisher.

Huys signed with his initials F.H., and Pieter van der Heyden with a monogram of the letters PAVE, but many of these plates have only the name of Cock as publisher. Some were undoubtedly also engraved by him, and other plates may have been the work of apprentices, not yet allowed to sign their names, until their election to the guilds.

Giorgio Ghisi, of Mantua (1520–82), was sent for by Cock and employed by him to engrave Raphael's *School of Athens*. This, and other Italian plates are alleged to have contributed to the enervating influence of the later Italian art upon that of the North.

It is, however, Cock's publication of prints after Hieronymus Bosch and Pieter Brueghel the Elder, that is now considered to be his chief achievement. A greatly increased interest has lately been taken in the landscapes after Brueghel, as well as in the weird subjects after him and Bosch.

Hieronymus Bosch (*c.* 1450–1516) was the instigator of the diablerie style. His real name was Jerome van Aken, but he was commonly called Bosch from his birth-place's Hertogenbosch (Bois-le-Duc).

Much speculation has been made as to whether he was a plain farceur, or if his pictures have hidden meanings. Did he portray his devils in such fantastic shapes knowing the difficulty they had in assuming human shape? Or was he a member of an heretical movement, the 'Homines Intelligentiae', his pictures having meanings unrecognisable by any but the fraternity?

Van Mander, writing eighty years after his death, knew no more than to say that he painted 'gruesome pictures of spooks and horrid phantoms of hell'. Lampsonius, thirty years earlier, could merely ask 'Jeroon Bos, what is the meaning of your pale features and frightened face, as if you imagined all the spirits of hell flying round your ears?'

Pieter Brueghel the Elder (*c.* 1528–69) was Bosch's chief follower. He died at Brussels, but may also have been born at Bois-le-Duc, and was first apprenticed to a pupil of Bosch and afterwards, it has been said, to Hieronymus Cock, though it has also been stated that he first began working for Cock in 1553.

Van Mander said he liked to frighten people with spooks and noises, and that he produced many spookish scenes and drolleries, for which reason many called him Pieter the Droll: 'there are few works by his hand which the observer can contemplate solemnly and with a straight face'.

Brueghel also did many views from nature, several of which were engraved. These were done from material collected during a journey to Sicily. 'It was said that when he travelled through the Alps he swallowed all the mountains and rocks and spat them out on to paper or canvas, such was his close imitation of nature.' Some of these were quite large, one being an etching, touched with the graver, known as *The Rabbit-Shooters* and the only work in this medium by Brueghel himself (Plate 28).

Another feature of his work was his peasant scenes, to obtain material for which he would disguise himself to attend the fairs, or, if at a wedding, pose as a relation taking gifts.

A number of delightful engravings of warships, including the Battle in Messina Straits, dated 1561, were made from his drawings, so that his work divides itself into four sections: The Landscapes, the Warships, the Diableries and the Peasant Scenes, numbering altogether over 270 engravings, mostly published by Cock. The principal engravers were Hieronymus Cock, Frans Huys, Pieter van der Heyden, Hieronymus Bos and Bartholomeus de Mumpere (Plates 29 and 30).

Later impressions exist, republished by Philip Galle and others. Eight of the warships had the numbers 5 to 8 added in the bottom right-hand corner and were issued with the four plates published by Adriaen Collaert of the discovery of America by Christopher Columbus, Amerigo Vespucci, etc. Other reprints were published by Philip and Jan Galle.

HENDRIK GOLTZIUS

Cock had a pupil named Cornelis Cort (*c.* 1530–78), who in turn taught a number of engravers in Rome, and influenced Hendrik Goltz, called Goltzius (1558–1617), one of a family of artists and one of the first Northern artists to assimilate the Italian style and at the same time show the great influence of Dürer and Lucas van Leyden. There is an early record of one of his prints, darkened by smoke, being mistaken for an unknown Dürer and selling for a high price. This may have been his *Pietà*, one of his most popular prints.

Altogether Goltzius engraved over 350 plates. Six large plates, 470 by 350 mm., are known as the *Masterpieces of Goltzius* (Bartsch 15–20), depicting scenes from the life of the Virgin: The Annunciation, The Visitation, The Adoration of the Shepherds, The Circumcision, The Adoration of the Kings and The Holy Family. They are fine plates, in the style of Dürer and van Leyden.

Soldiers and Standard Bearers, including *The Standard-Swinger* (Plate 31), are among his non-religious subjects, and in them Professor Hind saw his delight in rendering swelling curves. His work also included a number of fine chiaroscuro woodcuts.

In 1576 he settled at Haarlem and had many pupils there: among them Jacob de Gheyn the younger, Pieter de Jode the elder, Jacob Matham, Jan Saenredam, etc., who,

with their master, were the precursors of the amazingly accomplished and prolific Rubens, who directed a crowd of engravers, including Schelte A. Bolswert, Paul Pontius, Lucas Vorsterman, Jonas Suyderhoef, Pieter Soutman, etc.

Goltzius engraved some fine portraits with some small ones that appear to have been engraved on silver plates. His larger portraits include his master *Theodore Coornhert*, and a boy with a large dog, representing Frederik de Vries, son of the painter Dirck de Vries. This portrait is commonly called *The Son of Frisius* or *The Dog of Goltzius* and it has been deceptively reproduced in photogravure. In the copy there is a greater distance between the borderline and the platemark, the original plate measuring 360 by 265 mm. and the reproduction 370 by 280 mm., although the measurements are the same to the borderline, i.e. 340 by 262 mm. There is also a copy with the monogram composed of the letters R.G., instead of H.G.

His *Large Passion*, a set of twelve (B. 27–38) measuring 202 by 135 mm., were also very deceptively copied. In the copies *The Resurrection* (B. 38) lacks the number 12 in the bottom left corner; in *Christ before Caiaphas* (B. 30) the 7 at lower right is in the copy less than 2 mm. from the right border, whereas in the original the interval is nearly 3 mm.

ABRAHAM BLOEMAERT

Abraham Bloemaert (1564–1651) is regarded as a follower of Goltzius. He did only one etching himself – Juno – but provided the original drawings and paintings for a quantity of engravings in line and woodcuts in chiaroscuro.

He was the father of Cornelis Bloemaert (1603–84) and Frederik Bloemaert (*c.* 1610–69), who engraved a large number of plates, many being after their father.

HENDRIK COUNT GOUDT

Hendrik Count Goudt (1585–1630) was an amateur engraver of professional skill, received into the Utrecht painters' guild as an engraver.

His entire engraved work consists of seven plates after Adam Elsheimer, with whom he was in Rome from 1608 to 1611 (Plate 32).

These rich, dark engravings are important, as they must have helped to spread the chiaroscuro and night effects of Elsheimer, acknowledged to have had considerable influence on art, also on similar engravings and etchings by Jan van de Velde (see p. 101).

4. Line-engraving in Italy

ORIGIN

Early Italian engravers lagged behind the Northerners in the technicalities of the art, particularly the printing, where their ink, instead of being strong and black, was often greenish-grey. Nor, judging from uneven impressions, do they seem to have had the roller-press (Plate 33).

Nevertheless, their compositions benefited from the influence of some of the great artists of the Renaissance. Maso Finiguerra himself was believed by the late Sir Sydney Colvin to have drawn the *Florentine Picture Chronicle*, a collection of drawings in the British Museum, an opinion recently upheld by J. G. Phillips, in *Early Florentine Designers and Engravers*. Florence was undoubtedly the first and principal centre of the earliest Italian engravers, where the art was practised by the goldsmiths, and the goldsmith-painter-sculptors, those Cennini described as serving a thirteen-year apprenticeship.

One of the earliest of these is known as the 'Master of the Vienna Passion', from a set of prints housed in the Albertina, done a little before 1450. The earliest date on an Italian print is 1461, but Maso Finiguerra (1426–64) was working in 1449, as a goldsmith if not an engraver.

At this time two styles of engraving were developed in Italy, known as the 'Fine Manner' and the 'Broad Manner', the former attributed to Finiguerra's workshop. It consisted of fine cross-hatching in the shadows, printing mostly almost as a wash, due to lack of pressure, whereas the 'Broad Manner', consisted of open slanting parallel shading, often with a return stroke between the lines, thought to have originated in another Florentine workshop; it gave an imitation of pen drawing.

ANTONIO POLLAIUOLO

Antonio Pollaiuolo (1432–98), the celebrated Florentine goldsmith-painter-sculptor, made his famous engraving, the *Battle of Naked Men*, in the 'Broad Manner', although he was associated with Finiguerra (Plate 34). The Cleveland Museum possesses a first state, before rework in the background and on the thigh of the right leg of one of the men with an axe: they claim it shows a combination of the fine and broad manners. This is universally accepted as perhaps the greatest engraving of the 15th century in Italy, and the only one by his own hand, though a few others are from his designs and in the same style.

Between his parallel lines of shading, Pollaiuolo made a marked diagonal return

stroke, similar to that of Andrea Mantegna. The subject gave full rein to his knowledge of anatomy. Vasari said: 'He had a more modern grasp of the nude than the masters before his day, and he dissected many bodies in order to study their anatomy. He was the first to demonstrate the method of searching out the muscles, in order that they might have their due form and place in his figures, and he engraved on copper a battle of nude figures all girt round with a chain.'

The two central combatants are holding a chain, and this led Professor Erwin Panofsky to the conclusion that the subject represented the Roman, Titus Manlius, accepting a challenge to personal combat from a gigantic Gaul, during an invasion by them in 361 B.C. He killed his enemy and took from him the necklace he wore, from which incident he was given the surname of *Torquatus* (wearing a twisted collar or necklace).

One sees sometimes depicted in other old prints a sequel to this, when later, in 340 B.C., he condemned to death and executed his own son, after he had been victorious in a similar feat, because, as a Consul, he had by then expressly forbidden single combats with the enemy.

J. G. Phillips, however, has interpreted the scene as 'Jason sowing the Dragon's Teeth'. According to this mythological story, Jason, in his quest for the Golden Fleece, had to tame two bulls, with brazen feet and horns, breathing fire and smoke. With them he ploughed a two-acre field and sowed the teeth of a dragon, when the fierce armed men sprang up. He threw a stone or magic helmet in their midst, causing them to turn against each other, till they all perished. In these labours he was assisted by his wife Medea, whose knowledge of magic provided him with a draught to lull another watchful dragon to sleep and obtain the Golden Fleece.

SANDRO BOTTICELLI

Sandro Botticelli (1444/5–1510) was another famous Florentine artist to be concerned with engraving: it is thought that he was associated with Pollaiuolo.

He designed the plates to illustrate the 1481 edition of Dante's *Divina Commedia*, engraved by Baccio Baldini (1436?–87?), a Florentine engraver and niellist, who, Vasari says, worked principally from Botticelli's designs.

The illustrations to the *Divina Commedia*, and to Antonio Bettini's *Monte Sancto di Dio*, published in Florence in 1477, were perhaps the earliest attempts to use copperplates, printed on pages of text, instead of woodcuts, to illustrate a book, but cannot be regarded as successful. Nineteen plates were engraved for the Dante, but no copies are known with more than two or three printed in spaces left in the letterpress, the others being stuck in: few examples of the book, however, contain the full number of plates.

ANDREA MANTEGNA

Andrea Mantegna (1431–1506) was the most important Italian engraver outside Florence at this period. He was born in Vicenza and studied at Padua under Squarcione (1396/7–1468/72), by whom he was adopted as son and pupil at the age of ten. Squarcione, in his teaching, made use of his collection of casts, antiquities and drawings from the antique, and owned a cartoon by Pollaiuolo.

E

The style of engraving adopted by Mantegna was similar to the 'Broad Manner', and had a strong affinity with that of Pollaiuolo. Both first outlined their subjects and used the slanting, diagonal lines of shading, with a return stroke between the lines.

It is often said that Mantegna was influenced by Pollaiuolo in this style, but it must be the other way round if Professor A. M. Hind has correctly interpreted the probable dates of Mantegna's engravings. Of the seven plates now attributed to the master himself one, *The Virgin and Child*, may be as early as 1450, and might lend weight to the theory that when early art-historians spoke of him as the 'first' Italian engraver, they meant earliest and not foremost.

On the other hand Vasari said it was in Rome, in 1488, that 'this thing [engraving] came to his notice', through seeing the engravings by Baccio Baldini after Botticelli.

Mantegna entered the service of the Gonzagas at Mantua in 1459, and there is evidence of a school of engravers there before 1470, working after his designs. It would appear that some of these were pirates, in view of a document in the City archives, dated 1475 and addressed to Lodovico Gonzaga: a complaint by Simone Ardizzoni, painter and engraver, that he and Zoan Andrea had been attacked on the orders of, it is inferred, Mantegna, and left for dead in the street. Zoan Andrea (fl. *c.* 1475–1505) was the engraver of a group of *Four Women dancing*, taken from Mantegna's painting of Parnassus.

This painting, one of three now in the Louvre, had been painted for Isabella d'Este, wife of Francesco II, the successor of Lodovico Gonzaga. One of the figures supposedly represents the girl herself, and the collaboration between her and the ageing artist, in the last few years of his life, is a fascinating feature of the time.

Isabella, however, appears to have had an iron fist in a velvet glove, and certainly had the ardent collector's acquisitiveness to a marked degree. When Urbino was sacked by Cesare Borgia, her first idea was to acquire Michelangelo's Venus and Cupid, one of the spoils, and from the Pallavicinis, who had assisted in betraying her brother-in-law, Lodovico Sforza, to the French, she begged a beautiful clavichord. She drove a hard bargain with Mantegna, then old and in financial difficulties, for his most prized possession, his 'dear Faustina of antique marble'.

An unfortunate artist, Luca Liombeni, was threatened by her in a letter from Ferrara in 1491, that if the painting in the studiolo was not finished on her return 'we intend to put you into the dungeon of the castello. . . . You can paint whatever you like in the cupboards, as long as it is not ugly, because if it is, you will have to repaint it at your own expense, and pass the winter in the dungeon, where you can, if you like, spend a night for your pleasure now, to see if the accommodation there is to your taste.' (See Julia Cartwright's *Isabella d'Este*.)

Three of the engravings made in Mantegna's studio were from the *Triumphs of Caesar*, the paintings at Hampton Court, bought-in for £1,000 at the sale of Charles I's collection. These and other of his engravings are sometimes to be met with printed in a brown ink, a variation of the green-toned ink commonly used to print engravings in Italy at the time, which Mantegna seems to have avoided.

Mantegna's engravings are rarely to be met with in good condition and are

frequently cut. In good impressions the return strokes between the lines should be distinct: these diagonal return strokes were more lightly engraved than the others, so that they wore down and disappeared in late impressions (Plate 35).

The two principal engravers in the manner of Mantegna were Giovanni Antonio da Brescia and Zoan Andrea. Others who were influenced by his style were Giovanni Maria da Brescia and Nicoletto da Modena. A number of other engravers used the diagonal shading stroke initiated by the 'Broad Manner'. Jacopo de' Barbari and Benedetto Montagna also used it to some extent, and it is also to be seen in the school of Leonardo. Girolamo Mocetto (*c.* 1458–*c.* 1531) also used Mantegna's ideas.

LEONARDO DA VINCI

It is not known whether Leonardo da Vinci (1452–1519) himself actually engraved, but several prints exist which are in his style of painting or drawing. One of these, intertwining cords (copied by Dürer as 'knots') has an inscription 'Accademia Leonardi'. A series of 15th century Italian beauties has been thought done under his supervision, but the authorities believe only one of these to have a reasonable possibility of being his own work.

The only impression of this print is in the British Museum and shows the bust of a young woman, in profile to the left, with long, partly braided hair. A short slipped stroke on the forehead has been thought to indicate that it is the work of someone not experienced in engraving; also that it would have been removed if the plate had been intended for circulation. The shading, too, bearing in mind that it would be engraved in the reverse direction of the print, could be by a left-handed man, but this could apply to other plates, which have not been accepted as more than after his designs (Plate 37).

JACOPO DE' BARBARI

Jacopo de' Barbari (*c.* 1450–*c.* 1515/16) was a Venetian artist, responsible for thirty engravings and three large woodcuts. The engravings are mostly signed with Mercury's wand, entwined by two serpents, so that he has often been called the 'Master of the Caduceus'.

Professor Hind advanced the theory that all his engravings were done in Venice, before he entered the service of the Emperor Maximilian I in 1500, at Nuremberg, as a portrait painter and illuminist. In 1503–5 he had joined the Elector of Saxony at Wittenberg and elsewhere, but was again at Nuremberg in 1504–5.

In 1510 he was engaged by the Archduchess Margaret, Regent of the Netherlands, as a painter and 'varlet de chambre'. In 1511 he is spoken of as old and infirm and granted a pension, with money to pay his lodgings and expenses, including 'a handsome suit of clothes'.

Professor Tancred Borenius listed him among the four principal early Italian engravers, bracketed with Pollaiuolo, Mantegna and Giulio Campagnola.

The acquaintanceship between Barbari and Dürer is one of the most interesting events in the history of engraving. On their first meeting in Venice in 1494–5 Dürer

was much impressed by Barbari's theories as to the possibility of drawing the human form from a fixed canon of proportions. After 1500 he resided for some time in Nuremberg and it has often been considered that he was influenced by Dürer. On the other hand, if Professor Hind is correct in surmising that all his engravings were made in Venice before 1500, it seems more likely to have been the other way round, as already mentioned.

There is a strong *rapport* between Dürer and Barbari in several of their engravings, with a particularly noticeable likeness in Dürer's *Adam and Eve* to Barbari's Apollo (in *Apollo and Diana*) and Venus (in *Mars and Venus*) (Plate 38).

It seems now to be established that the two artists first met in Venice in 1494–5, because on Dürer's second visit in 1506 he wrote back to Willibald Pirckheimer in Nuremberg that he was no longer impressed by what he had seen eleven years before, and that some people sneered at 'Meister Jacob'. Later, however, in 1523, he wrote, 'I can find none such who have written how to form a canon of human proportions, save one, Jacopo by name, born at Venice and a charming painter. He showed me the figures of a man and woman, which he had drawn according to a canon of proportions. . . . If I had it, I would put it into print in his honour, for the use of all men.'

Professor Tancred Borenius speaks of the drooping attitudes and languorous expression which he gives to his figures, 'and the long, softly gliding curves which predominate in his designs'.

Professor Hind thought that, though Barbari was little considered in Italy, in the North he was something of a pioneer, influencing Lucas Cranach, the Court painter at Wittenberg, and being copied by several engravers.

GIULIO CAMPAGNOLA

Giulio Campagnola (*c*. 1482–*c*. 1515) was a follower of Giorgione, and developed a style considered to be the forerunner of stipple – engraving in dots. These dots, in Campagnola's work, are actually wedge-shaped flicks produced by a graver, dots are done with a mallet and punch: the *opus mallei* as practised later on by Rembrandt's friend and sitter, the Amsterdam goldsmith Jan Lutma and his son.

Giulio was praised in contemporary accounts as a youth of great and varied gifts. To his painting, sculpture and engraving, he added music, literature, Latin, Greek, Hebrew and poetry, and there is some evidence that he became a priest in his last brief years.

Some of the landscapes in his engravings were copied from Dürer, whose *Penance of St. John Chrysostom* he also copied. He was also influenced by Mantegna (Plate 36).

Domenico Campagnola (fl. 1511–63), is classed as a pupil and adopted son of Giulio, though his style of engraving rarely followed that of his master. He was apparently an assistant to Titian, and designed some fine woodcuts.

The Master of the Beheading of St. John the Baptist (fl. *c*. 1500) was another follower of Giorgione and Giulio Campagnola. The early French engraver Jean Duvet (q.v.) seems to have copied his style, and Bartsch attributed to Duvet a plate now given to the Master of the Beheading of St. John the Baptist: *Combat of Animals in presence of a Man with a Shield*, based on a drawing by Leonardo (Plate 39).

A unicorn in the print no doubt partly explained Bartsch's attribution. His title 'Poison and Counter-poison' also partly explains the obscure meaning of the subject: the unicorn's horn being the antidote to the poisonous emanations of the dragon.

MARCANTONIO

Marcantonio Raimondi (*c.* 1480–1534) was born at Bologna and apprenticed to the goldsmith-painter Francesco Francia. The monogram he used, composed of the letters M A F, stands for Marc Antonio de' Franci, according to Vasari.

He has been classed with Dürer and Lucas van Leyden as one of the three greatest early engravers, but was also the first of the interpretive engravers, who reduced line-engraving from an original form of art to a largely subordinate role: a means of reproducing the work of other artists.

He was guilty of flagrantly copying the works of Dürer, including seventeen of the *Life of the Virgin* (all that had been published at the time), and causing Dürer to complain to the Venetian Senate in 1506. This did not deter Marcantonio from copying also the *Little Passion*, merely substituting his own tablet for Dürer's monogram, which the Signoria forbade him to use.

The influence of Dürer's system of translating pictures into line, and avoiding the mere diagonal shading, not only influenced Marcantonio, but was, through him, of the utmost importance to the history of line-engraving. It meant the end of the 'Broad Manner' style of making a heavy outline of the figures and objects and shading with slanting diagonal lines, in imitation of pen-drawing.

Marcantonio is believed to have arrived from Bologna in Venice about 1505, and here, according to Vasari, he met some Flemings on the Piazza San Marco, with wood and copper engravings, which so amazed him he spent all his money on them. The copies he made were sold as Dürer's. Vasari goes on to say that Dürer was so enraged he at once came to Venice and complained to the Senate, but it has since been established that his first object in going there in 1506 was to paint an altarpiece for the German colony.

The subsequent years have been termed Marcantonio's Dürer period. From Venice he went to Florence and, on reaching Rome, made a beautiful engraving of the *Death of Lucretia* from a drawing by Raphael, which, again according to Vasari, inspired Raphael to issue prints after his own designs (Plate 40).

The printing and publishing of these prints were entrusted to Baverio de' Carocci, called Il Baviera, who had been employed by Raphael as a boy to mix colours, eventually becoming his pupil and the dearly beloved friend, to whom the great artist confided his mistress on his deathbed. Vasari says the prints were sold both wholesale and retail at considerable profit.

There have been critics to doubt whether the relations between Marcantonio and Raphael were as intimate as Vasari said. After the master's death in 1520 the engraver translated the drawings of other artists, twenty licentious subjects he engraved after Giulio Romano getting him into serious trouble. These were illustrations to Pietro Aretino's *Sonnets*, and for his share in this he was imprisoned by the Pope. The

destruction of the prints must have been efficiently carried out, apparently leaving only one complete impression in existence.

Vasari's account is that Giulio got Marcantonio to 'engrave the twenty sheets of the commerce of evil men and women, for each of which Aretino wrote an extremely lewd sonnet, so that I cannot say which is worse, the drawings or the words. This work was strongly condemned by Pope Clement, and if Giulio had not already set out for Mantua, he would have been severely punished. The designs were afterwards found in the most unexpected places, and were finally prohibited, Marcantonio being imprisoned. He would have come off badly if the Cardinal de' Medici and Baccio Bandinello, who was serving the Pope in Rome, had not got him released. The gifts of God ought certainly not to be employed, as they so often are, upon such utterly abominable things. . . .'

The Loves of the Gods are so rare, said Bartsch, that one has even doubted their existence: he himself had seen only the first plate of the set of twenty (B. 231). Passavant, in his additions to Bartsch's catalogue of old-master prints, described the whole set. Mariette, he said, possessed a complete set, supposed to have gone to the Bibliothèque Nationale, 'but all searches have been unsuccessful'. Some fragments are in the British Museum.

Marcantonio's career ended with the sack of Rome in 1527 in which one of his assistants, Marco Dente da Ravenna, was killed. He was well-nigh reduced to beggary as, besides losing everything, he had to ransom himself from the Spaniards. This done, he left Rome never to return.

In the field of line-engraving, Marcantonio has been blamed for inaugurating the almost completely interpretive role which it began to assume.

5. Line-engraving in France

SCHOOL OF FONTAINEBLEAU

France has occasionally laid claim to some of the earliest 15th century woodcuts, possibly with justification, and, in the early 16th century, a number of book-illustrations were produced in the dotted manner (*manière criblée*), punched in metal. It was not, however, till Francis I started the rebuilding of Fontainebleau, with the aid of Italian artists and craftsmen, that line-engraving began to be extensively practised, a studio or workshop being installed under the supervision of Il Rosso and Primaticcio, the first of a large number of Italian artists to be employed in the decoration.

The establishment of the 'School of Fontainebleau' was the culmination of several previous attempts to import Italian art into France. The campaigns of Louis XII and Francis I in Italy led to the importation of Solario in 1508 to decorate Cardinal Amboise's new palace at Gaillon. Andrea del Sarto in 1518 went to Paris in the service of Francis I and stayed for a year, during which he painted the picture of Charity, in the Louvre, and left with money for the purchase of works of art. In 1515 Leonardo accompanied Francis I to Amboise, where he died in 1519. Paris Bordone travelled to the French Court in 1538 and painted many portraits of women for the King. Only by the accident of an undelivered letter was Michelangelo prevented from going; Raphael was too busy, but accepted several commissions from Francis I 'a goodly Prince, merry of cheer', who, impressed by the wonders of Italy, had, like Louis XII, coveted Leonardo's *Last Supper*. Not finding anyone capable of removing it, he persuaded the artist himself into his service, and acquired the famous *Mona Lisa*, Louis XII having already collected the *Virgin of the Rocks*.

The Palace of Tè at Mantua is thought to have provided the inspiration for Francis I when he ordered the building and decoration of Fontainebleau. Many Italian artists and craftsmen were engaged, their director being Giovannibattista di Guasparra (1494–1540), known as Il Rosso, and Francesco Primaticcio (1504–70).

Il Rosso, the first to arrive, was a Florentine follower of Michelangelo; he had been imprisoned in the sack of Rome. Vasari tells us he was a man of splendid presence, a good musician, with an excellent knowledge of philosophy and architecture. In France he lived like a lord, with a great number of servants and horses, but poisoned himself in 1540, according to legend, out of remorse for having caused a fellow countryman, Pellegrini, to be tortured on a false accusation of robbing him.

Primaticcio, born at Bologna, was the most brilliant pupil of Giulio Romano, who had decorated the Palace of Tè. On the death of Il Rosso he took charge of the work

at Fontainebleau. Francis made him *Commissaire général des bâtiments de l'Etat*, and named him abbé of St. Martin de Troyes: for this reason he signed himself St. Martin Bolon. It was he who prepared the drawings and plans of the many works of sculpture, ornament, furniture, fountains, goldsmith's work and even spectacular fêtes.

Historical fables may have done injustice to two great men, whose energy, ability and fertility of invention made the palace of Fontainebleau the wonder of the civilised world and the envy of poorer monarchs.

Francis, the instigator, was well versed in the arts, in literature and languages; Il Rosso was the great inventor, both he and Primaticcio working with an army of assistants, including (after 1552) Niccolo dell' Abate: these assistants carried out the designs of the masters. Besides the innumerable decorations and stucco figures, the palace contained 400 paintings on the walls and ceilings, Primaticcio working on them for thirty years. They exist now in only a few rooms and galleries.

Cellini worked here, quarrelling with Madame d'Etampes, maîtresse-en-titre, their raised voices being heard on the occasion of the unveiling of his silver statue of Jupiter in 1545, the King breaking it up with 'Enough, enough'. Only a while before this, says Cellini, the King had patted him on the shoulder and said: 'My friend, I know not whose pleasure is the greater, that of the prince who finds a man after his own heart, or that of the artist who finds a prince willing to furnish him with the means for carrying out his great ideas.' He naïvely adds: 'My ill-luck willed that I was not enough awake to play the like comedy with Madame d'Etampes.'

Primaticcio carried on under Henri II (and Diane de Poitiers), a studio being set aside for the engravers and printers, to work under the supervision of these great artists; the aggrandisement of the palace was continued in the reigns of Henri II, Francis II, Charles IX and Henri IV, but the contemporary engravings are the only means of telling what the wall-paintings may have looked like. An etching of two Roman Women, attributed to Primaticcio, seems to be the only original work in this line, by the masters themselves, to survive. The names of several French artists employed, probably on the ornaments, are known.

Jean Duvet (*c.* 1485–after 1561) has the distinction of being the earliest known French line-engraver. It has been suggested his real name may have been Drouot, documents referring to him as 'Drouot dict Duvet', though also as 'Duvet dict Drouot'. He was a goldsmith of Langres, *Orfèvre du Roi*, under Francis I and Henri II, and in 1521 and 1533 assisted in the ceremonies for the entry of the former into the city. He may have visited Italy and Paris.

His style has great originality, apart from a strange resemblance to that of a Milanese engraver, known as the Master of the Beheading of St. John the Baptist, to whom four plates, formerly attributed to Duvet, have now been given.

A slender connection with the School of Fontainebleau rests upon a set of six engravings depicting the *Hunting of the Unicorn*, the principal participants being Henri II and Diane de Poitiers. It was from this set that he used to be called 'Le Maître à la Licorne'.

The casting of Diane in the role of a unicorn's decoy must have caused some raised

eyebrows among the courtiers, kicking their heels in the draughty corridors of the palace. The engravings undoubtedly had the royal approval, but the reason for the use of this particular allegory is unexplained, unless it was gross flattery. The legend of hunting the unicorn said that it could only be taken by setting a maid 'where he haunteth, and she openeth her lap, to whom the unicorn, as seeking rescue from the hunter, yieldeth his head and leaveth all his fierceness'.

One of the plates formerly attributed to Duvet, but now given to the Master of the Beheading of St. John the Baptist, also depicts the legend that the unicorn had the power to purify a stream of water with his horn. This close resemblance between subject and style of the two artists – a style that was otherwise original – has not been explained unless it could be by Duvet's suggested visit to Italy (Plate 41).

His chief work was the *Apocalypse*, published in book form in 1561, with twenty-three plates, a title-page and letterpress, but now of the greatest rarity in this form. The compositions of this set were markedly influenced by Dürer's woodcuts of 1498, but were carried out in Duvet's original style, which seems to have been one of the main sources on which William Blake based his work.

The *Apocalypse* was published with a *privilège* of the King, granted in 1556 for twelve years, a form of copyright which lasted up to the Revolution, and which is further discussed under 'Hogarth's Act'.

VERSAILLES, *etc*

Louis XIV continued the royal policy of aggrandisement, with the aid of Cardinal Mazarin and Colbert, who was responsible for founding the Académie des Beaux-Arts in 1648.

Le Sueur was the first director, followed by the more famous Charles Le Brun (1619–90). It has been described as paradoxical that an artist, now considered so inferior, should have been called upon to play such an important part in the history of art. Even when Napoleon's plunder was being returned to the European galleries, a painting by Le Brun was considered sufficient exchange for Veronese's *Marriage Feast at Cana*, the large size of which had created difficulties of transport. It had been removed from the convent of San Giorgio Maggiore in 1799 and taken to the Louvre.

Charles Le Brun was, however, a great director and decorator, his role at Versailles being equivalent to that of Primaticcio at Fontainebleau. He not only painted vast subjects 30 feet long (the Four Battles of Alexander were too large for a use to be found for them), he designed gardens, fountains, vases, urns, sculpture, even fêtes, funerals and fireworks and assisted in the surrender of towns. When Colbert bought the Gobelins factory for the King in 1662, Le Brun was made superintendent, designing furniture as well as tapestry.

At the Gobelins he opened an *atelier de gravure* in 1667, and, when Louis XIV started the *Cabinet du Roy*, he also contributed to this enormous work, which eventually, in 1727, was united in twenty-three volumes. The *Cabinet du Roy* was probably first put in hand in 1670, the first volume appearing in 1677. It consists of volumes of prints, at first published separately, commemorating the King's martial achievements,

his palaces, art treasures, etc. The plates for this enormous work are still preserved in the *Chalcographie du Louvre*.

A great deal of Le Brun's work survives only in engravings; his matchless goldsmith's work was melted down in 1689 to help pay for the royal defeats. He left four original etchings and over twenty engravers were employed to engrave his works at Versailles, Sceaux, the Tuilleries, the Louvre, etc.

ORNAMENT ENGRAVING

As engraving was a goldsmith's art it is not surprising to find that a number of early engravers made plates of ornamental work, but the publication and sale of small books of ornamental designs, with title-pages, for the use of goldsmiths and silver-smiths, became a prerogative of the French engravers, following the School of Fontainebleau, where a number of French artists were employed.

The chief of these French ornament engravers were

René Boyvin, of Angers
Jacques Androuet Du Cerceau
Etienne Delaune 'Stephanus'
Pierre Woeiriot
Georges Charmeton
Jean Le Pautre
Jean Bérain
Daniel Marot
André Charles Boulle
Noel Garnier, who worked in the first half of the 16th century, is described as the first *maître ornamentiste* who engraved on copper.

René Boyvin is known to have worked at Fontainebleau. Du Cerceau was a celebrated architect, as well as the leading *maître ornamentiste* of his time; he established a studio of engraving at Orléans.

Etienne Delaune signed his plates Stephanus (=Etienne) and was one of the most prolific ornamentalists.

PORTRAITS, 17TH CENTURY

Jean Duvet and the *maîtres ornamentistes* were almost the last of the original engravers interpreting their own compositions, with the exception, in France, of some gifted portraitists.

One of these was Claude Mellan (1598–1688), best remembered for his *Face of Christ*, engraved in one unbroken spiral line, commencing at the tip of the nose, light and shade being obtained by narrowing or thickening the line.

Jean Morin (*c.* 1590–1650) used dots to a large extent, thus anticipating the stipple engravers of the next century.

Robert Nanteuil (1625?–78) was the most famous of this group, engraving mostly after his own chalk and pastel portraits. He became Portrait Engraver to Louis XIV

in 1659, and raised the status of engravers by persuading the King to pass the Edict of St. Jean-de-Luz, by which engraving was raised from the Industrial Arts to the Liberal Arts.

Engraving in the 17th century had become, in general, almost entirely interpretive. In France engravings after Le Brun and Nicholas Poussin helped to dominate art, whilst engraved portraiture was a succession of elaborately accessoried 'limnings' of Kings, Queens, Ladies, Generals and Abbés, and not least the procession of *Maîtresses-en-titre*.

After a painting by Pierre Mignard we have *Henrietta Duchess of Orléans*, sister of Charles II, so excessively slight that Louis asked his brother why he had been in such a hurry to marry the bones of the Holy Innocents; *Louise de la Vallière*, the modest violet: Pepys recorded that the King went to see her publicly, his trumpets and kettle-drums with him; *Mlle. de Fontanges*, of whom the Abbé de Choisy said she was as beautiful as an angel and as stupid as a post; *Louise de Kerouaille, Duchess of Portsmouth*, whom Nell Gwynne "insulted and made faces at"; *Madame de Maintenon*, whose portrait was criticised by Cardinal Dubois: 'disguised as a saint, at the risk of the storm of jests which this burlesque involved'; *Madame de Montespan*, to whose eight children Madame de Maintenon had been governess.

Many portraits were engraved from the paintings of Hyacinth Rigaud and Nicholas de Largillière, two of the many artists to lose money in the crash of the Mississippi scheme of the Scottish banker, John Law. One of Rigaud's most famous portraits was a full-length of *Bishop Bossuet*, engraved by Pierre Drevet. It is said that once when addressing the King and Court, the Bishop declaimed that all the world was mortal. His sweeping eye then fell upon the King and he added 'at least, nearly all'.

Cardinal Dubois saved himself from loss in the Mississippi bubble by seeking the advice of the banker Antoine Crozat, going to see him armed with a magnificent Rembrandt.

The banker's brother, Pierre Crozat (1665–1740), the famous collector, was known as 'the poor Crozat', because he possessed a few less millions, his brother being 'the rich Crozat'. The *Recueil d'Estampes d'après les plus beaux tableaux . . .*, published from 1729 to 1742, of engravings of works of art in the Royal collection and elsewhere, contained so many belonging to Pierre Crozat that it was commonly called the *Cabinet Crozat*, and was one of the major productions of its kind.

WATTEAU

Another very important collection of engravings was the *Œuvre gravé* of Watteau, published in 1735, two large folio volumes containing over 270 plates. These two volumes, together with two smaller volumes of the *Figures de différents caractères*, issued in 1726 and 1728, form a set known as the *Recueil Julienne*.

Jean de Julienne, director of the Gobelins factory, undertook to commemorate his friend by having all his available works engraved or etched. This occupied fifteen years, and 100 examples of the large *Œuvre* were printed, only about thirty of which have remained intact, the rest having been broken up so that the plates could be sold separately.

The engravers employed by Julienne included François Boucher, B. Audran, P. Aveline, C. N. Cochin, J. P. Le Bas, J. E. Liotard, P. Mercier, G. Scotin, P. L. Surugue, N. H. Tardieu, etc., many of them well-known artists in their own right. Almost a new technique was required, mostly a combination of etching and engraving.

To print the plates Julienne had a press installed in his Paris house. Crozat's and other houses, both private and publishing, had similar presses, and were the cause of constant complaints from the copperplate printers' guild, established in 1692: *La Communauté des Maîtres-Imprimeurs en Figures dite de Taille-Douce de la Ville de Paris*. Crozat and Julienne were mentioned by name, as people powerful from their riches and credit . . . le sieur Crozat and le sieur Julienne, 'who have worked presses in their houses for a number of years'.

The dissemination of these engravings must have helped the influence which Watteau's art had on the 18th century, brightening the classical gloom, against which Hogarth also rebelled (Plate 42).

The light inconsequence of Watteau's subjects may have been a revolt against one of his first professional engagements – to paint an endless succession of the same St. Nicholas, for Métayer, whose studio was known as the Factory of Saints. Similar shops existed until quite recent times, the work usually being farmed out, the artists painting from a pattern which was sent them with a dozen or so blank canvases. On these they would paint replicas, painting all the skies, for instance, first; next all the foregrounds, and so on. One man, painting Eastern scenes, would obtain a long plank of wood. On the top part he would paint a long strip of blue for sky, on the lower part a long strip of yellow for sand. Next he would saw up the wood into sections and proceed to paint a pyramid, a camel and a palm-tree on each in turn, on the principle of mass-production. Métayer is said to have had a dozen or more specialists, some painting skies, others heads and draperies. Watteau, owing to his speed and ability, was allowed to paint the whole of his picture by himself. He said: 'I knew my St. Nicholas by heart and used to do him without the copy.'

He was rescued from this drudgery, earning twelve shillings a week, by Claude Gillot (1673–1722), Director of Costumes at the Opera and a scene-painter, who was the instigator of the Italian Comedy subjects, the Pierrots, Columbines and Harlequins, just returned after their banishment by Louis XIV.

The *Recueil Julienne* took fifteen years to complete, and some of the engravings have verses below which epitomise the gayer times following the demise of Louis XIV:

> Voulez vous triompher des Belles?
> Debitez leur des bagatelles;
> Parlez d'un ton facetieux;
> Et gardez vous bien au près d'elles
> De prendre un masque serieux.
>
> L'Amour demande qu'on l'amuse:
> Il est enfant: toute la ruse,
> Pour luy plaire, est d'estre badin:
> Et souvent au Sage il refuse
> Tout ce qu'obtient un Arlequin.

EIGHTEENTH CENTURY

Jean Marc Nattier (1685–1766), was another artist to supply the engravers with material, notably his portraits of Louis XV, his Queen Marie Leczinska and his daughters, the Mesdames de France, whom he portrayed in various classical guises, causing him to be called an historical painter turned portraitist.

The engraver Nicholas Cochin said he made people think that one of the principal pastimes of French ladies was to amuse animals; they were in the habit of giving white wine to eagles in golden goblets – an allusion to Hebe as a character for portraits. 'Apparently the clothes were those they wore *en negligé* in their rooms in summer. . . . There were many yards of material and a head-dress of cornstalks, flowers and pearls. . . . They were in the habit of leaning on pots overturned to water their gardens. . . . Evidently they took pleasure in agriculture.'

There was also one of the royal *maîtresses*, the *Duchesse de Châteauroux*, painted as 'Break of Day,' after whose death the Queen, terrified of ghosts, called out to a femme-de-chambre: 'Mon Dieu, that poor Duchesse! Suppose she came back!' 'Madame,' replied the lady, 'should she return your Majesty would not be the one to receive her first visit.'

And the *Comtesse de Mailly*, sister of the Duchesse: The Comtesse 'had the finest leg to be seen at Court', but was a great disappointment to everyone, for, if she asked nothing for herself, she also asked nothing for her friends.

Nattier lost his first money in the Law crash and undertook the task of making the drawings for the engravers of the Rubens paintings in the Luxembourg, of the history of Marie de Medicis.

Jacques-Philippe Le Bas (1707–83) was the leading Parisian engraver, and teacher, of his time. Line-engraving (taille-douce) had become the principal form of engraving in France and it was said that the art was almost born with Le Bas and died with him, shortly before the Revolution.

Most of the best-known engravers of this period were his pupils: Aliamet, Cathelin, Cochin, Eisen, Ficquet, Gaucher, Godefroy, Helman, Le Mire, De Longueil, Masquelier, Moreau le jeune, Strange and Ryland. They lived-in as apprentices, under Madame Le Bas's maternal eye.

He was very well liked, with a noted sense of humour. We have records of him claiming, as a youth, to be an accomplished violinist, so that, when a guest of the rich amateur and collector Crozat, he was nearly roped-in to lead the orchestra at a concert, and had to pretend he had cut his finger on his burin, as an excuse to avoid playing before the rich financier's guests.

There is a vision of him submitting his work to Madame de Pompadour, surrounded by courtiers at her toilet; for her brother, the Marquis de Marigny, he engraved one of his best-known sets, the *Ports of France*, after Joseph Vernet.

Cochin had obtained the commission to engrave these paintings from the Marquis, the famous *Surintendent des Batimens*, and did the preliminary etchings, engaging Le Bas to finish the plates by engraving.

Charles-Nicolas Cochin (1715–90), who did these brilliant preliminary outline etchings on the large plates of the *Ports of France*, belonged to a family of engravers. His father Charles-Nicolas Cochin *père* was a well-known engraver, and his mother and aunt were both professional engravers under their maiden name of Hortemels, the aunt marrying the engraver Nicolas-Henri Tardieu, her brother engraving for Crozat.

Cochin *fils* is spoken of as teaching Madame de Pompadour, who 'etched agreeably', though she probably owed most to Boucher.

The engravings of domestic subjects done after Jean-Baptiste-Siméon Chardin (1699–1779) still have some popularity: Saying Grace, Blowing Bubbles, The House of Cards, A Boy Drawing, The Governess, The Schoolmistress, The Hard-worked Mother, The Tapestry-maker. Over fifty line-engravings of this kind were done from his paintings, by C. N. Cochin, J. P. Le Bas, J. B. Lepicié, P. L. Surugue, L. Cars and others.

Chardin was also a painter of still-life, and on the day he was elected to the Académie and his pictures were on view, Largillière came up to them and said: 'You have some very fine pictures there, evidently the work of an accomplished Flemish painter; now let us see your own work.'

A story has been told that he was led to adding genre painting to his still-lifes by a friend's telling him he had refused to paint a portrait for 400 livres. 'What!' said Chardin, 'you refuse that large amount?' 'It would be,' replied his friend, 'if a portrait were as easy to paint as a sausage.'

One of the best engravings after him is *La Serinette*, engraved by Cars, supposed to represent Madame Geoffrin, famous for her literary and artistic salon, seated by a bird-organ, used to teach canaries to sing. The original painting, now in the Frick collection, was formerly in the possession of Louis XV.

François Boucher (1703–70), an artist of extraordinary gifts, is celebrated for his part in French art of the 18th century and for his artistic collaboration with Madame de Pompadour.

C. N. Cochin did an engraving of the ball at which she first succeeded in attracting the notice of the King, the *Bal des Ifs* at Versailles in 1745. The King and his party were dressed as clipped yew trees, and the *morceau du roi*, as Diana, aimed a jewelled bow and arrow at him.

Boucher himself did over 180 etchings, including 124 after Watteau for the *Figures de différents caractères*. It is possible to count the better part of a thousand plates done after him: line engravings, crayon-manner engravings, by Demarteau, pastel imitations by Bonnet.

In the words of the De Goncourt brothers: 'Female forms move and change at his touch. . . . Venus triumphant alternates with wanton shepherdesses. . . . Festoons of Cupids flutter about their mother like a feathered court.' Adverse critics said he painted nothing but mistresses. Diderot decried his 'simperings, affectations . . . nothing but beauty spots, rouge, gew-gaws. . . . What can there be in the imagination of a man who passes his life with loose women of the lowest class? . . . All his

compositions make hideous confusion in the eyes. He is the most mortal enemy of silence that I know. . . . When he paints infants he groups them well. . . . In all this numberless family you will not find one employed in a real act of life, studying his lesson, reading, writing, stripping hemp.' His work has been described as symbolical of the life of the Court: shepherds and shepherdesses dilly-dallying in the sunshine whilst the storms gather.

His most famous pupil and assistant was Jean Honoré Fragonard (1732–1806), who made a few etchings himself and supplied the designs for several famous engravings, such as *Les Hazards heureux de l'Escarpolette*. One painting of the subject is in the Wallace Collection, London, and another in the collection of Baron Edmond de Rothschild.

A feature of the engraved work in France in the 18th century is the 'Estampe galante', many of which show very attractive interiors of the period, with 'Louis quinze' furniture and decorations, elegant ladies and gentlemen, and the very public 'toilette' scenes, one of which was described by the Duchess of Northumberland (*Diaries of a Duchess*, edited by James Greig, 1926): 'I then went with the P. d'Henin to Mme. du Barri (who was putting on her robe) surrounded by the Comte de la Marche, the Prince de Soubise, the Comte de St. Florentin, Le Controlleur General des Finances & several others of the Ministers. She had 4 Femme de Chambre, 2 on their feet & 2 on their knees. She seem'd in a very bad Humour & call'd them a great many Betes & scolding one of them in particular, she said she believ'd never Sow produced a "Cochon si Bete". The Comte de St. Florentin said to her, "N'Impatientez vous pas Madame". She replied with great fierceness, "Taisez vous, cela savouroit beaucoup des Porcherons".'

Boucher's pupils included his two sons-in-law, P. A. Baudouin and Deshayes. The former designed several of the interiors of the aristocratic salons for the engravers, giving such a pleasant insight into the decorations, furniture and costumes of the period. Madame Deshayes, Boucher's daughter, was the subject of Louis Marin Bonnet's most successful '*imitation du pastel*', from seven or eight plates, known as the *Tête de Flore*.

P. A. Baudouin, was in fact one of the principal artists drawing these subjects, which included *L'Amour frivole*, a fitting title for many of the others also.

The engravers employed on his work were J. Beauvarlet, P. P. Choffard, Nicolas de Launay, N. J. Masquelier, J. B. Simonet, etc. Moreau le jeune in some cases made the preliminary etching on the plates, as a guide to the engraver. These preliminary etchings, as in other examples, are so fine and exact that H. W. Lawrence thought they might be actually made with a burin and not etched, as, however, they appear to be.

Sigmund Freudenberger (1745–1801), the Swiss artist, who was known as Freudeberg in France, designed a number of similar though mostly more respectable prints, and a large number were done after J. B. Greuze, of a more domestic character.

Nicolas Lavreince (1737–1817), who was really a Swede named Lafrensen, was the chief exponent of 'L'Estampe galante'. His pair *L'Assemblée au Concert* and *L'Assemblée*

au Salon, engraved by N. Dequevauviller, are among the best, also the pair *Le Coucher des Ouvrières en Modes* and *Le Lever des Ouvrières en Modes*, by the same engraver. *Qu'en dit l'Abbé?* is a delightful composition, showing the abbé in a fashionable salon, being asked his advice on some stuff by the ladies. Some of Lavreince's work was brilliantly translated into colours by Janinet.

The 'Estampe galante' culminated just before the Revolution in a series of thirty-six plates known as *Le Monument du Costume*. The work was published under the patronage of a banker named Eberts, the full title being self-explanatory: *Estampes pour servir à l'histoire des moeurs et du costume des François dans le dix-huitième siècle*, published from 1774 to 1783, in three 'suites'.

Freudeberg was the artist engaged to make the drawings for the 'Première suite' and Moreau le jeune for the 'Seconde suite' and 'Troisième suite'. In the first set the prints are surrounded by delightful engraved frames, but the second and third suites, for which Moreau made the drawings, are superior. His wife often acted as his model, her likeness being supposed in these engravings (Plate 43).

The technique employed for these plates was the usual one for the time: a preliminary etching was first made as a guide to the engraver. In the case of the Moreau plates several of the etchings were made by A. J. Duclos and P. Trière, other engravers such as I. S. Helman, C. Guttenberg and J. B. Simonet, finishing them.

After the Revolution the plates were reprinted at Neuwied in 1789: this 'Neuwied reissue' can be told from the original, because the letters A.P.D.R. (*Avec Privilège Du Roy*) have been removed from below the titles at the bottom. Some very rare and pretty small copies (*réductions*) were also made.

The subjects chosen were elegant scenes from the daily life of the upper classes, 'the code of fashion and etiquette': the Bois de Boulogne, Marly, the getting-up in the morning and the toilette, the whist party, the Opera and the announcement of the birth of an heir, '*C'est un fils, monsieur!*'.

The explanatory letterpress accompanying the plates contained an apology for showing only these elegant circles, as they were not to be considered representative of the Nation's usual habits. 'France was full of virtuous and respectable people . . . but the monotonous lives of decent and peaceful households could have no interest to the readers.'

Deceptive copies and reproductions have, of course, been made of this type of print. The pair entitled *Le Concert* and *Le Bal Paré*, by A. de St. Aubin and A. J. Duclos, were copied by L. Provost. In the copies:

> Le Concert has the name L. Provost sc. below the bottom right corner. There is a gap of 2·5 mm. between the lower half of the long S and the P in Par. In the original the S and the P almost touch.

> Le Bal Paré. In the copy there is no full-stop after the flourish after Paré. Between the i of Fils and the P of Par there are only four horizontal lines (including that touching the P): in the original there are six.

French line-engravings of this type and period are often to be found reproduced in colours. It is not impossible on extremely rare occasions to find a genuine one printed

in colours, but usually when these line-engravings are found thus they are reproductions made at the end of the 19th century. They were sometimes also reproduced in colours on metal plates; had these been the original plates, as is sometimes thought, the lettering would be engraved in reverse.

The 'Estampe galante' came to an end with the Revolution, when art became dominated by J. L. David and his leaning towards the classics, although he also painted some brilliant portraits.

Houssaye says: 'Le Brun provoked the decadence. . . . Watteau delivered art from the academic traditions of Le Brun; then David, who was a sculptor rather than a painter, created a counter revolution'.

Watteau's masterpiece *L'Embarquement pour Cythère*, in David's time was banished to a students' room of the Academy, where it became a target for the ridicule and the bread pellets of the pupils.

J. L. David earned the name of the 'Raphael of the Sansculottes', and became first painter to Napoleon in 1804, when he painted his Coronation, a picture that caused the Emperor to raise his hand in a theatrical gesture, saying, 'David I salute you!' The Coronation was engraved by J. P. M. Jazet. Another famous subject was '*Marat tel qu'il était au moment de sa mort*', engraved by L. Copia.

His loyalty to Napoleon was exemplified by his refusal to paint the Duke of Wellington, excusing himself by saying: 'Sir, I only paint history.'

Perhaps his most famous portrait was *Madame Récamier*, whose beauty was so great that members of a church congregation climbed on the chandeliers to see her. Engravings of the picture travelled everywhere, one observer declaring that he saw an impression among some exports destined for China. David painted her portrait with the aid of his pupil J. D. Ingres, but it was never finished, either because he was annoyed at her also asking Gérard to paint her, or because he was unwilling to let the lady see him in the spectacles which he had just been obliged to adopt.

Among his other sitters were Napoleon's sisters, of whom Pauline posed in the nude to Canova the sculptor. When asked how she could bring herself to do this she replied, 'There was a fire in the studio'.

Louis Leopold Boilly (1761–1845) was an artist who supplied the stipple engravers J. D. Bonnefoy, A. Chaponnier, S. Tresca and L. Darcis with many *scènes galantes* reminiscent of the pre-Revolution era; in fact, during the Revolution, they were denounced for indecency, with the demand that they should be burnt at the foot of the tree of Liberty.

He managed to satisfy the Republican Society of Arts, partly by painting *The Death of Marat*, and taking care to remove all traces of any offending pictures from his studio.

He was still painting at the age of eighty-three. It is supposed that he had a special varnish, the secret of which died with him.

Boilly was one of the first artists to practise lithography to any extent, a medium which took a strong hold and flourished more in France than anywhere else, being carried on by Charlier and Daumier, up to Odilon Redon, Toulouse-Lautrec and many other modern artists.

F

6. Line-engraving in Britain

Britain cannot claim to have been an early starter in the arts, least of all in engraving. In one example of Caxton's *Recuyell of the Historyes of Troye* is a very good engraving of Caxton presenting a copy of the book to Margaret of York, made about 1475, but Professor Hind, in *Engraving in England in the Sixteenth & Seventeenth Centuries*, thought it by a Flemish hand. He draws attention, however, to an engraving of the Virgin and Child, with devotional verses, bearing the inscription De Syon, proving that it was produced at the Brigittine Convent which stood on the site of Syon House before the Dissolution of the monasteries. This engraving is known only from modern impressions, but here again Professor Hind, who dates it about 1500, thinks it also by a Flemish artist, as were most of the engravings in England in the 16th century.

In 1540 a book on midwifery appeared, *The Byrthe of Mankinde*, printed and published by a physician named Thomas Raynold, but there is not enough evidence to claim the copperplates it contained as English.

Another physician, Thomas Geminus, published in 1545 what was probably a piracy of Vesalius's work on Anatomy, the original woodcuts being copied on copperplates, but there is evidence that he was a Flemish surgeon attached to the Court of Henry VIII. A second edition, in 1559, contained the earliest known portrait of Queen Elizabeth.

The earliest Englishman it seems possible to name as an engraver was John Shute, responsible for a book on architecture in 1563.

As the 16th century advanced, line-engraving began to flourish in England, though it was perhaps more commercial than artistic, depicting portraits, maps, and illustrating voyages. Some of the engravers were still Continental but others English, like various map-makers, or Augustine Ryther, said to be a native of Leeds, who engraved some of Saxton's maps and the plates illustrating the Battle with the Spanish Armada, from which the tapestries, from the designs of Hendrik Vroom, later burnt in the House of Lords, were woven.

England boasted three great cartographers in this period: Christopher Saxton (*c.* 1542–1610), John Norden (1548–1626) and John Speed (1552–1629). *Saxton's Survey of England* appeared in 1579, with maps engraved by Augustine Ryther, R. Hogenberg, etc.; John Norden's *Speculum Britanniae* in 1598, with maps engraved by P. van den Keere and W. Kip; and John Speed's *Theatre of the Empire of Great Britain*, in 1611,

with engravings by J. Hondius. Augustine Ryther and William Kip, it will be noticed, are the only apparently English names to appear.

Portraiture was plentiful in the reign of Queen Elizabeth, her own likeness becoming so numerous and frequently so bad that a proclamation was proposed in 1563: 'Forasmuch as through the natural desire that all sorts of subjects and people, both noble and mean, have to procure the portrait and picture of the Queen's Majestie, great number of paynters, and some printers and gravers, have already, and doe dayly attempt to make in divers manners portraictures of Hir Majestie in paynting, graving and prynting, wherein is evidently shewn that hitherto none hath sufficiently the natural representation of Hir Majestie's person, favor, or grace . . .' It goes on to propose 'a special conyng payntor' to take the natural representation of Hir Majestie and that others should be prohibited to 'draw, paynt, grave or pourtrayit hir Majestie's personege or visage . . . untill by some perfect patron [pattern] and example the same may be by others followed'.

Even that queer character Richard Haydock, who, Professor Hind reminds us, 'practised Physick in the day, and preached in the night in his bed', speaks of 'most lame, disproportioned and unseemlie Counterfeites (as they tearme them) of their livelie persons. And if I can deterre these saucie doultes from this their dizardly inhumanitie then I could wish that Alexander's Edict were now in force againe, who forbade that anie should carve his person save Lysippus; or paint his Counterfeit besides Apelles.'

There is no evidence that Queen Elizabeth was artistic; indeed, her religious convictions caused her to rebuke the Dean of St. Paul's for placing a new Prayer Book on her cushion, embellished with woodcuts of sacred subjects, thus leading to a renewed and hasty washing-out of paintings that seemed to be 'Romish and idolatrous'.

None the less, she seems not to have been averse to sponsoring painted portraits of herself, probably when she was young, 'of person tall, of hayre and complexion faire . . . of a stately and majesticke comportment'. In old age, with her 'nose a little hooked, her lips thin, and her teeth black', it doubtless required a tactful painter to 'limn' her satisfactorily.

Yet the painters seem to have flattered her little, if one excepts the picture by Hans Eworth at Hampton Court, where the beauty of the Queen is stampeding Juno, Minerva and Venus. A Latin inscription on the original frame reads: 'Juno is mighty with the sceptre, Pallas with her wit, and beauty blooms on the rosy features of Venus. Elizabeth came and Juno fled stricken, Pallas was amazed and Venus blushed.'

In her painted and engraved portraits the profusion of ornaments are marks of her fondness for dress: 'A pale Roman nose, a head of hair loaded with crowns and powdered with diamonds, a vast ruff, a vaster farthingale and a bushell of pearls are the features by which everybody knows at once the pictures of Queen Elizabeth.'

It is not known that the proclamation was ever issued, but it is thought the pattern may have been painted by Isaac Oliver, whose full-length portrait of the Queen, in the elaborate dress worn for the thanksgiving service at St. Paul's after the Armada, was engraved by de Passe, though Federigo Zuccaro and Lucas de Heere have also been mentioned as the 'certaine special conyng payntor'.

The number of portraits painted of the Queen was so great that Evelyn said, 'being called in and brought to Essex House (the Earl of Leicester's) they did for several years furnish the pastry-men with peels for the use of their ovens'. A peel was a long-handled shovel used to place things like bread in hot ovens – presumably an oak panel would have withstood the heat.

At any rate there is evidence of burnings and destruction: according to Sir Walter Raleigh, by the Queen's own commandment all pictures by unskilful and common painters 'were knockt in peeces and cast into the fire'.

The Richard Haydock mentioned above, who engraved his own plates for his translation in 1605 of Lomazzo's *Treatise on Painting*, was a physician at Salisbury, who 'would take a text in his sleep and preach a good sermon upon it, and though his auditory were willing to silence him by pulling, haling and pinching, yet would he most pertinaciously persist to the end, and sleep still'.

This, he claimed, was revelation, and put up a good performance when sent for by King James I, with 'an excursion against the Pope' included in his sermon. The King, however, does not appear to have been deceived.

James I was a great while pondering the subject of witchcraft. 'We need not cross the sea for examples of this kind, we have too many (God wot) at home. King James a great while was loath to believe there were witches; but that which happened to my Lord Francis of Rutland's children convinced him, who were bewitched by an old woman that was a servant of Belvoir Castle.'

One of the best-known of the Elizabethan engravers was William Rogers, who worked from about 1589 to 1604, the first date 1589 appearing on an elaborate full-length portrait of the Queen, entitled *Eliza Triumphans*, perhaps an official portrait commemorating the Armada.

Renold Elstrack (fl. 1598–1625) engraved some of the plates to a series of the early Kings of England, the *Basiliologia – the true and lively Effigies of all our English Kings*.

Encouraged by the presence of Sir Anthony Van Dyck, Lucas Vorsterman and Robert van Voerst also visited England, and in Cromwell's time Pierre Lombart, who was either Flemish or French, produced an equestrian portrait after Van Dyck, intended at first to be Charles I, but in the troubled times, had the head erased and altered so much – from Charles to Cromwell, and even Louis XIV and Gustavus of Sweden – that the late G. S. Layard wrote a book on it called *The Headless Horseman*.

WILLIAM HOGARTH

William Hogarth (1697–1764), painter, engraver, caricaturist and moralist, was one of the most important figures in the history of British engraving, as well as painting. He has been called the father of English caricature and the first British painter of international rank. He was the son of a Westmorland schoolmaster, who had opened a school in Bartholomew Close, where the artist was born. Apprenticed to a silver-smith, for whom he worked as an engraver of silver, he looked upon these years as wasted, and turned to engraving pictures on copper directly his apprenticeship expired.

To those who did not like him very much he was a consequential, strutting little

man, too susceptible to flattery, deriving, they said, unnecessary pleasure in gathering local colour for his 'moralizing pictures' in low taverns, gambling houses and bagnios.

To his admirers he was the friend of magistrates, a man who never played at cards, a moralist who campaigned against cruelty, lechery, gambling, drunkenness, hypocrisy, quackery and superstition.

Perhaps he would not altogether have agreed with the order in which these sins have been placed. Hosts of other imperfections are shown in his pictures: disease, squalor, vanity and ostentation, swindling and theft, but, when his friends remonstrated against the heart-rending incidents portrayed in his *Four Stages of Cruelty*, he replied that it was done deliberately, and, if his efforts had the least influence in checking the progress of cruelty, he would be prouder of these pictures than if he had painted the Raphael cartoons.

To benefit the Foundling Hospital he did try his hand at the 'grand manner', though it did not prove to be his forte. He should have realised with Dr. Johnson: 'I would rather see the portrait of a dog that I know, than all the allegorical paintings you can show me in the world.'

Nor was he a first-class engraver; in fact, for his series of moralising pictures, the *Marriage à la Mode*, he employed professional engravers. Vertue said he engraved in a strong manner, to print many. He became, however, a very brilliant painter of this type of picture, though surely not, as is commonly said, self-taught in this branch of art. His plates are usually lighter in the first states.

He disliked, however, to be thought a caricaturist. 'When I was at the house of a foreign face-painter', he said, 'looking over a legion of his portraits, Monsieur, with a low bow, told me that he infinitely admired my caricatures! I returned his congé and informed him that I equally admired his.'

He first studied drawing at John Vanderbank's Academy in St. Martin's Lane, and, in 1724, joined Sir James Thornhill's Academy in Covent Garden. But he appears to have become impatient with training and to have used a wonderful memory to develop a system of 'visual mnemonics'.

His elopement with Sir James's daughter Jane in 1729 seems to indicate a disapproval of him as a son-in-law, but his brilliance as an artist and – essential adjunct! – as a business man, soon led to reconciliation.

Hogarth himself was always a staunch supporter of his father-in-law, quick to lampoon any opposition. William Kent was the victim on more than one occasion, his chief offence the encroachment on Sir James's speciality, by painting the ceilings in Kensington Palace. When the Bishop of London ordered Kent's altarpiece in St. Clement Danes church to be taken down, owing to the controversy it had caused, Hogarth made a print of it with a key below, saying it was not a portrait of Prince James the 'Old Pretender' and his wife. Again, he showed a headless coachman driving through the archway of Kent's entrance to the Horse Guards Parade, illustrating the criticism that it was much too low.

It is these records of eighteenth-century London that add greatly to the interest of his pictures: 'The Cockney's Mirror', as he was termed by Marjorie Bowen. He was

chiefly famous for his 'Progresses', called by him 'modern moral subjects' and by Fielding 'comic history painting', all the plates mirroring the life, and often actual scenes, in London.

The *Harlot's Progress*, published in 1732, shows the perils of a young country girl coming alone to work in London, because she wants to be a lady, and Ronald Paulson, in *Hogarth's Graphic Works* says it may have been inspired by Steele's essay 'A Consideration of poor and public Whores' in the *Spectator*. Plate 1 shows an over-dressed girl, who has travelled by the carrier's waggon, for cheapness, from York, met by Mother Needham, a famous procuress, with a bagnio in Park Place, St. James's Street. She eventually died from exposure to a hostile public in the pillory at the corner of the two streets. The man lurking in a doorway is Colonel Charteris, who earned half a volume to himself in 'The Lives of the Rakes'. He made a fortune gambling and proposed a charity school for his illegitimate children and almshouses for their mothers.

Poor 'Moll Hackabout' comes to an early end, in six plates, showing her apprehended by Sir John Gonson, a London magistrate, beating hemp in Bridewell Prison, and the patient of quack doctors, including Dr. Jean Misaubin, whom Watteau is believed to have met when he visited London.

The *Rake's Progress*, published in 1735, shows in eight scenes, a young man running through a fortune left him by a miser and finishing in Bedlam (Bethlehem Hospital). In this series there is a view of St. James's Street from Piccadilly, looking very much as it is today. Another is a gambling scene inside White's Club, and a third shows a room in the Rose Tavern, Drury Lane, the rendezvous of ladies of the town, some of whom are busily robbing the drunken rake. The man coming into the room was a porter known as 'leather-coat', who for a pint of beer would lie in the road whilst a hackney carriage ran over him (Plate 44).

The *Marriage à la Mode*, 1745, a set of six plates, was engraved by professional French engravers, and occasioned the artist to visit France in 1743, when he was temporarily imprisoned as a spy at Calais, for sketching. It shows the marriage of convenience between the daughter of a rich City merchant and the son of a nobleman, who has impoverished himself by the fashionable building of an enormous house. In the last plate there is a 'caricature' of old London Bridge, with the houses on it leaning perilously over the river.

The set of twelve plates showing the careers of the *Idle and Industrious Apprentices* are nearly all London scenes: the looms in Spitalfields, the Lord Mayor's Show in Cheapside, the Guildhall banquet, a public hanging at Tyburn, etc.

Hogarth's business instincts led him, not only to open a shop of his own for the sale of his prints, but to adopt various means for the sale of his pictures also. These included a clock auction, five minutes being allowed for each lot; a not very successful postal auction, when bids were sent by post; and lotteries. For *The March to Finchley* subscribers paid 7s. 6d. for the prints, but 10s. 6d. included a chance in the lottery for the painting. By this means he raised £900, still retaining possession of the copperplate, from which to print further editions. Subscriptions to the *Harlot's Progress* brought in £1,200.

Hogarth suffered a great deal from the common practice of pirating successful prints and took a leading part in the passing of the engravers' Copyright Act, commonly known as 'Hogarth's Act'.

Their complaints were that printsellers took twice or three times the commission charged by the book publishers, and would often have cheap copies made of successful prints, which were then 'imposed upon the Incurious for the Originals, or at least are industriously dispatched to all Parts of the Country, where the Original is never suffer'd to appear'. Also, when the engraver called for his money he might be just handed back his unsold prints, eventually being forced to hire himself to the printsellers at their own terms.

Hogarth published his own prints, so it was only the piracies that troubled him personally, but the treatment his father had received with the publication of a Latin dictionary still rankled.

The Act was passed in 1735, and it will be noticed that prints published in Britain subsequently, in the 18th century and later, bear the words 'Published as the Act directs', or 'Published according to Act of Parliament', with the publisher's name and address.

The Act seems to have been modelled on the *privilège* (privilegium), which had been a safeguard, like a patent, to engravers and authors for some 300 years in some places on the Continent. In France the granting of this *privilège* was in the hands of the King; in Rome, the Pope; in Venice, the Signoria; elsewhere, in towns that came under his control, it was granted by the Emperor. In Britain there were patent laws, but they did not cover engraving and publishing.

Prints published in France had the words *Avec Privilège du Roi*, or *Cum Privilegio Regis*, often abbreviated to *A.P.D.R.*, or *C.P.R.* After the Revolution, plates bear the publisher's address and sometimes *Déposé à la Bibliothèque Nationale*. In early days publishers occasionally printed at the beginning of a book a copy of the *privilège*. One such, granted for three years by François I in 1527, reads:

> *Francoys par la grace de dieu Roy de frāce Aux*
> *baillifz preuost de Paris rouen Sens Troyes*
> *Senechaulx de Lyon et de Poictou et a tous nos*
> *aultres Justiciers et officiers ou a leurs*
> *lieuxtenās salut. De la partie de nostre biē*
> *ayme Nicolas Mauroy le jeune fils de Nicolas*
> *Mauroy laisne dudict troyes nous a estehumblemēt*
> *expose.... Et que aultre q̃ ledict exposāt ne les*
> *puisse imprimer ou faire imprimer ne en vendre ou*
> *faire vendre daultres que ceulx que ledict*
> *exposant aura faict imprimer jusques a trois ans*
> *prochainement.... Sur pene de cōfiscatiō de*
> *ce q'aura este fait au cōtraire et de cent marez*
> *d'argent a nous a appliquer cōtre chascune partie*
> *faisant le cōtraire et pour chascune foys....*

In the Spanish Netherlands the 'privilege' was granted by the King or the Infanta. The set of small landscapes after Brueghel, published by Hieronymus Cock in Antwerp in 1559, had *Cum gratia & priuilegio Regis*. Two *privileges* on prints after Rubens, issued in Antwerp, read: *Cum priuilegijs Regis Christianissimi, Serenissimae Infantis et Ordinum confaederatorum, Anno 1624*, and *Cum priuilegiis Regis Christianissimi, Principum Belgarum, et Ordinum Batauiae*. An abbreviation was also used: *C.P.S.C.M.*

In Rome the issue of privileges was done by the Pope, one such reading: *Cum priuilegio Summi Pontif. Phls. Thomassimus excudit Romae 1610*. Some of Claude's etchings, issued in Rome, have inscriptions similar to *Claudius C. inv. et f. Roma 1637 sub licentia*; other prints have *Con licenza de superiori*.

In Venice the Signoria issued these privileges or copyrights: we know that Dürer protested to them over the copying of his prints by Marcantonio, which, however, seems only to have led to the next batch of copies omitting Dürer's monogram.

Prints published in towns coming under the jurisdiction of the Emperor were granted privileges by him. We read that Dürer's widow was granted a *Privilegium* by Charles V for the *Treatise on Proportion*, published just after the artist's death, in 1528. Later, in the second half of the 18th century, prints have the words: *Se vend a Augsburg . . . avec Privilege de Sa Majesté Imperiale et avec Defence ni d'en faire ni de vendre les Copies*, or *Cum Gratia et Privilegio Sac. Caes. Maj. . . . exud. A.V.* (i.e. *Augusta Vindelicorum*, the Roman name for Augsburg).

The English act also imposed a fine (a shilling) for every impression of a copy found, the copyright to last for fourteen years, corresponding with the English patent law.

In anticipation of the Act, Hogarth held back his *Rake's Progress* till it became law, only to find that spies had viewed the paintings in his shop, copied them from memory and already issued them.

It seems, however, that the Act virtually put an end to pirates in this country, though quite a number of English prints were copied on the Continent, and, after the expiration of the fourteen years, the copyists got busy. Mrs. Hogarth, in 1767, was granted a further term of twenty years copyright, which did not include copies made between the expiration and 1767, in which year an amended Act was passed. Richard Earlom, in 1795, commissioned by Boydell, made an excellent set of the *Marriage à la Mode* in mezzotint, far better than the original line-engravings.

The rarest Hogarth prints are the small early ones, including trade-cards, similar to the one he did for his two sisters when they opened a milliner's shop. The larger plates and sets, after their first appearance, were issued in large volumes. These issues have been gone into and described in Ronald Paulson's *Hogarth's Graphic Works*.

The artist himself was issuing bound sets 'as early as 1736', and in 1749 he issued them in book form with a portrait of himself and his dog Pug. He also issued an edition with an engraving of himself painting the Comic Muse, watermarked Dupuy, Auvergne.

After Mrs. Hogarth's death in 1789 the plates were sold to John Boydell, who published a large volume of 103 plates in 1790. This issue has the title 'The Original Works of William Hogarth, Sold by John and Josiah Boydell, at the Shakespeare Gallery, Pall-Mall, and No. 90, Cheapside, London, 1790.'

Boydell's second edition of 107 plates had a title commencing: 'The Original and Genuine Works . . .' and no date.

His third edition, published in 1795 but undated, contained 110 plates, including *Before* and *After*, which had previously been suppressed.

At Boydell's sale in 1818 the plates were bought by Baldwin, Cradock and Joy, who added new ones, making 156 plates on 119 leaves, and published them in twenty-four paper parts from 1820 to 1822. They were also issued in two large volumes as The Works of William Hogarth, from the Original Plates restored by James Heath, Esq., R.A.

A number of other issues were published, some of which by Baldwin, Cradock and Joy had the suppressed plates in a pocket inside the back cover; afterwards the plates were bought by Henry G. Bohn, many already worn.

In 1864 the plates were acquired by Bernard Quaritch, the bookseller. A quantity of the unimportant, and much worn ones were given to the Government and melted down for the copper in the First War. The others are now in museums and collections.

The later 19th-century editions can be told from the earlier 18th-century ones from the fact that they are on 'wove' paper instead of 'laid'.

For the last thirty years of his life Hogarth ran Sir James Thornhill's Academy, moving it to Peter's Court, St. Martin's Lane. Four years after his death the newly-formed Royal Academy acquired the casts and apparatus to help start their drawing school.

SIR ROBERT STRANGE

Sir James Thornhill was the first British-born painter to be knighted and Sir Robert Strange (1721–92), the first engraver, if one excepts Sir Robert Peake, who may have been only a publisher, knighted for services in the Civil War.

Strange was a Scot and a staunch Jacobite, marrying a sister of Andrew Lumisden, private secretary to Prince Charles Edward. Owing to a condition she made, that he should enlist in the service of the Jacobites, he fought at Prestonpans and Culloden, where he was captured or escaped to France. Later he studied engraving under J. P. Le Bas in Paris.

Coming to London to practise his art he made enemies by refusing to engrave portraits of the King and the Earl of Bute. For this reason he was excluded in favour of Bartolozzi when the Royal Academy was founded.

Benjamin West, however, obtained him permission to engrave the *Vandyck portraits* of the House of Stuart, by which he is best known.

In return for West's introduction he engraved his picture of the *Apotheosis of the Royal Children*, an engraving which so pleased the King that he said, 'You may not care to be knighted by the King, so you must accept knighthood from the Elector of Hanover.'

Strange used a preliminary etching, in common with other engravers of the period, including Le Bas and Cochin. His work was famous on the Continent, where he became a member of the French Académie, and the academies of Rome and Florence.

WILLIAM WOOLLETT

Another famous line-engraver, a friend and contemporary of Strange's, was William Woollett (1735–85), whose first indication of a leaning towards the arts was to engrave a pewter pot with a Turk's Head, the sign of his father's inn.

He engraved a number of plates for Alderman John Boydell, later Lord Mayor of London, the first being Claude's *Temple of Apollo*. For Boydell he undertook the engraving of Richard Wilson's *Niobe*, which achieved its intention of rivalling the best Continental works of this kind.

For this plate Boydell paid Woollett over a hundred pounds in advances as the work progressed. This was an unheard of price at that date, but the print succeeded beyond expectations and produced £2,000 at 5s. a time.

The Death of Wolfe, after Benjamin West, is Woollett's most famous plate, the profits from which he shared with Boydell and William Wynne Ryland. The receipts were £15,000, his share being £5,000 to £7,000, with the title 'Historical Engraver to the King'.

So slow, however, was this type of work that he was always in narrow circumstances. One can imagine that his wife's numerous accouchements were no help: she was brought to bed five times with twins and once with triplets. The slowness of the work is emphasised by Benjamin West's account of how he sketched on a proof some alterations he wanted made to the *Battle of La Hogue*. When asked how long they would take, Woollett replied 'three or four months'.

The four *Shooting* subjects he engraved after George Stubbs are now sought for; also some attractive plates of gardens at West Wycombe, Whitton and elsewhere.

Woollett at one time lived at 11, Green Street, Leicester Square, and there is a tradition that he was in the habit of firing a cannon from the roof whenever he commenced an important engraving. He died from an injury received in playing bowls.

JOHN BOYDELL

John Boydell (1719–1804) was at first an engraver, but became celebrated as a publisher, who 'did more for the arts than all the nobles and paid nobly too'. His first publications were landscapes engraved and stitched together in booklets by himself. He became an Alderman in the City and Lord Mayor in 1790, and raised the export value of prints to the Continent to £200,000. Woollett's *Niobe* after Wilson was intended to be a rival to Lerpinière's *Storm* after Vernet. It was an example of his liberality that he had agreed to pay fifty pounds but eventually paid more than a hundred.

His publications included the *Houghton Gallery*, a two-volume record of the Earl of Walpole's pictures at Houghton, sold to the Empress Catherine of Russia; Claudes' *Liber Veritatis*; and *Views on the Thames*, after Joseph Farington, known as 'Boydell's Thames'.

His most ambitious enterprise was *The Shakespeare Gallery*. This was proposed at a dinner with a few friends, artists and booksellers, as an encouragement to historical painting in Britain. All told, nearly 170 paintings were commissioned from the

leading artists of the day. Reynolds at first thought it would be lowering his art to paint for a publisher, but yielded to argument reinforced by a £500 cheque – he was paid £1,000 for the first picture of *The Witches* in Macbeth.

One hundred of these pictures were engraved and published over a number of years and eventually published anew in two large folio volumes in 1805. They are mostly stipple engravings. The paintings themselves were exhibited in the 'Shakespeare Gallery' in Pall Mall, opening in 1789, at first very successfully, but the French Revolution destroyed the firm's export trade and made them bankrupt.

The Shakespeare Gallery cost £30,000, and, when the firm applied for permission to hold a lottery, the old Alderman claimed that he had spent £350,000 to promote Historical Painting in England. The lottery was successful and even left a surplus. The 'Josiah' who appears on many prints with John was his nephew.

Christian Josi, who worked both for Ploos van Amstel in Amsterdam and for J. R. Smith in London, testified to the popularity of English colour-prints on the Continent, lamenting that he could not sell his own work till he had added an English title.

WILLIAM BLAKE

William Blake (1757–1827), artist and poet, could be said to have revived the art of original line-engraving as opposed to the merely interpretive, even more than Hogarth.

He was apprenticed to James Basire (noted for enormous engravings, such as *The Field of the Cloth of Gold*, which he did for the Society of Antiquaries). He would have been apprenticed to Ryland but for his amazing prophecy of Ryland's death by hanging. He became a very fine professional engraver in line and stipple; his line-engraving of Hogarth's *Beggars' Opera* and his stipple engravings after Morland, Watteau and others are first-class work.

It is, however, original engravings after his own tempera paintings and water-colour drawings that made him famous and are now sought after. His illustrations to the *Book of Job* (Plate 45) have been very highly praised as examples of original line engraving, even by Ruskin, who said that otherwise he produced nothing but coarsely iridescent sketches of enigmatic dreams.

It is interesting to recall that his figures, so much resembling those of Raphael, Michelangelo and Jean Duvet, were based on engravings after those masters, which he is said to have seen and bought in the London auction rooms. To Langford, the auctioneer, Blake was his little connoisseur, to whom he would often knock down a 'cheap lot'. His largest single plate, *Canterbury Pilgrims*, he imagined to be in the style of Dürer, though this is difficult to see, perhaps because the pilgrims are setting forth from Southwark. He is known to have had an impression of the *Melencolia* hanging on his walls.

Blake's most notable achievement in the world of engraving was the invention of a method of relief-printing, by which he could illustrate, print and produce his own books entirely by himself, assisted by his devoted wife.

This method he claimed was revealed to him in a dream by his dead younger brother

Robert in 1787, and, in the morning Mrs. Blake was sent out to buy the necessary materials with their last half-crown.

The first plate produced in this way is believed to be *The Approach of Doom*, after a drawing by his brother, about 1788, and the first book the *Songs of Innocence*.

'Relief etching' was employed, eating away with acid the copper surrounding his drawing and writing, which, of course, would have to be in reverse on the plate. His own words were 'instead of etching the blacks, etch the whites'. The amount of this writing was considerable, too much to write in reverse, so it has been thought that he wrote it in an acid-resisting fluid and then transferred it to the plate.

Until recently it has been considered a mystery how he found such a substance that would not dry long before he was ready to place it face-down on the plate. S. W. Hayter, in *About Prints*, has suggested the use of a mixture of asphaltum (varnish) and turpentine or benzine, written with a fine brush on paper coated with gum arabic and soap, to be placed when nearly dry face-down on a warmed copperplate and passed through the press; the paper to be afterwards soaked off and the plate gently etched until sufficient relief was developed. By this method it is claimed the writing would remain moist enough on the paper to allow it to be transferred to the plate, where, when dry, it would prove acid-resisting.

Among the engravers and etchers who were followers of William Blake, three of the best-known were Edward Calvert (1799–1883), Samuel Palmer (1805–81) and George Richmond (1809–96).

7. Etching

Etching (the word is derived from the German *Aetzung* – biting) is descended from the decoration of armour and weapons and is based on the fact that, whilst acid will eat into metal, it will not attack wax or varnish. A thin layer of blackened wax is laid on a polished plate (usually copper). The design is drawn with a steel needle so that the bright copper lines show through the blackened wax ground. The back of the plate is then varnished with Brunswick black and the whole placed in a dish of diluted acid. When the parts required to print lightly (such as sky or distance) have been bitten enough, the plate is taken out and these parts varnished over. The plate is then replaced in the acid bath and the process repeated until the darkest lines have been bitten deep enough to hold the required amount of ink.

Early etchers built a ridge of wax round the edges of their plates, instead of immersing them. Sometimes they stood the plate at an incline in a trough and poured the mordant on it, the trough having a hole to allow the mordant to drain into a bowl below, into which a jug was dipped. The mordant was poured over the plate eight or ten times, when the plate was turned crosswise and cornerwise, and poured over in a similar manner each time.

For darker and lighter lines they used stopping-out methods and also made darker (deeper) lines by pressing harder on the needle when drawing the design through the etching ground.

Etchers like Callot and Bosse (in the 17th century), who made careful lines like engravers, used a hard ground which offered resistance and enabled them to control the needle better. For free drawing, such as done by Rembrandt, a softer wax ground was made, not to be confused with 'soft-ground etching', which was possibly not practised till the 18th century (see p. 120).

The wax ground used today is put on a warmed plate with a dabber or roller, the plate having to be thoroughly free from grease, or the ground will come away, allowing the acid to pit the surface of the copper: this is known as 'foul biting'.

The plate is next gripped at the edge in a hand-vice (French *étau*), and turned upside down while the ground is blackened with a lighted bunch of tapers (in old times the ground was sometimes whitened with a wash).

A favourite method of transferring a drawing to the ground as a guide for the etching needle, was to cover the back of the drawing with black or red chalk, placing it on the ground and indenting the lines with a sharp point, so that they showed up on

the ground. Sometimes a sheet of paper, the back covered with chalk, was placed between the drawing and the grounded plate.

If desired to etch a design in reverse, so that it prints the same way as the drawing or picture, a tracing can be made, which is dampened, placed face downwards on the blackened ground and rolled through the printing press, when the grey lines on the black ground will give a guide for the etcher, who looks at the reflection of the drawing in a mirror. Or a sheet of gelatine, with the scratched design (filled with chalk) instead of tracing paper.

To print a plate, the wax ground and varnish are removed; the plate is inked all over with a dabber, and the ink wiped off the surface, so that it remains in the lines (see section on printing).

Etching is more a means of artistic expression than any other form of printing, the term 'painter-etcher' being still applied to artists who practise this medium extensively.

Many etchers, such as Rembrandt, Whistler and his brother-in-law Seymour Haden, travelled with ready-prepared copperplates. They would make their etchings from nature and process them later in the studio, as Rembrandt did with *Six's Bridge*. Whistler would march into the Café Royal at the head of his young followers, one of whom would carry materials, in case of need. Sir Francis Seymour Haden, a surgeon and at first an amateur etcher, always carried plates on his duties or holidays. One of his best plates, *A By-Road in Tipperary*, was left behind forgotten in a stable, and only discovered some time later.

Most artists have tried their hand at etching, although Rubens and Velasquez possibly did only one plate each. Dürer did five, Constable four, while Van Dyck did twenty-one, including eighteen plates for his large work on the famous men of his time, the best portraits in pure etching ever made.

The first dated etching, and perhaps the first to be printed, is by the Swiss artist Urs Graf (1485/90–1529), a *Girl bathing her Feet*, dated 1513, the only known impression of which is at Basle. Dürer's were done from 1515 to 1518, but Daniel Hopfer (fl. 1493–1536), one of a family of Augsburg artists, has beeen thought to be the first, with a portrait of Maximilian's jester Kunz von der Rosen, but doubt has been thrown on this and whether the portrait represents Kunz.

These early plates were etched on iron, the first to use copper being the famous Leyden painter–engraver Lucas van Leyden (1493–1533). His work in etching was done about 1520 and he sometimes combined it with engraving, as in his portrait of the Emperor Maximilian. A follower of his, Dirk Vellert (fl. 1511–44), used a similar method.

This period saw the rise of landscape etching. Albrecht Altdorfer (*c.* 1480–1528) is called the father of German landscape, for his work in painting as well as etching, and was known as 'little Albrecht' to distinguish him from the greater Albrecht Dürer (see p. 42). Augustin Hirschvogel (1503–*c.* 1553) and Hans Sebald Lautensack (*c.* 1524–63) both etched pure landscapes.

A large number of Italian artists etched at this time, but few very effectively. Andrea Meldolla, called Schiavone (1522?–82) was at one time thought to have

invented etching, but Francesco Mazzuoli, called Parmigiano (1503/4–40), was etching before him, about 1520.

Other Italian etchers of the 16th century were Federigo Baroccio (1528–1612), who did about four very good etchings (Plate 46); Antonio Tempesta (1555–1630), noted for quantity rather than quality; the Carraccis, whose work Professor Hind dismisses as charming but unskilled; Michelangelo Merisi da Caravaggio (1573–1610), to whom a few etchings are attributed, curiously strong and rough, and Simone Cantarini.

Other etchers such as Jose de Ribera, called Lo Spagnoletto (1588–1652) (Plate 47), and Salvator Rosa (1615–73), carry us into the 17th century in Italy, where Giovanni Benedetto Castiglione, 'the Little Greek' (1616–70), did a number of rather sprawling etchings, but is noted as the inventor of the monotype, making some twenty prints in this manner.

In this method a picture is painted on a copperplate (on a 'white' ground), or the plate is inked all over and the high-lights scraped away (a black ground), and a print taken from it in the press. It is said he first dried the ink by heating the plate and using damp, unsized paper.

The monotype was revived by William Blake and has been used by several modern artists, notably Degas. Only one good impression could be obtained from a monotype, but Degas pulled one or two more and used the weak prints to work up compositions by colouring them. Later he printed his monotypes in colour, using oil-paints. E. P. Janis, in *Degas Monotypes* (1968), catalogues 321. A number of *sujets libres* were destroyed after his death.

Professor Sir Hubert von Herkomer (1849–1914), Slade Professor, invented a means of taking an electrotype from his monotype, calling it Herkomergravure (see Lost or Forgotten Processes).

THE SCHOOL OF NANCY

At the beginning of the 17th century a small group of etchers arose at Nancy, the capital of Lorraine. They included Jacques Bellange, Claude Deruet, Jacques Callot and Israel Henriet.

Jacques Bellange (1594–1638) studied in Italy, his style resembling that of Federigo Baroccio. Robert-Dumesnil listed forty-seven prints under his name, to which Georges Duplessis added four. Benezit and Thieme-Becker give his dates as flourishing between 1602 and 1617, and discount otherwise what is said about him. He is however, an example of changing fashions: whilst his prints now edge £3,000 each, Basan, in the 18th century said he was a bad painter and still worse engraver, adding that he etched several pieces of his own composition, which one finds much more bizarre than well-judged, with very little correction and a very bad style of engraving (Plate 48).

Only a few of his paintings are still left at Nancy, but it is known that he painted for Duke Charles III of Lorraine in the Ducal Palace.

Claude Deruet (1588?–1660), was another native of Nancy and, though slightly older, a follower of Callot, who etched a portrait of him, a small full-length in fashionable

clothes, *à la mousquetaire*, with his son Charles, who also became a painter. Part of Nancy is in the background, and Deruet's house 'La Romaine'.

Deruet was a pupil of Claude Henriet, father of Israel, before going to Italy to study under Tempesta. Returning to Lorraine, he became Director of Fêtes to Duke Henri II 'the Good'. Under him and Charles IV he obtained many distinctions, including ennoblement. Louis XIII stayed at his house, decorated him with the Order of St. Michael, and drew his portrait in crayons. His etchings are very rare: Dumesnil attributes three to him, to which Georges Duplessis has added four more. Claude le Lorrain is said to have worked under Deruet in Nancy in 1625–7.

Israel Henriet (*c.* 1590–1661) went from his birthplace Nancy to study art in Rome and finally settled in Paris, where he became a printseller and publisher, his name appearing on many prints, including those of his compatriots, as 'Israel'.

He inherited or acquired a large number of Callot's plates and continued to print from them. His stock descended to his nephew Israel Silvestre (1621–91), another Nancy etcher, and an imitator of Callot. Silvestre also inherited from Henriet a quantity of Della Bella's plates.

Jean Leclerc (1594–1633) was born at Nancy, studied in Italy and became painter to Henri II, Duke of Lorraine, embellishing several churches in Nancy. He is known to have done two etchings, both after his master in Italy, Charles Saracino; one of these etchings, in the second state mistakenly bears the name of Ribera.

Jacques Callot (1592–1635), the best known of the Nancy group of etchers, worked also in Florence and elsewhere. Intended for the church, he twice ran away from home trying to join his friend Israel Henriet, studying art in Rome. On the first occasion he travelled with a band of gipsies and later commemorated the event with a set of four etchings – *Les Bohémiens*. In Rome he was unfortunately recognised by merchants from his home city. On the second occasion he was overtaken and brought back by an elder brother, the artist Claude Callot, but gained his wish a few years later and was sent to Rome.

He is credited with a thousand plates, mostly small, the figures in them being often quite minute. In his larger plates of Fairs hundreds of these figures are introduced.

Most of his work was done in Florence and in Nancy, where he returned in 1621. In Florence he worked with Cantagallina and Parigi, recording a number of the festivities and the pageants with their elaborate cars and spectacles. One or two of these sets he duplicated when he returned to Nancy.

He is considered to have been at least one of the first etchers to have stopped out with varnish the skies and distances, for further bitings. He also used an etching 'needle' with an oval point (known as an *échoppe*), so that, when drawing through the ground, he could vary the width of his line by turning the point.

He also worked with his plate on an easel, in order not to injure his health with too much stooping, but is said to have suffered in later life from a stomach ulcer due to acid fumes.

Meaume (*Recherches sur la vie et les oeuvres de Jacques Callot*) tells a story that in 1633 Louis XIII entered Nancy after a short siege and wanted Callot to engrave a Siege of

Nancy, as he had already done of *La Rochelle*, but Jacques begged his Majesty with much respect to excuse him as he was of Lorraine and believed it was his duty to do nothing against the honour of his prince and against his country. The king received his excuse and said that the Duke of Lorraine was very happy to have such faithful and affectionate subjects. Some courtiers said sufficiently loudly that he should be made to obey the wishes of his Majesty. Callot, hearing this, replied that he would sooner cut off his thumb than do anything against his honour.

His *Misères de la Guerre*, however, are thought not to represent Louis XIII's invasion and taking of Nancy, but the life of a soldier, what he suffers and causes others to suffer (Plate 49).

Callot's etchings have been extensively and exactly copied, so that it is essential to have access to Lieure's catalogue when dealing with this master. Copies of the larger *Miseries of War*, made in Holland, are among the most frequent to turn up, but these can be recognised from their Dutch title instead of French. Late impressions from the original plates are also to be met with, in which the borderlines have been extended to enclose the verses below; the plates are preserved in the Musée Lorrain, at Nancy.

Stefano Della Bella (1610–64) was an Italian follower of Callot, a prolific etcher; making over 1,150 plates. He is sometimes coupled with Callot, though he was not, of course, of Lorraine (Plate 50).

ABRAHAM BOSSE

Abraham Bosse (1602–76) was born in Tours, worked in Paris and was a follower of Callot. Though etchers, both he and Callot seem to have touched up their plates with the burin.

For his etching he used a very hard ground and the échoppe or scorper, invented by Callot, which enabled him to make thick and thin tapering lines. This imitation of line-engraving shows how much line-engraving was esteemed in France then and through most of the next century.

Another original feature of Bosse's work was the clothing of Biblical characters in the costume of his own time: this, as the son of a tailor he was well qualified to do. In addition, the scenes of the *Prodigal Son*, the *Wise and Foolish Virgins*, etc., are shown to take place in contemporary rooms and surroundings, thus giving the most exact details, not only of the dresses, but the furniture and decorations of Louis XIII's time.

Ceremonies and events taking place in his day were also etched and engraved by him: an interior of *L'Infirmerie de l'Hôpital de la Charité de Paris* shows a very long chamber, with twenty beds a side (all four-posters), reminding us that he was also a teacher of perspective.

Bosse, as an engraver, was elected only to honorary rank when the Académie was formed in 1648, but was excluded entirely in 1661 because of his opposition to the tenets laid down by Le Brun, Colbert and the King. As an austere Calvinist he could not dissemble his disapproval, with the inevitable result of single-handed opposition to such powerful authorities.

CLAUDE LE LORRAIN

Claude Gellée (1600–82), was born at Chamagne in Lorraine and called Claude Le Lorrain (or, more usually, just Claude). He made forty-four etchings, mostly landscapes in the style of his superb oil-paintings and wash drawings of the Roman Campagna, but including thirteen plates of fireworks in Rome in 1637, for the accession of Ferdinand III as Emperor of the Holy Roman Empire.

One account of his early life says he became an artist almost by chance: that he was sent at the age of twelve with a party of pastrycooks to Rome, where he found employment in the house of Agostino Tassi, a landscape and marine painter, as cook, groom, colour-grinder and general factotum, very soon becoming Tassi's pupil. Under this account of his life it is said he had little education and wrote his own name with difficulty.

Another account says that he was left an orphan when not yet twelve and lived with his elder brother, who was a wood-carver in Freiburg in Alsace, being taken by another relative to Rome at the age of thirteen or fourteen. Here he was left to his own resources, apart from some uncertain remittances, until he entered the studio of Gottfried Wals, at Naples. Studying for two years at Naples he then returned to Rome, entering the studio of Tassi, a pupil of Paul Bril.

The first account was by Sandrart, who knew Claude intimately in Rome, and is the more usually accepted.

Claude was one of the greatest of landscape painters, capturing essentially that repose which was one of the features in a picture considered most desirable by Ruskin, who, however, pronounced the etchings to be like the work of a child of ten.

Claude, when he was in Nancy under Claude Deruet 1625–7 may have met Callot, but could have learned etching from several artists. He was certainly influenced by Joachim Sandrart, who lived in Italy from 1628 to 1635, and had therefore come to Rome before Rembrandt had started his etching career.

Although it has been said that Claude was aware of Dutch etching, surely he must have been unaware of the potentialities of the copperplate as displayed by the later Rembrandt. He himself was also an experimenter: Seymour Haden thought that one of his effects was obtained by roughening the plate with pumicestone and then using the scraper, a method, rather like mezzotint, that was used in modern times by Camille Pissarro.

One feels that had he known the effects obtained by Rembrandt he would have produced some striking plates. As it is, his etchings have great charm, but must be seen in early impressions. His masterpiece is the *Herdsman* (*Le Bouvier*) (Plate 51), where there is a masterly effect of leaves and branches blown back in the breeze. Sandrart said of his paintings, 'as if the trees rustled and moved in the wind'.

Claude's plates, like Rembrandt's and others, suffered from being reprinted in the late 18th century, and he is too often judged by these dry and ghostly impressions. To be seen properly they must be early and taken during his own lifetime, preferably before a number was engraved in the margin at the side and before the borderlines

were reinforced, though these are very rare. Numbers that appear at the bottom of some plates were not added till 100 years after his death.

Forty-one of the copper plates were listed in an inventory made after Claude's death; 200 impressions of them are known to have been printed in London in 1816. The inventory mentions a 'press'.

SIR ANTHONY VAN DYCK

Sir Anthony Van Dyck (1599–1641), Rubens' most brilliant assistant and subsequently Court painter to Charles I, etched twenty-one plates in all

> Titian and his Mistress, after a picture by Titian,
> The Reed handed to Christ.
> A portrait of Philippe Le Roy,
> and eighteen other portraits.

The eighteen other portraits were preliminary etchings, used for his *Iconography*, an ambitious work, commenced in Flanders when he was a young man of about twenty-six, depicting famous men of his time.

He did not actually meet all these people, some were already dead, and another was Erasmus, after a picture by Holbein, which he must have seen when it was owned by the Earl of Arundel.

Van Dyck made drawings or paintings in grisaille, and, in the eighteen cases mentioned, commenced the plates with preliminary etchings. The rest of the work was done in line by professional engravers already employed by Rubens, among them Schelte A. Bolswert, Pieter de Jode, Paul Pontius and Lucas Vorsterman the elder.

The few examples printed from the plates in the etched state, with only Van Dyck's work on them (Plate 52), are considered to be the finest portrait etchings in pure etched line ever made. It is now only these examples in the etched state that are sought for. Most of the others were spoilt by the line-engraved bodies and backgrounds added for the *Iconography*, the first eighty plates of which were published by Martin Van den Enden.

The plates were then acquired by Gillis Hendricx, the Antwerp publisher, who also published plates after Rubens. He had his initials G. H. engraved at the bottom in place of Martin Van den Enden. He also added plates to bring the total up to a hundred, and a title dated 1645.

The title reads *Icones Principum Virorum Doctorum* . . . and incorporates the word *centum*, for which reason this edition is known as the 'century'.

G.H.'s initials were afterwards erased, later editions being published up to 1759, with more plates added. In 1851, 124 of the plates were bought by the Chalcographie du Louvre.

About 1645 Jan Meyssens began to publish a similar series, in the form of the first series, mostly of portraits painted in London, engraved by Pieter de Bailliu, Cornelis Galle the younger, Wenceslas Hollar, Pieter de Jode, etc., many representing English ladies and gentlemen.

For an account of the falsification of the states of Van Dyck's etchings see section on States, p. 26.

Armand Durand also made reproductions in heliogravure, published in 1874, with a preface by Duplessis, generally printed on Van Gelder paper.

WENZEL HOLLAR

Wenzel Hollar (1607–77), though a Bohemian (Czech) is an etcher of great interest to Britain, his most important work being done in London.

Born in Prague, he studied in Frankfurt under Matthew Merian the elder, who etched 'the most views of places in Germany of any man that ever was'. In Cologne he met the great Earl of Arundel who was on one of his ambassadorial journeys, and coming to London in his entourage etched his first English plates in 1637.

Some of these plates were done from works of art in the Earl's collection, others are views of London, including Arundel House in the Strand, showing the courtyard and the great travelling coach being prepared for a journey with outriders.

At Arundel House he married 'my ladies wayting woman, Mrs. Tracey, by whom he had a daughter, that was one of the greatest beauties I have seen; his son by her dyed in the plague, an ingenious youth, drew delicately'. Professor Hind says that nothing else is known of the son, but he may have assisted his father, as his mother is also reported to have done. Francis Place said he died young.

About 1639 Hollar was employed as teacher of drawing in the Royal Household. In the Civil War he became involved in the hostilities on the Royalist side. Sir Robert Peake, the printseller, was appointed second in command at Basing House, and in 1644 Hollar, with Inigo Jones and William Faithorne, took up arms under the Marquis of Winchester. Hollar was taken prisoner before the fall of Basing House but escaped to Antwerp, where he rejoined his patron the Earl of Arundel.

He returned to England in 1652, but his former prosperity seems to have deserted him for we read of his employment by the printsellers for a shilling an hour, which he timed with an hour-glass. A man of scrupulous honesty, he would, if interrupted, immediately stop the hour-glass: 'a friendly, good-natured man as could be, but shift-lesse as to the world'. Bailiffs distrained on his goods in his last illness, though it was said they found only the bed on which he rested.

His work is careful and exact, often quite small, as in the case of his portrait of an American Indian brought from Virginia in 1645 (as he was in Antwerp at this time it may have been done from someone else's drawing). One of his views of *London and Westminster* is very large, and etched on four separate plates. His etching of *Shells* is said to have inspired Rembrandt's *Shell*.

Hollar's most sought after work is his London views, some of which have been copied deceptively. Other plates have been reworked and reprinted, such as the four views of *Islington and the New River* and the *Costumes of Gentlewomen*, which appear in a volume of reprints of plates by Rembrandt and others, issued about 1800.

Francis Place (1647–1728) said he was the most indefatigable man that has been in any age, and had a defect in his left eye, though he never wore spectacles, but always

held his hand before it when he wrought. 'He was always uneasie if not at work. He was one of great temperance. I don't think he in all his life time was ever seen in drink but would eat very heartily.'

Richard Gaywood (fl. 1650–80), was a close follower of Hollar's style, besides Francis Place, who was also a mezzotinter and supposedly an amateur.

There are some deceptive copies of Hollar's etchings, his popular views of London naturally coming in for the forgers' attention. A few of the most deceptive are noted here.

> London by Milford Staires (Parthey 911; Hind 80). In the original the bar across the top of the chimneys of the house to left of 'London' extends more to the right than to the left; in the copy it is more evenly spaced.

> Whitehall from the River (P. 912; H. 98). The post in left centre foreground in the original tapers to the right, in the copy to the left, and the man to right of it nearly touches it with his hand.

> Tothill Fields (P. 913; H. 106). In the original the lettering over Westminster Abbey, 'St. Peter in Westminster', stops at the last gable on the right; in the copy it extends the length of the roof.

> Windsor Castle from the South-East (P. 914; H. 113). In the copy the title 'Windsor' is much nearer the roofs and there are three nicks (embrasures) in the light side of the tower to right of it, instead of two as in the original.

> London from the top of Arundel House (P. 1011; H. 81). There is a distinct difference in the F of 'From' above the tower of St. Paul's. Also, in the original the church tower on the extreme right just touches the borderline, whereas in the copy it leans away and does not touch.

JAN VAN DE VELDE

The name Van de Velde is an important one in Dutch art, although the first of the line, Jan van de Velde the Elder, a writing-master, was a refugee from religious persecution in Flanders who settled in Rotterdam. His sons were Esaias, Jan II and Willem I.

Esaias (c. 1590–1630) and Jan II (1595/7–1642) both touched their etchings with the graver and did subjects after Willem Buytewech (c. 1585–c. 1624), considered one of the more interesting precursors of Rembrandt and a contemporary of Hercules Seghers.

Jan van de Velde II etched and engraved altogether some 500 pieces, including attractive landscape versions of the Four Times of Day, The Months and The Seasons and others in the dark, chiaroscuro manner after Elsheimer, possibly inspired by Goudt.

Willem I and his eldest son Willem II were the famous Dutch seascape painters, who worked first for the Dutch Government and later for Charles II and James II, but did not etch or engrave themselves.

Adriaen van de Velde (1635/6–72) was the second son of Willem I and famous as an etcher of landscapes with animals.

The portrait of Oliver Cromwell, with the mysterious aquatint ground (see p. 144),

may have been the work of a cartographer and goldsmith working in Haarlem about 1642, also named Jan van de Velde.

HERCULES SEGHERS

Hercules Seghers (*c.* 1590–1638) was a Dutch landscape etcher and painter of Haarlem, a pupil of Gillis Coninxloo, contemporary with Willem Buytewech and Esaias van de Velde. In 1614, at the age of twenty-four, he married a lady of property twenty years his senior, but before his death, about 1638, he appears to have married a second time, lost his property and turned to art dealing. His mental stability seems to have been questioned, without sufficient grounds.

His etchings were described as 'printed paintings'. In them he obtained effects of great beauty, with an ink of one colour on tinted paper, generally considered to be the first attempts at colour-printing from intaglio plates. The tints were applied either before or after printing. Another innovation was sometimes to print on linen, instead of paper.

He also imitated washes with an aquatint-like effect, obtained perhaps by applying acid or other mordant to the bare copper with a brush or feather, or applying the mordant in the form of a paste of oil and sulphur, which could be left to roughen the polished surface so that it would hold a film of ink when the plate was wiped. This was known as a sulphur-tint.

The experiments of Seghers must have been forerunners to those of Rembrandt, who owned one of his plates (Plate 54), altering the figures in it from *Tobias and the Angel* to the *Flight into Egypt*.

Sixty-four plates have been listed as his work, but of late some of these have been attributed to Johannes Ruischer, who, for working in the style of Seghers, is known as 'the young Hercules'.

REMBRANDT

Rembrandt (1607–69), or, to give him the full name that his initials imply, Rembrandt Harmensz Leidensis van Rijn, was the greatest of all etchers. It has been said of him that, although he did not invent etching, he certainly discovered what effects could be obtained by it, scorning previous 'rules'.

His life is mirrored in his work. Even in his etchings can be seen the happiness and sorrows of a lifetime; the happiness that runs in periods; the pleasures of success and affluence, followed by failure and bankruptcy. His busy needle, practising in spare moments on portraits of himself and his relations, has illustrated his career, so that it unfolds before us.

First we see the happy family circle of the early days in Leyden, when the young man returned from his brief apprenticeship in Amsterdam to ply his trade at home; the little plates, perfect miniatures, of his mother, with her kindly wrinkled face, patiently sitting to the brilliant son; the father, with his splendid cranial formation, sometimes wide-awake and aware, at others nodding and dozing as the deft needle records his features. The youth himself, practising with his own reflection, laughing, grimacing, staring, frowning.

In 1630 the circle has been broken, the mother appears in widow's weeds. In 1631/2 he has moved to Amsterdam, taking with him his unmarried sister Lysbeth. The beggars of the city begin to appear; he himself in fine clothes, with sword. Saskia, his wife, first appears in 1634, the year of their marriage.

Models would have been engaged for the benefit of his houseful of pupils. His own first dated nude is 1631. An early biographer described his nude figures of women as 'too pitiful for one to make a song about, for these are invariably figures before which one feels repugnance, so that one can only wonder that a man of such talent and spirit was so self-willed in the choice of his models. . . . Rembrandt would not be bound by any rules made by others.' 'If he painted, as sometimes would happen, a nude woman, he chose no Greek Venus as his model, but rather a washer-woman or treader of peat from a barn, and called his whim "imitation of nature". Everything else was to him idle ornament.'

His methods suggest that someone showed him how to make an etching, and he then, with his brilliant facility of draughtsmanship, proceeded to experiment. His approach to etching seems to be perfectly expressed in the story told of the publisher Vollard meeting Rouault, carrying a parcel of engraving instruments of all descriptions. In answer to Vollard's question as to what they were for, he replied, 'They are for making your damned plates. Call them what you will – etchings? Aquatints? I take a copper plate and just "get on with it".' Rembrandt's teacher may have been Jan Lievens (1607–74), a precocious youth, who had been etching at the age of eleven, and with whom Rembrandt first shared a studio.

Rovinski, in his *Rembrandt*, described his methods as 'picturesque disorder', the liberty he took with the work amounting almost to temerity. Houbraken said he had secret methods, and revealed them to no one before his death, but as Rovinski again said, 'all the secret consisted in having the genius'.

He approached the subject from a painter's point of view, rather than an etcher's. His object was to get effects, and for this purpose he started touching his etchings with drypoint almost from the start.

He broke the rules almost at once. For instance, in the miniature-sized portrait of his mother (Hind 1) (Plate 53), the left eye failed in the biting. Now, the correct proceeding would be to fill the lines with whiting and lay another thin wax 're-biting' ground with a leather roller, redrawing the failed lines where necessary if the mordant failed to re-expose the old lines, and bite them anew. But Rembrandt just scratched in the failed lines with his needle (drypoint), with the result that he could print only a very few impressions before the raised ridges of copper disappeared, flattened by the pressure of the roller-press, even though the rollers were in those days made of wood instead of steel.

A larger than usual early portrait of himself (H. 4), done in 1629, has a curious double line, which Hind thinks was done with a pen, but Rovinski 'one would say with two nails attached to one another'. The bold, rough effect has caused some authorities to doubt its authenticity, but it is accepted by most.

Another thing that might be called a technical fault was to cross-hatch too closely

on his wax ground, so that the minute pieces of copper between the lines would cave in when subjected to the pressure of the press. These places would then print grey through not holding the ink, so once again the drypoint needle would be used, only for the patches to revert to grey again as the drypoint wore away after a few impressions.

Rembrandt, therefore, from the start was strongly aware of the uses of drypoint; he must have known of Dürer's work in this field, especially the *St. Jerome by a Willow*, he himself making a plate with the same title. The work of the *Master of the House-book* would certainly have been known to him.

The touching of his plates with drypoint where places and shadows needed reinforcement became quite usual in his etched plates, and the strength of these touches enables the connoisseur to judge the quality and whether the impressions are early or late.

Occasionally in his later life he made a pure drypoint, like the *Landscape with a vista* (H. 263). In other cases, with a slight basis of etching, he worked up his large and powerful religious subjects with drypoint burr, which the French picturesquely call 'beards': *surtout avec les barbes* being their way of describing a fine impression.

The most popular of these plates, *Christ healing the Sick* (Plates 55, 56 and 57), known as 'The Hundred Guilder Print', inevitably needed constant work to repair the soft drypoint, with which nearly all the background is covered. This rich dark effect, obtained by cross-hatching with the drypoint innumerable times, has decidedly the effect of mezzotint, and it is not at all improbable that this was the artist's aim.

Mezzotint, as explained in the chapter on this process, was discovered about 1640, and von Siegen's letter to the Landgrave of Hesse-Cassel was written in 1642, from Amsterdam. Rembrandt's plate was done about 1649, so it seems reasonable to think that he knew about mezzotint, or at least had seen specimens of the prints.

The most accepted reason, by modern writers, for the name '*Hundred Guilder Print*' is the one put forward by Sandrart in 1675, that an impression realised this price during the artist's lifetime, but some 18th-century writers said it was because he exchanged one for a hundred guilders' worth of engravings by Marcantonio. The two big upright plates, *Descent from the Cross* (H. 103) and *Christ before Pilate* (H. 143), were known as 'The Twenty Guilder Print' and 'The Thirty Guilder Print' respectively. Otherwise it appears most of the etchings sold for less than a guilder, probably equal to about £3 today.

Rembrandt's collections (almost given away when he went bankrupt during a period of slump), coupled with his studies, made him well aware of the work of other artists. He knew the dark prints of his countryman Hendrik Count Goudt (1585–1630) and the experiments with tones and tints of his fellow citizen Hercules Seghers (q.v.), though it might be too much to suppose he knew the monotypes of his Italian contemporary Castiglione.

The presence of two presses in Rembrandt's house proves that he printed his own plates and, towards the end of his career, he devised a means of getting a lantern- or candle-light effect by leaving ink on the plates, only wiping clear the places where

the light struck, the rest having a transparent film of ink, giving a night effect, but not thick enough to prevent the structure of the composition showing through. By this means he could print the same etching with a daylight effect or the dark effect, which he otherwise obtained with closely hatched drypoint.

The ease with which he drew any subject before him enabled him also to excel in landscape work, though he did not start landscape in etching until about 1640 (beyond the occasional glimpse behind a subject), then he used both etching and drypoint.

The landscape known as *Jan Six's Bridge* (Plate 58), dated 1645, is pure etching, while *The Goldweigher's Field* of 1651 and the *Clump of Trees with a Vista*, dated 1652, are drypoints.

A story told of the first proves, if true, that Rembrandt was in the habit of carrying with him, as other etchers have done, a ready grounded plate, and also that he sometimes drew on the plate direct from nature. This story goes that once, when a guest at Burgomaster Six's country house near Amsterdam, the mustard was forgotten, and Rembrandt betted he could etch a plate before the servant sent for it could return.

Tradition had it that *The Goldweigher's Field* was so called because it was a view from the house belonging to Jan Uytenbogaert, Receiver-General, whose portrait Rembrandt etched as *The Gold-weigher*, but the locality has recently been doubted.

Other landscapes have the appearance of being done directly on to the plates, but generally speaking he seems to have worked from sketches and drawings.

Cloud effects were generally avoided in the landscapes, though slight lines and foul-biting occasionally appear. A notable exception is *The Three Trees* (Plate 59). This has mounting storm-clouds and, in the top left part of the sky, a large number of closely ruled lines, presumably simulating a rain-storm.

The most obvious technical innovations to be seen in his plates are the combination of drypoint with etching; the criss-crossing of drypoint lines, raising a burr to print dark over large areas, giving almost the effect of mezzotint, and the leaving of ink on a plate, for night effects.

Rembrandt's plates were not destroyed, a practice which only came into general use in the 19th century. The plate of the *Hundred Guilder Print*, a worn-out ghost, was acquired by an Irish professional soldier, who had fought at Culloden and Minden, Captain William Baillie (1723–1810). On retirement from the army he became a Commissioner for Stamps and a gifted amateur etcher and imitator of old-master drawings. He reworked the *Hundred Guilder Print* back to an excellent likeness of its earliest state. It appears thus in a large volume of his Works, published by Boydell in 1792. In a second edition, published in 1803, the plate is to be found cut into four pieces. It is possible that Baillie printed a hundred impressions, some on Japanese paper, before he cut the plate up.

Many of Rembrandt's plates were still being printed from at an even later date. Nearly eighty of them passed through several hands and belonged in the 18th century to a Paris engraver and dealer, P. F. Basan, who issued an edition about 1790. They were last printed as part of a tercentenary celebration in 1906, and are now in America, deposited with the North Carolina Museum.

Some other plates are known to exist, such as *Burgomaster Jan Six*'s portrait, which remained in the family, a few impressions being pulled about 1870. The plate of *The Gold-weigher* appeared in a sale before the war and is now in the United States.

A few of these plates might be said to be in reasonable condition still, but most of them are travesties of their appearance in the artist's time. Nevertheless, such is the magic of the name, collectors are sometimes paying fifty to a hundred pounds each for them in the auction rooms.

For all these reasons it is necessary to possess a catalogue of his work, with good reproductions, because, not only have the plates been reprinted, they have also been copied from the earliest times; not always to deceive, because to copy a Rembrandt was often one of the first tasks given to students in etching classes.

The whole of his work of over 300 plates has also been reproduced from time to time by photographic means, some of the photogravures done at the end of the last century being extremely deceptive (see chapter Hints to Collectors).

LIST OF CERTAIN DECEPTIVE COPIES OF REMBRANDT, EXCLUDING COPIES
IN REVERSE, SOME OF WHICH ARE ILLUSTRATED ON PAGES 110–114

Rembrandt in soft Cap called *Rembrandt aux trois moustaches* (B. 2; H. 57). Very deceptive copy, with slight differences in the hair; lacking the vertical slipped stroke close to the hat-band on the left.

Rembrandt and his wife Saskia (B. 19; H. 144). Difference in Saskia's chair, close to left border.

Rembrandt leaning on a Stone Sill (B. 21; H. 168). Deceptive copy or reproduction of the first state; the loop of the 6 in the date is not so large, top loop of the 3 is wider, and the loop of the 9 is in one piece, whereas in the original it is in two loops. The long tail of the f does not come below the 9 as in the original.

Rembrandt with plumed hat (B. 23; H. 110). There is a deceptive facsimile of the early three-quarter length state; also a copy of the cut down, oval state in which the b of signature is curved instead of being slightly bent backwards, as in the original.

Adam and Eve (B. 28; H. 159). Copy with difference in the lines in the top right corner, on the top of the serpent's hind leg; the eye of the elephant is black, instead of white as in the original. Lettered in the blank space at the bottom *No. 29 du Catalo.*, but this space is usually cut off.

Abraham casting out Hagar and Ishmael (B. 30; H. 149). Copy which sometimes has 29 in top right corner. Also with difference in signature, the d is open instead of closed.

Joseph's Coat brought to Jacob (B. 38; H. 104). Copy with R of signature different.

The Flight into Egypt: the Holy Family crossing a Brook (B. 55; H. 276). There is a copy measuring 88 × 142 mm.; the original is 94 × 144 mm.

Christ Preaching, *La petite Tombe* (B. 67; H. 256). Copy in which there are no foul-biting spots on the ground below the woman seated with her back turned on the right; the light patch on the wall above Christ's right hand is confused in the copy, whereas in the original it has the shape of a thin rearing horse's head.

Christ and the Woman of Samaria: upright plate (B. 71; H. 122). Copy in which the d of signature looks more like a b. Another copy with sky, and signature below well.

The Raising of Lazarus: the larger plate (B. 73; H. 96). Deceptive copy without the platemark around the arched top; in the original it is close around the arched work, the plate itself having been cut to this shape. Copy with differences in signature.

Christ healing the Sick. 'The Hundred Guilder Print' (B. 74; H. 236). Captain Baillie cleverly reworked the worn-out plate to an excellent likeness of its early state: he divided the rays around Christ's head more than in the original impressions (Plates 56 and 57).

The Agony in the Garden (B. 75; H. 293). There is a copy which is dark in the shadows like the best impressions of the original, but in the copy these shadows are etched instead of being in drypoint as in the original.

Christ before Pilate, 'Ecce Homo' (B. 77; H. 143). There is a copy with differences in the expressions on the faces.

The Crucifixion: small plate (B. 80; H. 123). Copy in which the line on the ground in front of (below) the fainted Madonna runs into the skirt.

The Descent from the Cross (B. 81; H. 103). Copy in which the top of the R of signature does not quite touch the bottom of the print, as it does in the original; a difference also in the bare feet of one of the men receiving the Body.

The Virgin with the Instruments of the Passion (B. 85; H. 193). Copy with a line below the Virgin's right arm, coming over the blank part of the horizontal fold in the cloak.

The Good Samaritan (B. 90; H. 101). Copy in which the obelisk leans more to the right than in the original.

St. Jerome reading (B. 100; H. 119). Copy with difference in the reeds above St. Jerome, at top left; the bottle's neck appears more broken.

St. Francis beneath a Tree, praying (B. 107; H. 292). Deceptive reproduction: there is a slight etched line along the platemark at bottom right.

The Strolling Musicians (B. 119; H. 142). There is a crude copy with the signature below on the right.

The Spanish Gipsy (B. 120; H. 184). Copy in which the lines in the lowest part of the shadow on the left of the feet of the two figures do not come so often over the horizontal line.

The Rat Killer (B. 121: H. 97). Poor copy with a snarling expression on old man's face in doorway.

The Schoolmaster (B. 128; H. 192). Copy which goes no farther at the top than the top of the arch.

Turbaned Soldier (B. 139; H. 99). Copy in drypoint; the top rein touches the skirt of the coat.

The Little Polander (B. 140; H. 138). Copy with tip of thumb, above right hand, rounded. In the original the tip of thumb is square.

Two Tramps (B. 144; H. 116). Copy in which the shading on the woman's back, immediately above the waist, is entirely covered with right to left diagonals; in the original these diagonals only go halfway up.

Man in Oriental Costume, 'The Persian' (B. 152; H. 93). Copy in which the R of signature has ragged outline.

The Hog (B. 157; H. 204). Copy by Byron in which the diagonals left to right, to the left of the man's head, are carried further down his shoulder.

Beggars behind a Bank (B. 165; H. 13). Copy by Bretherton with a difference in the top left corner.

The Leper (B. 171; H. 77). Copy of second state: the centre down stroke of the R is curved instead of straight.

Peasant with Hands behind him (B. 172; H. 16). Copy described by Bartsch, in which some left to right diagonals are missing from the bottom right corner.

Beggar seated on a Bank (B. 174; H. 11). Copy by Bretherton, with a difference in the shading below the button of the coat.

Peasant replying (B. 178; H. 115). Copy with a difference in the R of signature.

Artist drawing from a Model (B. 192; H. 231). There is a heavy copy in which the scratched lines of the unfinished portion are all etched, instead of being drypoint.

Study from the Nude: Man seated before a Curtain (B. 193; H. 220). There is a copy with a horizontal line above the signature.

Jan Six's Bridge (B. 208; H. 209). Very deceptive copy with slight difference in the signature and the f, and in far boat sail.

Amsterdam (B. 210; H. 176). In the original the lines along the bottom of the print have an upward curving space in the centre: there is a copy in which this line is straight. In another copy the longest reed above this space bends to the left at its top: in the original it bends to the right.

The Three Trees (B. 212; H. 205). Bretherton copy: lines in the sky above the right-hand tree, sloping diagonally from left to right, meet in a point; in the original these lines pass through the shading on the right without meeting.

Three Gabled Cottages (B. 217; H. 246). Copy, seen on old paper, where the downstroke of the b in signature is not so straight as in the original. The Bretherton copy has a difference in the bottom right corner.

Landscape with a Road beside a Canal (B. 221; H. 264). Copy by Richard Wilson with a difference on the left.

Landscape with a Flock of Sheep (B. 224; H. 241). Copy by Baillie: with differences, such as in the bottom left corner.

Landscape with a Cottage and Hay-Barn (B. 225; H. 177). There is a deceptive copy, heavier, especially in the background on the right, also with slight differences in the signature. The copies by Bretherton and Lucy Brightwell, of Norwich, have differences in the little wheel on the ground below the cart.

Cottage with a Mill Sail (B. 226; H. 178). A second mill sail (?) is seen in a fork of the large tree on the left: in the original these are straight diagonal lines, in the copy they curve.

The Windmill (B. 233; H. 179). Copy in which the foul-biting in the sky has been imitated and the craquelure lines actually etched. The copy by Lucy Brightwell has NN above the signature. Another copy has a difference in the signature.

Landscape with a Cow drinking (B. 237; H. 240). Copy in which the cow lying down nearly touches the one drinking.

Old Man shading his Eyes with his Hand (B. 259; H. 169). Copy with a ragged appearance and difference in the scratched lines below. In the lines slanting from left to right, below the beard on the left, the second and third lines from the bottom do not touch at the tops as in the original.

Bust of old Bearded Man looking down (B. 260; H. 47). Copy in which the descending lines of shading behind the shoulder on the left rarely touch or cross, as in the original.

Young Man meditating (B. 268; H. 151). Copy in which the b of signature is more rounded at the back than the original.

Cornelis Claesz Anslo (B. 271; H. 187). Deceptive copy with 38 mm. between top of chair and left borderline. The back of the chair on the right, on which is the signature, is more rounded at its top left corner (the inner line).

The Gold-weigher (B. 281; H. 167). This plate was reworked by Captain Baillie: in this reworked (third) state, some vertical lines of shading reach above the foot of the chair-leg, to be seen under the kneeling boy's leg. Baillie also made a copy of this plate, with lines that look like a double-S on the mouth of the bag of gold.

Lieven Willemsz van Coppenol: the smaller plate (B. 282; H. 269). Copy, more engraved than etched, with the vertical bar in the window at top left much closer to the left borderline.

Lieven Willemsz van Coppenol: the larger plate (B. 283; H. 300). Copy measuring 333 × 285 mm., the original is 341 × 290 mm. There are also copies by Denon, Basan and Morley with differences in the shading to left of the quill.

Jan Six (B. 285; H. 228). Copy in which vertical lines are ruled evenly from top to bottom in the triangular light space at the top of the window, instead of having an erased appearance as in the original. In another copy there is a difference in the shape of the book he is holding.

Third Oriental Head (B. 288; H. 133). Copy with differences in the signature.

Bust of a Man (Rembrandt's father) wearing a high cap (B. 321; H. 22). Copy with difference in expression of right eye and in the lines above shoulder on left.

Bust of a Young Man in a Cap (B. 322; H. 65). Copy without the shading on the lapel.

Three Heads of Women (B. 368; H. 152). Copy in which the top ends of some of the lines of shading on the right, sloping downward from left to right, are on the same level.

OSTADE, BEGA, *et al.*

Adriaen van Ostade (1610–85), the famous Haarlem painter of Dutch peasant scenes, may have been a pupil of Frans Hals and was certainly influenced by Adriaen Brouwer and Rembrandt (Plate 60).

He made fifty etchings of peasants and their life, of similar subjects to his paintings, very rare in early states, before the borderlines were strengthened with the burin and the shadows reinforced with fine serrated lines, the ends of which can be seen in places where they encroach into light areas.

The plates were sold at his sale in 1685, and his son-in-law again announced the sale of the fifty plates in 1686; in 1694 they again appeared in a sale. A few years later they were acquired by Bernard Picart, who issued an edition of them between 1710 and 1730, adding a title and portrait of the artist.

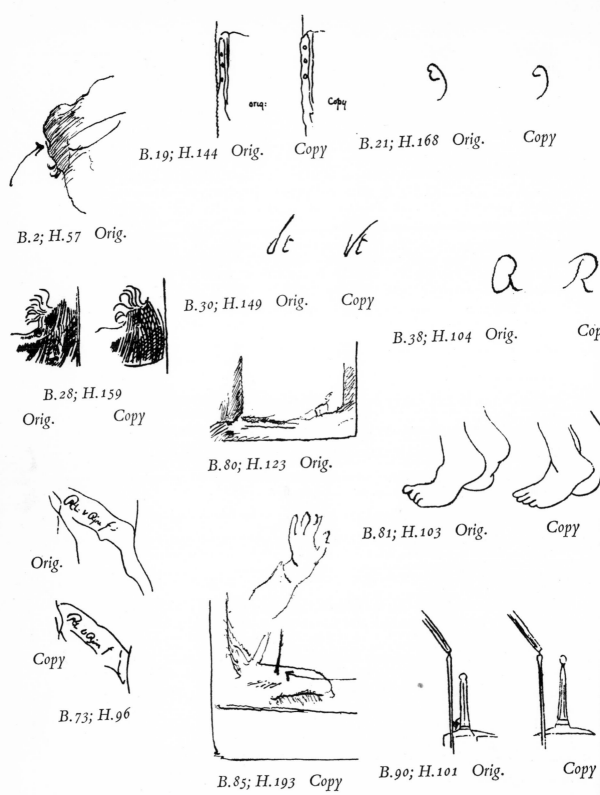

B.19; H.144 Orig. Copy

B.21; H.168 Orig. Copy

B.2; H.57 Orig.

B.30; H.149 Orig. Copy

B.38; H.104 Orig. Cop

B.28; H.159
Orig. Copy

B.80; H.123 Orig.

Orig.

B.81; H.103 Orig. Copy

Copy

B.73; H.96

B.90; H.101 Orig. Copy

B.85; H.193 Copy

THE ILLUSTRATIONS ON THIS AND THE FOLLOWING PAGES REFER TO THE LIST COMMENCING
ON PAGE 106.

B.120; H.184 Orig. Copy

.100; H.119 Orig. Copy

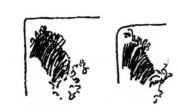

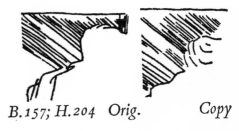

B.144; H.116 Copy B.152; H.93 Copy

B.157; H.204 Orig. Copy

RH RH

B.165; H.13 Orig. Copy B.171; H.77 Orig. Copy B.172; H.16 Orig.

R R

B.174; H.11 Orig. Copy B.178; H.115 Orig. Copy B.192; H.231 Orig. Copy

B.208; H.209 Orig. Copy

B.212; H.205 Orig. Copy B.217; H.246 Orig. Copy

B.221; H.264 Orig. Copy B.224; H.241 Orig. Copy

B.225; H.177 Orig., *wheel enlarged* Orig. Copy

 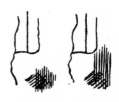

B.233; H.179 Orig. Copy

226; H.178 Orig. Copy

.260; H.47 Orig. Copy B.268; H.151 Orig. Copy

1st & 2nd state. 3rd state
(Orig.) (Copy)

B.283; H.300

Copy by Denon

Orig. Copy
B.281; H.167

Copy by Basan

Copy by Morley

B.285; H.228 Orig.

Orig. Copy

B.288; H.133

B.322; H.65 Orig.

B.368; H.152 Orig.

Cornelis Bega (1620–64), also born and died at Haarlem, was a pupil of Ostade, whose style his thirty-nine etchings closely resemble. His plates were also bought by Bernard Picart and issued as a collection with an engraved title.

Jan van Goyen (1596–1656) is credited by Hollstein with ten etchings, seven of which, however, have been ascribed to Jan van der Capelle.

Jacob Ruysdael (*c.* 1630–82) did twelve or thirteen etchings. The first three were reprinted by Basan in the 18th century; the others are very rare.

Paul Potter (1625–54) etched eighteen plates.

TIEPOLO

Giovanni Battista Tiepolo (*c.* 1696–1770) was born in Venice, the son of a merchant captain. He married Cecilia, a sister of Francesco Guardi, and was the father of Giovanni Domenico and Lorenzo Tiepolo, both of whom assisted him in his painting and etching.

Giovanni Battista succeeded Piazzetta as President of the Academy of Fine Arts in Venice, but went to Madrid in 1762 and died there in 1770.

He etched over thirty plates, mostly in two sets, the *Scherzi di Fantasia* and *Capricci*. Giovanni Domenico reprinted these plates as a Recueil in 1775, adding numbers to the *Scherzi* but not to the *Capricci* (Plate 61).

Giovanni Domenico Tiepolo (1726–1804) etched 177 plates, a number being after paintings or drawings by his father. Lorenzo (1727?–after 1772) did nine large etchings after the magnificent rococo ceilings by his father.

CANALETTO *and* BELLOTTO

Antonio Canale (1697–1768), famous painter of Venetian scenes, was called Canaletto to distinguish him from his father Bernardo Canale, a theatrical scene painter. The family claimed noble descent.

Canaletto assisted his father, but is usually said to have been a pupil of Luca Carlevaris, or at least more influenced by his work. He visited Rome about 1719 and was in England from 1746 to 1750, returning again in 1751 and seemingly staying till 1753, making paintings and drawings of London, Warwick and Alnwick Castles.

He made thirty-four etchings, two being unique and one known by only two

examples. The other thirty-one, all views of Venice, were published as a set, including a title-page (Plate 62). Four of these thirty-four were due to larger plates being divided.

This title-page bears the name of Joseph Smith, a merchant and British Consul at Venice, Canaletto's principal patron, whose art collection was bought for the Royal Collection by George III for £20,000 and included over fifty of the finest Canalettos.

Consul Smith's library forms part of the King's Library in the British Museum. A stray volume of Canaletto's etchings, in the Consul's binding, found its way into the auction sales recently and sold for £10,000. One alone of the Canaletto paintings might now be worth double the total paid for the whole collection.

He was a collector who followed his own inclinations and patronised other contemporary Italian artists, including Zuccarelli and Sebastiano Ricci. Horace Walpole, who visited him, appears not to have noticed another possession – Vermeer's *Lady at the Virginals*, which was thought to be a Mieris. 'Do you remember', he wrote to Horace Mann, 'how angry he was when showing us a Guido, after pompous rooms full of Sebastian Riccis, which he had a mind to establish for capital pictures, you told him he had made amends for all the rubbish he had showed us before?'

In the first edition of the set of thirty-one etchings, the twelve large plates (thirteen if one counts the fact that the twelfth was divided in two) are without the letter and number in the bottom right margins present in the second edition.

The first edition has been seen printed on paper with the watermark A on the title and a crowned shield with three stars in the other plates; also with a watermark of three crescents or Cs. The smaller plates in these sets were printed up to four on a sheet.

In technique Canaletto worked all over his plates, except the high-lights, with open lines, without cross-hatching, his water being expressed with close waving lines, reminiscent of the wavelets in his paintings.

Sets of views of Venice after Canaletto were done in line-engraving by other engravers, the best of which are by Brustoloni.

Similar engravings of his London views were published in London by Sayer & Bennett, Laurie & Whittle, Bowles and others. These are usually coloured and the contemporary issues can be told because the skies are nearly always coloured with body-colour, the rest with ordinary water-colour.

Bernardo Bellotto (1720–80), who also called himself Canaletto, was a nephew and pupil of Canaletto, and one feels that Horace Walpole may have had a change of heart when he invited him to England. In 1746/7 he went to Dresden and worked as Royal Painter for the King of Poland in Dresden and Warsaw. He also worked in Austria for Maria-Theresa.

In all he made thirty-seven etchings, including seventeen of Dresden and eight of Pirna, in a technique similar to his uncle's. The Dresden and Pirna views are very large, measuring up to about 21 by 33 inches, and, by reason of their size, are stronger bitten than the uncle's (Plate 63).

The plates for these Dresden and Pirna views were nearly all sold by the Cabinet of Prints, Dresden, about 1850, to a Berlin print publisher, who reprinted them. These

reprints can usually be told because they mostly show rustmarks, printed from the rusted plates.

PIRANESI

Giovanni Battista Piranesi (1720–78) was born in Venice, the son of a stone-mason. At eight he was sketching; and while still a child was apprenticed to his uncle, Matteo Lucchesi, an architect.

In his working life Piranesi etched at least 1,300 plates, mostly of large size, averaging one a fortnight, yet, in spite of the skill and patience required, he is said to have been of impulsive and even violent character. At eighteen he quarrelled with his uncle and went to Rome, where most of his work was done on the Roman ruins and antiquities.

Whilst studying etching under Giuseppe Vasi, author of a vast view of Rome on several sheets, he threatened the life of his master for, he thought, withholding from him some secret of etching. While sketching in the Forum he encountered his future wife, terrifying her and her parents to consent to a marriage within five days. This, he said, was for the sake of the girl's small dowry, sufficient for the publication of some etchings.

One should hesitate to believe these stories without proof. Old art-historians had a habit of inventing characters to suit artists' styles. If bandits were often introduced into their pictures, then they had themselves been bandits. Andrea Castagno, because he painted in a powerful style, was labelled a murderer for four centuries, till the discovery of a document proved that his 'victim' had outlived him by several years.

Piranesi for his work needed extraordinary patience and exactitude, quite at variance with his alleged impulsiveness. In his technique he very rarely cross-hatched, shading rounded columns, for instance, with long parallel lines of varying thickness and spacing, often using the swelling line, reinforced with the graver. His draughtsmanship was mostly very exact,* although imaginative, cracks in an obelisk in the foreground of Santa Maria Maggiore having been found to tally with a recent photograph. In his later life he was assisted by two sons, Francesco and Pietro, and a daughter Laura.

The etchings most often seen are the large *Vedute di Roma* (Plate 64), measuring on an average about 18 by 24 inches and numbering nearly 150, but his famous set, immortalised by De Quincey, is the imaginary Prisons – *Carcere d'Invenzione* – vast interiors, with soaring columns and stone stairs, implements of torture, etc. (Plate 65).

Piranesi had a special interest in Britain, having been particularly patronised by wealthy travellers on the grand tour, many of them bringing home sets of his work, or at least the *Vedute di Roma*. Consequently, nearly all the examples coming on the market have been sent from houses in Britain. It has been said that his work influenced British architects like Robert Adam and Sir William Chambers. He was elected to the Society of Antiquaries in England and knighted by the Pope in 1765, using the title Cavaliere.

* The handling of the first states of the *Carceri* is quite free.

In 1798, twenty years after his death, the two sons, possibly accompanied by their sister, sailed for Paris with over a thousand of the copperplates. The ship was captured by the British as a prize, but the Admiral either knew about Piranesi, or treated the travellers as neutral or allies, and saw them safely to France.

Purists have lamented that the Admiral did not heave this colossal weight of copper overboard, thus preventing all the subsequent reprints of poor quality.

The first reprints, known as the Paris edition, were reasonably good, but it has been said that the plates could be hired by anyone to do a day's printing, eventually being acquired by Firmin-Didot in 1810 and republished in twenty-seven volumes in 1835–9. They were finally acquired by the Regia Calcografia in Rome (some 1180 plates in all), whose reprints bear a blind stamp in the margins.

Sets of Piranesi's prints and works on antiquity were originally issued in over twenty volumes, measuring approximately 21–24 by 17–18 inches. This meant that the large plates were folded, so that the *Vedute di Roma* and *Carceri* invariably show a centre fold, generally faint.

> *Vedute di Roma.* Apart from very rare proofs and impressions published by Bouchard e Gravier, a large number of the plates have a publication line with the artist's address, followed by the price: *A paoli due e mezzo.* Impressions published in Rome after the artist's death in 1778 have had this price removed, the publication lines ending in . . . *Trinita de' monti.* Impressions printed in Rome have a fleur-de-lys watermark. The first Paris edition of 1800–7, issued by the sons, are in the same state, with the price removed, but often have a watermark including the name T. DUPUY, AUVERGNE.* Impressions published between 1800 and 1835 have Arabic numbers in the right top or bottom corner. The Firmin-Didot impressions of 1835–9 have additional numbers running from 682 to 821, and are on wove paper. Modern impressions are on wove paper, with the blind stamp of the Calcografia Camerale, or (after 1870) Regia Calcografia. All editions until Firmin-Didot are on thick laid paper.
>
> *Carceri d'Invenzione.* The first edition was published by Bouchard, with the title *Invenzioni Capric di Carceri*, and consisted of fourteen plates. The second edition was published by Piranesi, with the title *Carceri d'Invenzione*, and made up to sixteen plates, with numbers added at the top I to XVI, and the plates darkened and strengthened. The Firmin-Didot reissues have added Arabic numbers at the tops, from 349 to 364.

THE 19TH CENTURY

The 18th century was noted for the etchings made by the Tiepolo family, Canaletto and Piranesi. Otherwise etching had been mostly used to provide etched outlines for engravers, or for aquatinters and hand-colourists. As an art it was kept alive as a 'hobby' by men like Gainsborough, who must have been a pioneer in the soft-ground method.

At the beginning of the 19th century, Thomas Girtin in 1802 did twenty outlines in soft-ground for a series of *Views of Paris*, to which F. C. Lewis applied an aquatint grain.

A little later two practitioners were Sir David Wilkie and Andrew Geddes.

Sir David Wilkie (1785–1841) made about thirteen etchings and drypoints between

* This was a laid paper, always with the same watermarked date 1742 (see Paper section).

1819 and 1824, sometimes to be found in book form, the best-known being *Searching for the Receipt*.

Andrew Geddes (1783–1844) could claim to be one of the pioneers of the revival of etching, which took place in the middle of the century. He made about forty plates, mostly between 1822 and 1826, both portraits and landscapes, one of the best portraits being a drypoint of his mother.

J. M. W. Turner etched a few outlines for the plates of his *Liber Studiorum*, and Constable made four or five experiments.

East Anglian artists followed Gainsborough in a liking for soft-ground, and John Crome included some in over forty etchings he made, though they were not published till after his death, when thirty-one plates were published as *Norfolk Picturesque Scenery*, in 1831.

John Sell Cotman used etching for his considerable publications on old architecture. His most delightful work was a booklet of etchings and soft-grounds, entitled 'Liber Studiorum', published in 1838 (Plate 67).

Eugène Delacroix (1798–1863) etched twenty-four plates. He also did one aquatint.

In the 1840s a group of artists known as the 'Barbizon School', from the name of the village near Fontainebleau where they worked, began to take up etching as part of their profession. Among them were Charles Jacque, C. F. Daubigny, J. F. Millet and J. B. C. Corot.

Charles Emile Jacque (1813–94) was the most prolific of them, his catalogued plates (including a few lithographs) numbering nearly 500. His system of hatching influenced Whistler in his early 'French Set'.

Jean Baptiste Camille Corot (1796–1875) made fourteen etchings, plus a number of lithographs. He also did a large number of *clichés-verres* together with other Barbizon artists about 1860. See Lost or Forgotten Processes.

Jean François Millet (1814–75) etched twenty plates, mostly farm and domestic subjects, in which he was probably influenced by Charles Jacque.

Charles Francois Daubigny (1817–78) was the most prolific after Charles Jacque, etching over 100 plates.

Theodore Rousseau (1812–67) made only four etchings, but their merit has been praised.

Felix Bracquemond (1833–1914) of Paris, etched over 800 plates, some of them after pictures by other artists – Delacroix, Meissonier, Millet, etc. He was trained as a painter and lithographer and is said to have taught himself etching from Diderot's Encyclopedia, making his first attempt in 1849. He was one of the leaders of the 'revival' of etching and lithography (see Lithography).

Charles Meryon (1821–68) was the first of the great etchers of the revival. He was named after his father, a doctor who was private secretary to Lady Hester Stanhope, his mother being French. He made a four years' voyage to the South Seas as a midshipman in the French Navy.

He resigned from the Navy on his return to France and started to paint the Assassina-

tion of Captain Dufrêne in New Zealand in 1772, and it was not till then that he discovered he was colour blind, a fact which did not deter him doing a pastel of a ship in full sail, called 'The Phantom Vessel', engraved by T. Chauvel.

He was taught etching by Eugène Blery, copying at first etchings by old Dutch masters, particularly Zeeman, whom he admired as a marine artist.

The first twenty-two of his famous views of Paris were published from 1852 to 1854 in three paper parts, with the printed title *Eaux-fortes sur Paris*. Early states of these plates are sometimes printed on yellow or green paper, the green-paper impressions giving almost a moonlight effect and being particularly sought after. Some of these plates have been very deceptively reproduced by the Autotype Company on a white Van Gelder paper, with a Fortune watermark.

Meryon first made very exact pencil drawings of his subjects, and, like Callot, fixed his plate on an easel; but it is hard to believe that he held his etching needle out at arm's length, working slowly from bottom to top, saying to astonished beholders, 'Are not houses built from the bottom up? Why do you wish that I should reproduce them by reversing the process?'

His mental illness, accelerated by poverty, began to show in 1858, with the introduction of figures in his skies, sometimes not inappropriate, like the marine monsters in the *Ministère de la Marine*. Eventually he was found in bed, keeping everyone at bay with a pistol. He allowed Leopold Flameng to make a drawing of him sitting up in bed, but then tried to snatch and destroy it. A reproduction of this drawing commonly turns up in collections of his etchings. He died in Charenton asylum in 1868.

NAMES OF SOME ARTISTS WHO PRACTISED ETCHING SINCE THE MID-19TH CENTURY REVIVAL

Sir Francis Seymour Haden. A distinguished doctor, who had studied in Paris. At first an amateur, who made his first etchings in Italy in 1843–4. Renewed his effort after marrying Whistler's sister 'Dasha', but had the inevitable quarrel with his brother-in-law. A portfolio of his etchings was published in Paris by Philippe Burty as *Etudes à l'Eau-forte*.

James Abbot (McNeill) Whistler. Finished his *French Set* in 1858. Settled in Chelsea in 1859; The *Thames Set* in 1871; *Venice Set* 1880; *Twenty-six Etchings* 1886. Thought only the etcher could print his own plates well.

Walter Richard Sickert and Theodore Roussel were pupils of Whistler.

Alphonse Legros (1837–1911). One of Whistler's 'Society of Three' in Paris, the other being Fantin-Latour, who did only two etchings, but many lithographs. Legros was first etching in 1857. Settled in London. Became a teacher in the Engraving class at South Kensington and Slade Professor at University College.

Other famous etchers:

Felix Buhot	Camille Pissarro	Edgar Degas
Edouard Manet	A. T. Steinlen	J. L. Forain
Albert Besnard	Kathe Kollwitz	Edvard Munch

Max Liebermann	P. R. Picasso	Van Gogh
Anders Zorn	Sir D. Y. Cameron	Sir Muirhead Bone
James McBey	Augustus John	F. L. Griggs
Graham Sutherland		

Odilon Redon, Paul Cézanne and Toulouse-Lautrec also did a few etchings, though they were chiefly lithographers.

VARIATIONS IN ETCHING

SOFT-GROUND ETCHING appears to have come into use soon after 1750, and is so called because the plate is grounded with a softer wax, containing more tallow than is the case with ordinary etching. The process is very simple: a sheet of thin paper is laid over the ground and a drawing made on this paper with a lead pencil. When the paper is peeled off, some of the wax adheres to it where the pencil has pressed. The plate is then immersed in the acid bath and bitten like an ordinary etching, the result, when printed, being an extraordinary resemblance to pencil drawing, with a line full of character.

Thomas Gainsborough has been thought to be the possible inventor, his sixteen etchings being done in this manner (Plate 66), some with the addition of aquatint. They were published by Boydell in 1797, nine years after the artist's death, with the addition of his name below and a publication line. Rowlandson also etched four plates after him in the same style, which have Rowlandson's name as the etcher below, but if cut off, they can easily be mistaken for Gainsborough's. Other East Anglian artists such as Crome and Cotman successfully practised it, some of Cotman's soft-grounds in his *Liber Studiorum* being among the best ever done in this medium (Plate 67).

The clever imitations of drawings engraved in the 18th century by men like Ploos van Amstel appear to have some soft-ground etching in them, and later on Thomas Girtin used it for his twenty views of Paris, to which F. C. Lewis added an aquatint ground.

An off-shoot of soft-ground etching is the textile ground, in which a sheet of material is laid on the wax ground and rolled through the press. Using this method some modern artists have obtained the effect of a collage: a picture made up of pieces of material stuck on.

A 'sand-grain' can be made by placing a sheet of sand-paper on an ordinary wax ground and rolling it through the press.

Foul-biting is really accidental, through the mordant getting under the wax ground and pitting the surface of the polished metal, but the effect is deliberately obtained by roughing up the surface by wiping acid on it with a feather, or a brush, in which case it is known as 'brush etching'.

A 'sulphur-tint' is obtained by covering the plate (or the required place on it) with oil and powdered sulphur.

One should also mention the practice, used by a few artists capable of very rapid work, of placing the grounded but untouched plate in the acid bath and then starting

work. This was a method of the late James McBey: he was thus enabled to draw his foregrounds in the acid bath first, allowing them longer to bite than his distances.

DRYPOINT, though not etching at all, is usually classed with it because of its frequent use with etching, as in the work of Rembrandt. The lines are scratched on the plate, lightly or strongly (or lines already etched are further dug out by the needle), raising a ridge, known as burr (French *pointe sèche* or *barbes*; German *kalte nadel*). It is the ridge which holds the ink: if looked at through a magnifying glass the actual furrow will be seen to be holding no ink at all.

This ridge is very delicate on soft copper; it can be partially rubbed down with the fingers. Even with modern steel facing (first used in the middle of last century) it wears down very quickly. In Rembrandt's day wooden rollers instead of the steel ones were used in the presses, but, even so, any good impression of drypoint, not re-worked, must be very rare.

The tool used is mostly a sharpened steel etching needle, but an engraver's burin can be used; the first to practise it about 1480, the Master of the Hausbuch, may have used one.

CLICHÉS-VERRES (see Lost or Forgotten Processes).

8. Mezzotint

SEVENTEENTH CENTURY

The invention of mezzotint engraving is credited to Ludwig von Siegen (1609–
c. 1676), who was born at Utrecht and served as an officer in the army of the
Landgravine of Hesse-Cassel. One of his plates, completed in 1642, was an excellent
portrait of her and was sent by him to her son in that year (Plate 68).

A mezzotint by Jobst Bickart bears the date 1637, but this is presumed to be the date
of the painting from which it is taken – a portrait of Johann Reinhard, Baron von
Metternich-Winneburg (Hollstein 2).

History says the discovery was the result of chance, and improved 'by a German
soldier, who, espying some scrape on the barrill of his musquet and being of an
ingenious spirit, refined upon it, until it produced the effect you have seen'. This
savours much of the stories beloved of the early art-historians, and was told in a
similar manner of Prince Rupert, to whom von Siegen had imparted the secret:
the Prince noticed a sentry trying to remove rust from a fusil-barrel, 'which had formed
some kind of picture'.

Prince Rupert, when in England, explained the process to the diarist John Evelyn,
who published in 1662 a little book 'Sculptura', the first edition of which was
illustrated with a plate by Prince Rupert, the *Head of the Executioner* (for the second
edition the plate was copied by Richard Houston). From the wording of this book it
was for a long time believed that the Prince was the inventor, a view which was
supported by a copy of Prince Rupert's self-portrait, engraved in mezzotint by his
assistant Wallerant Vaillant, which had an inscription in Dutch that he was the in-
ventor of 'the black picture art'.

Evelyn purposely kept his description of the process 'aenigmatical', so that anyone
interested would have to approach him personally and he could prevent the know-
ledge falling into incompetent hands. One of those to whom he showed it in
1665 was Samuel Pepys: 'The whole secret of mezzotinto and the manner of it,
which is very pretty, and good things done with it.' Sir Christopher Wren was
also thought interested and the possible engraver of two Negro Heads in the British
Museum.

At its start mezzotint, as practised by von Siegen and his followers Prince Rupert,
Canon T. C. Furstenberg, and Jan Thomas of Ypres, seems to have been a different
process from what it became in the 18th century: the early practitioners raised burr to
hold the ink only where they wanted it, doing this with little toothed wheels; the later

men raised this burr all over the plate, with a rocker, so that it would print jet black, and scraped away their half-tones and high-lights (Plate 70).

Both Cyril Davenport (*Mezzotints*, 1904) and Charles E. Russell (Supplement to Chaloner Smith's *British Mezzotint Portraits*) thought that von Siegen was trying to find a means of making dots, easier than the laborious *pointillé* or the *opus mallei* (mallet and punch) methods, in which each dot was made individually, and that, as a soldier, the rowel of his spurs may have suggested the roulette wheel, but, in fact, roulette engraving was used by goldsmiths in the 15th century.

With little toothed 'roulettes', of varying sizes, and a broad one, known as an 'engine', burr was raised on the polished copperplate to hold ink in the places and in the amount (darkness) required. It is possible that von Siegen may have used a burnisher to lighten the burr where it was too dark; the introduction of a scraper for this purpose may have been due to Prince Rupert, some of whose plates were extremely good. His print of the Executioner of John the Baptist known as *The Great Executioner* (Plate 69), after a painting by Ribera (Lo Spagnoletto) compares well with anything done in later years.

William Sherwin (fl. 1669–1714) was taught mezzotint by Prince Rupert, though he is said to have obtained first a clandestine view of the tools through the connivance of one of the Prince's servants. He is thought to have used a half-round file, pressed down with a heavy piece of lead, to ground his plates (i.e. raise the burr). His portrait of Charles II, 1669, is the earliest mezzotint produced in England actually dated. It has been said that, like most of the earliest mezzotinters, he was an amateur, but this seems unlikely, because he engraved nearly forty portraits in both line and mezzotint, as well as plates out of books, like the long Procession for the Coronation of James II. The supposed amateur status may have arisen owing to his marrying the heiress to the Duke of Albemarle.

Alfred Whitman, in *The Print Collector's Handbook*, said Prince Rupert was the first to ground the plate all over. Alexander Browne, in *Ars Pictoria*, 1675, also described the grounding of a plate all over, but only in two or three different directions, with the 'engine', and then the use of the burnisher to remove the burr for the lighter parts. He himself may have been only a publisher.

Browne may have been the first to advocate grounding the plate all over at the start, but the first man to ground his plate all over in the later method, with a 'rocker', is thought to have been Abraham Blooteling (1640–90), a Dutch engraver in line and mezzotint, who came to work in England in 1672 and produced, among others, three fine mezzotint portraits, after Sir Peter Lely, of Charles II, James II and the Duke of Monmouth.

EIGHTEENTH CENTURY

Blooteling's method was the one adopted in the 18th century, when the art reached its zenith and became known as the *manière anglaise*, owing to its extensive practice there. The plate was 'grounded' with a 'rocker' like a small, thin axe-head with a sharp, serrated edge. Later on the rocker was fitted with a rod, about three to four

feet long, extending at right-angles from it, the other end terminating in a ball, which was allowed to rest in a cup or groove. The serrated ege could thus, with the pressure of the hand, 'rock' the plate all over in many (sometimes more than eighty) different directions, in order to raise a burr which would hold the ink and print a rich, velvety black. Forty directions were usually enough.

Working from dark to light, the engraver would scrape away the requisite amount of burr, to hold less ink, until he reached his highlights, when he would remove the burr altogether and burnish the places to remove the scratches. To facilitate his work he would at first cover the grounded plate with black chalk and draw his subject on it with white chalk, to act as a guide. When reproducing a painting it was customary to engrave in reverse, so that the prints came out the right way round. Scratching the design on a sheet of gelatine, inked and passed face downwards through the press, transferred the design in reverse.

The mezzotint burr, being raised up on the surface of the plate, was extremely delicate, and it was in the dark parts, where the burr had not been scraped down, that the first signs of wear would show. Only twenty or thirty fine impressions would be possible; after probably less than a hundred the plate would have to be reworked.

The first engraver to use a steel plate for mezzotint, was William Say (1768–1834), in 1820 for a portrait of Queen Caroline. Thomas G. Lupton was granted a medal by the Society of Arts, in 1823, for engraving in mezzotint on steel. The practice of steel-facing copperplates was first done about 1860, though too heavy a deposit was laid on some of the first, such as Whistler's 'Thames Set' etchings, filling the lines and crevices too much. A great advantage of steel-facing was that it could be removed.

In view of the delicacy of the mezzotint on copper and the few fine impressions obtainable, it is less surprising that the process was not much practised on the Continent after its first discovery, than that it should have become so popular a medium in Britain. It reached perfection in the second half of the 18th century, when it was mostly used to reproduce oil-painted portraits by Ramsay, Reynolds, Gainsborough, Hoppner, Romney, Joseph Wright, Raeburn and other great British artists.

Some of the best-known engravers were James McArdell, Edward Fisher, William Pether, Richard Houston, Valentine Green, John Raphael Smith, John Jones, James and Thomas Watson (no relations), William and James Ward (brothers), John Young, James Walker, Charles Turner and Samuel William Reynolds. The engravers who preceded them had been exact and very prolific in their work, but hardly anything more. These men were John Smith, John Faber, father and son, William Faithorne the younger, John Simon and numerous others, whose work is mostly interesting for historical and biographical reasons. John Smith's best work was done after Sir Godfrey Kneller, including the *Earl of Annandale*, *Thomas Tompion* the horologist, and *William Wycherley* the dramatist.

IRISH MEZZOTINTERS

Following the predominantly Dutch element of the 17th century a number of Irish mezzotint engravers worked in London during the 18th century, a forerunner being

Edward Luttrell (1650–*c*. 1710), a Dublin lawyer, and another of the early mezzotinters whose amateur status would seem to be in question. It is related by Walpole that he persuaded his publisher, John Lloyd, to bribe Abraham de Blois, who laid the grounds for Blooteling, to impart the secret, but that, having obtained it, Lloyd withheld it from Luttrell and traitorously passed it on to his friend Isaac Beckett (1653–1719), described as the first professional English mezzotinter. Luttrell was left to acquire the art from Jan van Somer (1641–*c*. 1724), or, it may be, from his younger brother Paul van Somer.

James McArdell, Edward Fisher and Richard Houston were among the Irish contingent working in London. Several had been pupils of John Brooks (fl. *c*. 1730–55), who was also an enameller on china and given charge of a factory at Battersea, which appears to have failed owing to his dissipated habits.

More than one of his pupils have been tagged with a similar vice. Richard Purcell (*c*. 1736–65), according to Chaloner Smith, fell completely into the powers of the publisher Robert Sayer, 'and produced for him copies of the works of McArdell, Watson and others, adopting the alias of "Corbutt" '. Sayer is said to have had him arrested and confined in the Fleet debtors' prison, 'in order', as he said, 'to know where to find him'.

Thomas Frye (1710–62) was also famous for his connection with Bow china, bringing his clay from South Carolina, and calling it 'New Canton'. He was himself a painter and mezzotinted a series of eighteen life-sized heads from his own drawings, known as his 'large heads'. Those that are portraits of well-known people he sketched surreptitiously at the theatre. George III and Queen Charlotte, who figure in the series, observed him and obligingly remained as still as possible.

James McArdell (*c*. 1729–65) and Richard Houston (*c*. 1721–75) were Brooks's most famous pupils. The former was the favourite engraver of Sir Joshua Reynolds, who is quoted as saying that his fame would be preserved by McArdell's engravings when the pictures had faded away. Perhaps an unfortunate remark from this superb portrait painter, who, through a belief that the secrets of the old masters had been lost, was always experimenting, so that certain of his pictures had the reputation of fading even in his lifetime owing to his use of bitumen. Horace Walpole suggested he should receive, instead of a lump sum, an annuity only for so long as his pictures lasted.

Richard Houston was a very skilled and successful exponent of mezzotint but intemperate in his habits.

Edward Fisher (1730–*c*. 1785) was perhaps a pupil of McArdell and at first a hatter. He also engraved after Reynolds, who described him as 'injudiciously exact', for overfinishing minor parts.

Charles Spooner (d. 1767), another pupil of Brooks, was greatly attached to McArdell. He outlived him by two years and at his own request, was buried beside him.

Other Irish mezzotint engravers were Thomas Beard (fl. 1728), William Baillie 1723–1810), John Murphy (*c*. 1748–after 1820), Michael Ford (d. 1758), John Dixon (*c*. 1730–after 1800), James Watson (1739?–90) and Thomas Burke (1749–1815).

VALENTINE GREEN, J. R. SMITH, et al.

Valentine Green (1739–1813) is perhaps the most famous of the 18th-century mezzo-tint engravers, particularly in the interpretation of Sir Joshua Reynolds, his master-piece being the three *Ladies Waldegrave*. Though at first meant to be a lawyer, he was apprenticed to Robert Hancock, of Worcester.

He attained great honours, becoming an Associate as an engraver to the Royal Academy and Mezzotint Engraver to His Majesty in 1775. In 1789 he was granted the privilege of engraving the pictures in the Düsseldorf Gallery (now part of the collection in the Pinakotek, Munich), but a great deal of his property suffered destruction in the siege of the city in 1798.

John Raphael Smith (1752–1812) is often described as the best of all these unsurpassed engravers in mezzotint. He was the son of Thomas Smith 'of Derby', who must have had high hopes of both his sons to name them Thomas Correggio and John Raphael. The latter, however, disappointed his father so much that he was apprenticed to a linen-draper at the age of ten.

Mrs. Julia Frankau, in *John Raphael Smith His Life and Works*, thinks he was just a misunderstood, slow-developing boy, and that the attempts to beat precocity into him warped his character, so that in later life he became one of those who cheated poor Morland in his cups.

Morland called him 'Old Drapery Face', an allusion to the successful drapery shop he opened in the Strand, where Angelica Kauffmann was one of his customers. Un-fortunately there is evidence in his work that ladies frail as well as fair were among his acquaintances, and, although a prodigious energy replaced the indolence of boyhood in a combination of drapery and art, he joined the convivial set of Thomas Rowland-son.

Mrs. Frankau, however, at the finish, seems led to doubt the intensity of the con-viviality, in view of the nearly 400 plates that Smith engraved in mezzotint and stipple, and many small portraits he drew, mainly in pastel. Perhaps the wines were of better quality in those days of light taxation, or, unlike poor Morland, he had the sense to heed Hogarth's warning and avoid the pernicious London-made gin.

In art, the lessons of boyhood must have been remembered, because he not only became the finest of all the famous mezzotint engravers of the 18th century, but also excelled in stipple and could handle a paint-brush with tolerable effect. The original oil-painting for his stipple-engraving '*What you will*', sold recently, was a very deli-cately handled portrait of an attractive wanton. His small pastel portraits are very competent; at Goodwood there are a number which he drew of the guests while staying with the Duke of Richmond, but most of his work of this nature was probably done after the French Revolution had ruined the trade in exporting prints to the Continent: then he drew as many as forty in a week, at two guineas a time, and could do one in an hour.

His first mezzotint was a portrait of Pascal Paoli, the Corsican hero, published in 1769, presumably by Smith himself, as it does not have a publisher's name, but

where he gained his knowledge of the art is not known. Mrs. Frankau suggests W. Humphrey, who helped him publish some of his plates, possibly a relation of the Mrs. Humphrey who published James Gillray's caricatures. Early on he is thought to have engraved some plates for the publisher Carington Bowles (Plate 71), where he may have gathered hints; or why not from his convivial artistic friends? Some of his earlier plates have become so rare they are never seen, perhaps because they were considered rather discreditable. In 1776–7 he engraved a set of six portraits of 'ladies of the town', which are quite often to be seen, but he also made a set of whole-lengths in the nude, and these are never to be found at all. It is related that George IV had a set, which was destroyed on the orders of William IV!

Smith's first meeting with Morland was in 1780 and led to the buying of thirty-six paintings, with which he opened a 'Morland Gallery'. From these he and his apprentice William Ward engraved many of the subjects which bear their names. It is reported that he got James Ward to copy the pictures, to be sold as Morlands, though James himself denied copying any but *The Travellers*.

Smith engraved the work of many other artists, including Gainsborough, Reynolds and Romney. Among his several apprentices were, besides the two Wards, S. W. Reynolds, John Young, Jane Thompson, and, for a time, Peter de Wint and William Hilton. Copley Fielding and Sir Francis Chantrey acknowledged a debt for his advice, and Turner and Girtin earned pocket-money colouring his prints.

James Ward described him as a brutal tyrant to apprentices. There is a record that he haled William Hilton before the magistrate as an idle fellow, and he drove a hard bargain with Peter de Wint for his release, and with William Ward to release his younger brother James.

LANDSCAPE IN MEZZOTINT

Landscape, in the 18th century, had, unfortunately, come to be considered a form of art lower than portraiture and the classical or historical pictures, fondly thought by their perpetrators to be the 'grand manner', so that there are only a few things such as Kirkall's engravings after Ridinger, or the excellent oak trees in mezzotints after Morland's works and the landscapes in horse pictures by Stubbs, Agasse, Chalon, Ben Marshall and others to show what could have been done in this respect.

Mezzotint was used, in conjunction with etching, by Richard Earlom, when he engraved the drawings by Claude in his *Liber Veritatis*. Two hundred of these were at first published, and in 1819 another hundred were issued, after various other drawings by Claude: they are often to be found in three volumes.

Although this was quite a meritorious achievement, it met with severe criticism from Count Léon de Laborde: 'It is impossible to reproduce in a more futile manner, more insipid, more monotonous, in a word more banal, a collection of 200 drawings which are masterpieces by their depth, their sentiment, their variety and their distinction.'

Turner also employed mezzotint for his *Liber Studiorum*, which he may have started in his curious desire to emulate or outshine the great Claude. Turner, however, made drawings with the express purpose of having them engraved and published, whereas

Claude's drawings were only made in order to identify and authenticate his paintings, the engravings being made more than a hundred years later.

Charles Turner, who, though no relation, had been a fellow student with the great J. M. W. Turner at the Royal Academy school, was employed to engrave most of the first plates of the *Liber Studiorum*. Seventy-one plates were actually published, several of the etched outlines and occasionally the mezzotint as well, being done by the artist. In most cases the etched work was done first, but in a few cases it appears that the mezzotinting was reinforced by the etching.

Most mezzotints, on examination, show from early times that they have been assisted by etched work, George White (*c.* 1671–1732) being the first to make an extensive foundation of etching before laying the mezzotint ground, though in later times etched lines were added when the work was well advanced. In the 19th century a very decadent form of 'mezzotint' was started, best described by the term 'mixed method', as it embodied nearly every form of engraving.

It was John Constable who made a real attempt to have oil-painted landscapes engraved in mezzotint, by commissioning David Lucas to produce the plates for his *English Landscape Scenery*. When he published this work in 1830 he was still smarting under Sir Thomas Lawrence's dictum that he was lucky to be elected a Royal Academician as a mere landscape painter.

PORTRAITS IN MEZZOTINT

When it comes to mezzotint portraits, it is a valuable aid to memory to know something of the painters and their sitters. Experts who astonish others by their ability to recognise portraits with no name attached to them, have usually founded their knowledge on this fact. Some account, therefore, should be given of the fashionable painters who supplied the engravers with so much of their material. Like Van Dyck, who so strongly influenced them, they bowed a new sitter into their studios every hour or so; most of them did little but paint the heads.

Sir Peter Lely (1618–80) painted a series of fascinating portraits of the ladies of Charles II's Court, known as '*The Windsor Beauties*', but now hanging at Hampton Court: these were engraved by Thomas Watson.

Sir Godfrey Kneller (1646–1723) had a 'factory' with assistants for nearly everything. Horace Walpole justifiably said that portraits of the type he painted all looked alike, save that some were turned to the right and others to the left. A number of Kneller's pictures were engraved in mezzotint by John Smith (*c.* 1652–1742) and John Simon, who at one time lived with him, and occasionally an interesting one occurs. A mezzotint of *John, Earl of Tweeddale* has actually been attributed to Kneller himself, though Chaloner Smith, in *British Mezzotint Portraits*, gives it to John Smith.

John Faber the younger (*c.* 1684–1756) engraved forty-seven mezzotints of the members of the Kit-Cat Club, from the original paintings done during the years 1700–20, now in the National Portrait Gallery. The prints were first published in 1723 and are sometimes to be found in book form, with a double-portrait as a folding plate. The Whig political club used to meet at The Cat and Fiddle, near Temple Bar, kept by

Christopher (Kit) Cat, who was famous for his mutton pies. Kneller was a member and painted the portraits for a fellow member, the publisher Jacob Tonson. The ceilings of Tonson's house were too low to take whole-lengths, so the size decided on was 36 by 28 inches, which came to be known as Kit-Cat.

Allan Ramsay (1713–84) was the son of the Edinburgh poet, author of *The Gentle Shepherd*, who, when his son was leaving to study in Italy, wrote 'he sets out for the seat of the beast beyond the Alps . . .' A young doctor, later Sir Alexander Dick, accompanied him, and wrote from Rome; 'So soon as we came into the Pope's dominions the wine was not bad, but the air smelled sulphur.'

Dr. Johnson said of him: 'Well, Sir, Ramsay gave us an excellent dinner. I love Ramsay . You will not find a man in whose conversation there is more instruction, more information, or more elegance, than in Ramsay.' A scholar and linguist, he was even accused of aspiring rather to the reputation of a man of taste than a painter.

In 1761 he was appointed first Painter to George III, due in part, it is thought, to the influence of his fellow Scotsman Lord Bute.

J. T. Smith tells us: 'I once heard Ramsay say that Lord Bute's leg was allowed to be the handsomest in England; and that whilst he was standing to him for his whole-length portrait (engraved in stipple by Ryland), his Lordship held up his robes considerably above his right knee, so that his leg should be entirely seen; in which position he remained for the space of an hour. . . . When the Marquis of Rockingham was standing to Sir Joshua Reynolds for his whole-length portrait (engraved by Edward Fisher), his Lordship asked the painter if he had not given a strut to the left leg; "My Lord", replied Sir Joshua, "I wish to show a leg with Ramsay's Lord Bute".'

Ramsay's appointment turned his studio almost into a factory for the fabrication of replicas of the large whole-length Coronation portraits, of which about 100 pairs were made for presentation to ambassadors, governors of colonies, etc.; they are still to be seen in some of the mansions of the nobility. Lord Harcourt's pair was used to settle a gaming debt with Lord Jersey.

Several of Ramsay's portraits have been rendered famous through engravings, such as *Flora Macdonald* and *Rousseau*.

Another is a full-length of *Lady Mary Coke*, in white satin, engraved by James Mc-Ardell (Plate 72), with a theorbo nearly as tall as herself, on which she was wont to make the weird noises described by Walpole: 'As she had no ear for music her acquaintances suffered terribly from her performances.' Noises which may have been a contributory cause – who knows – for her husband, son of the Earl of Leicester, shutting her up in the towers of Holkham immediately after the wedding ceremony, in his and his father's efforts to force her consent to the production of an heir, and drinking himself to death.

Only a copy of the painting hangs at Holkham, and a nursery-maid's bogy-story has led to the rumour that the ghost of 'the white lady' haunts this noble monument to the genius of William Kent. In the biography 'Coke of Norfolk' we read that her beauty was of a peculiar nature. She was nicknamed the White Cat on account of the deadly pallor of her face and her hair of all but albino fairness; 'While her dark eyes

I

had the alternate sullen glow and fiery blaze of the animal after whom she was named.'

Sir Joshua Reynolds (1723–92), that 'most invulnerable man', was the most successful portrait painter of all time. Several attempts have been made to pin petty jealousies to him, none of which has been proved.

It is true that he appears to have been a great snuff-taker. J. T. Smith says he took such great quantities of it when painting that he frequently inconvenienced those sitters who were not addicted to it, so that by sneezing they upset their positions and often totally destroyed expressions which might never return. When he was painting at Blenheim the large group of the *Marlborough Family* (engraved by Charles Turner), in 1777, the Duchess ordered a servant to bring a broom and sweep up the snuff from the carpet; 'but Sir Joshua, who always withstood the fantastic head-tossings of some of his sitters, by never suffering any interruption to take place during his application to his art, said the dust raised by the broom would do more damage to his picture than the snuff could possibly do to the carpet'.

He liked wine, though we never hear of him the worse for it. On one occasion, when returning with Dr. Johnson from a friend's house, he remonstrated with him for drinking eleven cups of tea. 'Sir', said the Doctor, 'I did not count your glasses of wine, why should you number up my cups of tea?' There are two mezzotint portraits of the Doctor after Reynolds, one of which shows him peering at a book with myopic eyes, and led to him saying: 'He may paint himself as deaf as he pleases, but I will not be blinking Sam in the eyes of posterity.'

Sir Joshua had the reputation of being generous to engravers with the loan of his paintings. Among the mezzotints, the most favoured by collectors have been the whole-lengths of ladies, in their long, swishing silk and satin gowns, with park-like backgrounds, balustrades and columns of mansions.

The best of the full-lengths are:

Catherine, Lady Bampfylde, by Thomas Watson. Mother of Lord Poltimore. Lived for many years separated from her husband Sir Charles Bampfylde, till he was shot in 1832, when she came to London to help in attending him.

Mrs. Billington, by James Ward. She is represented as St. Cecilia, and the *Dictionary of National Biography* says she was one of England's greatest singers. She was the daughter of musicians (her mother was the Mrs. Weichsel singing in Rowlandson's *Vaux-Hall*) and married a double-bass player at Drury Lane. It was considered poetic justice that she died from ill-treatment from her second husband, when she was suspected of murdering her first. Scandal connected her with the Prince of Wales and his brother the Duke of Cumberland, who, owing to her coarse manners, said he only enjoyed her company when he opened his ears and closed his eyes.

Lady Sarah Bunbury (*née* Lennox), by Edward Fisher. She is sacrificing to the Graces, although Mrs. Piozzi said 'She never sacrificed to the Graces; her face was gloriously handsome, but she used to play cricket and eat beefsteaks on the Steyne at Brighton.' *Diaries of a Duchess*: 'We went to the Drawing Room. Ld. Westmorland by mistake kiss'd Lady Sarah Lennox's hand instead of the Queen's.'

Mrs. Carnac, by J. R. Smith. Second wife of General John Carnac, distinguished officer of the East India Company. One of the most beautiful of the whole-lengths, she died in Bombay, aged twenty-eight (Plate 73).

Mrs. Crewe, by Thomas Watson. In the character of St. Genevieve. She gave a dinner to celebrate the return of Charles James Fox to Parliament in 1784, when everyone wore the Washington colours. 'True blue and Mrs. Crewe,' toasted the Prince of Wales. 'Buff and blue and all of you,' she replied.

Diana, Viscountess Crosbie, by W. Dickinson. She was the daughter of Lord George Sackville, the brilliant soldier, dismissed for failing to pursue the French at Minden in 1759.

The Duchess of Cumberland, by James Watson. Walpole's 'Everybody's Mrs. Horton', whose marriage to the Duke of Cumberland, brother of George III, so displeased the King and was one of the *mésalliances* leading to the Royal Marriages Act.

Elizabeth, Countess of Derby, by W. Dickinson. Daughter of James 6th Duke of Hamilton and his wife the beautiful Elizabeth Gunning. Reputed to have been mistress of the Earl of Dorset at Knole before the arrival of Signora Baccelli. The notices of her death in 1797 added: 'her own family paying her debts, which amounted to £5,000'.

The Duchess of Devonshire, by Valentine Green. Famous Whig political hostess. Inaugurated the canvassing for votes by women, and the driving of voters to the polling stations in carriages. *Lady Louisa Manners*, afterwards Countess of Dysart, by V. Green. She became Countess of Dysart in her own right, because of the deaths of her five brothers, and continued her father's generous patronage of Constable, living to be ninety-five.

Mrs. Mathew, by W. Dickinson. She came from Tipperary, and was described by Walpole as 'a most perfect beauty, an Irish Miss Smith'.

Mrs. Musters, by J. R. Smith. Fanny Burney called her the reigning beauty of the day. 'She was most beautiful, but most unhappy; and it was to her that a gentleman at a ball handed a glass of chalk and water, with an apology, saying Chalk is thought to be a cure for the heart-burn; I wonder whether it will cure the heartache?'

Mrs. Pelham, by W. Dickinson. She is depicted feeding chickens, and makes a very successful mezzotint.

Mary Isabella, Duchess of Rutland, by V. Green: 'very beautiful, and brilliant leader of fashion'.

Emily Mary, Countess of Salisbury, by V. Green. At the age of eighty-five she lost her life in a fire which destroyed the west wing of Hatfield House in 1835. In her youth she was of vigorous constitution, a leader of *haut ton* and a fine horsewoman.

Charlotte, Lady Talbot, by V. Green. Younger sister of the Countess of Salisbury. 'She died in Duke Street, Grosvenor Square, 17th January 1804, from taking cold, having travelled to town in wet clothes for the express purpose of choosing an elegant dress for the Queen's birthday.' She was a violent Tory, and was indignant to find she had been wearing a Fox cockade someone had pinned in her hair at the breakfast given by the Prince of Wales at Carlton House during the Westminster Elections.

Sir Joshua Reynolds liked to paint what, in his day, were termed 'fancy subjects'. Mason the poet recorded that he frequently visited him when he was painting his first Venus, the head of which he finished from a beautiful girl of sixteen, his man Ralph's daughter. But on a second casual visit he found a very squalid beggar-woman sitting in the chair, with a naked child, seemingly nourished rather with gin than with milk, and from which the artist was painting the carnations of the Goddess of Beauty.

It has been said that two ladies of the town, whose portraits Reynolds painted, may

also have sat to him for nymphs and Venuses. One was 'sweet *Nelly O'Brien*, the most beautiful if not the most famous of all the courtesans of the 18th century'. Walpole wrote that when Reynolds was painting a portrait of Lady Bolingbroke, Lord Bolingbroke said: 'You must give the eyes something of Nelly O'Brien, or it will not do. . . . As he has given Nelly something of his wife's, it was but fair to give her something of Nelly's.'

Kitty Fischer, of whom he painted several engraved portraits, may have been introduced to him when she was under the protection of his friend Admiral Keppel, in whose frigate he sailed as a young man to study in Italy. She was spoken of as 'kept by subscription of the whole club at Arthur's'. The Duchess of Northumberland (*Diaries of a Duchess*, 21st July 1761) recorded: 'A quarrel also happened this evening at Ranelagh, between Poll Davis and Kitty Fisher, two very pretty Women of the Town (the first kept by Lord Coventry, the second by Mr. Chetwynd), in which the former not only boxed the other's Ears, but also hit Ld. Coventry a slap on the face, for which she was turned out of Ranelagh and forbid to come there any more.'

Several of these fancy subjects were engraved in mezzotint, such as *The Snake in the Grass*, by William Ward, but, generally speaking, stipple was considered a more suitable medium for these lighter deviations from the serious business of portraiture.

Thomas Gainsborough (1727–88) could probably be considered as the greatest of British artists. He preferred landscape to portraiture, but excelled in both, the portraits of his two daughters, when children, being perhaps finer than anything done in this field. It seems a pity that they were not engraved in mezzotint by the 18th-century masters.

He was not handicapped with a desire to emulate the 'grand manner', his style seems more to have captured some of the lighter French touch, which he may have absorbed from his friend Gravelot, who had been one of Watteau's engravers. The picture of 'Musidora' in the Victoria and Albert Museum, is almost a replica in reverse of Watteau's *Diana at the Bath*. Writers have drawn attention to other paintings resembling the work of Watteau. From his Bath period onwards he acknowledged a great debt to Van Dyck, especially in his full-length portraits, but several, like the *Blue Boy* and the *Honorable Mrs. Graham*, were only engraved by later and less talented engravers.

One of his contemporaries who engraved his portraits was his nephew and assistant Gainsborough Dupont, his masterpiece being a full-length of the Rev. Sir Henry Bate Dudley, 'the fighting parson'. Unfortunately very few original impressions of this print exist. It appears to be a brilliant combination of mezzotint and drypoint, unique in its way, and may have been due to the family inventive genius.

Gainsborough constructed a peep-show, now in the Victoria and Albert Museum. Reynolds described how he would gather earth and plants to make landscapes on a table, with pieces of mirror for water. It is not impossible that he was the first to discover soft-ground etching.

Both his brothers must have been gifted inventors. Humphrey, an Independent Minister, won a fifty-pound prize from the Society of Arts for a tide-mill, and his family claimed that he had anticipated Watt's invention of the steam-condenser.

Poor John, the other brother, known as Scheming Jack, competed with a chronometer for the Government's prize of £20,000 and was awarded a sum of money. One of his many inventive activities took the form of a pair of wings, with which, on a morning appointed, he appeared on the top of a neighbouring summer-house: 'waving his pinions awhile to gather air, he leaped from its summit, and, in an instant dropped into a ditch close by', and was drawn out amidst shouts of laughter from the crowd of spectators who had gathered to watch his ascent.

Gainsborough Dupont also engraved the Van Dyck-style portrait of *Colonel St. Leger*, the *Three Eldest Princesses* and *George III*, who preferred Gainsborough to Sir Joshua Reynolds. It has been suggested that the King may have been a mite suspicious of the Whiggish leanings of some of Sir Joshua's many friends, though Gainsborough also painted the *Prince of Wales*, in a style similar to the portrait of Colonel St. Leger: this was engraved by John Raphael Smith.

Gainsborough had other Whig sitters, beside the *Prince of Wales* and the *Duchess of Devonshire*. At Holkham he was a welcome visitor of the *Earl of Leicester* and tutor to his two daughters Jane and Anne, and painted a full-length portrait of the Earl in 1778 in a costume possibly similar to the one he wore later when presenting the address to the King after bringing forward Fox's successful motion, won by 178 Ayes to 177 Noes, that the Independence of America should be recognised. As Knight of the Shire he had the right to appear at Court in his boots and country clothes and on this occasion appeared before the King unceremoniously wearing his country garb – top-boots with spurs, light leather breeches, a long-tailed coat and a broad-brimmed hat; but it caused the greatest horror at Court.

His Majesty, as the bluff, 'farmer-king', seems to have liked the 'natural gentleman' who was not only unsycophantic but with all his simplicity had wit too. One of his letters preserved in the Royal Academy says: 'Now, damn gentlemen, there is not such a set of enemies to a real artist in the world as they are, if not kept at a proper distance. They think . . . they reward your merit by their company and notice; but I, who blow away all the chaff, and by G—, in their eyes too if they don't stand clear, know that they have but one part worth looking at, and that is their Purse; their Hearts are seldom near enough the right place to get a sight of it. If any gentleman come to my house my man asks them if they want me (provided they don't seem satisfied with seeing the pictures) and then he asks what they would please to want with me; if they say a picture, "Sir, please to walk this way, and my master will speak to you"; but if they only want me to bow and compliment, "Sir, my master is walk'd out" – and so, my dear, there I nick them. Now, if a Lady, a handsome Lady comes, 'tis as much as his life is worth to send her away so . . .' '. . . most provokingly I have had a parcel made up of two drawings and a box of pencils, such as you wrote for, ever since the day after I received your favour enclosing the Tenths and directed for you to go by the Exeter coach, which has laid in my room by the neglect of two blockheads, one my nephew (Gainsborough Dupont) who is too proud to carry a bundle under his arm, though his betters, the journeyman tailors, always carry their foul shirts so; and my d— cowardly footman who forsooth is afraid to peep into the street for fear of being

pressed for sea service, the only service God Almighty made him for . . . but surely I shall catch Bach soon . . .' 'And, do ye hear, don't eat so devilishly . . .' '. . . In all but eating stick to Garrick; in that let him stick to you, for I'll be curst if you are not his master . . .'

Gainsborough painted five pictures of *Garrick*. The full-length standing by the bust of Shakespeare, engraved by Valentine Green (destroyed by fire a few years ago), was considered his best likeness by Mrs. Garrick. He had great difficulty in painting the actor, who was 'now squinting like Wilkes and now appearing as handsome as Lord Townshend, anon his cheeks were dilated and he puffed and gasped like the leviathan Johnson, and then his cheeks wore the pinched aspect of Sir John Hawkins, so that the baffled Painter was compelled to throw down his brush in despair'. 'He never found any portrait so difficult to hit as that of Mr. Garrick; for when he was sketching in the eyebrows, and thought he had hit upon their precise situation, and looked a second time at his model, he found the eyebrows lifted up to the middle of his forehead, and when he a third time looked they were dropped like a curtain close over the eye. So flexible and universal was the countenance of this great player that it was as impossible to catch his likeness as it is to catch the form of a passing cloud.'

Northcote related that he overheard Garrick telling Reynolds with glee the truth of the matter, that he was playing on Gainsborough the joke he had previously played on the other artists, altering his features imperceptibly till – it is said of Hogarth – the enraged painter, discovering the trick, drove him forth with threatening palette and brushes.

George Romney (1734–1802) was the only one of the great British 18th-century portrait painters who could be said to be afflicted with an artistic temperament. Though he provided amply for his wife in Kendal, he never brought her down to London. He may have fallen under the spell of the beautiful Emma Hart, Lady Hamilton. He never exhibited at the Royal Academy.

He was one of the poet William Hayley's guests at the literary parties at Erstham, where everyone posed as a character from Greek mythology. He had, in fact, a more than usually strong desire to paint classical scenes in the 'grand manner', and, judging from his drawings, may have had some justification for it: though his patron Lord Thurlow said when he heard Romney was painting for Boydell's 'Shakespeare', 'Before you paint Shakespeare, for God's sake read him!'

Engravings of Lady Hamilton, after Romney, total nearly thirty, in different media. The first picture the artist painted of her, as *Nature*, was engraved both by J. R. Smith and Henry Meyer (Plate 74), in mezzotint, extremely attractive prints, especially when in colours. Valentine Green engraved her as *A Wood Nymph*. She sat to nearly all the leading artists, the wits saying Sir William made money selling the pictures, just as he did antiques.

Among other mezzotints after Romney, some of the half-lengths are the most successful, like *Mrs. Davenport*, by John Jones and *Miss Cumberland*, by J. R. Smith. Among the whole-lengths *The Clavering Children*, by J. R. Smith, is very good; also Sir William Hamilton's first wife, *Lady Isabella Hamilton*, by James Walker.

The Rev. Matthew William Peters (1742–1814), an Irishman, was yet another of the 18th-century artists to supply engravers with designs. He was a professional artist who visited Italy and first made an unsuccessful attempt to set up his easel in Dublin, but by 1766 had returned to London.

He had the distinction of being the only Royal Academician to become a clergyman, a distinction all the more remarkable when one reads how the prudish male visitors to the exhibitions would blushingly hurry their women-folk past his 'topless' semi-nudes, considered highly indecent by many people. His fellow academicians, those whose works were hung near his, were annoyed also to find the spectators passing that section of the exhibition with averted eyes. 'Every man who had either his wife or his daughter with him must for decency's sake, hurry them away from that corner of the room.'

It was said: 'In his clerical capacity Mr. Peters painted an infant soul borne by angels to heaven, but in his purely artistic capacity he painted Venuses, and gained thereby the name of the English Titian. His recumbent *Lydia* (engraved by W. Dickinson) was covered with a gauze, which the wits called episcopal lawn.' Perhaps his most successful work in this style, a portrait said to be of Mrs. Jordan entitled *Love in her Eyes sits playing*, is best known, like many of his other pictures, by the fine engraving made from it in mezzotint by J. R. Smith (Plate 75).

Mrs. Jordan, celebrated actress, lived a life of 'blameless irregularity' with the Duke of Clarence ('Binnacle Billy'), afterwards William IV, who fathered ten of her fifteen children. When he proposed to reduce her allowance from a thousand to five hundred pounds a year, she cut off the bottom of a playbill and sent it to him: 'No money returned after the raising of the curtain.'

Peters was an exponent of the 'plurality of livings', as Chaplain to the Prince of Wales, for whom he had decorated the ceilings of Carlton House, with three livings from the Duke of Rutland, becoming Chaplain to the Royal Academy on his resignation in 1788. He may have been influenced to retire from professional art by incurring the disapproval of his clerical superiors by his work for the Shakespeare Gallery. In 1811 he moved from Leicester to Brasted Place in Kent, because, according to one gossip, a certain sketch of his and the incident connected with it aroused the indignation of the matrons of this parish.

Sir Henry Raeburn (1756–1823), 'The Reynolds of the North', was a brilliant and powerful portrait painter, whose style lent itself admirably to the mezzotints into which several of the leading engravers translated his work.

He was apprenticed in Edinburgh to a goldsmith named Gilliland, a generous master who recognised his ability and took him to the Scottish portrait-painter David Martin, former pupil and assistant to Allan Ramsay, and also allowed him all his time to paint in return for a sum to pay for his apprenticeship, or a share in any profits.

He impressed Sir Joshua Reynolds on visiting London about 1785. Sir Joshua advised him to study in Italy, saying: 'Young man, I know nothing of your circumstances; young painters are seldom rich, but if money be necessary for your studies abroad, say so, and you shall not want it.' Raeburn, however, had already married one of his sitters, a rich widow twelve years older than himself.

His thousand or more portraits include half a dozen of *Sir Walter Scott*, such as the full-length with his bull-terrier Camp, on whose death Scott refused an invitation to dine out because he had lost 'a very dear friend'. This picture was engraved in mezzotint by Charles Turner.

Another famous plate by the same engraver is *Lord Newton*, Judge of the Court of Session, 'famous for law, paunch, whist, claret and worth'.

John Hoppner (1758–1810) was born in Whitechapel, the son of German parents, his father a surgeon who returned with George II from one of his visits to Hanover. George III encouraged his study of art at the Academy School, with an annuity, entrusting his education to the Royal Librarian, and this was one of the things causing the rumour that he was a natural son of George III.

He himself engraved two plates in mezzotint, of a Boy and a Girl. His paintings were engraved in this medium by a number of the leading engravers, including J. R. Smith, W. Ward, C. Turner and S. W. Reynolds.

The Daughters of Sir Thomas Frankland, by William Ward, is considered one of the finest of this type of mezzotint, other successful plates being *The Douglas Children* and *The Hoppner Children*, by James Ward, and *The Godsal Children*, by John Young.

SUBJECTS IN MEZZOTINT

Another type of mezzotint deserving mention is the subject picture, and the picture composed of a group. Many such pictures, by 18th-century and older artists, were engraved in mezzotint: those after paintings by Rembrandt alone number 190 (including portraits), and were the subject of a book by the late John Charrington. The classical, mythological and children subjects were more often engraved in stipple.

In this field of the subject picture one feels that the previous mention of Richard Earlom (1743–1822) is worthy of amplification. Although he engraved over forty portraits, his best work, unlike that of his contemporaries, was in a much wider field of subject. Son of the Vestry Clerk of St. Sepulchre, he was taught painting by Cipriani, whom he assisted in decorating the Lord Mayor's coach; in mezzotint he is said to have been self-taught.

One of his largest plates, *The Life School at the Royal Academy*, after Johann Zoffany is a complicated and animated scene of the male nude model being posed before all the assembled members, excepting, that is, the two lady members, Mary Moser and Angelica Kauffmann, who are discreetly represented by their portraits hanging on the walls. Nor is there any pot of porter on the mantelpiece beside Richard Wilson, Zoffany having hastily painted it out of his original when he heard that 'Red-nosed Dick' was choosing a stick to beat him (Plate 76).

Earlom's plates after Joseph Wright of Derby are beautifully drawn and delicately scraped, *An Iron Forge* (Plate 77) and *A Blacksmith's Shop* being miracles of light and shade from the sparks and firelight playing on the old buildings and the children and others watching, but must be seen in early proof state.

The *Fruit* and *Flower Pieces* after Jan van Huysum must rank as nearly the perfection of the art. These were published in Boydell's *Houghton Gallery*, for which Earlom

engraved a large proportion of the plates. For Boydell he also engraved Claude's above-mentioned *Liber Veritatis*, then in the possession of the Duke of Devonshire and now in the British Museum.

A few prints by an engraver named 'Henry Birche' have been accepted as the work of Richard Earlom: for instance, *Labourers*, after George Stubbs, and *Gamekeepers* after George Stubbs and Amos Green (Wessely 142 and 143). These were published by Evans, and it is assumed the engraver was tied to Boydell and could not use his own name.

Johann Zoffany (1733–1810), a founder member of the Royal Academy, though originally a German artist who had first found employment in England as a painter of clock faces, painted several theatrical compositions containing the portraits of actors like David Garrick in character, ably engraved by Valentine Green, James McArdell and others. His large group of *The Life Class* has already been described.

The fire-lit forge scenes of Joseph Wright of Derby have also been mentioned. He specialised in candle-lit scenes as well – *The Orrery* and *The Air Pump* were engraved by Valentine Green.

Henry Morland (*c.* 1730–97) was another artist who painted candle-lit scenes in addition to other pictures which were later engraved including *A Girl Soaping Linen* and *A Girl Ironing*, believed to represent Morland's wife but sometimes mistakenly called 'The Misses Gunning'. These pictures were engraved by Philip Dawe, a pupil and possibly relation of the artist. Henry Morland is also celebrated as the father of the more famous George Morland (1763–1804), one of the most prolific suppliers of material for the engraver's skill.

The earliest artistic efforts of George are said to have been made at the age of three, on dusty tables; from four to six years old he was exhibiting, at the Association of Artists, drawings 'which astonished every spectator', and the Royal Academy had accepted his drawings at the age of ten.

His father is supposed to have kept him hard at work at home during his youth, but somewhere he learnt to be a fine horseman, who rode in races at Margate when twenty-one, capable at the same age of driving spirited horses and ladies about London.

His principal engraver was William Ward, one of whose sisters, Anne, he married, William in turn marrying Morland's sister Maria, herself an exhibitor at the Royal Academy. His wife and her sisters were his principal models in the many pictures he painted in a constant struggle to satisfy his creditors (Plate 78).

The brothers-in-law at first lived together but separated after a quarrel, when Morland moved to the country at Camden Town, conveniently 'at the back of Mother Black Cap's' tavern. As a result of his prospering affairs he soon moved to a larger house and took in a friend named Irwin, who acted as his agent, selling chiefly to John Raphael Smith, the brilliant engraver, who was also a printseller and publisher. Morland found him a doughty champion of the bottle, unlike poor Irwin, who succumbed at twenty-five, Morland saying he was the first man he had killed.

J. R. Smith engraved some thirty-four subjects after Morland, in both mezzotint and stipple, most of which he also published, at prices rarely exceeding half a guinea. His own original work was usually in pastel, the mezzotint of *The Promenade at Carlisle*

House being his most famous original composition. This depicts the interior of a house in Soho Square, where Assemblies, Masked Balls and Concerts were held by Mrs. Cornelys. At the height of her success she had three secretaries, a female confidante, a dumb attendant and thirty-two servants; also a Queen of Beauty and Fashion, Miss Gertrude Conway, who married the Earl of Grandison. The masquerades often finished with a general pandemonium and Mrs. Cornelys was eventually fined fifty pounds for keeping a disorderly house. She was finally made bankrupt by the opening of the Pantheon in Oxford Street.

There is a very deceptive reproduction of *The Promenade at Carlisle House*. It is the same size (about $12 \times 15\frac{1}{2}$ inches; 303×390 mm.), printed in colours, on thin wove paper, watermarked O.W.P. & A.O.L. (the original would be on laid paper). Under a powerful magnifying glass the reproduction is fuzzy where the sharp lines of the mezzotint rocker should show, and there is also roulette work on the waistcoat of the man standing inside the inner doorway, said to represent Dr. Johnson.

A move to a small house opposite the White Lion in Paddington provided Morland with material for his pictures of stables, waggoners and hostlers. *The Farmer's Stable*, in the National Gallery, engraved by William Ward, is believed to represent the interior of the White Lion stables.

Occasional flights from his creditors provided further material. While sketching on the coast of the Isle of Wight for his pictures of *Smugglers* and *Fishermen*, engraved by William Ward, or *The Fisherman's Hut*, engraved by J. R. Smith, during the threatened invasion from France, he was arrested on suspicion of being a spy.

Another flight to Leicestershire resulted in his collaboration with the famous amateur sporting artist, Charles Loraine Smith, in *A Litter of Foxes*, engraved by Joseph Grozer. From this visit may also have come the set of four *Fox Hunting* scenes, engraved in mezzotint by Edward Bell.

James Ward (1769–1859), Morland's other brother-in-law, was a curious antithesis to him, religious, abstemious and strong-minded, perhaps bigoted. Nevertheless he had a remarkable talent. At the age of nine he worked twelve hours a day washing bottles in a warehouse on Four Cranes Wharf. When his brother William's time was nearly out he also served a brief apprenticeship to J. R. Smith, but eventually became indentured to his brother.

Some of William Ward's plates after Morland were probably engraved by James, as it was customary for the master to treat the work of his apprentices as his own.

James undoubtedly learned painting from Morland, though it may have been only from observation; it is questioned whether he was given any direct lessons. His earlier works were so like Morland's that dealers would buy them in order to resell them as being by the better-known artist.

From William, to whom he owed so much, came the suggestion that William should do the engraving and James supply the paintings. This collaboration produced a number of famous subjects in the Morland style: *The Citizen's Retreat* (Plate 79), and *Selling Rabbits*; *Compassionate Children* and *Haymakers*; *Gleaners Returned*; *Happy Cottagers*; *Industrious Cottagers*; *Outside a Country Alehouse*, etc.

Some of these pictures were engraved by James himself: *The Cowhouse*; *The Dairy Farm*; *A Livery Stable*, etc. Another plate was *The Fern Burners*, but only a few proofs before any letters were pulled, and most of these are in the British Museum. The plate, however, fell into unscrupulous hands and was given the engraved title of *The Fern Gatherers*, the better-known names of George Morland and J. R. Smith being engraved on it as the painter and engraver. Any impressions with this lettering are reprints and of no commercial value.

Good impressions of any mezzotints after Morland and James Ward, especially if printed in colours, are extremely rare. They have also been extensively reproduced. In the partially scraped parts (the half-tones) of a mezzotint one should be able to see some of the sharp, interrupted lines made by the rocker, some of these lines appearing slightly stronger than their surroundings, and with the appearance of etched lines.

The soft French paper, mentioned in the section under Paper, was used largely for mezzotints. Though interrupted by the Napoleonic wars, it was resumed after 1814 for a time. The watermark is a dovecote, called by the French 'Les Pigeons', or the name T. DUPUY/AUVERGNE 1742.

William Redmore Bigg (1755–1828) was another artist to paint pictures in a style similar to Morland's, engraved by William Ward, John Jones, J. R. Smith and others.

A number of humorous subjects were done after John Collet and Richard Dighton, published by men like Carington Bowles and Robert Sayer, under whose names they are often catalogued.

Elisha Kirkall (*c.* 1682–1742), who is also known for his work in the chiaroscuro medium, did a set of six mezzotints after paintings by George Lambert and Samuel Scott of East India Company stations (Cape Town, Bombay, etc.). The original paintings were hung in the Court Room of the Company in East India House, Leadenhall Street. The prints were published by T. and J. Bowles. Kirkall also mezzotinted a set of landscapes with hunting subjects after Ridinger.

The limited number of good impressions obtainable from a mezzotint plate, and the consequent introduction of steel instead of copper, must have led to the decline of the art. The last notable exponent was Samuel Cousins (1801–87), whose best plate was probably the portrait of *Master Lambton*, known as the 'Red Boy', after Sir Thomas Lawrence, but he never equalled his predecessors, and mezzotint, whilst far from being a lost art, has never again reached the heights attained by its 18th-century exponents.

9. Stipple

ORIGINS

Stippling is a term applied to drawing in dots. Thus the dotted manner in engraving was called stipple and was a descendant of the goldsmiths' art of *opus punctile* or *opus mallei*, in which dots were made by a punch hit by a hammer or mallet. Flicks were made with the graver.

Giulio Campagnola was the first engraver extensively to employ this method. Others like Federigo Baroccio and the well-known Amsterdam goldsmith Jan Lutma and his son used it in the 17th century, and many engravers used flicks to supplement their lines, a notable example being Jean Morin (*c.* 1590–1650), the French portrait engraver.

An essential difference between 18th-century stipple engraving and the punch methods was the development of using acid to bite the preliminary dots into the plate. A wax ground was laid as in ordinary etching and dots were pricked through the ground with an etching needle. When this work was sufficiently advanced the plate was bitten in the acid bath like an etching; then, the wax ground having been removed, the dots were enlarged and augmented by a curved burin.

A forerunner, from which the stipple print may have developed, was the crayon-manner, used to imitate chalk drawings. Jean Charles François (1717–69) was recognised by the French Académie as the first exponent of crayon-manner, and in 1758 was granted a pension as *Graveur des Dessins du Roi*, although claims were made by two much better-known engravers: Gilles Demarteau the Elder (1722–76) and Louis Marin Bonnet (1734/43–93), both of whom are mentioned in connection with Colour-printing (Plate 80).

The crayon-manner engravers imitated lines by means of tools such as little roulette wheels, making close dots through a wax ground, so that they could be etched, or sometimes working on the plate direct, a method frequently called roulette engraving. The stipple engraver made a field of dots all over his plate.

Whilst used largely to interpret portraits, and even landscape, stipple became best known for its lighter and gayer classical and mythological subjects, illustrations to romances and poems, such as Gay's *Shepherd's Week* and Thomson's *Seasons*. It was extensively used to translate what artists like Reynolds termed their 'fancy subjects'. It went well with the Neo-Classical Adam style and Angelica Kauffmann decorations. Few drawing rooms up to recent times were not hung with them, often printed in colours.

They were used to represent children subjects, also pastoral and cottage scenes; harvesting; the labourer returned from his work, from dawn to dusk, pausing for his luncheon in the fields – strong and virile and healthily tired – he had perhaps been the 'lord', leading a row of scythers, work that would have floored the unfortunate 'cits' from the towns in a very short time.

Marian and Colin Clout vie with *Venus and Adonis*. It is idyllic and represents the settled order and contentment of the rural 18th century – something lost. Wars never directly touched the country, but occasionally we see Colin inveigled into taking the King's shilling at the local inn by the recruiting sergeant and his drummer, or the sailor's return from his adventures.

William Wynne Ryland (1732/38–83) was trained both in England and France, producing some of the first crayon-manner imitations of drawings in this country. He was one of the first to develop the stipple print, his subsequent work representing paintings and covering the whole surface, as illustrated by the portion of Bartolozzi's portrait of Napoleon after Appiani (Plate 81).

Ryland was very successful. He was appointed Engraver to the King and became almost an official stipple engraver of the works of Angelica Kauffmann, but was of extravagant habits and was eventually hanged for alleged forgery in connection with some bills.

The tragic story is related by Mrs. Julia Frankau in *Eighteenth-Century Colour Prints*. Before his own trouble arose, he had already exerted his influence to obtain a reprieve for his brother Richard, condemned to death for highway robbery, so could hardly expect the royal clemency a second time.

He made a confession to a crime against God, which appears not to have been forgery, but an attempt at suicide when about to be arrested.

BARTOLOZZI, *et al.*

The chief exponent of stipple in the 18th century was Francesco Bartolozzi (1728–1815), an Italian, invited to London by George III's librarian in 1764. He was originally a line-engraver and began in England by engraving drawings by Guercino and others in the royal collection.

One of his chief works in stipple was the *Imitation of Original Drawings by Hans Holbein*, published 1792–1800, from the Holbein drawings of the Court of Henry VIII, now in Windsor, which had been discovered by Queen Caroline in Kensington Palace, after many journeyings from collector to collector.

Bartolozzi's stipple prints became so popular in London that he had a studio employing nearly fifty pupils and assistants. He himself was constantly interrupted by the *haut-ton* calling to see his workshop. Most of the stipple engravers of the period learned in his studio, and the words 'pupil of Bartolozzi' are often to be seen on prints, after their names (Plate 82).

There were 300 stipple engravers working in London at one time, the most prolific besides Bartolozzi and Ryland being:

Thomas Burke	Thomas Gaugain	John Ogborne
Thomas Cheesman	Charles Knight	P. W. Tomkins
J. M. Delattre	William Nutter	

In addition there were men who engraved in both mezzotint and stipple, like John Jones, George Keating, J. R. Smith and William Ward.

One of the largest works to be produced in stipple was the *Shakespeare Gallery*, published by Alderman John Boydell. The great revival of the plays had inspired him to commission the leading artists of the day to paint large Shakespearean scenes. These when hung formed his famous *Shakespeare Gallery*, and were engraved in 100 large plates, published from 1790 to 1804, being finally issued in two large folio volumes. Some of the most attractive plates are the *Merry Wives of Windsor*, after the Rev. Matthew William Peters, the Royal Academician who took holy orders.

The most famous stipple engravings of the 18th century are undoubtedly the *Cries of London*, after paintings by Francis Wheatley. The set consists of thirteen plates, the engravers employed being Luigi and Niccolo Schiavonetti, Giovanni Vendramini, Anthony Cardon and Thomas Gaugain, all of whom had been pupils of Bartolozzi, who also had an interest in the firm of Colnaghi & Co., the publishers, between 1793 and 1797.

When the original plates were worn out, another set was started by an engraver named Tam Alliprandi, and they have, in fact, been copied more than any other engravings in the world.

The engraved surface (i.e. the actual picture) in the originals should measure 357 by 280 mm., with slight variations. The most common copies to be met with have the word 'd'après' before the engravers' names, instead of 'Engraved by', proving that this set at least was not published to deceive.

In nearly all the other copies the lettering is the same as the originals, because the reproductions have been made by photographic means. There are also modern versions, signed by legitimate modern engravers.

It is sometimes said there should be fourteen, not thirteen, in the original set, but this is because there are two 'states' of Plate 12, *Hot Spice Gingerbread*, one having an extra figure inserted.

ANGELICA KAUFFMANN

Angelica Kauffmann (1741–1807), beautiful and gifted Swiss artist, arrived in London with Lady Wentworth in 1766, at the age of twenty-four or twenty-five. Immediately she became the rage, Garrick writing:

> 'While thus you paint with ease and grace,
> And spirit all your own,
> Take, if you please, my mind and face,
> But let my heart alone.'

Her mythological and classical subjects supplied several engravers, besides Ryland, with material. She had many sitters for portraits, and suitors for marriage, but, in

little more than a year, had succumbed to the blandishments of an impostor, masquerading as a wealthy Swedish Count, Frederick de Horn, to whom he had been valet and from whom he had stolen money, jewels and credentials. He stayed at Claridge's, hiring a coach, servants and liveried footmen, dazzling Angelica and persuading her to marry him secretly in St. James's Church, Piccadilly. Soon after, the real Count visited London, astonished to be congratulated on his marriage to a beautiful and gifted artist. The villain already had a wife in Germany, a shattering blow for Angelica, a devout Catholic, so that she was brow-beaten into paying him maintenance, and was only married after his death twelve years later, to Zucchi.

Angelica herself etched a few plates, but she is remembered mostly for the number of stipple engravings done from the subjects which she designed for the decoration of ceilings and furniture.

10. *Aquatint*

ORIGINS

The origin of aquatint is obscure, partly because several different ways of pitting the surface of a copper plate have been classed by some writers as aquatint.

For the sake of clarity 'aquatint' should only apply to those porous grounds which are laid with the aid of resin: either the 'dust ground' of powdered resin, patented by Le Prince, or the 'spirit ground', possibly discovered by P. P. Burdett.

Some of these methods of roughening the surface of a plate have been described as 'foul-biting' in the section on Etching, and originated through the acid getting under the wax because the surface of the plate was not properly cleaned of grease before the wax ground was laid. There is also the method of sifting grains of sand or salt on to an etching ground before it has cooled and hardened, so that the acid will bite through them, and the sand-grain, made by placing sandpaper on the wax ground and running it through the press, before biting, which could, perhaps, be classed as a half-way step to aquatint.

Hercules Seghers managed to obtain a film of ink on his plates, which has been described as some form of aquatint, though it may be brush or direct etching: laying acid on the plate with a brush or feather. Adam Bartsch, in his *Peintre-Graveur*, even describes Castiglione's monotypes as done in the aquatint style.

All this, however, does not explain the undeniable fact that a perfect aquatint ground exists on a portrait of Oliver Cromwell, by Jan van de Velde (fl. 1642–53), i.e. more than a hundred years before the patenting of the resin ground by Le Prince.

This Jan van de Velde is not thought to be the well-known etcher and engraver of the same name, but a goldsmith and map-engraver of Haarlem, working after 1642, who engraved the portrait of Oliver Cromwell after 1653, with a clear and unmistakable aquatint ground. There is also aquatint in his portrait of Queen Christina of Sweden, about 1650.

An engraver and glass-painter named Gerhard Janssen, a Dutch artist who died in Vienna in 1725, also used aquatint in his plates.

J. B. LE PRINCE

Jean Baptiste Le Prince (1734–81) patented a dust-ground process in 1768. He was an adventurous youth as well as a gifted artist; he managed the difficult task of becoming a pupil of Boucher and at eighteen married a woman twice his age for her money. He travelled extensively, especially in Russia, where he was presented to the

Czar. On one of his voyages the ship was captured by British pirates, whom he proceeded to charm with his violin. He returned to France, patented his process, made much money and spent it, bought a country house in which he died, finally leaving to a young niece who had cared for him, in the words of Jules Hedou, 'quite a fine collection of creditors'.

The invention which he patented in 1768 was the powdered resin ground, called by him *manière au lavis*, as it gave a perfect imitation of wash drawing. Le Prince may have beaten others by a short head. The wife of an inventor named Boizot put in a dispute a few years later, but the matter seems to have been settled to the satisfaction of the French Académie. The Abbé Saint-Non published aquatints in 1766.

The aquatint process consists of laying on a copper plate a ground which is porous to acid. This is done by covering the surface with resin in minute and very close specks. In the method practised by Le Prince, known as the dust-ground, powdered resin is put in a box; the plate is then placed in the bottom of the box face upwards; a handle is turned, sending the resin up in clouds inside the box. Time is allowed for the dust to settle and usually the handle is turned again (Le Prince's box contained a flywheel worked by a cord pulled from outside).

When the resin has finally settled the plate is carefully removed. It is then warmed till a sheen appears over the layer of resin dust, showing that it has melted sufficiently to adhere to the plate. The plate is then bitten in an acid bath as in etching: the acid will not attack the resin, but will bite all round the little granulated specks and globules, so that the lines will appear like a fine network of etched lines, giving, when printed, the effect of a wash drawing. The process was mostly used in conjunction with etching, the outlines being first etched, and the plate being grounded and bitten again with the aquatint 'wash' (Plate 83).

Some very clever imitations of old drawings were done, using chiefly aquatint and soft-ground etching. These can be quite deceptive, although not made at the time with any intention to deceive. The best of these were done by Cornelis Ploos van Amstel (1726–98), an amateur collector of drawings, who added roulette work and other touches to achieve his results, and issued them between 1765 and 1787. He is one of those who might claim to have anticipated the invention of Le Prince.

Fortunately for the collector of drawings he always printed a coat-of-arms on the backs. He also used, when printing in colours, a separate plate for each colour and did claim to have anticipated the invention by François Janinet of printing each colour from a separate aquatint plate. A book of his prints, with others added, was published in 1821.

P. P. BURDETT, PAUL SANDBY, *et al.*

The first artist to practise aquatint in England appears to have been Peter Perez (or Pery) Burdett, F.S.A. (fl. 1771–4), of Liverpool, at one time resident in Derby, a friend of Joseph Wright of Derby, appearing in Wright's pictures *The Orrery* and *The Gladiator*. In 1773 Burdett exhibited 'The effect of a stained drawing attempted by printing from a plate wrought chemically, without the use of any instrument of sculpture.'

K

In the Liverpool Public Library there is an impression of his aquatint after Wright of Derby, *Boys blowing the Bladder by Candlelight*, with an inscription saying it was the 'First specimen of aquatinta invented in Liverpool by P. P. Burdett, 1774, assisted by Mr. S. Chubbard, portrait painter'.

He appears to have used the spirit method which, it has been supposed, was invented by Paul Sandby (1725–1809): resin dissolved in rectified spirits of wine. Sandby, however, did not use aquatint before 1775, although he left a note dated 1776 (in the British Museum) laying claim to the invention.

It has been supposed hitherto that Sandby learned the process from the Hon. Charles Greville, and that Greville had bought the formula from Le Prince; it is now thought that Burdett may have learned it in France soon after 1770.

Burdett, Sandby, and most other British engravers used the spirit ground, particularly for landscapes and Sporting prints. In this method the resin, dissolved in spirit, is poured over a warm plate, when the spirit evaporates, leaving minute granulations of resin, the more resin the coarser the grain.

Other methods are to shake the resin on to the plate from a muslin bag, by which means the thickness of the resin can be varied from place to place, or to spray a spirit ground with a mouth-spray.

The late Tomas Harris thought that this last method may well have been used by Goya. The size of the grains of resin can be varied by the distance from the plate at which the spray is held: fine in some areas and coarse in others.

FRANCISCO GOYA

Francisco Goya (1746–1828) was an early exponent of aquatint, first using it in 1778. Unlike most artists of the time he laid his own grounds, whereas others rarely did more than etch their outlines and get an expert to lay the aquatint. Apart from some early etchings, mostly after paintings by Velasquez, and over twenty lithographs (four of bull fighting), done late in life, all his plates have a carefully-laid aquatint grain, with occasional drypoint and other touches.

His first large set of plates, the eighty *Caprichos*, was published in 1799, 300 sets being printed (24,000 impressions in all). When, in 1803, he sold these plates to King Charles IV in exchange for a pension for his son, 240 sets remained unsold (Plate 84).

Tomas Harris and Vindel both say that no more were printed till about 1850, but Lefort and Delteil both give an edition dated about 1806, and this would appear to be confirmed by examples printed in a black ink, instead of the reddish-brown of the first printing, that have appeared occasionally in the salerooms.

The only other set published in his lifetime was the *Tauromaquia* of 1816: thirty-three plates of bull-fighting, made up to forty in the second edition of 1855.

His two other large sets, *Desastres de la Guerra* and *Proverbios*, were only printed in proof state during his life, and first issued as complete sets in 1863 and 1864 respectively, after the death of Goya's son. It is possible that Goya did not publish them because the *Tauromaquia* had also been a commercial failure, like the *Caprichos*.

See Lost or Forgotten Processes, for *The Giant*.

SUGAR AQUATINT

In order to avoid the tedium of stopping out all the parts of a plate save those still to be bitten darker, a means was devised of actually painting only the parts to be re-bitten. These were painted over with a composition soluble in water, the whole plate being then coated with acid-resisting varnish and, when dry, immersed in water. The composition would dissolve, allowing these areas to be rebitten darker; the original ground would remain undisturbed and protected in the parts already bitten enough.

Based on the above was the sugar- or lift-ground aquatint (French *réserve*). It was used by Rouault and other modern artists to imitate broad brush strokes. A syrup of sugar, soap and gum arabic* (which would not dry completely) was prepared and the drawing made with brushes, using this composition, directly on to the copper plate; the plate was then dipped in and coated with an acid-resisting varnish. After being allowed to dry the plate was next placed in hot water, so that the sugar mixture slowly dissolved, lifting the varnish and the brush strokes beneath. An aquatint ground was then laid on the copper where thus exposed, and the plate bitten in the acid bath as in ordinary aquatint.

* Ingredients, apart from the sugar, vary.

11. Lithography

Lithography was invented by Aloys Senefelder (1771–1834). Although intended for the law, Aloys was a playwright and was seeking a cheap way of printing the parts of his plays when he invented lithography. To what extent it was an accidental discovery, or only a Vasari-like story, is confused by his own inadequately explained description of how he wrote a laundry-list for his mother on a slab of limestone:

> I had just ground a stone plate smooth in order to treat it with etching fluid and to pursue on it my practice in reverse writing, when my mother asked me to write a laundry list for her. The laundress was waiting but we could find no paper. My own supply had been used up by pulling proofs. Even the writing-ink was dried up. Without bothering to send for writing materials, I wrote the list hastily on the clean stone with my prepared stone ink of wax, soap and lamp-black. . . .

It is thought that at this stage of his experiments Aloys was writing on stone with an acid-resisting ink, and eating away the surrounding blank space with acid. Examples of relief prints from marble, of this period, with the stone eaten away, have been met with: William Blake used the method, with metal.

Maybe in an attempt to wash his laundry-list off the stone he wetted it and found that the water slid off the greasy writing, so that it was unnecessary to eat away the stone surrounding the inked lines.

His account of the invention appeared in 1798 and was obviously the result of long research. The word 'lithography' was not used by him: he called it Polyautography and chemical printing, the system being based on the principle that oil will not mix with water. He had already realised the possibility of using materials other than stone from which to print his process.

When using limestone the practice is, after the drawing has been made, to wash the surface with weak nitric acid, known as an 'etch'. This is said to open the pores of the stone more, or fix the drawing, but the purpose has also been described as changing the untouched surface (that part not drawn on with the greasy chalk) from a carbonate of lime, an absorbent of grease, to nitrate of lime, a grease-repellent and also hygroscopic.

It is also washed with gum arabic, then entirely cleaned, appearing quite blank and level before printing. The stone is kept moist and, when an inked roller is passed over it, the ink adheres only to the greased parts. The effect of a water-colour wash can also be imitated and the resultant print is called a lithotint.

The process has become very complicated and needs the aid of Felix Brunner's book *A Handbook of Graphic Reproduction Processes*, to explain the details.

Senefelder's first patent had been granted in 1798. The English patent was taken out in 1801, after his visit in that year. Philip André, brother of Senefelder's partner in Germany, stayed on in England, and sent stones to many of the leading artists, with instructions.

The result was his publication on 30th April 1803 of *Specimens of Polyautography*, containing twelve plates by:

Benjamin West, 1801	Conrad Gessner	James Barry
Richard Cooper, 1802	William Delamotte, 1802	R. Corbauld, 1802
Sir R. Ker Porter, 1803	Heinrich Fuseli	Warwick
Thomas Barker of Bath	Thomas Hearne	Thomas Stothard

These early specimens were done with the pen, the first chalk drawing on stone being done by H. B. Chalon, of two horses, in 1804. Vollweiler re-issued some of the early stones in 1806, with a number of new ones. The name 'lithograph' was coined in France about the time of the first issue, 1803.

In regard to the use of materials other than stone for lithography, Senefelder said: 'the chemical process of printing is not only applicable to stone but likewise to metals. . . .' It seems possible, however, that Gottfried Schadow (1764–1850), who used zinc plates (zincography) before 1827, was the first to do so.

It was also found possible to draw with lithographic crayon on paper and transfer the drawing to the stone. In this way it was not necessary to write or draw in reverse. This is known as a transfer-lithograph and was the subject of a lawsuit in 1897 between Joseph Pennell and Walter Sickert.

The transfer system was a recognised method and Pennell's work was done in this way, but other artists have said that it does not give so good a result as the direct drawing on the stone, and is not proper lithography. Sickert, taking this point of view, had written in the *Saturday Review* that Pennell's were not true lithographs, and neither he nor the editor, the truculent Frank Harris, would withdraw. Pennell was awarded fifty pounds damages and costs.

Whistler, who had also taken to the transfer system, was his chief witness and we have Pennell's account of how 'the Master', after concluding his evidence, placed his hat on the rail of the witness box, slowly drew off first one glove and then the other, adjusted his monocle and said, 'And now, my lord, may I tell you why we are all here?' To which the judge replied, 'No, Mr. Whistler, we are all here because we cannot help it'. No one ever knew whether Whistler was about to deliver something momentous relating to lithography or not.

Another form of transfer-lithography was drawn on special autographic paper and known as autography. This paper is prepared to allow the drawing to be transferred like the pictorial transfers to be bought in sheets.

France became the chief centre of lithography in the 19th century, in which Daumier did his 4,000 political caricatures and satirical scenes of Parisian life (Plate 85), serving three months in prison, with the editor and printer of *La Caricature*, for his *Gargantua* (L.D. 54), a satire on Louis-Philippe.

Daumier followed Carle and Horace Vernet, Grandville, Pigal and others, with Géricault, Gavarni and Barye. What is known as the revival of etching and lithography has been traced to the shop of Cadart, the publisher, where a group of young artists used to meet – Bracquemond, Manet, Legros, Ribot, Vollon, Fantin-Latour – who helped in the publication, in 1862, of the first number of the *Société des Aqua-Fortistes*. Cadart sent lithographic stones to Manet, Ribot, Legros and Fantin-Latour, whose 'musical' and other lithographs were claimed by his cataloguer and biographer Hédiard to have played a leading part in the 'revival'.

The modern movement in lithography, and prints in general, has become too vast to be dealt with in a book on old prints. Toulouse-Lautrec in his short life produced 370 prints, all but nine of them lithographs (Plate 86). Odilon Redon was called a 'Magician with a stone'. Other famous practitioners were Renoir, Vuillard, Bonnard, Gauguin, Carrière, Munch, Degas, Cézanne, Forain and Picasso.

Although lithography has been criticised as lacking in character compared with etching, it allows free expression in drawing, and the covering of large surfaces, and productions of this sort should not be confused with mechanically produced and printed specimens, although, as a commercial proposition, lithography thrived in all countries. The ability to print them mechanically, with little deterioration, enabled cheap prints to be run off in almost unlimited quantities.

Where account books of old firms have been available some enlightening facts can be learned. The great American firm of Currier and Ives (1834–1907), self-styled 'Print Makers to the American People', printed many thousands of lithographs, large and small, the most sought-for now being those relating to the settling of the West, the early trains and steamboats, etc. The smaller prints were sold to stall-holders by the thousand, at the rate of six dollars a hundred; the largest were only three dollars each. One of these, entitled *The Road – Winter*, showing Mr. and Mrs. Currier driving in a sleigh, realised $2,800 in 1967.

12. *Printing*

The printing of plates is almost an art in itself. To print an intaglio plate it is first dabbed with ink all over, while warm, then 'rag-wiped' with an open-work muslin cloth, partly starched; next a finer cloth is used, and it is easy to wipe some of the ink out of the lines. This is especially so with drypoint, where the ink is held on the surface by the raised ridges of copper. For this reason the printer, having taken off most of the ink with the gauze, will next 'hand-wipe' the plate by taking a touch of whiting on the side of the palm: with a drypoint in particular he can thus push the ink up against the ridges, leaving the surrounding surface clean.

There is also a practice known as 'retroussage', in which a fine muslin cloth is loosely folded and dragged lightly over the already wiped plate. This is done while the plate is still warm and the ink thus partly liquid. It is effective in darkening the tone of an etching with close hatching, as it pulls the ink and lays it between the lines on the surface. It is, however, frowned upon by the purists and, if overdone, can give a watery effect. The purists are also inclined to frown upon 'fat' printing: the practice of getting effects by leaving ink on the surface. This, however, can be quite attractive if properly managed. Seghers and Rembrandt seem to have been the first to experiment in this way, Rembrandt obtaining wonderful night and lamp-light effects; in some cases it is possible to compare examples of his plates when clean-wiped and with surface ink.

In fact, when in the hands of a master, the effect of inking the surface of the plate can be very pleasing. Although Whistler started and finished his etching career with clean-wiped plates, he designed some of his Venice plates to be printed in this way: in his *Little Venice* he etched the distant shoreline across the plate, the effect of foreground water being obtained entirely by the film of ink. The *Nocturnes* in Venice were done in this way, but with more ink.

Whistler did, in fact, print most of the Venice plates himself, and there can have been few more competent than he. Goulding, the famous professional printer, has left an account of how Whistler would hire the use of a press with himself, a boy, as his assistant. On a later occasion, when Goulding was in practice on his own and had printed E. R. Smythe's etching of a little country girl, Whistler saw it and said 'Goulding is playing the devil with this, let me try'. The resulting impressions make the etching almost more like Whistler's own work than Smythe's. Goulding said of his printing that 'no two proofs were ever alike – nor do I expect he intended them to be – but they were all Whistler'.

Seymour Haden believed in wiping with muslin and not by hand, using an ink which left the plate easily, without much rubbing or heat. The proofs were then to be dried in the air without any pressure, not even laid on each other. They were to remain four or five weeks spread out, so that the lines would harden and remain in relief. They could then be slightly damped and given a gentle pressure. In early representations of copperplate printers at work, the prints are to be seen drying, like washing, on lines strung across the studio.

By sticking the proofs, as they come from the press, on boards with gummed paper at the edges, they will dry 'drummed' without need of pressing and thus flattening the raised lines.

COLOUR-PRINTING

The earliest examples of printing in more than one colour occur in books. Soon after the invention of movable type, about 1450, prayer- and devotional-books were printed with the instructions to the priest and congregation in red (the rubrications, from the Latin *ruber* – red).

The first sheets of the 'Mazarin' Bible, printed in 1456, had initials as well as headings in red, and in 1457 initial letters were printed in red and black, or red and blue, by Fust and Schoeffer, successors of Gutenberg, at Mainz, in a Latin Psalter.

The unknown 'Schoolmaster of St. Albans' in 1483 printed a *St. Albans Chronicle* with the initials in red. In his *Book of St. Albans*, 1486, heraldic shields were printed in two or three colours.

In 1485 Erhard Ratdolt printed a second edition of John Holywood's *Sacrobosco*, with small astronomical charts in red and black, one being in red, orange and black.

Ratdolt's *Obsequiale Augustanum*, 1487, had as a frontispiece a woodcut of Bishop Friedrich von Hohenzollern, printed in black, red and bistre, considered as the first example of colour-printing, apart from initial letters and charts. In 1513 an edition of Ptolemy's Atlas had a woodcut map printed in black, red and olive-green.

Some of the colours on single woodcuts (not in books), in the 15th century, are said to have been applied from blocks instead of by hand, but an example usually quoted – St. Anthony of Padua, in the Ashmolean Museum (C. D. 42 Schreiber 1233a), is given a date at the end of the century. It is described as partly printed in colours, partly with stencil, and as the oldest single woodcut printed in colours.

Albrecht Altdorfer (*c.* 1480–1538) produced his *Beautiful Virgin of Ratisbon* from a black block and at least five colour-blocks, though this was not till about 1520. This is sometimes classed as a chiaroscuro woodcut, though it does not possess a printed ground. The subject of this woodcut was an old carved figure of the Virgin and Child, erected at Ratisbon (Regensburg) on the site of the destroyed Synagogue, and credited with miraculous powers, drawing pilgrims from far and wide.

Chiaroscuro (discussed in the woodcut chapter) was probably begun in 1508, inspired perhaps by the practice of Mair von Landshut (fl. 1492–1514), who printed woodcuts and engravings on paper tinted with water-colour.

Lucas Cranach in 1507 produced a *St. George* printed from two blocks, a black and

a white, on a ground coloured blue with water-colour, and not, therefore, a true chiaroscuro woodcut, which must have a printed ground, even if partly cut away for highlights.

Cranach produced full-scale chiaroscuros, with printed grounds, bearing an even earlier date – 1506 – but signed with a winged serpent, a device on his coat-of-arms: as the arms were not granted him till 1508, it is commonly thought the date 1506 must be a mistake for 1509.

The honour of producing the first full chiaroscuro may belong to Jost de Negker, the Antwerp cutter working at Augsburg on the vast woodcut commissions of the Emperor Maximilian I. These were under the direction of Konrad Peutinger, the scholarly town clerk of Augsburg, who in 1507 received a letter from the Chamberlain of Frederick the Wise, Elector of Saxony, challenging him to produce anything comparable to 'the Knights in armour, of gold and silver' which he enclosed.

This enclosure must have been Cranach's *St. George and the Dragon*: the only example now remaining is in the British Museum, and, as mentioned above, does not have a printed ground.

The Chamberlain's challenge, accepted by Peutinger, resulted in Jost de Negker's equestrian portrait of the Emperor Maximilian, after a drawing by Hans Burgkmair. The earliest known examples of this, however, are also without a printed ground, but there are examples known with a printed ground and the date 1508. As this date was subsequently altered to 15 8 (without the 0) and later still to 1518, it was held by Campbell Dodgson and other authorities that 1508 is the right date, brushing aside the suggestion that the 0 has been replaced after the first printing.

It has to be remembered that woodcuts, of which the first edition consisted of a black outline block only, had colour-blocks for chiaroscuro cut and added for a subsequent edition. This happened to some of Dürer's woodcuts, colour-blocks being added to the outline, years after the first issue.

In Italy, as stated already in the woodcut section, Vasari claimed the invention for Ugo da Carpi (*c.* 1455–1523). He was considerably older than Cranach, Burgkmair and Negker, but did not apply for a patent at Venice till 1516, his first dated woodcut in chiaroscuro being 1518.

Ugo da Carpi and his followers Antonio da Trento, Bartolommeo Coriolano, J. N. Viscentini reproduced the grisaille-type of drawings in subdued tones, practised by Raphael, Parmigiano and others.

Antonio da Trento, of Mantua (b. 1508), was a pupil of Parmigiano and was accused of absconding in 1530 with some of his master's drawings. It is thought he went to Fontainebleau to work under Primaticcio, adopting the name of Antoine Fantose or Antonio Fantuzzi.

Some very good work in chiaroscuro was done in Flanders and Holland by Hendrik Goltzius (1558–1616), and the Bloemaerts, who sometimes used an engraved outline.

Since the early days, chiaroscuro has been revived from time to time, first by Andrea Andreani (*c.* 1560–1623), who acquired old blocks by da Trento and others, often adding his own monogram. His most notable personal achievement was a series of

nine subjects from the *Triumph of Caesar*, dated 1598, after Mantegna. These should be accompanied by a frontispiece and two sheets of columns, intended to be cut up and placed between the subjects, when arranged in a row.

The drawings for these Triumphs were made by Bernardo Malpizzi, a painter of Mantua, who, Bartsch thinks, might also have drawn the subjects on the blocks. Malpizzi made his drawings at Mantua before Charles I bought the originals, now at Hampton Court, having been bought-in at the sale of the Royal collection for £1,000.

Andreani made another large work after a mosaic by Beccafumi in Siena Cathedral. This was made in ten sections, totalling 7 feet by 3 feet.

A second reviver of chiaroscuro was Count Anton Maria Zanetti (1680–1757), who reproduced a number of drawings by Parmigiano, which he had found in the collection of the Earl of Arundel, the great collector, who had fled with his collections to Holland on the outbreak of the hostilities between Parliament and Charles I. It has been suggested that these drawings may have been those abstracted from the artist's studio by Antonio da Trento.

A third artist to revive chiaroscuro was the Englishman John Baptist Jackson, who claimed the rediscovery of a lost art and has been dealt with in the woodcut chapter.

An artist named William Savage (b. 1770) perfected a system of printing pictures in colours, using as many as twenty-nine wood-blocks. A daughter of his expressed the opinion that George Baxter (1804–67) had discovered nothing new and was not entitled to his patent.

Baxter used metal plates as well as wood-blocks, especially a key-plate, usually an aquatint, the principle being not dissimilar from the methods used to imitate old-master drawings by Elisha Kirkall, Knapton, Pond and Skippe.

In spite of the statement of Savage's daughter, Baxter's cataloguer, C. T. Courtney Lewis, says 'how he obtained all his effects no one knows'. A number of other firms were licensed to print his 'oil-colour prints', known as Baxter Licensees, until what was difficult and exacting work was superseded by chromolithography.

CHROMOLITHOGRAPHY

Chromolithography is a word coined by Godefroi Engelmann for a process he patented in 1837, blending colours from stones superimposed one upon another. Senefelder, the inventor of lithography in 1798, had thought of many ways of using his process. He propounded the idea of adding colours to an outline in his book on lithography (*Complete Course of Lithography*, 1818–19), and this had already been done in 1808, when Dürer's drawings in *Maximilian's Prayer Book* were reproduced in Munich.

Engelmann aimed at using a large number of stones superimposing colours one upon another to imitate the effect of a painting or water-colour drawing. A London-Welsh architect, Owen Jones, had already been at work for a year, on similar lines, when Engelmann took out his patent in 1837. Owen Jones's work, commenced in 1836, was entitled *Plans, Elevations, Sections and Details of the Alhambra*, printed by Day and Haghe and first published in 1842.

Another of the earliest examples of chromolithographic work with no hand-colouring was Thomas Shotter Boys's *Views in Paris, Ghent, Antwerp and Rouen,* published in 1839. Boys's *London as it is* 1842 was printed with a black and one tint-stone, the rest of the colouring being added by hand (see Hand-coloured section).

A brilliant example of chromolithography, and of colour analysis was Robert Carrick's interpretation of Turner's *Rockets and Blue Lights*. This achievement took twenty printings, some stones applying two colours, and was published in a book, an impression from each of the coloured stones being followed at the end by the finished chromolithograph, size 27 × 21 inches.

The imitation of paintings was carried further by impressing the pattern of canvas on to the chromolithographs, when dry, from a metal cylinder. The Victorian 'oleograph' was made in this way and afterwards varnished.

13. Colour-printing from Intaglio Plates

1. FROM ONE PLATE (single plate printing)

Hercules Seghers (c. 1590–c. 1628? – see Etching section), the Dutch landscape artist, senior to Rembrandt, made some very attractive attempts at a colour effect, but seems only to have used an ink in one colour, the rest of the colour being applied with water-colour washes by hand or stencilled.

Johannes Teyler (fl. 1650–1700), of Neymegen and Rome, was the first to print from one plate inked in several colours. He is said to have been a Dutch military engineer and published a series of line engravings of various subjects, including flowers and birds, with a title *Verscheyde Sorte van Miniatuur*, 1693, and a sub-title describing it as *Opus Typochromaticum*.

Robert Laurie (1749–1804), a mezzotint engraver and publisher, was awarded a prize of thirty guineas by the Society of Arts for demonstrating the printing in colours from a single plate, by inking the plate 'with stump brushes'.

This method, judging from the description, would appear to be the same as that which came to be most favoured by copperplate printers in Britain in the 18th century: the printing from a single plate, inked in colours for each impression. It was a laborious and very skilled process.

The printer had a 'palette' of colours, carefully mixed to match the picture or drawing from which the engraving was made. Each colour was in its turn applied to the required part of the plate, the darker tones first, by means of a small ball of rag at the end of a stick, known as a *dolly* (French *poupée*). After the application of each colour that portion of the plate had to be wiped ready for printing, and great care had to be used to avoid the encroachment of one colour upon another. The process had to be repeated for each impression taken.

All kinds of intaglio plates were printed by this means, particularly those engraved in mezzotint and stipple, and a revival was staged in the first half of the present century, to produce mezzotint and stipple prints in colours in the 18th century style.

Aquatints of views and sporting subjects were frequently printed in two colours, ready for the colourist, as described under Hand-coloured Prints.

An exception to this rule is to be seen in some of the plates engraved by J. C. Stadler after Joseph Farington, R. A. Farington made his drawings with a careful outline in brown ink, tinted with subdued colours. The means Stadler employed to imitate this is notably to be seen in some plates published by W. Byrne in 1789, where it is obvious that three or four separate plates were used: one heavily etched for the outlines

in brown, and others in aquatint, one for each tint; the brown outline was obviously printed last. The same result was obtained in the set of four large views of London bridges.

Joseph Constantine Stadler (fl. 1780–1812) appears to have been a German, settled in London; Farington was a leading Academician in his day, famous also for his recognition and encouragement of the genius of John Constable, and his authorship of the Farington *Diaries*.

A hand-coloured print can be told from one printed in colours, especially a stipple or mezzotint, by the dots or grain not being in colours, just black under a coloured wash.

2. FROM SEVERAL PLATES

Whereas Britain, in the 18th century, had favoured the inking of a single plate for printing in colours (*à la poupée*), France mostly used a separate plate for each colour (printing *au repérage*).

This method of printing in colours stemmed from the three-colour theory of Sir Isaac Newton, and the first engraver who attempted to put the theory to practical use was Jacob Christoffel Le Blon (1667–1741), born at Frankfurt, but possibly related to the Flemish or French ornament engraver Michel Le Blon. He used mezzotint plates, printing blue, yellow and red, but found it necessary to use a fourth, a black ground plate. He called these 'printing paintings' and made passable portraits of Louis XV and George I.

In 1720 he came to London, patenting his process and forming a company called 'The Picture Office', which, however, was commercially unsuccessful. The stock was sold and the company wound up. Le Blon left in 1732, to try again in Paris, where he was granted another patent for twenty years, but again without commercial success.

Malcolm Salaman attributed his failure to injudicious choice of subjects, but there is a mystery about what happened to the prints produced in these ventures. He is believed to have made some forty-nine sets of plates, printing 10,000 examples, very few of which have survived, unless, as R. M. Burch suggests, they are masquerading as paintings, heavily varnished.

Horace Walpole's description seems to be unjust: 'Of surprising vivacity and volubility, and with a head admirably mechanic, but an universal projector, and with at least one of the qualities that attend that vocation, either a dupe or a cheat. I think the former, though as most of his projects ended in the air, the sufferers believed the latter.'

In 1730 Le Blon published an explanatory book, *Coloritto: or the Harmony of Colouring in Painting: Reduced to Mechanical Practice, under Easy Precepts, and Infallible Rules . . .* Four plates illustrated the process, a fifth being an artist's palette to show the colours referred to in the text. In specimens seen the finished plate, a girl's head, showed quite a lot of hand-colouring. Later, a supplement and a second edition, with more plates, were issued.

J. F. Gautier-D'Agoty (1717?–85) assisted Le Blon, and claimed, apparently without justification, the invention of printing in colours from four plates, obtaining a privilege for thirty years from the French King in 1741. At times he may have used up to seven plates.

His sons, and an Italian follower, Carlo Lasinio, carried on the process with tolerable success. Edouard Gautier-D'Agoty did a passable, if rather weak portrait of Madame du Barry with her negro-boy servant 'Zamore', who later betrayed his former mistress to the 'Terror'.

François Janinet (1752–1813) claimed the invention of printing *au repérage* from aquatint plates instead of mezzotint. Below examples of his work can be seen the words: *Gravé à l'imitation du lavis en couleur par F. Janinet, le seul qui ait trouvé cette manière.*

Manière au lavis is the French equivalent for *aquatint*, and Janinet, his pupils and followers used this method instead of mezzotint, which was never popular in France. He certainly got beautifully delicate results, never surpassed, using up to seven plates.

He had the sense to choose, for some of his work, the popular, frivolous subjects that might have helped Le Blon financially. His three best are in this genre: *L'Aveu difficile*, *La Comparaison* and *L'Indiscretion* (Plate 87), all after Lavreince; a very rare fourth plate, *La Joueuse de Guitare*, was probably intended to complete the set.

Madame de Pompadour is said to have posed for the original Boucher picture of *La Toilette de Venus*; and another successful nude was *Les Trois Graces*, after Antonio Pellegrini.

A portrait of *Marie Antoinette*, after J. B. A. Gautier D'Agoty, was issued with a separate border, printed in umber, gold and blue: one of these colours, usually the blue, is sometimes missing from the border (Plate 88). Another portrait with a separate oval border was *Mlle. du T . . .*, after J. Lemoine. The sitter was Rosalie Gérard, called du Thé, an actress who numbered English lords among her protectors and once occupied a house in London.

With his pupil Descourtis and others, he engraved over forty landscapes in colours to illustrate a work on *Les Montagnes de la Suisse*.

In his private life Janinet is famous for an attempted balloon ascent, with the Abbé Miollan. This was advertised to take place publicly from the Luxembourg Gardens on a Sunday, in July 1784, admission being three livres per person. The balloon was a dirigible and the largest to date, measuring 110 feet high, and a large crowd gathered. The ascent was due precisely at midday, but the unhappy authors failed to inflate the balloon, setting it on fire instead, so that it was completely destroyed. At two o'clock a dense smoke arose and the Abbé and his friend Janinet wisely decided to flee, because at this moment the spectators broke the barrier of boards and added them, with the chairs, to the fire. The guard, even though numerous, had not dared to oppose the fury of the people. Many satirical songs and prints appeared, to make them as ridiculous as possible, the Abbé being sometimes portrayed as a cat and Janinet as a donkey.

Charles Melchior Descourtis (1753–1826), a pupil of Janinet, made a number of

successful plates, the largest being *L'Amant Surpris* and *Les Espiègles*, after J. F. Schall. Two of his plates (*Foire de Village* and *Noce de Village*, after N. A. Taunay) fit in with two others by Debucourt (*Le Menuet de la Mariée* and *La Noce au Château*) to form a set of four.

He engraved two portraits of Princess Françoise Sophie Wilhelmine de Prusse, wife of William V of Holland, the best impressions of which were printed on tinted paper.

Pierre Michel Alix (1762–1817) assisted in the production of the plates for *Les Montagnes de la Suisse*, but is noted mostly for his portraits, including one of *Marie Antoinette*, which is very rare, because it is believed that he destroyed any impressions in his studio on the outbreak of the Revolution. The portraits and events he portrayed, however, run impartially through the political crises until the restoration of Louis XVIII.

Philibert Louis Debucourt (1755–1832) was one of the most famous and successful of the engravers of colour-prints from several plates. He was himself a fine painter in a careful, almost miniature, style, and his best prints are from his own compositions, many with the interest of depicting life in Paris at the time, before, during and after the Revolution.

Several of his earlier prints are in the vein of *l'amour frivole*, such as *Les Deux Baisers* (Plate 89); later he marched with the times, including costumes and caricatures, after Carle Vernet, of the British and other visitors to Paris after 1814–5.

His two famous Promenades (*Promenade de la Galerie du Palais-Royal* and *La Promenade Publique*) were done in 1787 and 1792.

A third similar plate, *Promenade du Jardin du Palais-Royal*, formerly attributed to Debucourt, is now given to Louis Le Coeur, after C. L. Desrais.

There is a very deceptive reproduction of *La Promenade Publique*: it has no publication line below the title, and the artist's name is some distance below the border of the actual picture, whilst in the original the D nearly touches it.

Ploos van Amstel (1726–98), a merchant and amateur, is sometimes credited with the printing of aquatints in colours from several plates, before Janinet or any of the others who practised it. But he confined himself to imitating old-master drawings, from his own collection, by a complicated method which, from the appearance of the prints, required soft-ground etching, and possibly stipple and roulette, besides aquatint.

In 1765 he described himself as the inventor of his process, and in 1768, to allay doubt demonstrated it in public before a Commission including the Burgomaster of Amsterdam, who testified to his production of colour-prints with 'varnishes, powder and liquids'. Nevertheless, there is a conflicting statement that he tried to keep it secret, making his apprentice give a bond of 3,000 florins.

His prints are beautifully made and so deceptive they have often masqueraded as original drawings, when under glass: fortunately he printed a coat-of-arms on the backs. A collected edition of his work was published in 1821 by Christian Josi, who had assisted Ploos van Amstel and later worked for J. R. Smith.

Side by side with the aquatint plates, stipple prints in colours from several plates were being used to imitate crayon drawings, for this reason known as the 'crayon manner' (see Stipple).

Jean Charles François (1717–69) is first mentioned in this connection. Gilles Demarteau the Elder (1722–76) and Louis Marin Bonnet both laid claim to the invention, Demarteau and his son making a large number of imitations of black and red drawings from two plates, as well as others in colours from more plates, from drawings by François Boucher, J. B. Huet, etc.

Louis Marin Bonnet (*c.* 1743–93) claimed two inventions. One was the *imitation du pastel*, with which he made some perfect examples from pastel drawings by Boucher. He used up to eight plates, one of which would put on the high-lights in white, with quite a raised-up impasto. His *Tête de Flore*, after Boucher, is the best-known of these (Plate 90). It is a portrait of Boucher's daughter, Madame Deshayes, though at one time thought to be Mme. Baudouin, the other daughter. Impressions sometimes turn up lacking the white plate. A companion plate was made of *Mlle. Coypel*.

Bonnet's other invention was the printing of borders in gold. He did a number of half-length figures of girls, after Greuze, Parelle and others, entitled *The pretty nosegay Garle* (*sic*), *Provoking Fidelity*, *The Charms of the morning*, *The Milk Woman*, *The Woman taking coffee*, etc., with gold borders, and some *Bustes de jeunes femmes*, after Le Clerc, have the inscription *L'Invention de cette nouvelle Manière de Graver et d'Imprimer l'Or, a été trouvé par Louis Marin, et mise au jour le 16 Novembre, 1774*.

Bonnet frequently signed himself 'Louis Marin' and occasionally 'Tennob', his name in reverse. He published a catalogue of over a thousand prints, so is thought to have had pupils or assistants. It is a tribute to the popularity of British prints on the Continent that the most expensive items on his list had English titles, sometimes misspelt, as in *The pretty nosegay Garle*. His address was *au Magazin Anglais*.

When using separate plates for each colour, care was necessary that each one registered in the right position on the one sheet of paper. To do this the plates were stacked in an exact pile and a hole drilled through them, usually at top and bottom, and often at the sides.

The first impression from the first plate left indentations in the paper, known as point-holes or register marks, so that the printer, when placing the paper face down on the next plates, would prick through these marks with a needle and find the corresponding holes in the plates.

These point-hole marks can, therefore, be an indication as to the genuineness of a print, particularly a print of the 18th century although, of course, if near the edge of the plate, there is always the possibility of their being cut off. Sometimes the marks are to be found in broad borderlines (see Plate 1), when near the edge of the plate they are usually not so conspicuous.

In lithographic stones holes were similarly drilled in each one at exactly the same spot. In some modern colour prints, the register holes are to be seen in the actual work, especially if there were no blank margins.

In chiaroscuro woodcuts the pins were placed in the frame, or tympanum, of the printing-press.

Reverting to metal plates, once a key-plate has been made, a guide to the colour-plates can be made by tracing the outline with a needle on transparent gelatine, filling

the scratches with whiting, placing it face-down on the plate (which has been slightly greased) and running it through the press; the white lines showing on the plate can then be scratched with the drypoint.

After a print from the first colour-plate has been taken, it can, while still damp, be placed face-down on the next plate (slightly greased) and run through the press. The ink will be in part transferred to the plate, allowing it to be dipped in a very weak acid solution for from five to ten seconds, when the surface will be sufficiently roughened to show the design.

In the case of colour-prints published without any margins, i.e., cut close to the picture, three or four horizontal lines were engraved on the plates in the side margins, and one or two vertical lines at the tops; V-shaped pieces were cut out of the margins of the paper, so that, from the back, the points of the V's could be registered with the lines on the plates. This system was followed by Theodore Roussel and his pupil Robertine Heriot, for colour-plates of flowers: the finished prints were cut close and mounted like drawings.

When exact registration was not so important, a place for the plates was marked on the bed of the press, so that they could all be placed one after the other in the same position. The sheet of paper for the print had wide margins, so that the plates could be changed and run through the rollers, leaving one end of the paper constantly imprisoned under the top roller and the bed.

14. Hand-coloured Prints

Nearly all the woodcuts and metal-cuts produced in the first part of the 15th century were coloured by hand; even in the second half, books with illustrations, like the *Nuremberg Chronicle*, were published plain or coloured, but the line-engravings were much less frequently coloured, being evidently regarded as works of art, capable of existing without further adornment. The woodcuts, engravings and etchings produced in the late part of the century, and subsequently by artists such as Dürer, Cranach, Lucas van Leyden, and others of a similar standing, were also deemed to be finished prints in black and white.

Generally speaking, apart from book-illustrations, especially of natural history, the hand-colouring of prints, specifically designed for colouring, was not resumed till the 18th century, when landscapes, costume prints, caricatures and sporting prints, with only etched outlines, were printed, and then coloured with water-colour by the artist, or trained colourists.

These prints are often referred to as water-colours with etched outlines, and were, in fact, a means of duplicating water-colours, the shadows being first put in with a brush and indian-ink wash, in the manner of the 18th century water-colourists.

After the introduction of aquatint, the shadows were sometimes added by this means: aquatints of the period nearly always having an etched outline, and being quite often published both plain and coloured. Examples intended for colouring were printed in pale green, or greenish-blue, for the skies and distances, brown being used for the foregrounds (Plate 91). Seascapes were printed all in green.

This is an almost infallible rule for aquatints of the early 19th century, though a lightly printed brown tone sometimes lent itself to colour. If a black aquatint is coloured, the colouring was almost certainly added at a later date. The rule of printing in two colours, those examples intended to be coloured before publication, applies also to colour-plates in books such as Ackermann's *Microcosm of London*, many of which have been broken up for the plates to be sold separately. In Herring's racehorse prints, besides the two colours there are flesh tints and some printing in colours in the jockeys' jerseys.

SWISS PRINTS AND OTHER VIEWS

The Swiss have reason to claim the revival of colouring prints by hand, the two men who pioneered the method of colouring etched outlines being Johann Ludwig Aberli (1723–86), in the field of landscape, and Siegmund Freudenberger (1745–1801), with his delightful Swiss costumes and cottage scenes.

Aberli took out a patent in 1766, though his method consisted only of etching an outline, putting in the shadows with a brush and indian ink, and colouring with water-colour. The great advantage was the possibility of employing colourists to duplicate from an example by the artist himself.

The medium-sized Aberli plates were reprinted in London: eight oblongs measuring 200 × 300 mm., or 220 × 360 mm., and two uprights 310 × 230–33 mm. The colouring of these reprints is quite good, but not so delicate as the original issue. They still have French titles, but an English publication line, just below the prints (above the titles): 'London, Published May 2d 1804, by Charles Richards No 349 Strand'. When dealing with these prints one should look carefully to see if there are signs of this English publication line having been erased from the paper.

Some of Aberli's pupils or assistants afterwards produced similar works of their own. Heinrich Rieter, a pupil of Aberli, produced even larger landscapes than his master, and had in turn a pupil named Johann Jacob Biedermann (1763–1830), whose largest landscapes, called 'grands Biedermanns' (*c.* 390 × 590 mm) are the most valuable of all (Plate 92).

Siegmund Freudenberger lived in Paris for eight years from the age of twenty, and was commissioned to make the first set of twelve drawings for the series of thirty-six engravings known as the *Monument du Costume*, depicting the costumes and dresses of ladies and gentlemen of the French aristocracy before the Revolution.

Back in Berne, Freudenberger made the beautifully coloured scenes of peasant costumes and cottage life in the Cantons, which are his best artistic work. One of his colourists was Gottfried Mind (1768–1814), who is spoken of as a cripple and feeble-minded, living in Berne. After the death of the master he took to drawing his beloved animals, specialising in children and cats, becoming known for this reason as the 'Raphael of Cats'.

Another pupil was Simon Daniel Lafond (1763–1831), who assumed the role of Freudenberger's successor, apparently reprinting from the plates, which are sometimes to be met with uncoloured. There are also some very deceptive contemporary copies.

The reprints of Freudenberger's plates are on hard paper and the plates appear to have been rebitten. Some of the differences in the copies illustrated on page 164, are:

Départ du Soldat Suisse. In the window at the right, there is a black patch in the top right corner in the original, which does not appear in the copy. In the gate on the left, the line of the right hand post is intact below the top bar in the original, but broken in the copy.

Retour du Soldat Suisse. The post on the right in the original has a knot-hole in it, which does not appear in the copy.

Chanteuses du Mois de Mai. In the original the thumb of the man in doorway is straight; in the copy it curves up. The copies have *Dessiné par*, instead of *S. Freudenberger fecit*.

La Petite Fête Imprévue. The rush to the left of the dog's left foreleg has a crisscross in the original; in the copy this line only makes a loop on top.

La Toilette Champêtre. In the original the knot marked in the diagram is composed of a short stroke, with a shorter stroke underneath it; in the copy it is an oval, not quite joined at the ends.

Peter Birmann (1758–1844), a pupil of Aberli, is claimed to be the inaugurator of the practice of printing aquatints in two colours when they were intended to be finished by hand.

Départ du Soldat Suisse

Orig. Copy

Orig. Copy

Retour du Soldat Suisse

Orig. Copy

Chanteuses du Mois de Mai

Orig. Copy

La Petite Fête Imprévue

Orig. Copy

La Toilette Champêtre

Orig. Copy

The two Lorys, Gabriel Ludwig Lory, the father (1763–1840), and Mathias Gabriel Lory, the son (1784–1846), began to use the newly patented aquatint, and illustrated some fine books, with plates of Swiss scenery and costumes, in this manner (Plate 93). On at least one occasion they ventured outside their own country to make a set of fine views of St. Petersburg. As they both signed G. Lory, their works are difficult to separate.

Franz Niklaus König (1765–1832) was another well-known etcher and aquatinter of scenes and costumes, his largest set of twenty-four Cantonal costumes, known as *Le grand König*, being hand-coloured soft-ground etchings.

Markus Dinkel (1762–1832), who first worked for the elder Lory, produced a set of delightful half-length Costumes, sometimes to be found stitched together in book form, each plate with a leaf of description, giving the names of the girls.

Gottfried Locher (1730–95) did a set of full-length costumes.

But the era was terminated by the invasion of Napoleon and the disruption of tourism and trade, though Johann Christian Reinhart (1761–1847) might be said to have attempted a revival with his set of Costumes. These represented both men and women, full-lengths, two or three figures to a plate. The set was issued in 1802–3 and in 1808–9, both these issues consisting of forty-four plates. A later issue was made in 1819, of forty-six plates. The first issue has white margins (showing the platemark) and lacks the plate of Geneva costumes. The later issue has the margins cut off and the plates mounted like drawings on buff paper.

The beauty of these prints depends on the colours being unfaded; blue in the skies is particularly fugitive, so the collector should beware of blank skies, or light reddish-purple. The finest specimens to come on the market have been those brought back in the 18th and 19th centuries from the 'grand tour' and preserved by librarians, inserted in large volumes and thus protected from prolonged exposure to the light. Since these libraries in the large houses and castles, both in Britain and on the Continent, have mostly been dispersed, it is very difficult to find good examples of the coloured Swiss print.

Great Britain is very fortunate to have had the R. W. Lloyd collection bequeathed to the British Museum. Mr. Lloyd was a well-known mountaineer and industrialist, who had collected Swiss prints out of interest in the subjects, for many years. Of the 'grands Biedermanns' he had no fewer than thirty examples each worth up to £1,000 if put on the market to-day.

Other countries, of course, produced their own views of cities and beauty spots, Saxony and Austria, for instance, publishing a number of views in a style similar to the Swiss. Very attractive views of Vienna were made, some being revised from time to time, with the dresses altered to accord with the changes in fashion.

The actual etched outlines themselves, without aquatint, were mostly printed in black, but occasionally in some costume prints a brown or blue-grey ink was used, which is difficult to detect in determining whether they are coloured prints or original drawings. A series of large prints of the Decorations of the Vatican, engraved by Volpato, were printed in a coloured ink, merging well with the colouring.

A large number of views of London, Paris, Rome, Venice, Amsterdam and other

cities was published towards the end of the 18th century in London, by Laurie & Whittle, R. Sayer, Bowles, etc., some of the London and Venice ones being after Canaletto, and these were published coloured. The old colouring done at the time of publication can usually be told because the skies were coloured with body-colour, while the remainder – the buildings and foreground – was coloured with ordinary transparent water-colour wash. The white-lead in the body-colour has sometimes turned black in places, owing to the action of sulphur in the air.

Similar views were done, with the titles on top in reverse, which are known as 'Optical Prints'. They are sometimes found in their original box, the inside of the lid being a mirror. The box also housed a large magnifying glass, the idea being to look at the reflection of the prints through the glass. These prints are rather cruder than the other views, and the skies coloured with ordinary water-colour wash, like the rest of the view.

The same publishers issued a number of mezzotints of a comic and satirical nature, after John Collet, a follower of Hogarth, and Richard Dighton. The subjects represented are such things as caricatures of fashion, elegant ladies visiting Cox Heath, the Volunteer military encampment, Miss Wicket and Miss Trigger, lady cricketer and sportswoman, and these were published plain or coloured, mostly with body-colour.

CARICATURES

The caricature, political and social, became a branch of the hand-coloured etching trade. Vast quantities were produced in Britain in the 18th and 19th centuries, often replete with 'honest vulgarity', and hired out by the publishers for a good evening's entertainment.

The artists of these were sometimes semi-amateurs, such as Henry William Bunbury, F. G. Byron, Henry Wigstead and John Nixon. Among the professionals were William Heath (1795–1840), who used a little figure of Paul Pry as a signature, and James Gillray (1757–1815), who at first signed with the letters JS interlaced (Plate 94).

Gillray was a reluctant apprentice to a letter-engraver, ran away to join the strolling players and was afterwards a student at the Royal Academy. Before taking exclusively to caricature he engraved several competent plates in stipple.

He is believed to have drawn his caricatures straight on to the copperplate, providing a constant supply for his publisher, Mrs. Humphrey, who had a shop below his lodgings in St. James's Street, and looked after the artist when he developed intemperate habits.

One of his caricatures greatly offended the Prince of Wales, having reference to the Prince's support of the Whigs. It was entitled *L'Assemblée Nationale*, with Charles James Fox proclaimed First Consul of the new republic of England, and included a recognisable portion of the Prince's figure. A large sum of money was paid for the destruction of the plate, which, however, was only hidden and reappeared after the artist's death, among his other plates. They were rescued by H. G. Bohn, a well-known publisher, when they were about to be sold for old copper. Bohn reprinted them, on thick white paper, and republished them in a folio volume, uncoloured.

THOMAS ROWLANDSON

Thomas Rowlandson (1756–1827) probably provided more work for the colourist than any other single artist. He was the son of a City merchant and educated in Soho, when it was an aristocratic quarter. He studied art in the Academy schools of London and Paris, and, in the course of his career, as W. H. Pyne has put it, covered enough paper 'to placard the whole walls of China and etched as much copper as would sheathe the British navy'.

His talents were well recognised by Sir Joshua Reynolds and others, who deplored the fact that he did not take up the higher branches of art, in which he at first started, but his bent was the droll and comic. Early we hear of him disturbing the peace and pose of the female model in the Academy School with a peashooter, after her careful arrangement by old Moser, the Academician.

As it was, he achieved the individuality so many artists have striven for. His studies made him a masterly draughtsman with a wonderful facility for simplifying any subject he undertook. His earlier water-colour drawings, and the plates engraved from them, are very beautiful, especially the less satirical ones, and the success of these no doubt confirmed him in specialising in the lighter side of art.

The drawing of *Vaux-Hall*, exhibited at the Academy in 1784, and bought for a pound in an Essex shop a few years ago, was undoubtedly his masterpiece. The plate made from it was admirably etched by Robert Pollard, father of the celebrated coaching and sporting artist, and aquatinted by Francis Jukes (Plate 95).

Even the famous *Promenades* of Philibert Louis Debucourt (which *Vaux-Hall* may have inspired) though much stronger on account of being printed in colours, do not approach it for artistic achievement.

The many recognisable characters of the time in this print of Vauxhall seem to convey to the spectator the whole spirit of the 18th century. It shows on the left a portion of the Rotunda in Vauxhall Gardens, with Mrs. Weichsel, mother of Mrs. Billington, singing to the accompaniment of the orchestra, led by Barthelemon. In one of the supper-boxes beneath are the figures of Dr. Johnson, Boswell, Oliver Goldsmith and Mrs. Thrale, obviously enjoying their food, without any complications. In the crowd listening and walking beneath the trees the Prince of Wales escorts Mrs. Robinson, the actress, while the two dainty figures of the two famous beauties, the Duchess of Devonshire and her sister Lady Duncannon, gaze into the trees with feigned oblivion of the stares to which they are being subjected. Just behind them is a bespectacled Reverend Sir Henry Bate Dudley, looking not one whit like the 'Fighting Parson' so gallantly portrayed by Thomas Gainsborough.

Sir Henry was the founder and proprietor of the *Morning Herald* so it is fitting that he should have beside him the kilted James Perry, editor of the *Morning Chronicle*. An erect gentlemen on the left, rudely quizzing the two ladies through an eye-glass, has been identified as another journalist, Captain Topham, editor of the *World*.

Rowlandson himself is spoken of as a large man with a healthy appetite, who suffered from the fashionable vice of gambling, and is supposed to have lost a £7,000

fortune left him by a French aunt, and any other money that came his way. Like poor Morland, with his financial difficulties, he seems to have been driven to ever harder work. His publisher, Rudolf Ackermann, and doubtless also the publisher's skilled colourists, were hard pressed to cope with the amount of his output.

Joseph Grego, in his *Rowlandson the Caricaturist*, states that researches have convinced him that at this period the artist had a system for duplicating his drawings by making an outline in reverse and taking offsets with damp paper, possibly, one would think, passing them through the printing press.

RUDOLF ACKERMANN

Rudolf Ackermann (1764–1834), the famous publisher, was born in Germany and trained as a coach-builder, practising his trade in Paris and in London, where he helped design a £7,000 state coach for Dublin, and was given the task of preparing the hearse for Nelson's funeral.

He was also an inventor, and constructed a machine to distribute leaflets from a balloon, but his main career was as a publisher, chiefly of hand-coloured prints, and books with coloured plates, which he issued from the 'Repository of Arts', in the Strand, started in 1795.

He was noted for philanthropy, and the help he gave to Continental refugees, particularly the French émigrés. The late Martin Hardie tells us, in *English Coloured Books*: 'He had seldom less than fifty nobles, priests, and ladies engaged in manufacturing screens, card-racks, flower-stands and other ornaments.'

Doubtless among them were some of the colourists he trained, unexampled in the flawless washes they could apply, whose numbers must have been large. The *Microcosm of London* alone contained 104 plates, which meant 104,000 prints to be coloured, for the 1,000 copies of the book issued. One can visualise the ladies turning their drawing-room accomplishments to practical use, aided by demonstrations from skilled artists.

Perhaps from Rowlandson? After all, he had a French aunt, had been partly trained in Paris and spoke the language – if one dared put the roué in juxtaposition to the elegant and cultured ladies!

The plates in the *Microcosm of London* were the joint efforts of Rowlandson and an émigré architect, C. A. Pugin, who drew the buildings and interiors, whilst Rowlandson peopled them with innumerable figures from his fertile imagination, etching all the outlines of the plates, ready for the aquatinter's grain, and colouring at least one proof as a guide to the army of colourists.

One of the more remarkable things about Ackermann was the way in which his business flourished, in spite of the French Revolution and Napoleonic Wars. Whereas Boydell and J. R. Smith were crippled by the interruption of Continental trade, Ackermann concentrated on books, views and sporting subjects, appealing to home demands. The happy relation with Rowlandson produced the *Tours of Doctor Syntax* where the words were supplied by another extravagant gambler, W. H. Combe – Walpole's 'infamous Combe', who, in writing was as prolific as Rowlandson in drawing, but less successful in keeping himself out of the debtors' prison. Sporting

artists like Henry Alken supplied the etchers and colourists with a constant flow of designs. It is, in fact recorded that the colourists had difficulty in keeping pace with the printers, in the case of popular subjects.

THE CRUIKSHANK FAMILY

The Cruikshank family (Isaac, the father, and his two sons, Isaac Robert and George) played one of the most important parts in the history of coloured caricature and book illustration. There was also a grandfather, a customs-officer at Leith, who took to art as a profession, and apparently to drink, after losing his job, due to the disturbances of the 1745 rebellion. Isaac Cruikshank (1756?–1811?), the father, came to London about 1788 and worked as a water-colourist and caricaturist.

Isaac Robert Cruikshank (1789–1856), who often signed just Robert Cruikshank, received some instruction from his father, then had an interval as a midshipman in the East India Company, and was mourned by his family for three years as lost when he failed to return from his first voyage. He had, in fact, been accidentally left behind at St. Helena, getting a passage home on a whaler.

In the meantime his more celebrated younger brother George had already become a professional caricaturist, so that Robert decided to resume his artistic career. He became successful as a miniaturist and portrait painter, and, on the print side, special-ised in satirising the exaggerated absurdities of the fashionable dandies of the Regency: the Monstrosities, as he termed them (Plate 96).

His most famous incursions into Corinthian life were his illustrations to books such as *Life in London; the Day and Night Scenes of Jerry Hawthorn Esq. and his elegant friend Corinthian Tom, accompanied by Bob Logic, the Oxonian, in their Rambles and Sprees through the Metropolis*. The characters of Tom, Jerry and Logic represented himself, his brother and Pierce Egan, editor of *Boxiana*.

The book was first published in 1821 and had phenomenal success, even to being dramatised. In this first work he collaborated with George. He also illustrated a sequel in 1828, after a similar publication in 1825, called *The English Spy*.

Also, in the sporting field, he designed and etched two coloured panoramas entitled *Going to a Fight* and *Going to the Derby*. These consisted of more than forty scenes, on strips, joined together, and sold in wooden cylinders, so that they could be pulled out and wound back again. The scenes of *Going to a Fight* started in the Castle Tavern, Holborn, thence by stages to the fight at Moulsey Hurst, finishing at Tattersall's, illustrating 'the Sporting World in all its variety of style and costume'.

George Cruikshank (1792–1878), son of Isaac and younger brother of Isaac Robert was drawing at the age of seven and etching at twelve, when the success of a carica-ture made him at once a professional.

His father was curiously indifferent to his success, saying that if it were his destiny to become an artist, then he would need no instruction. Fuseli, in charge of the Academy School, gruffly told him to 'fight for a place'. Thus the celebrated caricaturist and book-illustrator of Dickens and Ainsworth, etcher of thousands of items, buried in St. Paul's, was almost, if not quite, untutored. His horses and wasp-waisted females were

criticised and he himself was acutely conscious of his lack of academic training, patiently copying from casts of the antique, even at the age of sixty.

In the print world it is his caricatures that most concern us. These consisted of an etched outline, coloured with water-colour: the usual method of caricaturists of the period. The subjects dealt with were mostly political, or social scandals, many of which are difficult to understand without an intimate knowledge of the times. Favourite victims were Napoleon, Wellington, the Prince Regent, Pitt and Fox, Joanna Southcott, and Mrs. Clarke's sale of military commissions (Plate 97).

One caricature in particular he described as the greatest happening of his artistic life: *Bank-note – not to be imitated*, published in 1818, and inspired by his horror at seeing, on his way home, the bodies of several women hanging opposite Newgate, for passing forged one-pound notes. This caricature precipitated a revision of the harsh penal code, and earned its publisher £700, actually wearing out one plate and necessitating the etching of a second. Later he devoted his talents to book illustration.

In 1847 and 1848 he published two series, each of eight plates, entitled *The Bottle* and *The Drunkard's Children*. Both of these had such a success, they are said even to have converted the artist himself to total abstinence, *The Drunkard's Children* being produced as a drama in eight theatres at the same time. Later he made a very large etching of a seven-foot picture he had painted, called *Worship of Bacchus; or the Drinking Customs of Society*. In this print Cruikshank etched the outline and the plate was finished by Charles Mottram.

These temperance prints marked the commencement of a decline in his art, and a strange contrast between the hard-swearing Corinthian and the chairman at temperance meetings. His publisher William Hone had written in 1821 that he could not get on with his publications 'without my friend George Cruikshank will forswear late hours, blue ruin,* and dollies'.

COLOURED LITHOGRAPHS

The colouring of lithographs became a common practice after the 1820s, but when publishers advertised lithographs as 'tinted' they did not mean coloured, but only that the lithographs were printed with a ground applied with a 'tint-stone': thus it meant only black and yellow or grey.

In this connection the famous series of London views by Thomas Shotter Boys, entitled *London as it is*, published in 1842, was advertised both as tinted and coloured. The tinted impressions were just the black and grey ones and were published bound up in one volume with the printed letterpress explaining the plates, the plates themselves having margins.

In the coloured examples as originally issued the plates were coloured with water-colour, and were mounted on cards with the margins cut off, to simulate drawings, with a single yellow line drawn round them on the mounts. The explanatory letterpress was stitched as a separate book with paper covers, and the whole contained in a portfolio, with a gilt emblem of the London Stone on the cover. Examples found

* Gin.

coloured, and with the margins not cut off, do not belong to the original coloured issue, but are the black and yellow 'tinted' ones, coloured by someone later on.

Some very deceptive copies of Boys's *London as it is* were made in the 1920s. The following are some of the definite differences:

> *Mansion House, Cheapside etc.* In the copy the S of Lombard Street on the left is in reverse: in the original it is the right way round.

> *St. Paul's from Ludgate Hill.* In the copy the lowest lettering on the back of the van (starting *Wigs*) after VAUX is almost obliterated.

> *The Strand.* In the original the letters in the name BUSHELL on a house on the left are almost level: in the copy the B is much taller.

> *Entry to the Strand from Charing Cross.* In the original the name MORLEY's on an hotel on the left has an apostrophe: in the copy it is left out.

> *Piccadilly looking towards the City.* CUDLAM on the shop next but one to the Egyptian Hall is quite distinct in the original: in the copy the L is replaced by a C. In the original the third poster on the left on the first floor of the Egyptian Hall reads Indians/Catlin: in the copy the lettering is indecipherable.

The cutting and mounting of coloured lithographs and aquatints to imitate drawings was not uncommon. William Daniell's *Views of Windsor and Eton* were issued in this way.

The artist of hand-coloured prints often made no more than a pattern for professional colourists, some of whom were themselves quite gifted artists. It is well known that Turner and Girtin both did this when young. There is an unconfirmed story that Girtin, when apprenticed to Edward Dayes, artist and mezzotint engraver, complained of the time he had to spend colouring prints, and was hauled before the magistrate as a refractory apprentice and sent to prison. Mr. Harry T. Peters gives us an intriguing account of the system of colouring the vast amount of prints issued by the great American firm of lithographers, Currier & Ives:

> In the Currier and Ives shop the stock prints were colored by a staff of about twelve young women, all trained colorists and mostly of German descent. They worked at long tables from a model set up in the middle of the table, where it was visible to all. The models, many of which were colored by Louis Maurer and Fanny Palmer, were all first approved by one of the partners. Each colorist applied only one color, and, when she had finished, passed the print on to the next worker, and so on until it was fully colored. The print would then go to the woman in charge, known as the 'finisher', who would touch it up where necessary. The colors used were imported from Austria and were the finest available, especially valued because they did not fade in the light.

SPORTING PRINTS

Sporting prints form an important section of the hand-coloured variety of print. They fall most easily into the system of grouping them under the names of the artists, rather than the engravers, especially as artists like Henry Alken often etched the outlines themselves, the engraver only putting on the aquatint. Some sporting prints are only coloured etched outlines, without any aquatint grain.

The coloured sporting print reached its zenith in the first half of the 19th century, often depicting the hard-riding Corinthian of Regency days, with an element of farcical exaggeration. Sometimes they were based on the poems of Somerville, or the writings of the sporting journalist Nimrod (C. J. Apperley). The famous Squire Osbaldeston figured in them, triumphing in a steeple-chase, or 'taking a cooler' in a brook. Ruskin, whose criticisms, however, were so often wrong, complained of the 'quantity of British squires flourishing whips and falling over hurdles'.

The portraits of racehorses, such as Herring's *Winners of the Derby* and *St. Leger*, remind us that there were several types of sport not laying themselves open to the controversial argument of cruelty. Coaching ranked as a sport when it became fashionable for a young man to learn how to handle a four-in-hand. Some enthusiasts, like Sir John Lade, even grew to look like stage-coachmen, and aspired, in Captain Gronow's words, to spit like the professionals.

Though representations of The Chase go back to the earliest times of painting and engraving, not till the late 18th and early 19th centuries were the British producing their unique type of this form of art. Before this, prints of this style, after 18th century artists like Wootton, Seymour, Tillemans, Stubbs and others, were rarely meant to be coloured. Mezzotints and line-engravings continued to be produced in black and white in the 19th century, but, in the case of aquatints, or prints with etched outlines only, they were invariably intended to be coloured.

As in landscapes, the aquatints were frequently printed basically in two colours: light green or pale blue for the skies and distances, and brown for the foregrounds, the rest being hand-applied water-colour. On rare occasions the name of the colourist was engraved on the plates: on the *Beaufort Hunt* the name of F. Rosenberg and, on some of Herring's racehorses, C. Simpson.

Thomas Rowlandson and his brother-in-law Samuel Howitt produced some of the earliest sets of this particular type of print, the latter's *Orme's British Field Sports* – a set of twenty fine coloured aquatints – remaining unbeaten in its field. It is when sets such as this have remained bound and thus unfaded, that the finest examples are met with (Plate 98).

Henry [Thomas] Alken (1785–1851) was the most prolific and perhaps the best known of sporting artists. His father was Samuel Alken, a well-known aquatint engraver.

Though it has been decided there is no truth in the old idea that he was huntsman, groom or trainer to the Duke of Beaufort, as a rider to hounds with the Melton Hunt he had knowledge of his subjects, his first hunting set being published in 1813, under his own name; till 1819, however, he mostly used the pseudonym of Ben Tally Ho! because, it has been suggested, he wished to remain anonymous to his fellow-huntsmen. Another reason, perhaps, was that, trained as a miniature painter, he wished to dissociate himself from these often semi-satirical sporting prints.

We know that Sir Joshua Reynolds did some clever caricatures of his associates when a student in Rome, but spent the rest of his life regretting them, because he thought it bad for a serious portrait painter to be found guilty of the distortion of such a light and frivolous form of art.

By 1819, Alken must have found that sport was his metier. He was a fine painter and an exquisite pencil draughtsman, seemingly using the edge of a soft lead, sharpened wedge-shaped, to give his lines their firm and perfect character. His etchings and soft-ground etchings lose a little of this beauty, but are none the less firm and exact.

Like Rowlandson, he was from time to time called upon to etch the designs of amateurs and correct their drawing, whilst retaining their ideas and compositions. In the case of *The Beaufort Hunt*, one of the finest sets produced, the first drawings were by an amateur, Walter Parry Hodges, of Dorset, and before commencing etching, Alken made his own drawings, correcting the faults of the amateur (Plate 99).

This set, advertised as *Hodge's Fox Hunting*, was published at four and a half guineas: it included wrappers, a frontispiece with a fox's mask ('The Sportsman's Arms'), a dedication and eight large coloured plates. A year later a supplementary plate entitled *Consequences* was published, at twelve shillings and sixpence, coloured. The engraver was Henry Alken and, most exceptionally, the name of the colourist appears: F. Rosenberg.

This set was never reprinted, unlike so many sporting prints, in fact the words 'Proof impression' always appear on the plates. Slight variations of 'state' occur: *The Death and Treeing* has been seen spelt 'Treeng', and a variation in the plate numbers at the tops has occurred.

Another famous set for which he did both the pictures and etched the outlines was the *Quorn Hunt* (Plate 100), but on this occasion F. C. Lewis laid the aquatint grounds. They illustrated an article by 'Nimrod' (C. J. Apperley), with extracts from the article below the plates. These plates have not only been reprinted, but a deceptive set of copies was made, published by Sheldon: the copies can be told because they lack the extracts from the article below.

The Quorn Hunt was also published at four and a half guineas, or seven and a half guineas mounted and varnished 'Ackermann style'. This meant that the engraved print was cut close and stuck on a sheet of paper, the cut-off title was stuck below and the whole varnished to imitate a painting, not needing a glass. Prints treated in this way are now considered to be more or less spoilt.

The so-called *First Steeple Chase on Record, or the Night Riders of Nacton*, a set of four, published at £1 16s. by Rudolf Ackermann in 1839, illustrates an article in *The Sporting Review*, giving an account of a race by moonlight, from the Cavalry Barracks at Ipswich to Nacton Church, four and a half miles away. The riders, Cavalry officers, wore nightshirts, and, though not the first steeplechasers, they may have been the first to ride by moonlight. Reprints of this set are very common, with Ackermann's name altered to Ben Brooks.

Alken's work is remarkable for the number of sets published in wrappers, with a title-page and two or three pages of explanatory letterpress. Most of these sets depict the gay and light-hearted Corinthians, some of them Meltonians, performing almost impossible feats with exaggerated ease, soaring over five-barred gates in a 'look no hands' attitude. 'Cuss me feller, but you will get hurt one day if you git so much in the way', says one, to a boy who tries to open the gate.

Martin Hardie (*English Coloured Books*) said that some of Alken's sets – those containing several items on each plate – were drawing books, lending weight to the statement that he had, early on, been a drawing master.

A digression may here be permissible to discuss the difference between a book and a set of prints. The late Francis Harvey, printseller of St. James's, who helped compile the lists of prints in Captain Frank Siltzer's *British Sporting Prints*, made a distinction between 'Books' of prints and 'Sets' of prints, especially those after Henry Alken. This has led to an argument between bookmen and printmen as to what should be the distinguishing differences.

Bookmen say that anything published with a title-page is a book, but printmen hold this to be far too arbitrary. They point out that few sets of prints were published without an explanatory title, even the Wheatley *Cries of London* being originally published in a portfolio with a title-page.

A fair judgment would seem to be: if the plates are illustrative of the text, it is a book; but if the title and any letterpress are merely explanatory of the plates, then it is a set of prints.

John Frederick Herring (1795–1865), famous for his racehorses, was also, in his young days, a coach-painter and a professional coachman.

Every year, for many years, he painted the winner of the St. Leger and the Derby, commencing with *Filho da Puta*, winner of the St. Leger of 1815. At this time he was living at Doncaster, and the first twelve plates were published by Sheardown and Son, Doncaster, engraved by Thomas Sutherland (the 1826 plate is after D. Dalby). The plates were then taken over by S. & J. Fuller, with their name appearing as publisher on these and the subsequent yearly plates (a blind Minerva Head stamp appearing in the lower margin means the prints were subscription ones).

These racehorse prints were from time to time issued in book form with a title *Portraits of the Winning Horses of the Great St. Leger Stakes, at Doncaster*, and *Portraits of the Winning Horses of the Derby Stakes at Epsom*, the number of plates varying according to the year in which the volumes were issued. The earliest examples have only the first ten Sheardown plates, from 1815 to 1824.

It is usually only when found in these books that the plates show their real unfaded beauty (Plate 101).

Herring had sons who also painted, so that he generally put 'Senior' after his name.

Other artists who designed a number of racehorse prints were Harry Hall, Charles Hancock and Charles Hunt.

James Pollard (1797–1867), another large producer of Sporting Prints, engraved a number of his own paintings and drawings. This is not surprising, because he was the son of Robert Pollard, a fine engraver, whose splendid job of the outline for Rowlandson's *Vaux-Hall* has already been mentioned.

James's best-known prints are the numerous coaching scenes, contemporary with the hey-day of the 'sport', the first being dated 1815, and showing a stage coach flying a banner to announce the peace as it galloped through the countryside and towns. A later issue, republished at the passing of the Reform Bill, has 'Reform' on the flag.

Sometimes he shows the struggles of the drivers and guards to keep running and deliver the mail, through storm, snow and flood, a mild and pleasing example being *Approach to Christmas*, which shows the Norwich Coach driving through the snow down the Mile End Road, and post-chaises with schoolboys returning for the holidays, firing peashooters at the pedestrians (Plate 102).

Many of Pollard's scenes are recognisable, even named, like the *Eagle, Snaresbrook*; *The Falcon* at Waltham Cross; *Highgate*; *Scenes on the Road to Epsom*, starting at *Hyde Park Corner*; the old *G.P.O.*, and galleried inns like the *Swan with two Necks*, now pulled down, *The Elephant and Castle, The Peacock, Islington, The Angel, Islington, The Gloucester Coffee House, Piccadilly, Windsor Park, Epping Forest*, etc.

In preparing his aquatint grounds James must have used a special resinous gum, which 'crystallised' in an oblong manner, giving the grain the appearance of short parallel lines, rather than the minute circles or twirls of the usual ground.

Thomas Rowlandson, some of whose work has already been described, was a pioneer in the field of British sporting prints, his first print of this type, *The Huntsman*, being published in 1785. This was an etching with aquatint, as was a large set of Hunting prints he published himself from 1786 to 1788. Another large and rare set, published by Ackermann in 1801, shows views of Windsor and Eton.

Rowlandson was closely followed by George Morland and by Samuel Howitt, Rowlandson's brother-in-law, with his famous set of twenty *Field Sports*, published 1807 to 1808, by Edward Orme, originally in ten paper wrappers (only three complete examples are known thus), more often met with in book form – a large folio.

George Stubbs (1724–1806) was one of the few earlier sporting artists to gain recognition from the Royal Academy.

Sporting paintings form a branch of art almost exclusively British. Their merits lie not so much in technical ability as in capturing the atmosphere of landscape and country life, where they succeed in a manner that is often denied to more accomplished works, though Stubbs himself was an artist in the full sense of the word. He was elected an A.R.A. in 1780 and R.A. in 1781, but, owing to a dispute, did not retain full academic honours.

He was born in Liverpool, the son of a currier and leather-dresser, and was an anatomist as well as an artist. We are told that at the age of eight he was borrowing bones to draw from a neighbouring doctor; at twenty-one he was lecturing on anatomy at York Hospital, and a few years later, in 1750, was commissioned by Dr. John Burton to illustrate a book on obstetrics. For this purpose he acquired the technique of etching from a house-painter in Leeds, making his first trial on a worn halfpenny.

After a brief visit to Italy in 1754 he devoted himself to the anatomy of the horse. In this connection some tall stories are told of his phenomenal strength, one of them being that he would carry the dead carcases of horses up three flights of stairs to his dissecting room in a farmhouse in Lincolnshire, keeping them in the house for six or seven weeks. The necessity of using an attic in the house, when presumably there were sheds and barns remains unexplained.

As a result of these researches, he published his book, *The Anatomy of the Horse*, in 1766, the plates for which he etched himself.

He was one of the earliest designers of the British Sporting Print, though his first prints at least were not intended for colouring.

In the same year, 1766, that he published the *Anatomy of the Horse*, a print of *Gimcrack* was engraved by Pether and published by T. Bradford. *Gimcrack* again figured in the prints of horses he designed for *The Turf Review*.

Stubbs had painted sixteen pictures of celebrated horses for *The Turf Review* when war with France interrupted them. Those already done were engraved in stipple by his son George Townley Stubbs, and published in 1794 and 1796 by Messrs. Stubbs, Turf Gallery, Conduit Street. They were republished in 1817 by Edward Orme, New Bond Street. Smaller plates were also published in 1794–6. The size of the larger plates is about 390 × 500 mm., and the smaller plates 195 × 250 mm.

Engravings after Stubbs are in mezzotint, stipple or line, not in aquatint. A fine set of Shooting subjects was engraved in line by William Woollett.

An occasional example is to be met with printed in colours, but any found hand-coloured were almost certainly done later.

Dean Wolstenholme (1757–1837) was descended from Sir John Wolstenholme, of Stanmore, Middlesex, though born in Yorkshire, where he owned a large estate. The loss of both the estate and a fortune of £100,000 caused him to come to London and take up art professionally.

His first dated set was published in 1806, aquatinted by R. G. Reeve, who was also the publisher. In 1817 his son, Dean Wolstenholme junior, began engraving some of his plates.

The son became a professional artist, engraver and publisher, some of his work being for George Baxter, notably on the ground plate for the large *Queen Victoria Opening Parliament*. His own original work included a series of aquatints of pigeons, the original plates of which are still in existence.

One of the most famous collaborations of father and son was *The Essex Hunt*, a set of four large views of Matching Green and other places near, with known huntsmen taking part. There are deceptive reproductions of these, the same size as the originals. In plate 4 (the Death) of the reproductions, the words 'Engraved by D. Wolstenholme' are only 2½ inches long, instead of being 3⅝ as in the originals.

Another famous set, engraved by the son, is *Hertfordshire; Village Scenery*, containing very pretty views of Whitewell, near Welwyn and the neighbourhood (Plate 103).

There were also *Surrey Views*, and a similar set known as *Colonel Jolliffe's Hounds*. An oblong set of *Fox Hunting* (about 220 × 665 mm), engraved by Thomas Sutherland, was first published by Burkitt & Hudson, and reissued with the address of R. Ackermann and no date.

Wolstenholme's prints were often reissued in this way, especially when the plates were acquired by Ackermann, but worn-out reprints are not so often met with as in the work of other sporting artists.

To interpret his father's style of painting Dean junior used a mixture of etched lines with aquatint. Using mezzotint instead of aquatint, S. W. Reynolds and J. Bromley also achieved this style in a fine and rare plate of Lord Glamis and his Staghounds meeting in Hertfordshire.

Sporting Prints, particularly those produced in the 19th century by etching and aquatint, were not considered to be great art, nor would they have claimed to be. They were done at a time when nobody understood the action of the horse, which was only revealed by the moving camera. Even the great anatomist Stubbs drew a galloping horse at full stretch, and to represent a whole field at full stretch at the same moment became the recognised convention for indicating speed.

They were not the type of print that museums could be expected to collect, their function being exposure on the walls of sporting squires and gentry. Only the few examples preserved unframed in libraries reveal their true unfaded colours, and such specimens are of the greatest rarity. Two or three examples, for instance, are all that exist of *The Beaufort Hunt*, complete in the original wrappers. One (from the Schwerdt collection) now belongs to the Mellon Foundation; the Duke of Beaufort appears to have given his for the Red Cross Sales in the first World War, though it is believed to have appeared again in a sale, lacking a plate and with others torn.

This is, however, only to scratch the surface of a vast subject, made so much larger because so many Sporting Prints have been constantly reprinted, the plates of a large number being still in existence. It is impossible to know or remember all that have been reprinted, so that it is best to approach any print of this kind with the idea of a reissue in mind.

The early editions of practically all Sporting Prints, from 1810 to 1850, are printed on Whatman paper (see section on Paper and Watermarks). It is best to get to know the appearance of this, as, in framed prints, it is not possible always to take them out for examination. Beware also of a print purporting to be published before 1840, with a broad bevelled platemark (see section on platemarks). A number of poor reprints are on a yellowish paper with a canvas-like surface at the back. Howitt's *Orme's British Field Sports*, published 1807 to 1808, are on a paper similar to Whatman, but with the watermark E. &. P. These papers are 'wove' and thus without wire-marks.

In the case of reprinted aquatints, constant printing has often worn away the fine grain in the skies, in the hills on the horizon and on the faces. This grain is like a fine and clear network, and the clouds should be shaded with it; the hills and the faces should have some, in addition to the etched outlines. The faces should not appear devoid of any shading (see Plate 83).

These points about grain will not act as a guide to prints with etched outlines only, but the colouring in both cases should be first class, if not faded, and the washes of water-colour without blemish.

In many prints having racehorses or coach-horses in them, a wash of gum arabic has been put over the colours on the horses to give them a sheen: this should not have been cleaned away in the best examples.

M

A number of these prints have been reproduced by photographic and lithographic methods, some going back to the 1880s, enlarged to the size of the originals. Occasionally these can be deceptive, especially if dirtied up, but the earlier ones, at least, could never copy the clear-cut lines of network in original aquatints. The photographs have a fuzzy appearance, particularly in the corners, where these early enlargements of photographs tended to go out of focus.

Many other artists produced sporting pictures which were engraved.

Jacques Laurent Agasse (1767–1849), originally a Genevan artist, was responsible for several fine and interesting sporting prints in the British style. He first came to England about 1790, to work for Lord Rivers at Strathfieldsaye (before it was given to the Duke of Wellington). Here he painted a fine picture of *The Stud Farm*, not, however, engraved. Later on he came back to England, when Napoleon overran Geneva, and worked permanently in London. His most famous print, engraved by C. Rosenberg, is *The Last Journey on the Road*, said to represent the George and Dragon at Horndean, or Petersfield and the last stage to Portsmouth. The first state has the title *The Road Side*.

Henry Bernard Chalon (1770–1849) was another artist not altogether indigenous, as he had a Dutch father. He and Agasse were friends in London, and some very fine mezzotints were engraved by William Ward after his pictures of racehorses.

Richard Barrett Davis (1782–1854) was a noted sporting artist, whose father and brother were both royal huntsmen. He designed sixteen plates (twelve lithographs and four aquatints) for a publication called *The Hunter's Annual*, which ran from 1836 to 1841, with portraits of the professional huntsmen of the leading hunts, on their favourite hunters.

John Ferneley (1782–1860), of Melton Mowbray, had a number of pictures engraved, including a set of ten plates by Edward Duncan, of the *Exploits of Count Sandor in Leicestershire*. Sandor was a Hungarian aristocrat, whose feats as a follower of hounds startled even the Meltonians.

Charles Cooper Henderson (1803–77) designed a number of large prints of coaching: *Coaching Recollections*, *Coaching Incidents*, etc.

Ben Marshall (1767–1835) was trained as a portrait painter under L. F. Abbott. He did not design any hunting subjects, but, perhaps because he was a native of Leicestershire, he produced fine portraits of racehorses and hunters, mostly with jockeys, grooms, trainers or owners and occasionally with hounds; and a large pair of fighting cocks, engraved by Charles Turner, who also engraved his two full-length portraits of the prize-fighters John Gully, who became a Member of Parliament for Pontefract, and Gentleman John Jackson. Looking at the fine figure of Gentleman Jackson, one can see why Sir Thomas Lawrence used him as a model for the figures of some of his less endowed sitters.

F. C. Turner (fl. 1814–57) was responsible for a considerable number of prints of Hunting, Steeple Chasing and other forms of sport; he exhibited at the Royal Academy, from London addresses, and was a member of the Society of British Artists, yet nothing is known of his life, nor even his Christian names. One of his most famous hunting

sets illustrated a poem by Somerville, 'A Southerly Wind and a Cloudy Sky, Proclaims a Hunting Morning . . .' His steeple-chase and racing sets included *Aylesbury*, *Leamington*, the *Liverpool Grand National*, and *Ascot Heath Races* (Plate 104).

James Ward (1769–1859) did a series of *Lithographic Drawings of Celebrated Horses*, and painted a very fine and large picture of *Ralph John Lambton, on his horse Undertaker, calling Hounds out of Cover*. The name of Charles Turner appears on the mezzotint plate as the engraver, though a letter written by James Ward implies that he started it.

William Webb (fl. 1819–50) painted a famous portrait of the fearless and eccentric *John Mytton* on Sir Oliver, with his huntsman and hounds, engraved in mezzotint by W. Giller. One can only wonder if John Mytton was always sober when he went duck hunting on the ice in his night-shirt, or set the night-shirt alight to cure the hiccups. The earliest state of this plate has a facsimile of Mytton's signature below, and is before the coat-of-arms. It was published in 1841 and again in 1847.

GLASS PAINTINGS

All through the 18th century and later, it was a practice to stick prints face downwards on glass, rub away the paper and colour them from the backs: a variety of coloured print, although in art circles they are usually classed with furnishing objects. Mezzotints were most frequently used, the paper being well soaked before the prints were stuck on the sheets of glass. Then, the paper still being kept damp, it was carefully rubbed away till little remained but the ink of the subject. After drying, the backs of what was left of the prints were given two or three coats of mastic varnish to render them transparent, then coloured from the backs.

Modern varieties or fakes can be told by the perfection of the glass, 18th-century glass being wavy, with air-bubbles here and there, and frequently darker in tone.

15. *Lost or Forgotten Processes*

Some of the methods practised in the earlier days of print production have long been discarded and their ways and means have become obscure. In the 15th and 16th centuries there were examples in which woodcuts or metal-cuts were used to impart a sticky substance to the paper, instead of ink, to which gilding or coloured wool-dust could be made to adhere.

Into this category come what are known as paste-prints and flock-prints (in German: *Teigdrucke* and *Samtdrucke*), dating from about the third quarter of the 15th century.

Paste prints were printed from metal-cuts, impressed by hand-pressure into a thin layer of paste-like substance spread on paper, giving the effect of ridges in relief, and leading to the theory that they could be intended to imitate tooled leather. In some examples traces of thin gold leaf and other decoration have been observed. The 'paste' is of a dark brown tone, possibly tinted. About 200 examples are known, many only fragmentary and mostly unique. There is a very rare variety in which the paste is thicker (up to 5 mm.): the prints being known as sealpasteprints (*Siegelteigdrucke*).

In flock-prints, printed from wood-blocks, an appearance of fabric was first given to the paper, by placing a piece of material on it and impressing the grain into the paper, under enormous pressure. This was coated with a brownish varnish, and a picture printed on the prepared ground, using paste instead of ink. Wool-dust (coloured perhaps with crimson) was then sifted on to the paper, usually to represent a robe and pressed where it was desired that it should adhere, the rest of the wool being shaken off. Few of these prints have survived.

It will be remembered that in the early days of chiaroscuro printing from wood-blocks, the paste method is thought to have been used for the application of gold and silver. The imitation of the grain or pattern of material on the paper reminds us that in the 19th century the pattern of canvas was given to paper by a metal cylinder, as in the case of the Victorian oleographs.

Other prints occasionally show effects which are difficult to explain, though Rembrandt's are no longer accounted mysterious, except for the early self-portrait attributed to him (B. 338; H. 4), where the double, thick and thin, line appears to have been done with a pen, or 'two nails tied together'.

Tools may have been designed for one occasion and then discarded. William Blake is believed on one of his plates, to have used a 'comb', and his reverse writing was for long a mystery, though some good attempts have been made recently to explain it. To print his monotypes he is thought to have painted them on millboard,

instead of a metal plate. In recent years it has become known that William Strang designed a graver shaped like a hook, so that it could be pulled instead of pushed.

There is also the familiar puzzle of Van de Velde's portrait of Cromwell, with an aquatint grain, seemingly applied more than a hundred years before the process was patented by Le Prince. Complicated methods by men like Ploos van Amstel and George Baxter have led writers to claim unknown secrets for them.

Results have sometimes been achieved by machines, superseded by more convenient scientific aids and since forgotten. In the middle of the 19th century John Leech was availing himself of an ingenious machine by which it was possible to reduce or enlarge drawings and prints. These were made or printed on a sheet of rubber, which was expanded, or reduced, to the required size The process was shown in 1860.

Leech, by this means, enlarged some of his drawings (and at least one print, an illustration to *Handley Cross*) some eight times, and then transferred the enlargements to lithographic stones. Rough prints were made from these on canvas and coloured with oil-paints, to produce what he called 'Sketches in Oil', exhibited in 1862. Sets of twelve and six of these were in turn chromolithographed and published by Agnew & Son.

An effective means of reproducing lace, ferns and leaves, called 'nature printing', was invented in the mid 19th century. These objects were placed between a copper plate and a soft lead plate, and put through a roller press under heavy pressure, when the patterns would be implanted perfectly on the softer metal. Electrotypes were then taken for printing in colours. In 1855 Henry Bradbury produced in this way *Ferns of Great Britain and Ireland*.

'Herkomergravure' or 'Herkotypie', was a name coined for another process benefiting by the discovery of electrolysis. Sir Hubert von Herkomer (1849–1914), R. A. and Slade Professor of Art, first made monotypes, and from these took electrotypes, which could be used for printing.

Typographic etching is yet another process relying on electrolysis. In this case, when the drawing has been made through the wax ground, this ground is built up (thickened) by melting more wax on it by means of a pencil of wax and a hot metal rod, great care being taken not to allow the wax to enter the lines. Any lettering required is impressed into this wax with type, the whole acting as a mould from which an electrotype can be taken.

Books full of beautiful and perfect butterflies are occasionally to be seen, actually printed from butterfly wings on gum-prepared paper, the bodies being cut away and inserted by hand or by an engraving. The wings were removed, leaving the colours, which tend to come away to the touch.

Goya's *Giant* is also the subject of some speculation, both as to the correct title and the method employed to engrave it. The Spanish mostly call it *El Coloso* (*Colossus*), but a rather tentative suggestion has been made that it represents Goya's idea of Napoleon, and again that it is Prometheus, chained to a rock, for passing all mankind in cunning and fraud, deceiving Jupiter and stealing fire from the chariot of the sun (Plate 105).

As to the method employed, it has on more than one occasion been authoritatively called a mezzotint, and, in as much as the picture is produced from a black-printing ground by scraper and burnisher, this description might be allowed. But the ground was obviously not laid by a rocker, nor by a large number of cross-hatched and etched lines – the *manière noire* – alternatively suggested by Tomas Harris.

It could well be that the ground was made by placing sandpaper on a wax ground and running it through the printing-press, until, after biting, it would hold enough ink to print black: the sand grain ground.

It has also been described as basically aquatint.

Dr. Auguste L. Mayer says: 'The plate has first received a deep ground of aquatint, from which the lights and middle tones have been worked out with scraper and burnisher.'

Elizabeth du Gué Trapier, in *Goya and his Sitters*, 1964, p. 32, writes that Goya was taught *grabado al humo* (mezzotint) by an artist named Sureda. 'As Sureda was known to have been an engraver and painter, this story is substantiated by the fact that Goya, to make the *Giant*, aquatinted the entire copper plate and then scraped it like a mezzotint.'

Lefort and Delteil, in their catalogues of Goya's prints, do not venture an opinion, but quote V. Carderera, in the *Gazette des Beaux Arts*, to the effect that the artist made a ground that would print black with nitric acid, and then scraped out his lights, as in mezzotint. It would, however, be impossible to make a ground of this sort without laying a porous ground: if acid were laid on the bare surface of the plate, it would roughen it, but simply dissolve it away if the biting were prolonged.

Only six impressions are known, because, according to Goya's son, the plate broke in the printing.

Senefelder, besides his 'chemical' lithographic process is credited with the invention of a system of *Lithographic Engraving* or engraving on stone, in 1796. The stone was rubbed with an oxalic acid solution and covered with a very thin coating of gum, then washed and dried and blackened with lampblack so that the work would show. The engraving was then made with suitable fine tools or needles and the lines thus made filled in with oil and allowed to stand until the oil had been absorbed. After being gummed over again, the stone was inked with a dabber, like an engraving, using a soft ink, wiped off with a soft cloth. Dampened paper was placed on the stone and sufficient pressure applied to pull out the ink from the greasy furrows. The thin coating of gum remained and prevented the stone from absorbing grease accidentally while printing.

Cliché-verre is a name applied to a form of photographic print developed in conjunction with the early photographers and practised mostly by Corot and other members of the Barbizon school, about 1855–60.

A sheet of glass was covered with an opaque white film and placed on a black ground, the design being then drawn with a point through the white film, so that the lines showed up black. The black ground was then removed and a sheet of sensitised paper substituted and exposed to the light. By stamping (*tamponnage*) with a metal

brush, or dragging it over the opaque ground, the brush held perpendicularly, a tint effect could be obtained, varying as the stamping was more or less repeated. Lines of varying thickness, which in an ordinary etching would be obtained by longer biting, would be done by an oval point (*échoppe*), or by using points of differing thickness when drawing through the opaque ground.

A variation of this method, sometimes called 'etching on glass', was used by George Cruikshank from 1864. Instead of sensitised paper, a polished zinc plate was used, covered with a sensitised photographic ground, and exposed to the light. Where the light passed through the lines scratched through the white opaque film, similar lines appeared, hardened by chemical action, on the zinc plate, which was then immersed in a corroding solution, eating away the parts not exposed to the light and leaving the lines of the drawing in relief. When sufficient relief had been obtained, the plate was mounted on a block of wood ready for printing.

At least one process appears to be irretrievably lost. This was a means of reproducing paintings, initiated by Francis Eginton (1737–1805), and called 'Pollaplasiasmos', later altered to 'Polygraphy'.

Eginton was an aquatint engraver, an enameller and a painter of stained glass, a brother and uncle of John and Francis Eginton, the stipple engravers. He was employed by Matthew Boulton in his Birmingham Soho works, and went into partnership with his employer in making 'mechanical paintings'. Using possibly the same process, Joseph Booth, a portrait miniature painter, formed a Polygraphic Society for their exhibition, from 1784 to 1794, with premises in Pall Mall. Some valuable pictures were bought, including a Claude for 400 guineas, the reproductions of which measured 40 by 50 inches. These large prints cost twenty guineas, but there were cheaper ones at two and a half guineas.

A suggestion has more than once been made that some form of photography was used, based on the action of light on chemicals. This claim was advanced by Sir F. P. Smith, curator of the Patents Museum, reading a paper to the Photographic Society in 1863, though it appears to have been generally dismissed at the time as unreasonable.

An advertisement of the process appears in *The Diary*, or *Woodfalls Register*, for 15 February 1791.

> The novelty of the Polygraphic invention renders it necessary to inform those still unacquainted therewith that it is a new art for taking pictures from Originals in Oil Colours, by a chemical and mechanical process, by which ingenious means the correctness of the drawing, and the spirit and effect of the best masters, either old or modern, are so closely imitated as to render these pictures scarcely distinguishable from the originals themselves. A view of the last exhibition at the Polygraphic rooms in London, where several capital pictures by Claude de Lorraine, Teniers, Vernet, and many others, were hung up with the Polygraphic pictures taken from them, convinced the numerous inspectors of the truth of this assertion.
>
> And the Society, who have engaged to promote and diffuse the advantages arising from this valuable discovery, assure the public that, under its present state of improvement, these productions are equal in durability to the paintings of the first masters in oil colours.
>
> The numerous orders the Society have been honoured with, from people of the first rank and taste, evince how well they are calculated to decorate apartments with elegance, though at

a very moderate expense; since the price of these pictures, considering their size, does not exceed that of first rate prints, with their frames and glasses included. The purchasers of these pictures have frequently had the satisfaction of seeing them, when hung up in their apartments, taken for capital originals of great price.

From the aforesaid considerations, they cannot fail proving very profitable adventures to merchants and captains of ships and traders in general to many parts of Europe and America, as well as the East and West Indies, and likewise to dealers in pictures in every part of this Kingdom.

H. G. Clarke, in the *Printing Review*, 1933, wrote extensively on the process, giving the invention to Booth, who first exhibited the prints in 1784 but forbore to take out a patent for fear of giving away the secret, as emissaries from the Continent were just waiting for the specification to appear. Francis Eginton, Clarke says, was only employed by Boulton to supervise the work.

Clarke was convinced it was an aquatint process and connected with Watt's invention of a press for letter-copying. The screw-down press for copying typewritten letters, or those written with copying ink, was used well into the present century, a sheet of tissue paper being placed over the letter and a damp cloth placed on top, when they were put in the press and screwed down. By this means a copy was transferred to the tissue. Matthew Boulton made the presses in his Soho, Birmingham, works, and Clarke concluded that the same ingredients in the copying ink could be mixed with paints, so that a picture painted with them could be transferred to copperplates. He estimated that at least three of these transfers could be made from each picture, to give three key plates, the design being then etched or bitten into the copper by the aquatint method.

The prints were made in an ordinary copperplate printing press, and when desired to simulate oil-paintings, were varnished and laid on canvas. But Booth called his method a 'chemical and mechanical' one and claimed to achieve his results without the aid of an engraver. Mr. Clarke also seems to dismiss too lightly the chemical knowledge of the age.

Arthur T. Gill, writing in the *Photographic Journal*, October 1963, on *The Supposed Early Photographs*, discussed again the claim that these pictures were produced by some early knowledge of the principles of photography and the action of light on chemicals. He found references to sun pictures, the employment of a camera obscura, the famous Lunar Society, and some evidence of a secret process that caused Sir William Beechey to express alarm for the livelihood of painters. The Lunar Society, so-called because their meetings took place at the full moon, was a gathering of local Birmingham scientists and chemists, including James Watt, Matthew Boulton, Joseph Priestley and Erasmus Darwin. Josiah Wedgwood was an occasional visitor and his son Thomas has become known as 'the first photographer' because of a paper he contributed in 1802 to the Journal of the Royal Institution: 'An account of a method of copying paintings upon glass and of making profiles by the agency of light upon nitrate of silver.'

The fact that chloride and nitrate of silver turn black on exposure to light was known to the old alchemists, and it is recorded that Josiah Wedgwood himself had already some

success in experiments. A letter from James Watt to him says: 'Dear Sir, I thank you for your instructions respecting the Silver Pictures, about which, when at home, I will make some experiments.' Mr. Gill also quotes an interesting extract from Sotheby's catalogue of a portion of the Library of Samuel Timmins, 20th April 1899: 'A portrait of John Wesley, taken by electricity by Dr. Priestley', hinting back to the learned gatherings of the Lunar Society and the mysteries of the 18th century.

After all the evidence he gathered, Mr. Gill concludes that 'we do not know the answer'. The only certain thing about the Polygraphic prints seems to be that, although some eighty were produced, they were not a commercial success. What has happened to them might well be thought another mystery. The only two examples noticed in the saleroom have been masquerading as paintings. In fact it has been said that, when varnished, they have frequently been exhibited in salerooms as original paintings of considerable merit. A very large one after P. J. de Loutherbourg, of *Skating*, has had to be tested with a varnish solvent, to see whether it 'came away' or was an old oil-painting capable of withstanding a mild solvent. Some pictures by Wright of Derby, including *An Iron Forge*, are also believed to have been reproduced.

Five Polygraphic pictures are in the Science Museum, South Kensington, London, and three others in the Birmingham Science Museum. The largest of those in South Kensington measures 30 by 43 inches and is printed in two sections, the join being cut to follow the outlines of bodies for concealment. All are printed on paper stuck on canvas. The three in Birmingham are Summer and Winter scenes, measuring 35 by 48 inches, with no joins.

The size, 35 by 48 inches, is larger than the supposed largest sheet of paper made at the time, which might have little significance, but the fact that there are no joins suggests that the prints were not made in an intaglio roller printing press. All very large prints of this kind were normally printed in sections subsequently joined together.

A curious fact has come to light through the prints belonging to South Kensington having been stored in Kent and caught in the floods of 1968. One of the smaller ones, after Kauffmann, has been washed entirely away, leaving the paper blank, and the largest also has been washed away where it was immersed in the water. Cleaners and restorers of prints are constantly immersing them in water and it is well known that intaglio prints are practically impervious to it and can be soaked for very long periods, the ink being unaffected as it is mixed with boiled linseed oil.

A connection between the Boulton–Eginton and Booth processes seems to be only partially proven. Walter G. Strickland's *Dictionary of Irish Artists* gives Joseph Booth as the inventor of 'The Polygraphic Art' and quotes the *Dublin Chronicle*, May 19–22, 1787: 'a picture is copied and multiplied to any number with such accuracy of drawing, colouring and manner that it requires the eye of a master to discover the original from the copy'. He also quotes a paper to the Royal Irish Academy that the results were obtained by a series of stencils and successive printings.

Strickland's description of Booth, d. 1789, as an English artist working in Dublin,

hardly ties in with his London activities, though apparently confirmed by the paper read to the Royal Irish Academy.

William T. Whitley, in *Artists and their Friends*, says Booth's prints were made for a long time in a factory at Woolwich. He quotes the *Morning Herald* 1789 condemning 'a gallery of wretched daubs' and Booth himself as 'a celebrated charlatan'.

Others, however, praised them and the Boulton–Eginton ones were spoken of as so good they were indistinguishable from original paintings. It is probable that some results were better than others. The large one in the Science Museum, South Kensington, after Benjamin West, is not very satisfactory.

Whitley records that Sir Joshua Reynolds sold his *Laughing Girl* to the Polygraphic Society and painted a portrait of C. J. Fox for them. Other artists reproduced were Cosway, Northcote, Morland, Wright of Derby, Kauffmann, Opie, Beechey, Hoppner, Hamilton, Wheatley, Greuze and De Loutherbourg.

He quotes a reference to the production by J. R. Smith of 'coloured impressions of his plates in oil to resemble paintings of a superior kind', but this may mean the custom of some artists of colouring prints after their works with oil paints, so that it is difficult to see the grain of the print underneath, then varnishing them, cutting off the margins, mounting them on canvas or panel and framing them to imitate oil paintings. Sporting prints were the most frequently treated this way, some of Dean Wolstenholme's being particularly deceptive.

Index

1. Detail from a portrait of Mably, engraved by P. M. Alix, showing broad border-line and register mark

2. G. Demarteau: detail from a pastoral after J. B. Huet, crayon manner; from a genuine example

Dessiné par J. B. Huet Pe

3. Detail from a reproduction of plate 2 with roulette work in the black border and outer border

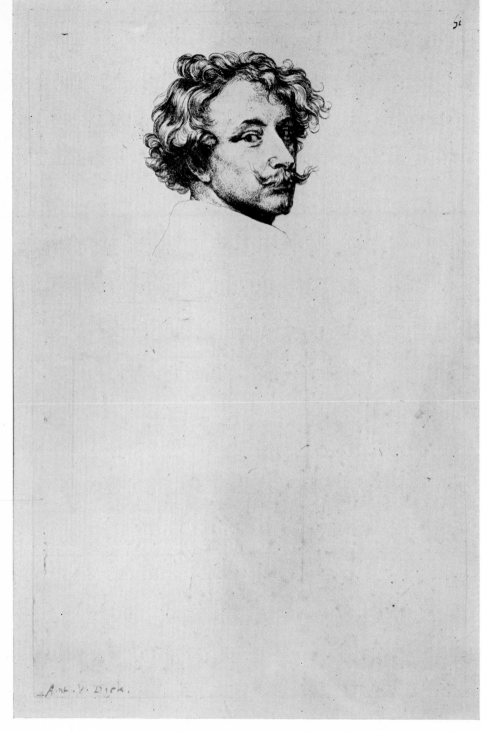

4. Sir A. Van Dyck: self-portrait; etching, first state

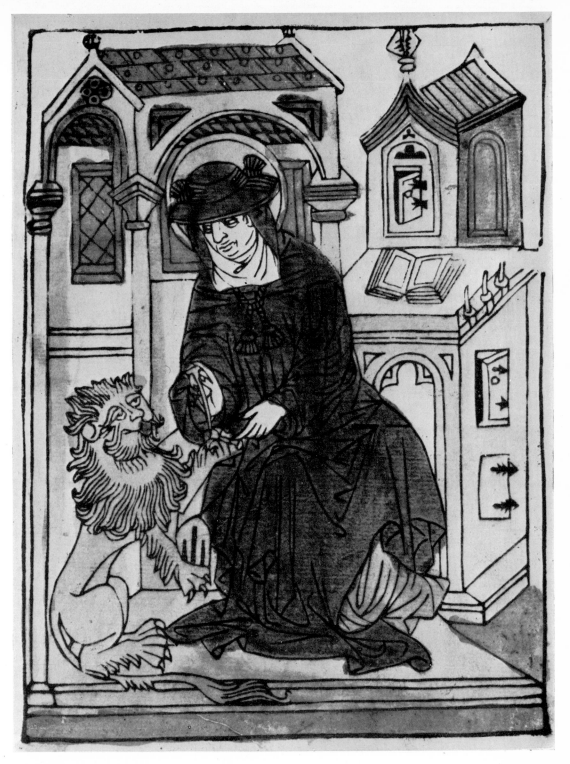

5. Woodcut, 15th century, *St. Jerome* (Schreiber 1543), coloured. *From an impression in the British Museum*

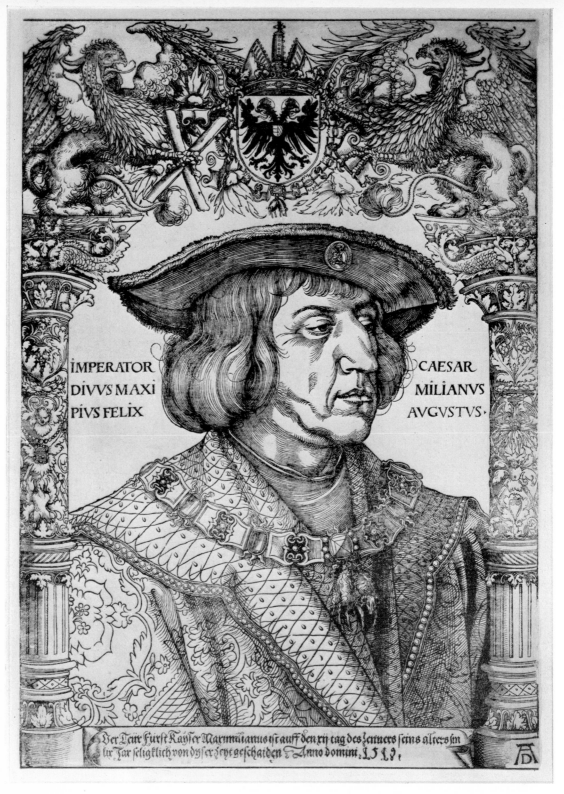

IMPERATOR
DIVVS MAXI
PIVS FELIX

CAESAR
MILIANVS
AVGVSTVS·

6. Albrecht Dürer: *The Emperor Maximilian I* (Bartsch 153); woodcut

7. *The Agony in the Garden*; metal-cut (dotted print), 15th century

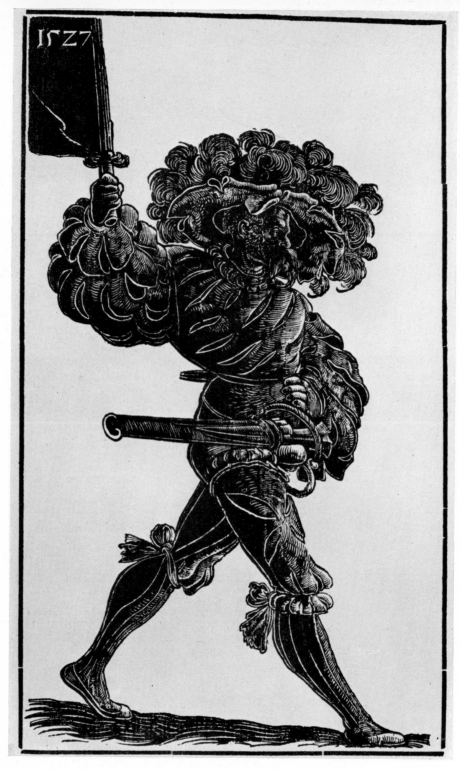

8. Urs Graf: *A Standard-Bearer*; white-line woodcut

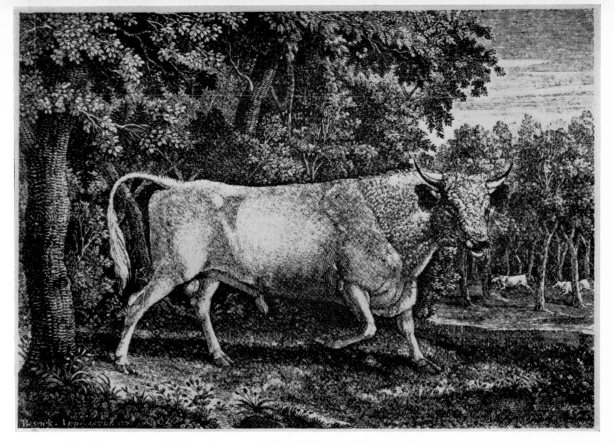

9. Thomas Bewick: *The Chillingham Bull*; wood-engraving

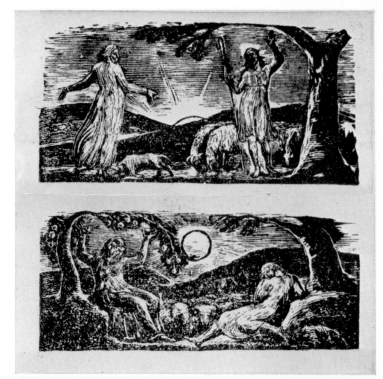

10. William Blake: illustrations
to *Imitations of Virgil's First
Eclogue*; wood-engravings

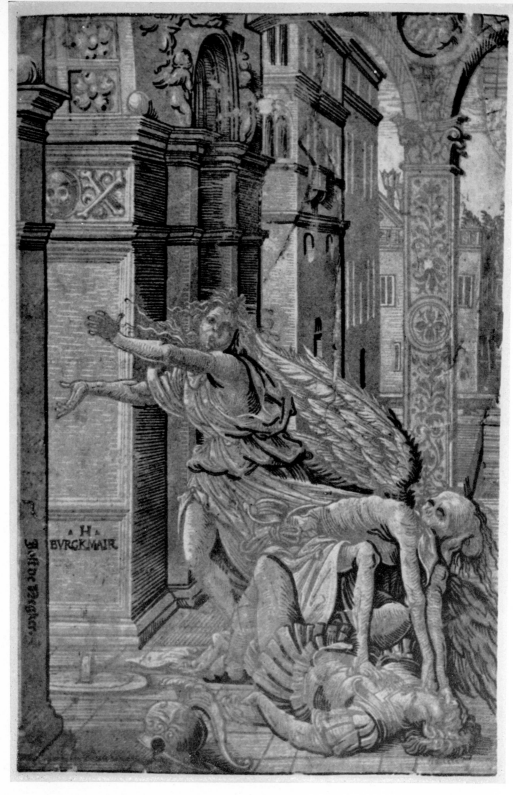

11. Hans Burgkmair: *Lovers surprised by Death* (Bartsch 40); chiaroscuro woodcut

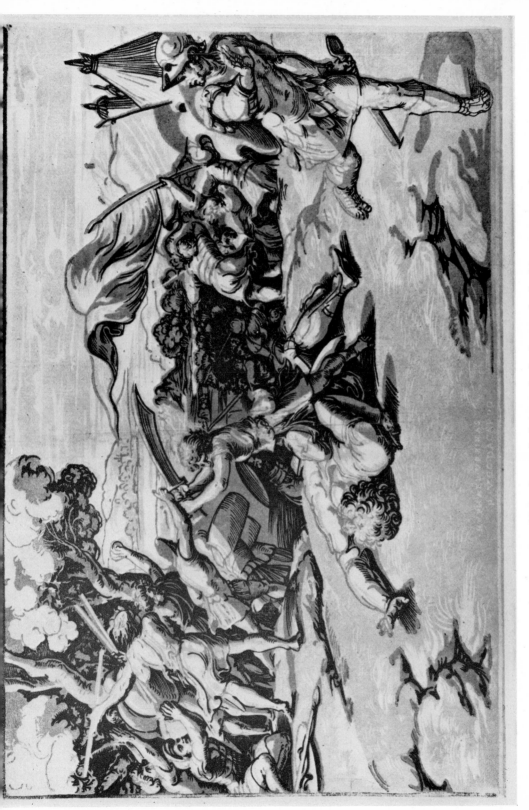

12. Ugo da Carpi: *David beheading Goliath* (Bartsch 8) after Raphael; chiaroscuro woodcut

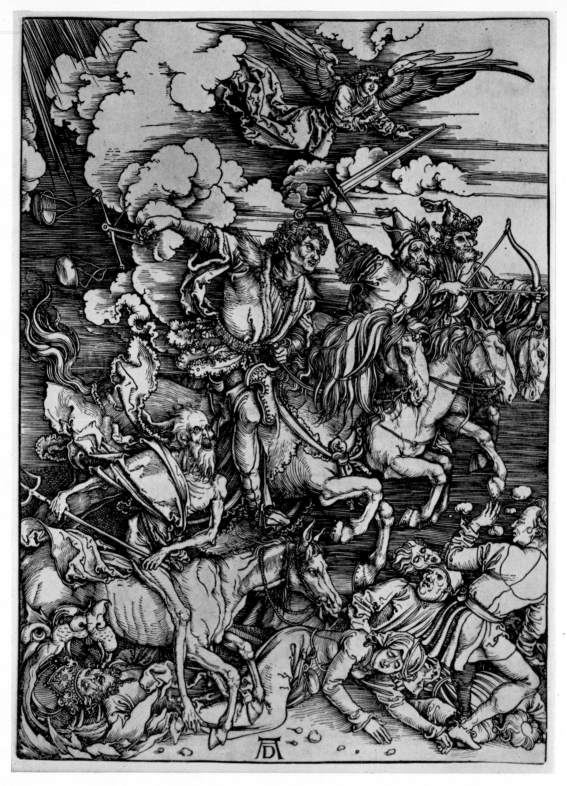

13. Albrecht Dürer: *The Four Horsemen of the Apocalypse* (Bartsch 63); woodcut

14. Albrecht Altdorfer: *The Beautiful Virgin of Ratisbon* (Bartsch 51); woodcut in colours

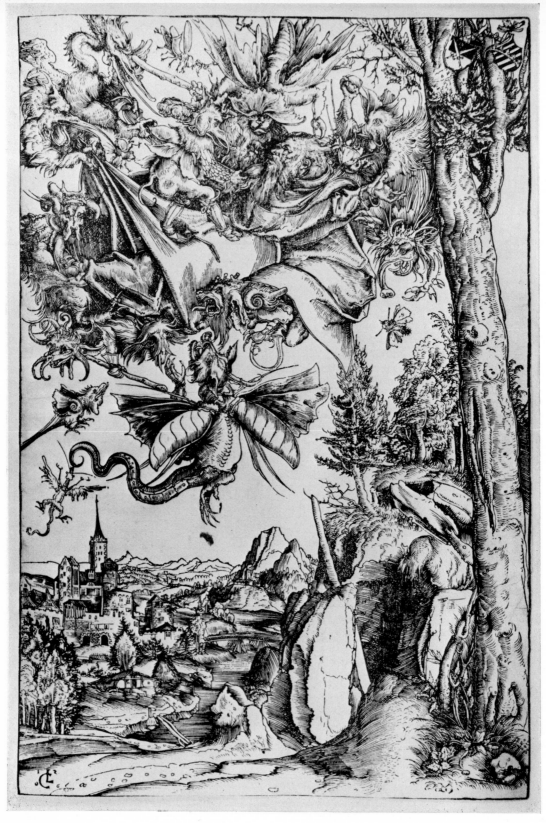

15. Lucas Cranach the Elder: *St. Anthony tormented by Demons*; woodcut

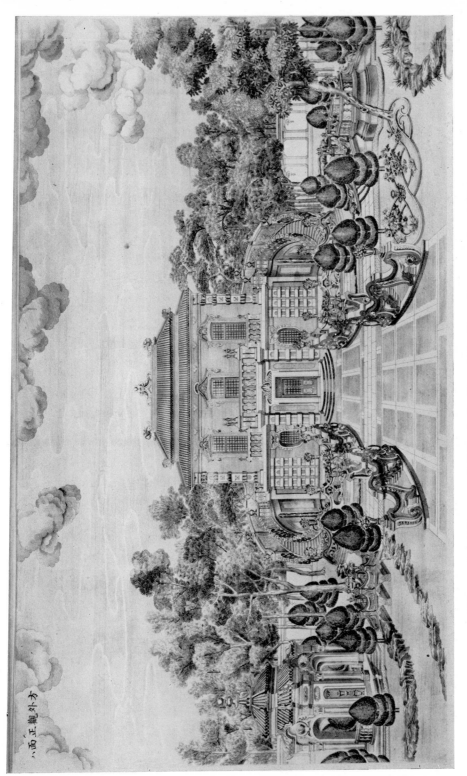

西正觀外方

16. Chinese school: *European Building in the Yuan Ming Yuan*; line-engraving, 18th century

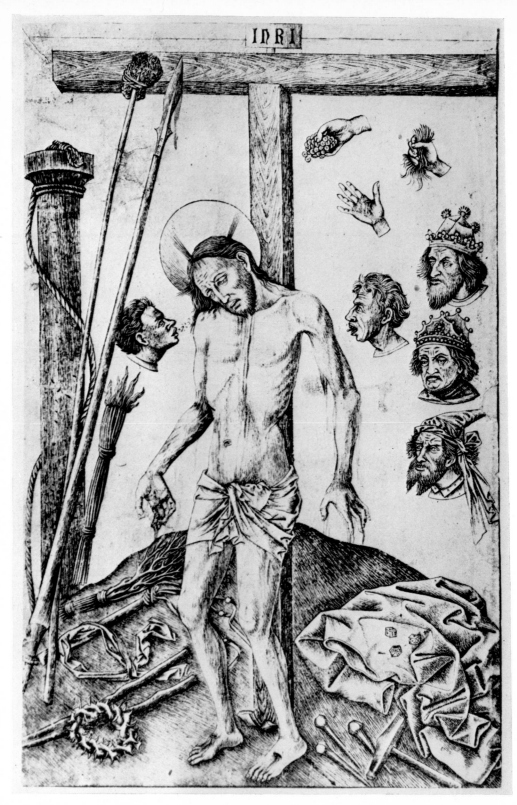

17. The Master of the Playing Cards: *The Man of Sorrows* (Lehrs 28); line-engraving

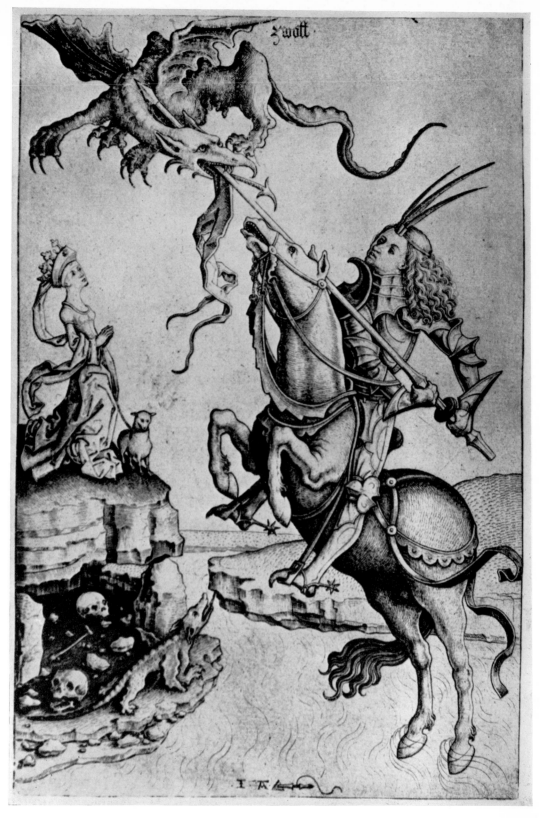

18. Master I.A. of Zwolle: *St. George* (Lehrs 17); line-engraving

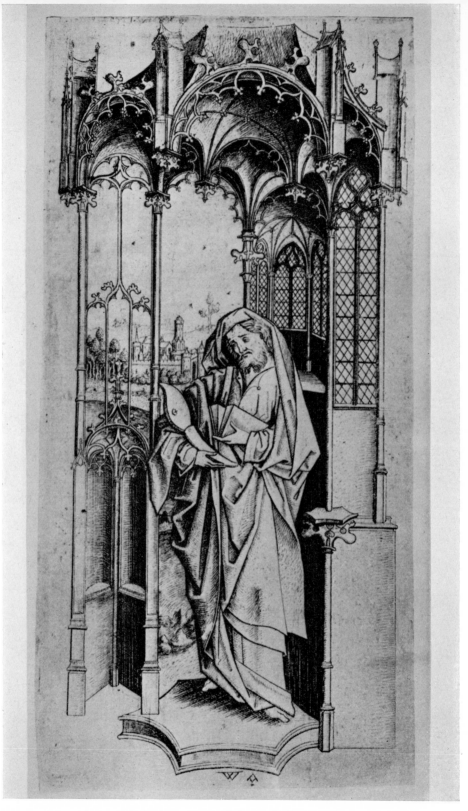

19. Master W A : *St. Bartholomew* (Lehrs 14); line-engraving

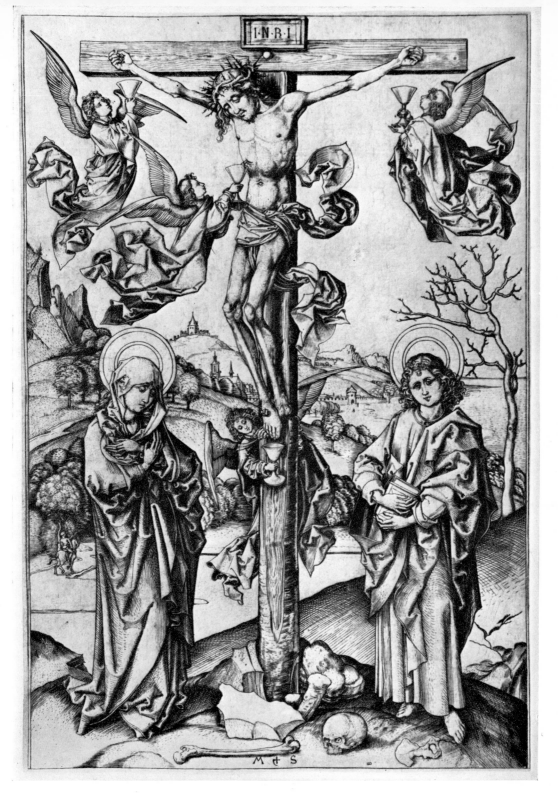

20. Martin Schongauer: *The Crucifixion* (Bartsch 25); line-engraving

21. Israhel van Meckenem: panel of ornament (Bartsch 206, Lehrs 620); line-engraving

22. Master M.Z.: *The Grand Ball*, 1500, Count Albrecht IV of Bavaria and Countess (Bartsch 13); line-engraving

23. Albrecht Dürer: *Four Witches* (Bartsch 75); line-engraving

24. Albrecht Dürer: *The Knight, Death and the Devil* (Bartsch 98); line-engraving

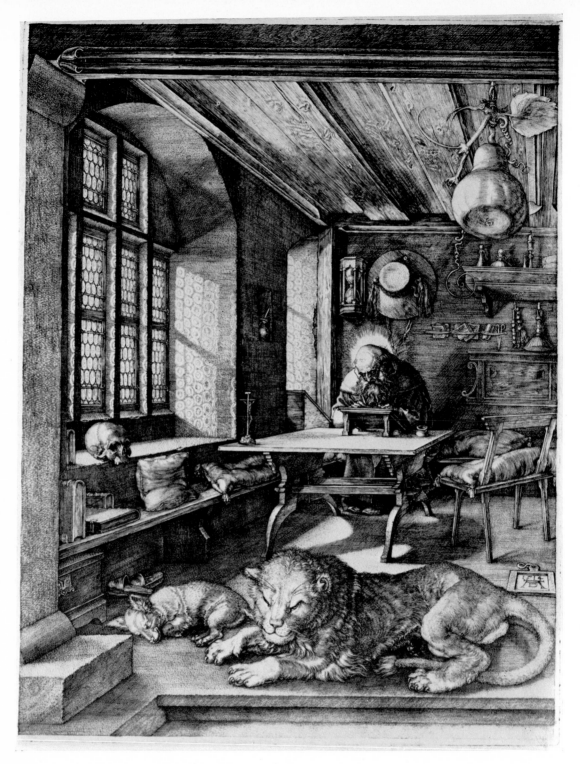

25. Albrecht Dürer: *St. Jerome in his Study* (Bartsch 60); line-engraving

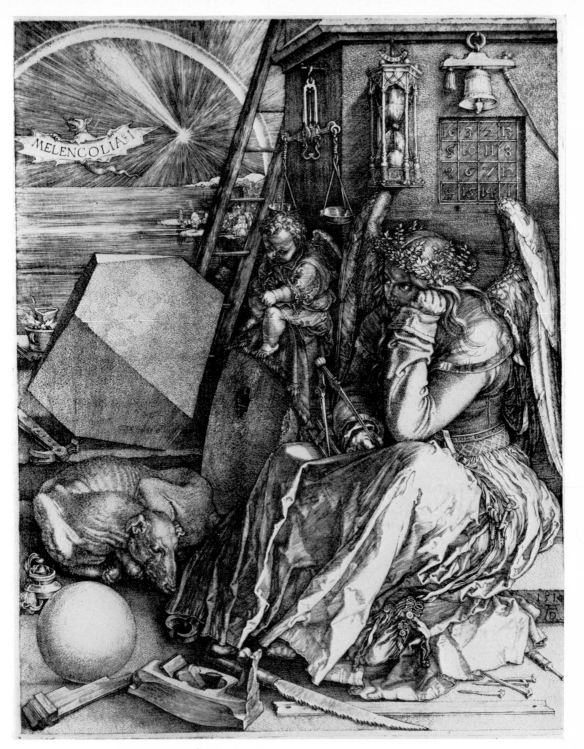

26. Albrecht Dürer: *Melencolia* (Bartsch 74); line-engraving

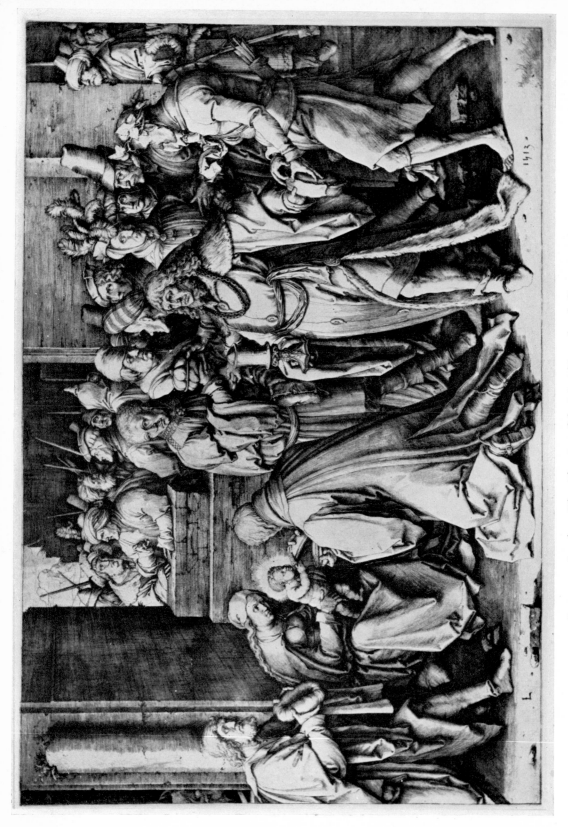

27. Lucas van Leyden: *The Adoration of the Magi* (Bartsch 37); line-engraving

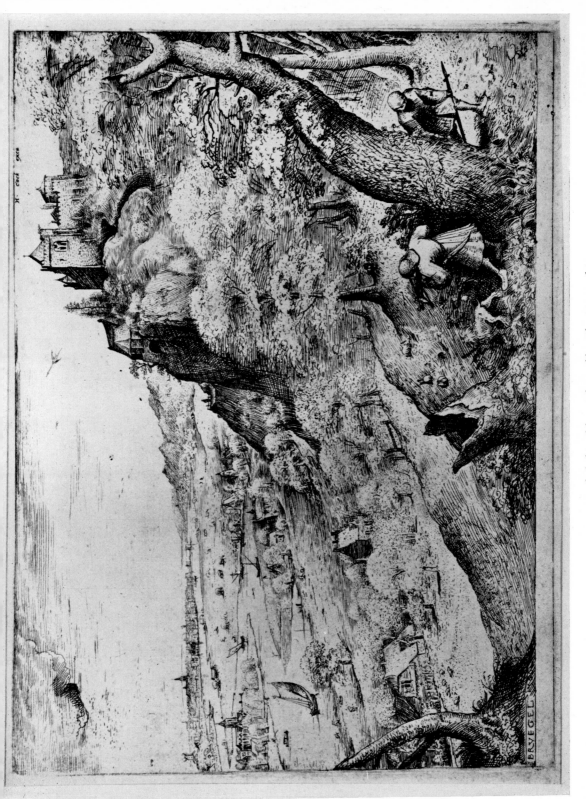

28. Pieter Brueghel the Elder: *The Rabbit-Shooters*; etching

P. brueghel. Inuentor. Cock excud. cum gratia. 1558. H.

QVIS METVS AVT PVDOR EST VNQVAM PROPERANTIS AVARI?
Ecce beleesthepit staemte noch goedsich vermaen die staepende ghuerithepit niet aen

AVARITIA

29. Pieter Brueghel the Elder (after): *Avarice*; line-engraving

Cum privileg.

30. Pieter Brueghel the Elder (after): *Man-of-War*; line-engraving

Signifer ingentes animos, et corda ministro,
Me stat stante phalanx, me fugiente fugit.

31. Hendrik Goltzius: *The Standard-Swinger* (Bartsch 125); line-engraving. *By courtesy of Douglas Ash, F.R.S.A.*

Dum *fragam genitrix, tædas accendit in Ætna,*
Et tot'notam quærit in, orbe suam.
Pietas qui congexit anum, simplicimque loquit.
Scanti limbram rusticiy dulce lædit.
A. Elsheimer pinxit. Cardinali amplissimo in deuoti animi testimonium. H Goudt sculpsit et dicauit Romæ: 1610.

Scipioni Burghesio
S. R. E.

Dum bibit acceptum, Risit puer improbus illam.
Nec satis hoc, auidam dixerat ille Deam,
Lidentem Liquida fertur sparsisse polenta,
fugisset sed iam Stellis factus erat.

Janus Rutgers,

32. Count Hendrik Goudt: *Ceres seeking her Daughter*, after Elsheimer (Hollstein 5); engraving

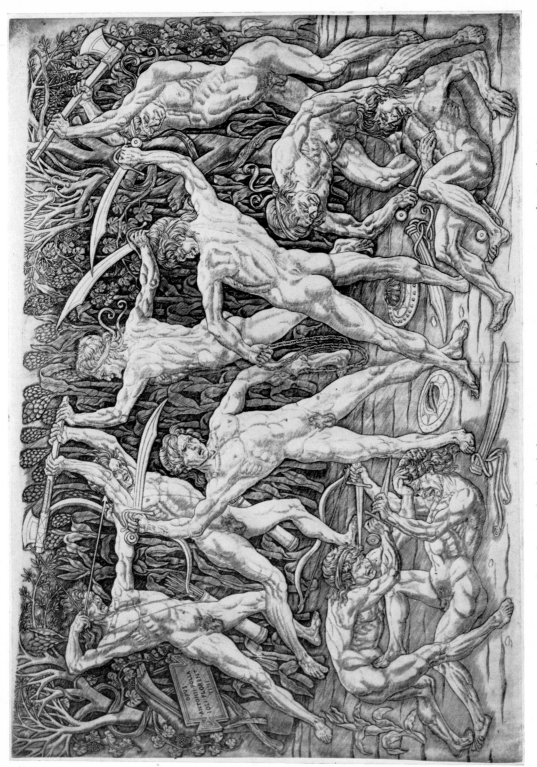

34. Antonio Pollaiuolo: *Battle of Naked Men*; engraving. *From an impression in the British Museum*

Bon Padua

35. Andrea Mantegna (school of): *The Descent into Hell* (Bartsch 5); line-engraving

36. Giulio Campagnola: *St. John the Baptist* (Hind 12), possibly after Mantegna; engraving

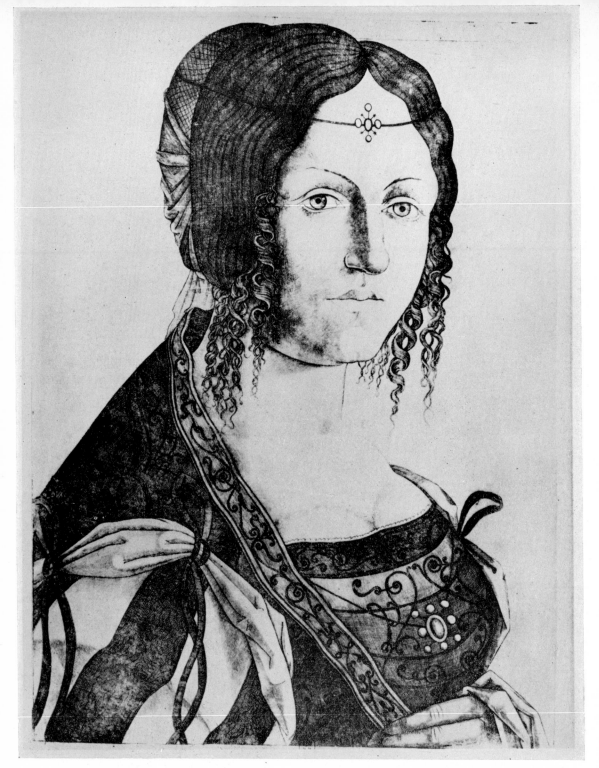

37. School of Leonardo da Vinci: *Portrait of a Lady*; engraving

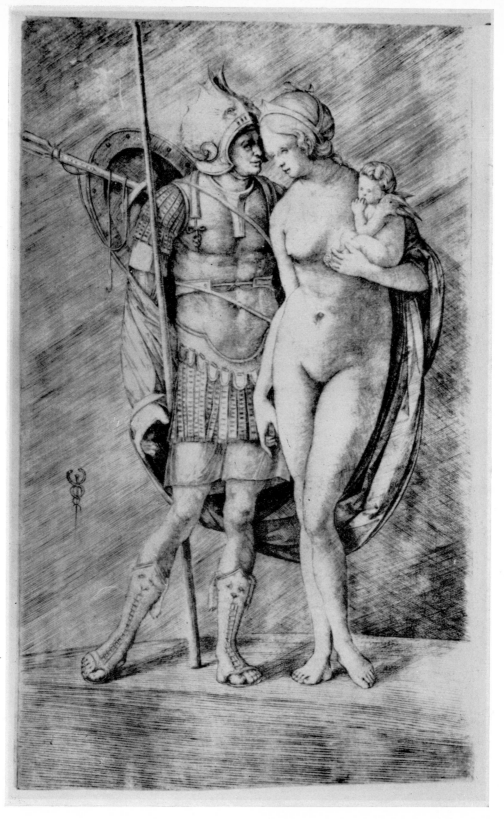

38. Jacopo de' Barbari: *Mars and Venus* (Bartsch 20); line-engraving

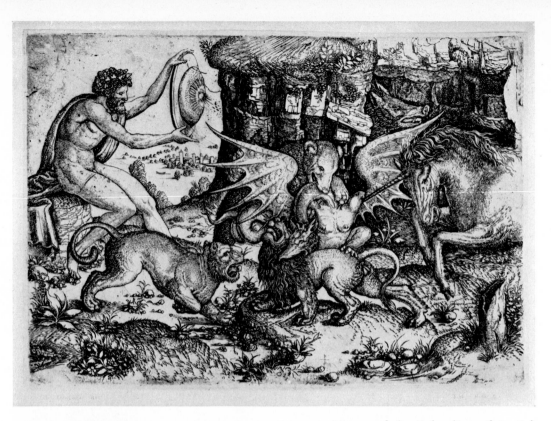

39. Master of the Beheading of St. John
the Baptist: *Combat of Animals*; line-
engraving

40. Marcantonio: *The Death of Lucretia*,
after Raphael; line-engraving

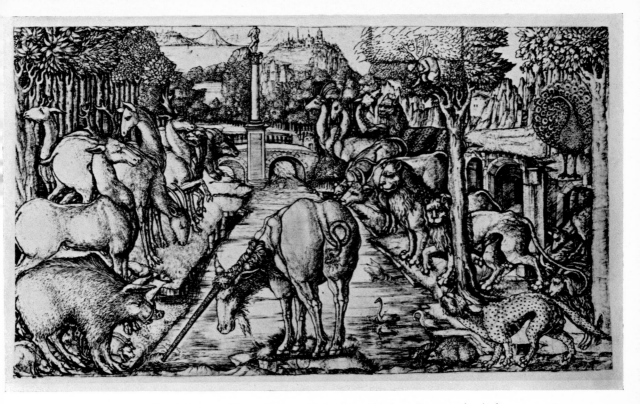

41. Jean Duvet: *The Unicorn purifies a Spring with his Horn* (Robert-Dumesnil 59); line-engraving

A. Watteau pinxit. Lau. Cars Sculp.

FÊTES VENITIENNES FESTA VENETA

Gravées d'Apres le Tableau original peint par Watteau Sculpta juxtà Exemplar à Watteavo depictum cujus
haut de 1.pied 9.pouces sur 1.pied 5.pouces altitudo 1.pedem cum 9.uncüs et latitudo 1.pedem
 de large. Du Cabinet de M.de Jullienne. cum 5. continet.
a Paris chez la Veuve de F.Chereau,graveur du Roy rue S.Jacques auxdeux pilliers d'or, Avec Privilege du Roy.

42. L. Cars: *Fêtes Venitiennes*, after Antoine Watteau; line-engraving

J.M.Moreau del. Carl Guttenberg fc.

Le Rendez-vous pour Marly.

A.P.D.R.

43. C. Guttenberg: *Monument du Costume: Le Rendez-vous pour Marly,* after Moreau le jeune;
line-engraving

Invented Painted Engrav'd, & Publish'd by Wm Hogarth June ye 25 1735. according to Act of Parliament.

44. William Hogarth: *A Rake's Progress*, plate 3: *The Rose Tavern, Drury Lane*; line-engraving

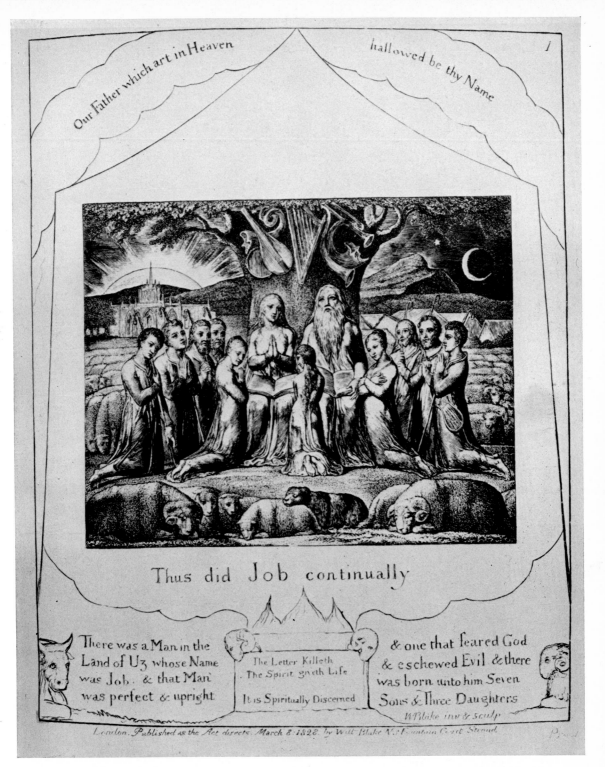

45. William Blake: *Illustrations of the Book of Job*, plate 9: *Job in Prosperity*; line-engraving

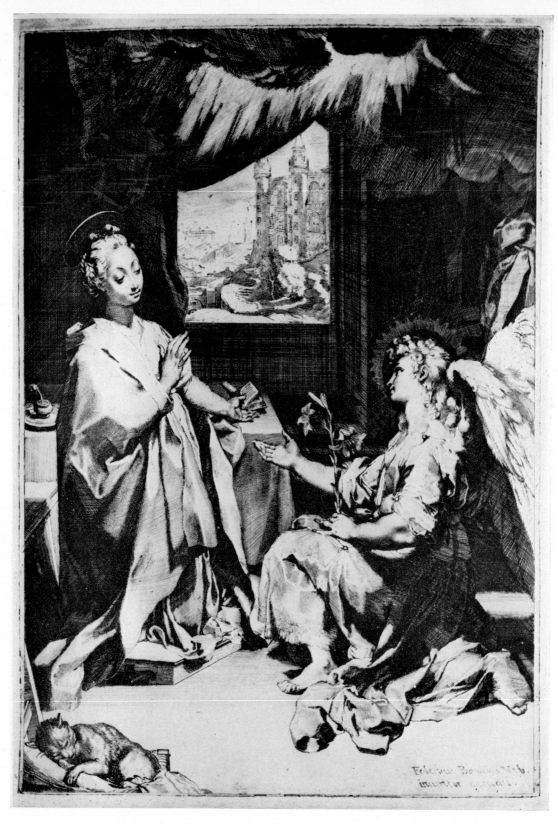

46. Federigo Baroccio: *The Annunciation* (Bartsch 1); etching

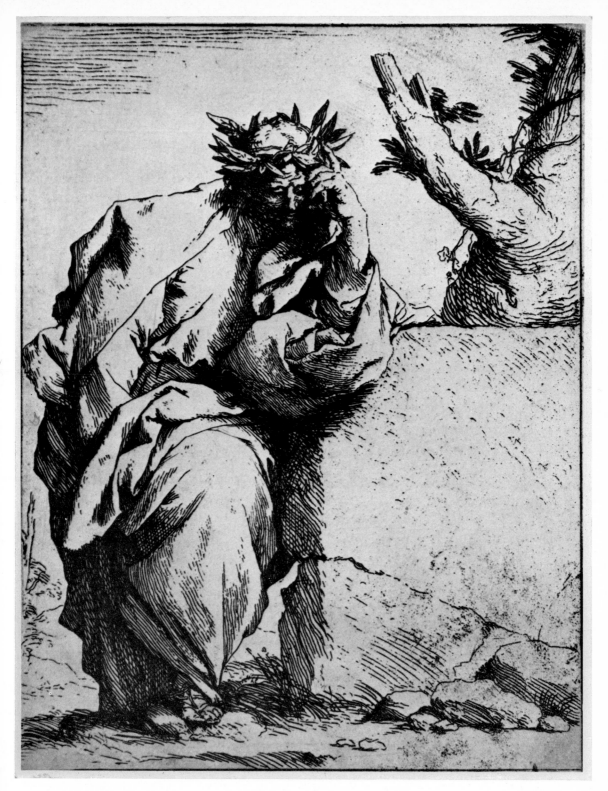

47. Ribera: *The Poet* (Bartsch 10); etching

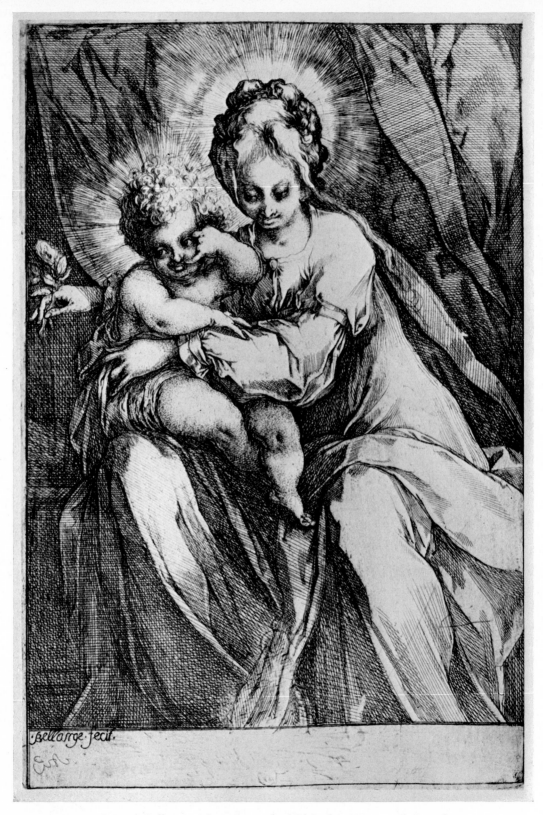

48. Jacques Bellange: *The Virgin and Child* (Robert-Dumesnil 4); etching

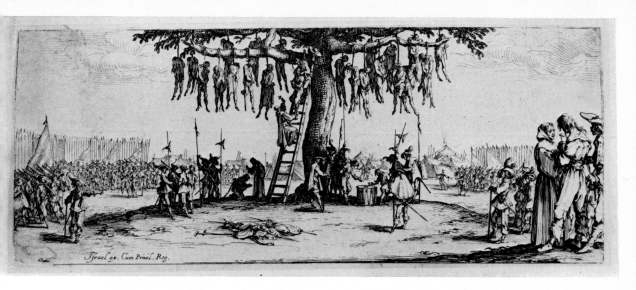

49. Jacques Callot: *Misères de la Guerre*, one of the large plates; etching

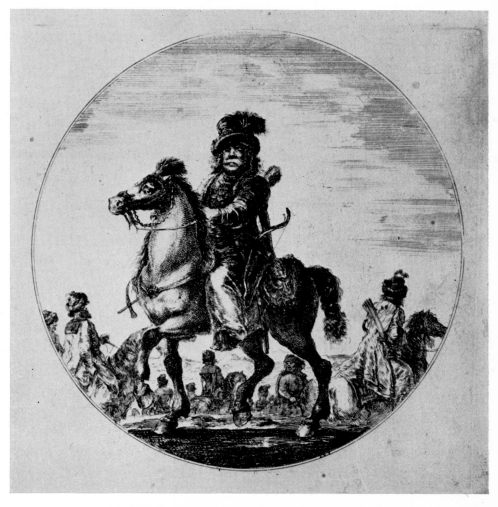

50. S. Della Bella: *Hungarian Cavalryman* (De Vesme 278); etching

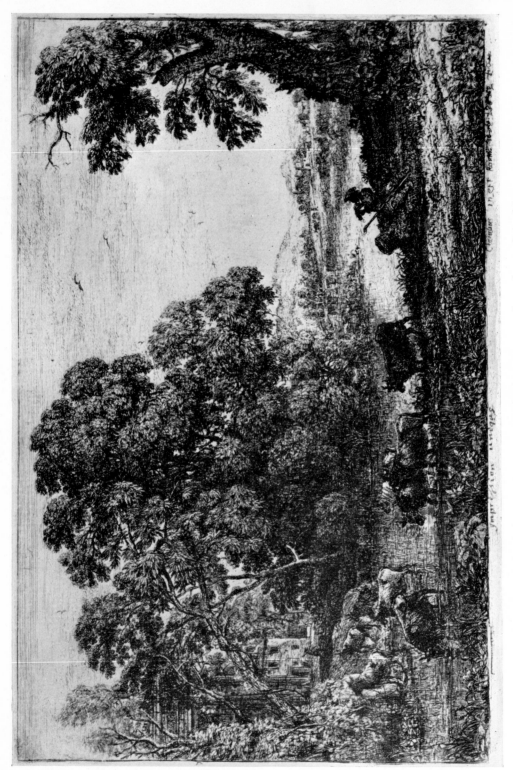

51. Claude le Lorrain: *Le Bouvier* (Robert-Dumesnil 8, Blum 18); etching

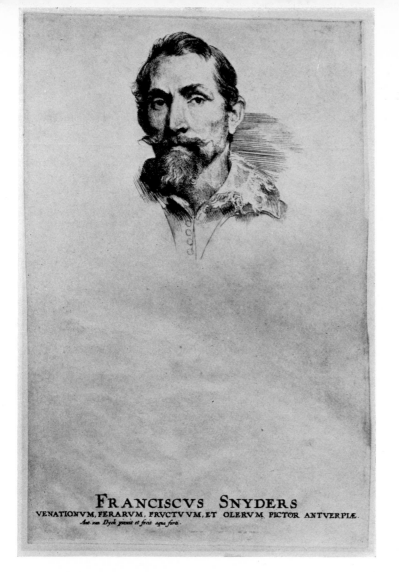

FRANCISCVS SNYDERS
VENATIONVM, FERARVM, FRVCTVVM, ET OLERVM, PICTOR ANTVERPIÆ.
Ant. van Dyck pinxit et fecit aqua forti.

52. Sir A. Van Dyck: *Frans Snyders* (Dutuit 11); etching, second state, before the body and hands were engraved by J. Neefs

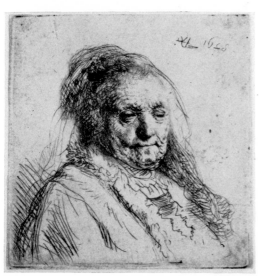

53. Rembrandt: *Rembrandt's Mother* (Bartsch 354, Hind 1); etching

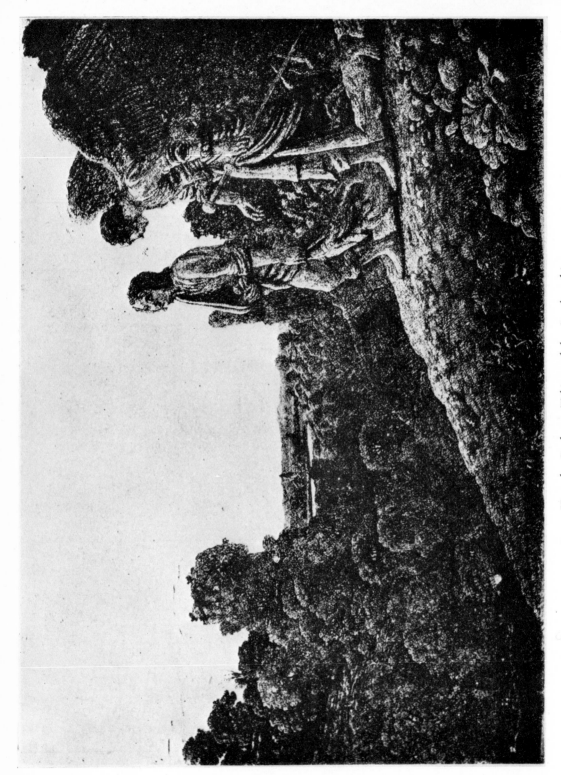

54. Hercules Seghers: *Tobias and the Angel*; etching

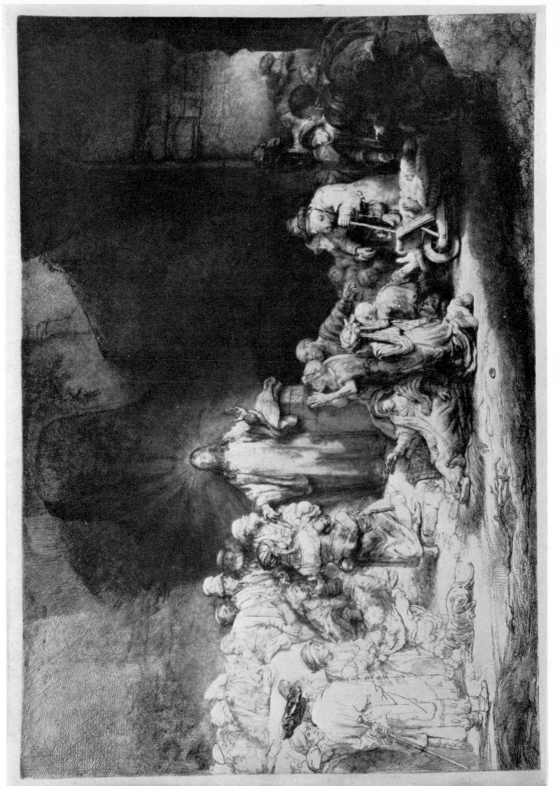

55. Rembrandt: *Christ Healing the Sick (The Hundred-Guilder Print)* (Bartsch 74, Hind 236); etching and drypoint

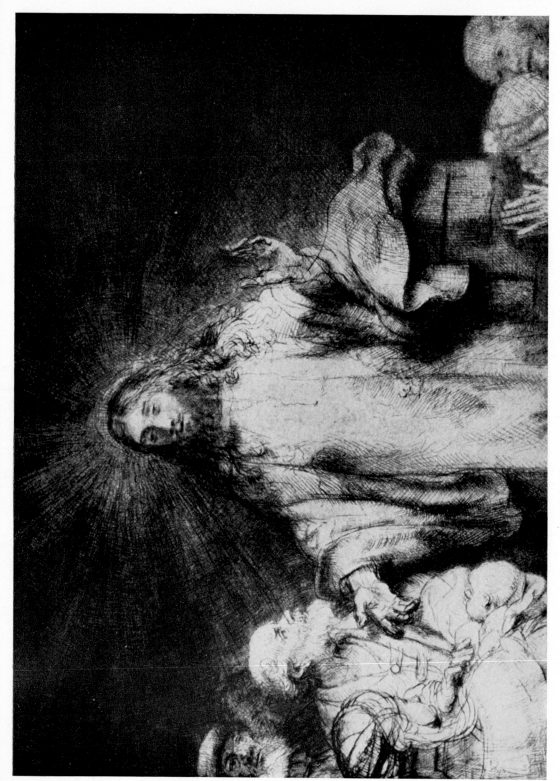

56. Rembrandt: detail from *The Hundred-Guilder Print*

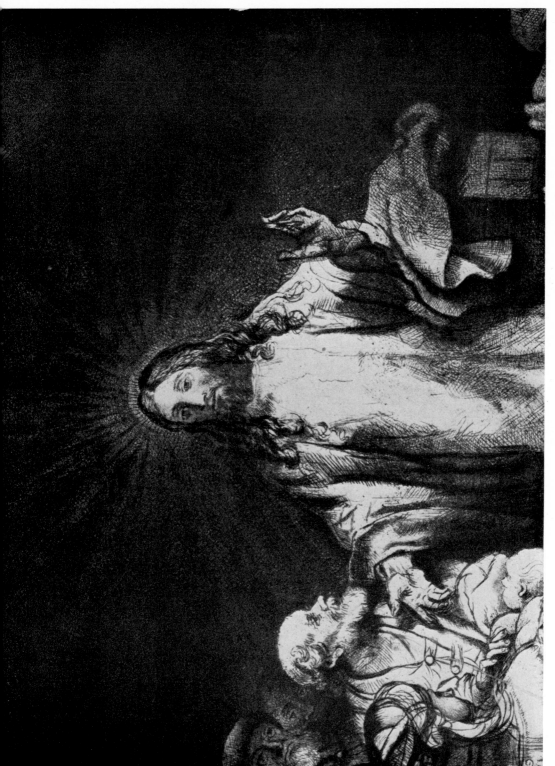

57. Rembrandt: detail from *The Hundred-Guilder Print* as reworked by Captain William Baillie

58. Rembrandt: *Jan Six's Bridge* (Bartsch 208, Hind 209); etching

59. Rembrandt: *The Three Trees* (Bartsch 212, Hind 205): etching and drypoint

60. A. van Ostade: *The Family* (Bartsch 46); etching

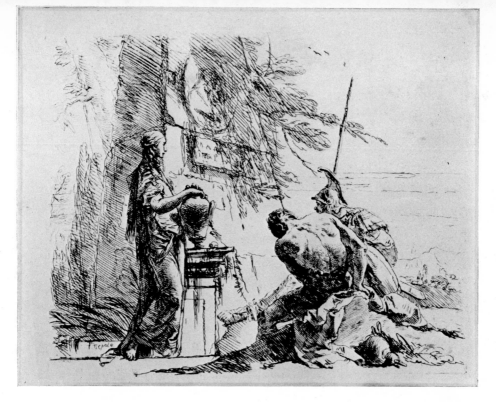

61. G. B. Tiepolo: *The Woman with her Two Hands on a Vase* (De Vesme 6); etching,
from the set of ten *Vari Capricci*

62. A. Canaletto: *La Torre di Malghera* (De Vesme 2); etching

Vue laterale des Galleries du Zwinger.

avec le Pont qui dégage vers l'Allée.

63. Bernardo Bellotto: *Vue Latérale des Galeries du Zwinger à Dresde* (De Vesme 21); etching

64. G. B. Piranesi: *Vedute di Roma: St. Peter's with Forecourt and Colonnades* (Hind 3); etching

65. G. B. Piranesi: *Carceri*, plate 3 (Hind 3); etching

66. Thomas Gainsborough: *A Woodland Glade* (Woodall 14); soft-ground etching

67. J. S. Cotman: plate from his *Liber Studiorum*; soft-ground etching

68. Ludwig von Siegen: *Amelia Elizabeth, Landgravine of Hesse*; mezzotint

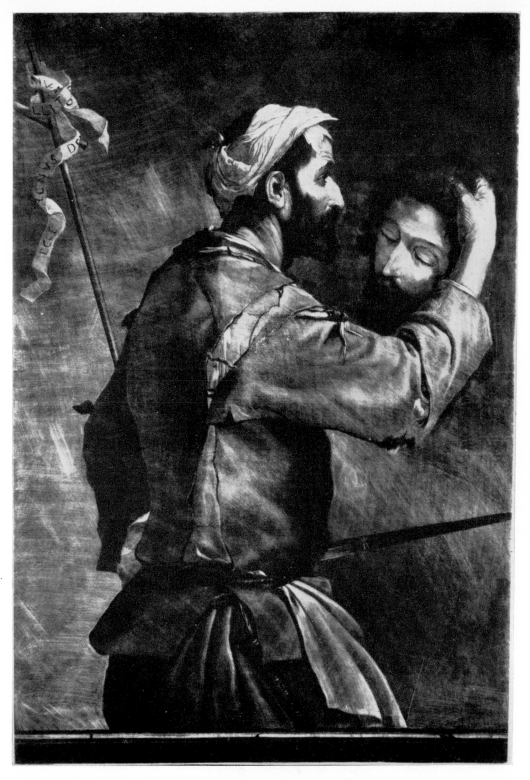

69. Prince Rupert: *The Great Executioner*, after Spagnoletto; mezzotint. *From an impression in the British Museum*

70. Specimen of mezzotint ground
laid with a rocker

A LADY IN WAITING.

71. J. R. Smith: *A Lady in Waiting*;
mezzotint, published by
Carington Bowles

72. James McArdell: *Lady Mary Coke*, after
Allan Ramsay; mezzotint

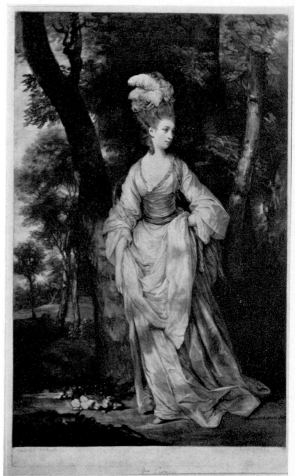

73. J. R. Smith: *Mrs. Carnac*, after Sir J.
Reynolds; mezzotint

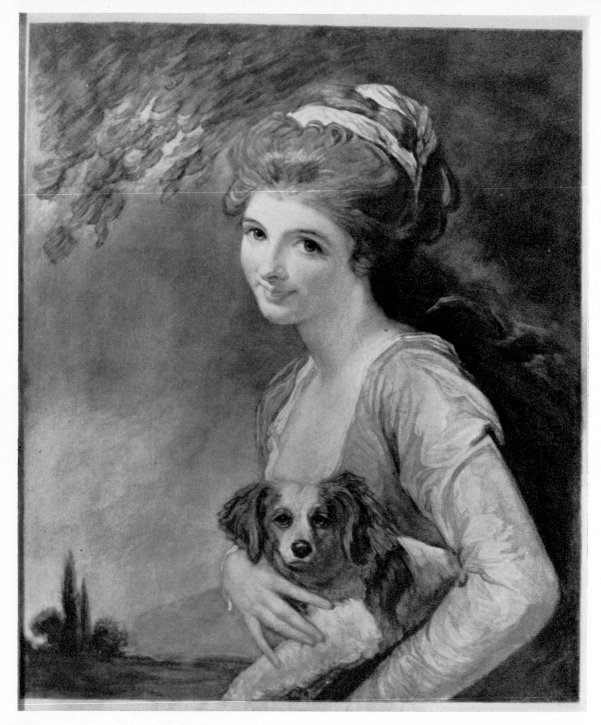

74. Henry Meyer: *Lady Hamilton* (Horne 42), after G. Romney; mezzotint

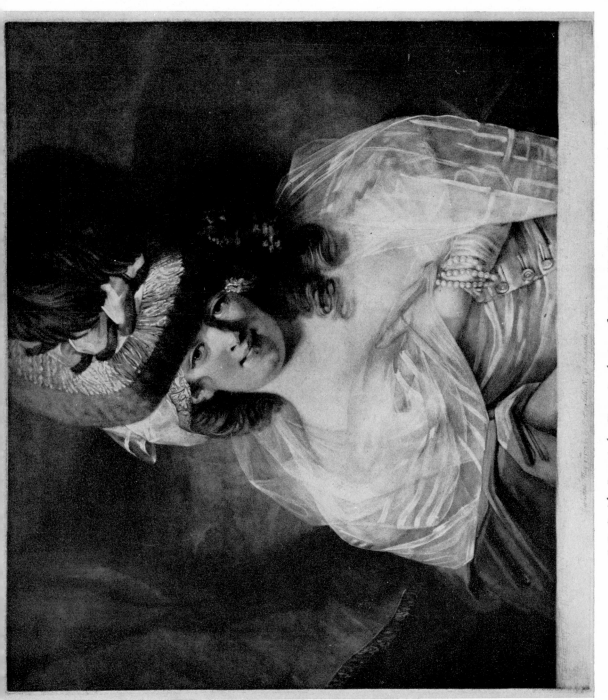

75. J. R. Smith: *Love in her Eyes sits playing*, after Rev. M. W. Peters; mezzotint

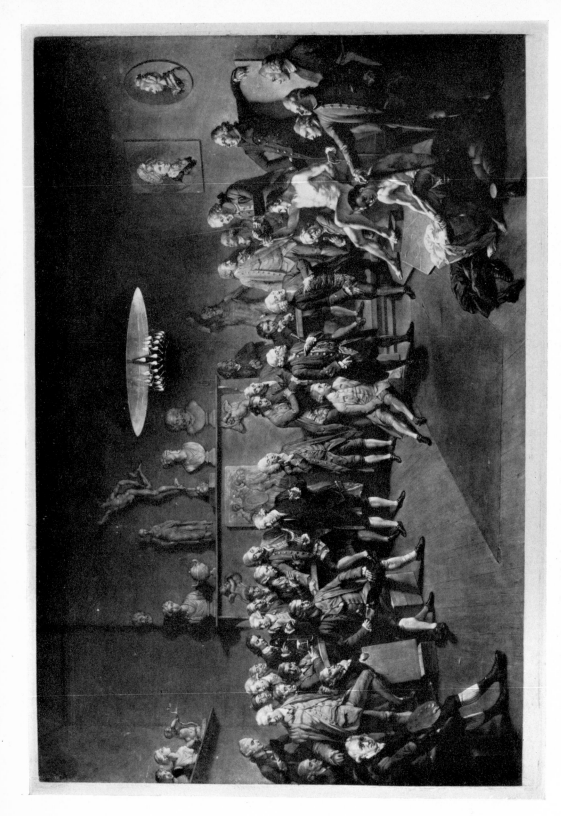

76. Richard Earlom: *The Life School at the Royal Academy, after Zoffany; mezzotint*

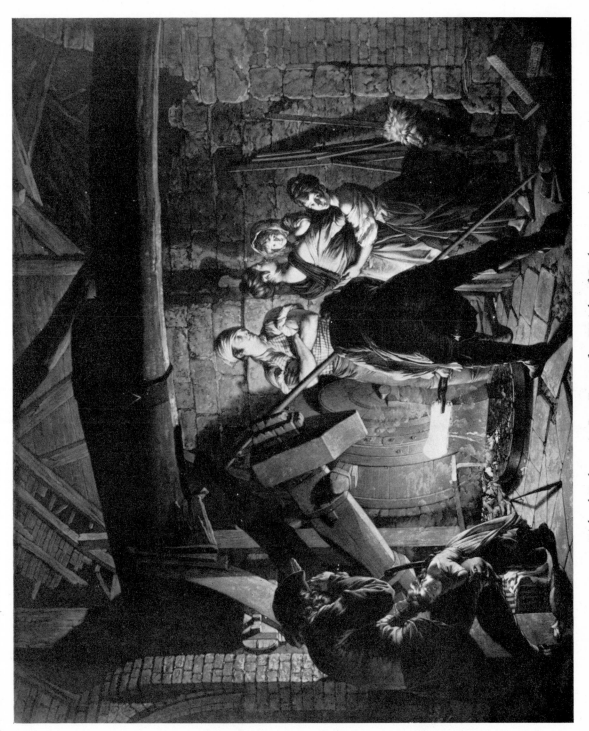

77. Richard Earlom: *An Iron Forge, after Wright of Derby; mezzotint*
By courtesy of Christopher Mendez, Esq.

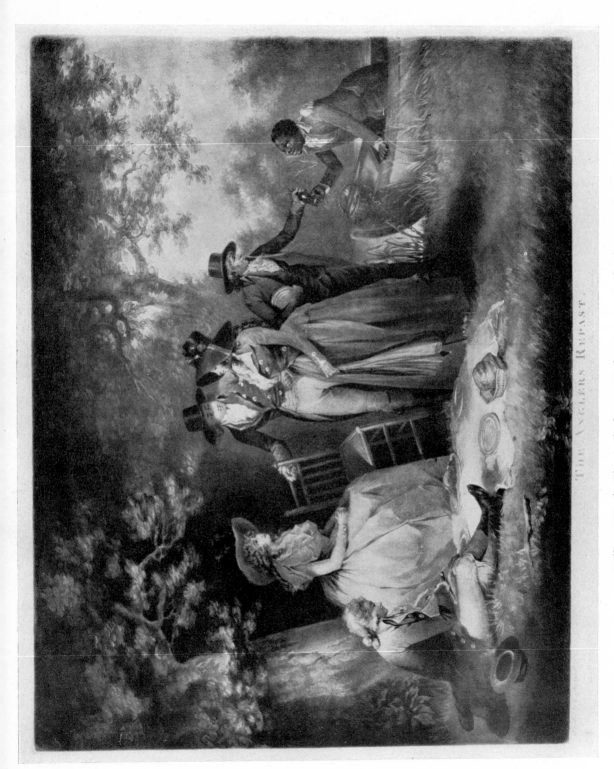

The Anglers' Repast.

78. William Ward: *The Anglers' Repast*, after George Morland; mezzotint

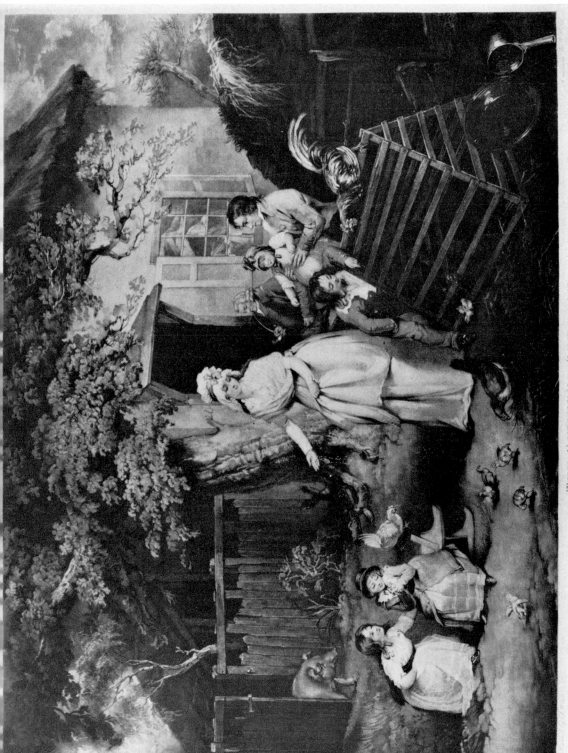

THE CITIZEN'S RETREAT

79. William Ward: *The Citizen's Retreat*, after James Ward; mezzotint

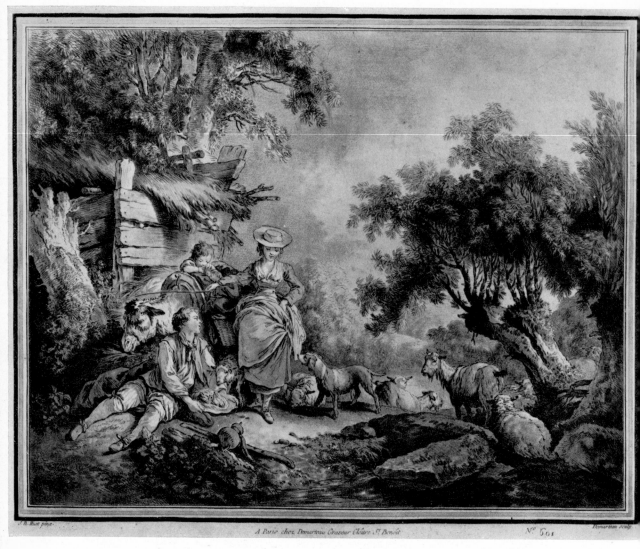

80. G. Demarteau: *Grande Pastorale*, after J. B. Huet; crayon manner and aquatint

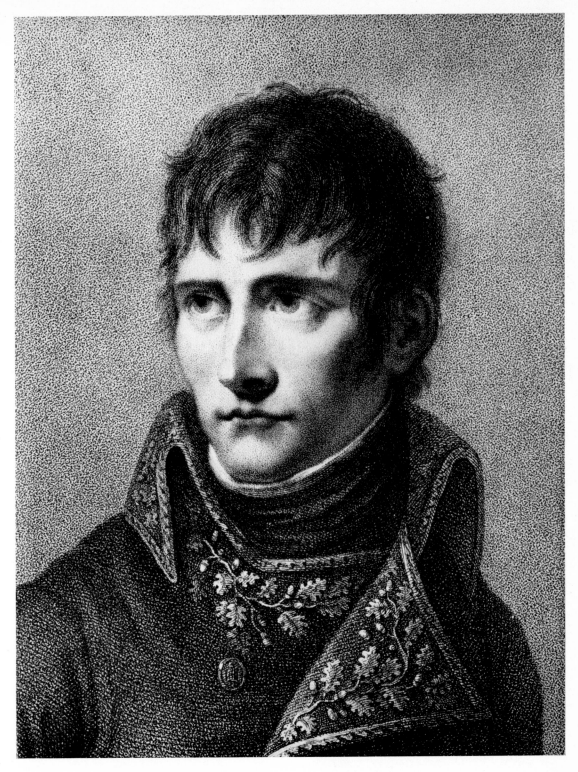

81. F. Bartolozzi: detail of *Napoleon*, after A. Appiani; stipple

The PROMENADE in St. JAMES'S PARK

82. F. D. Soiron: *The Promenade in St. James's Park*, after Edward Dayes; stipple

83. M. Dubourg: *George III hunting in Windsor Park*, after J. Pollard; detail showing aquatint ground

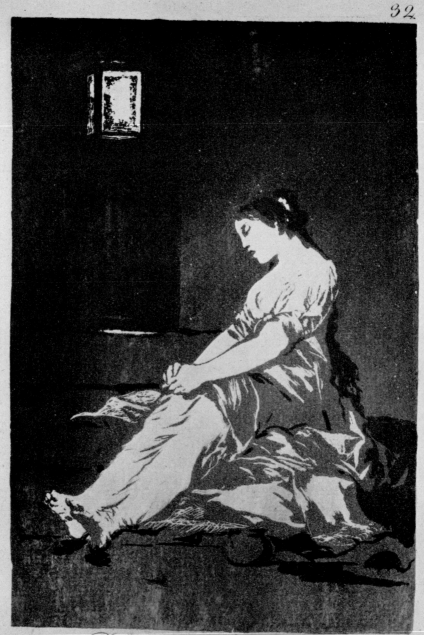

Por que fué sensible.

84. Francisco Goya: *Los Caprichos*, plate 32; aquatint

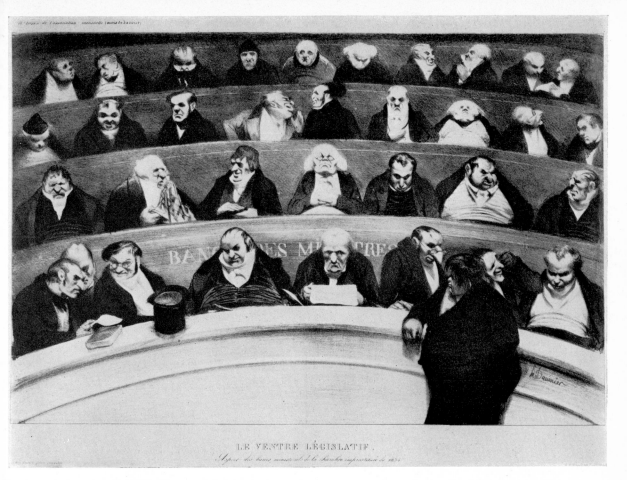

85. H. Daumier: *Le Ventre Législatif*; lithograph

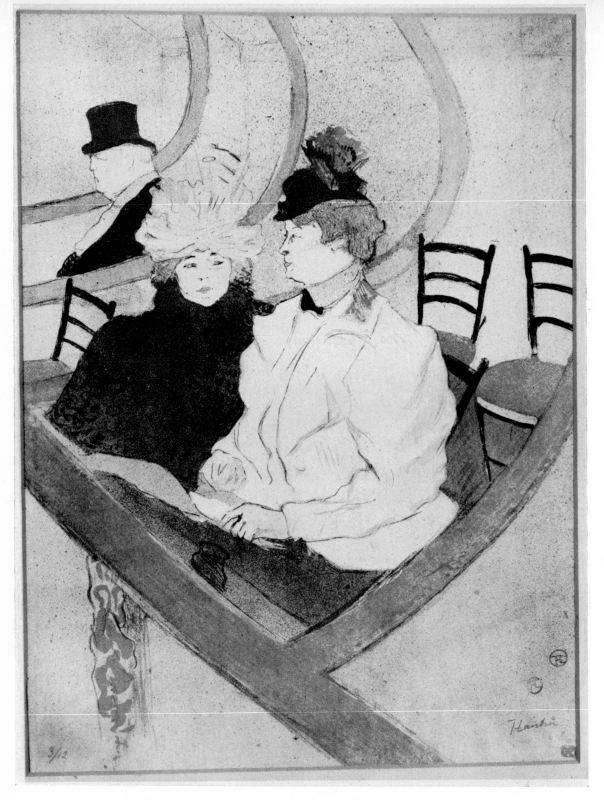

3/12

86. Toulouse-Lautrec: *La Grande Loge*; lithograph in colours

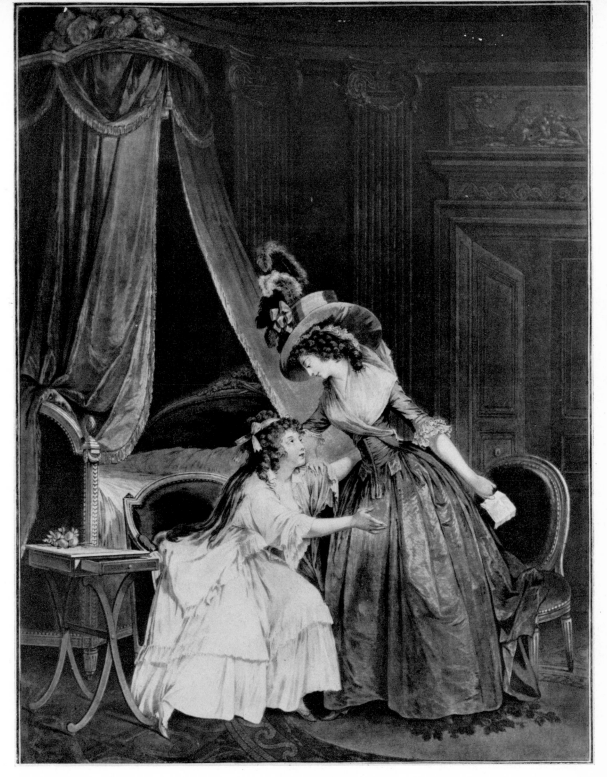

87. F. Janinet: *L'Indiscretion*, after N. Lavreince; aquatint, printed in colours

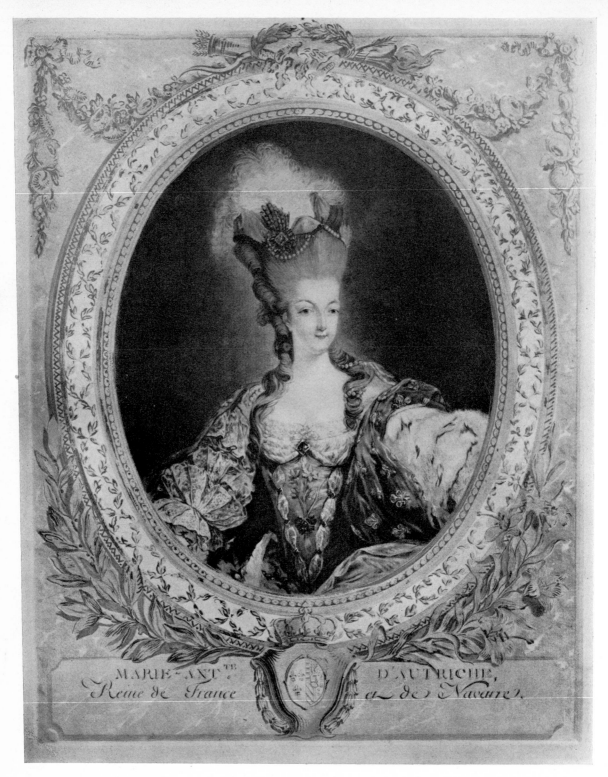

88. F. Janinet: *Marie-Antoinette*, after Gautier-D'Agoty; aquatint, printed in colours

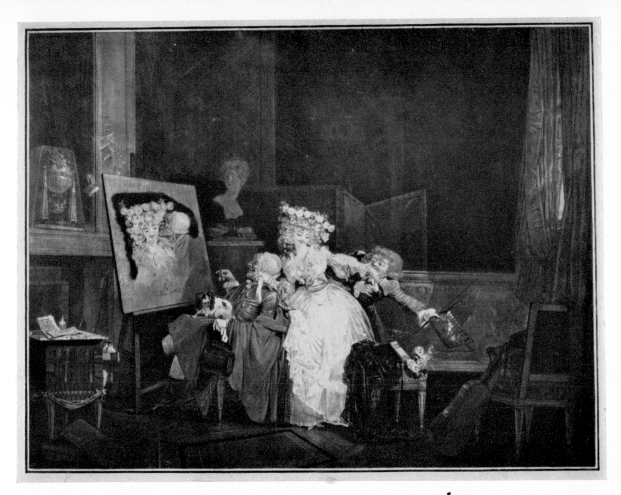

89. P. L. Debucourt: *Les Deux Baisers*; aquatint, printed in colours

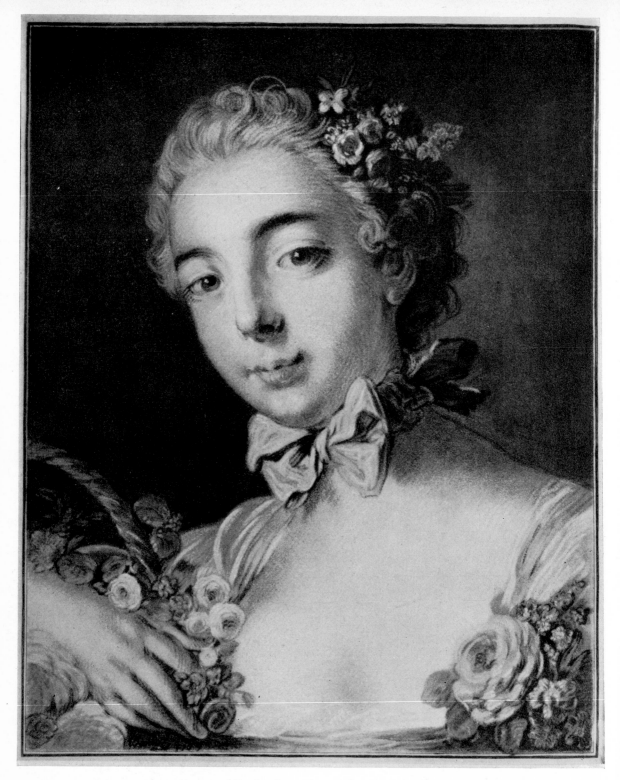

90. L. M. Bonnet: *Tête de Flore*, after F. Boucher; imitation of pastel

91. R. & D. Havell: *Oxford*, after W. Havell; coloured aquatint

92. J. J. Biedermann: *View of Geneva*; coloured etching. *From an impression in the British Museum*

93. G. Lory: *Swiss Costumes*; coloured aquatint

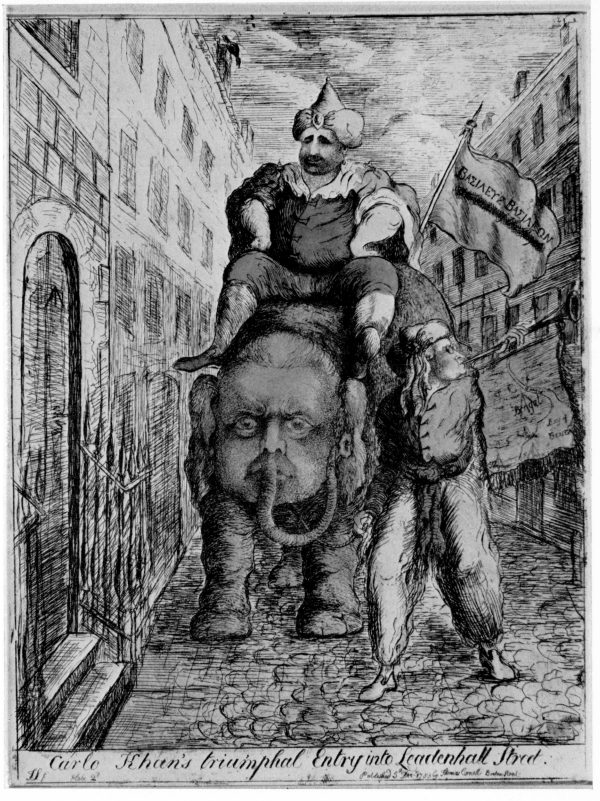

Carlo Khan's triumphal Entry into Leadenhall Street.

Published 5th Dec 1783 by Thomas Cornell Bruton Street

94. James Gillray: *Carlo Khan's Triumphal Entry into Leadenhall Street*; coloured etching

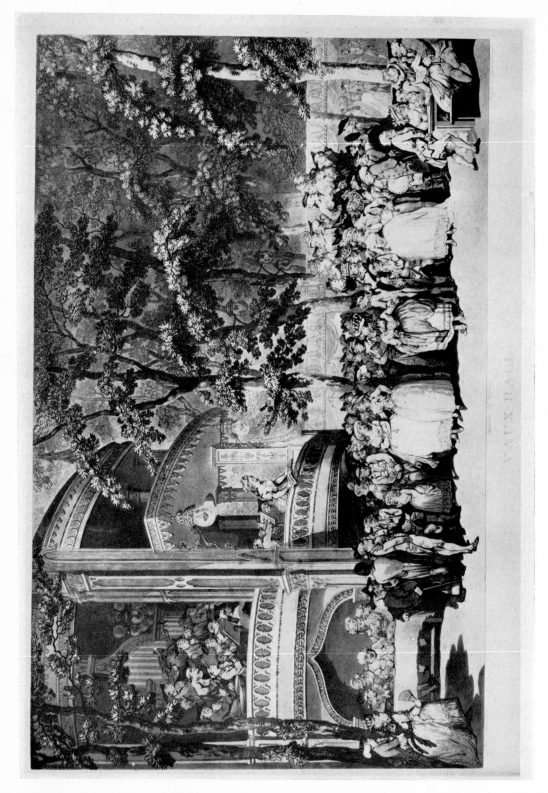

95. R. Pollard and F. Jukes: *Vaux-Hall*, after Thomas Rowlandson; etching and aquatint

96. I. R. Cruikshank: *Monstrosities*: coloured etching with aquatint

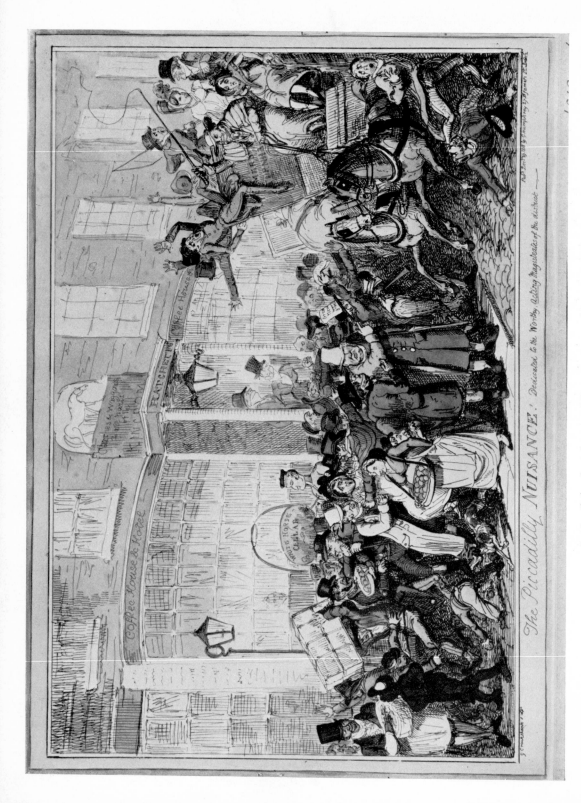

97. G. Cruikshank: *The Piccadilly Nuisance*; coloured etching

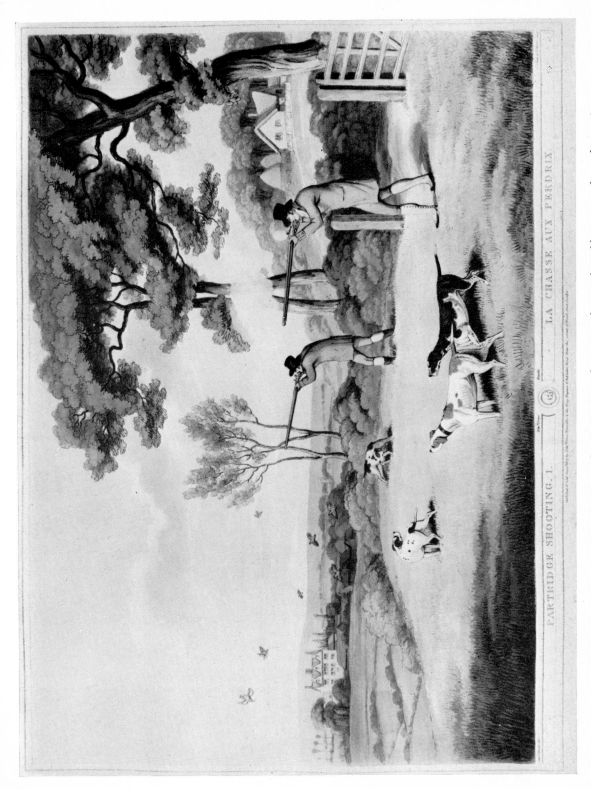

PARTRIDGE SHOOTING. I. LA CHASSE AUX PERDRIX

'98. Clark and Merke: *Partridge Shooting*, after S. Howitt, from *Orme's British Field Sports*; coloured aquatint

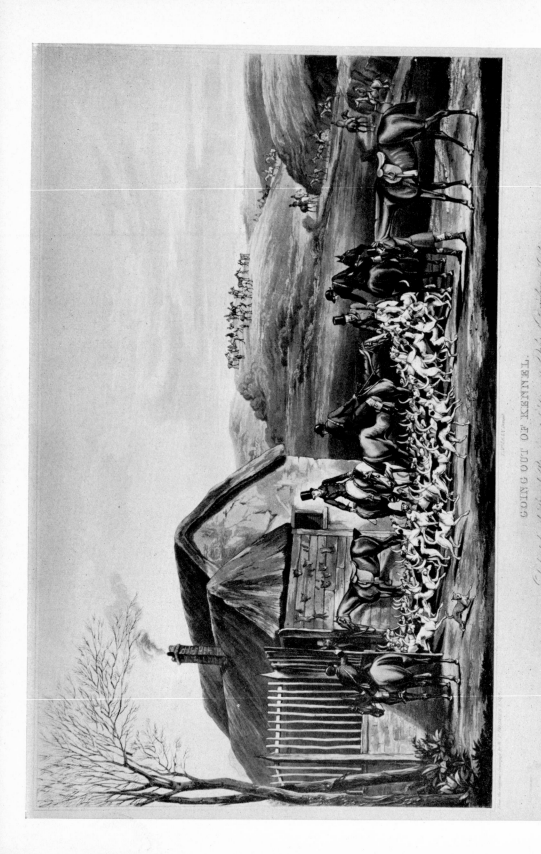

GOING OUT OF KENNEL.

99. H. Alken: *Going out of Kennel*, after W. P. Hodges, from *The Beaufort Hunt*; coloured aquatint

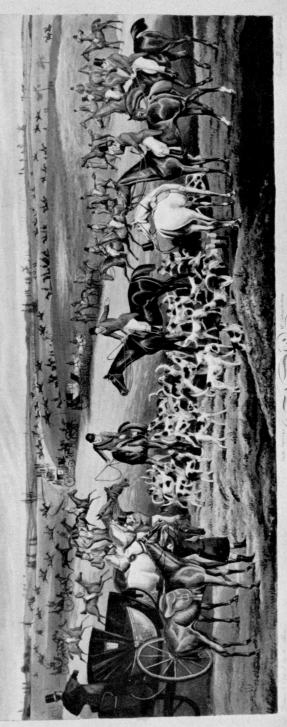

100. F. C. Lewis: *The Meet*, after H. Alken, from *The Quorn Hunt*; coloured aquatint

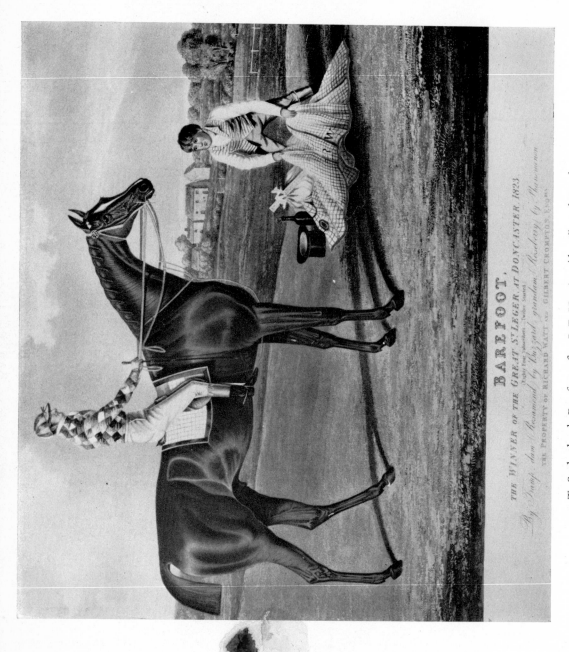

BAREFOOT,
THE WINNER OF THE GREAT St LEGER, AT DONCASTER, 1823.
Carlo Four Subscribers. Twelve Started.

By Tramp, dam Recommend by Whisker, grandam Racebody by Highflyer.
THE PROPERTY OF RICHARD WATT and GILBERT CROMPTON, Esqrs.

101. T. Sutherland: *Barefoot*, after J. F. Herring (detail); coloured aquatint

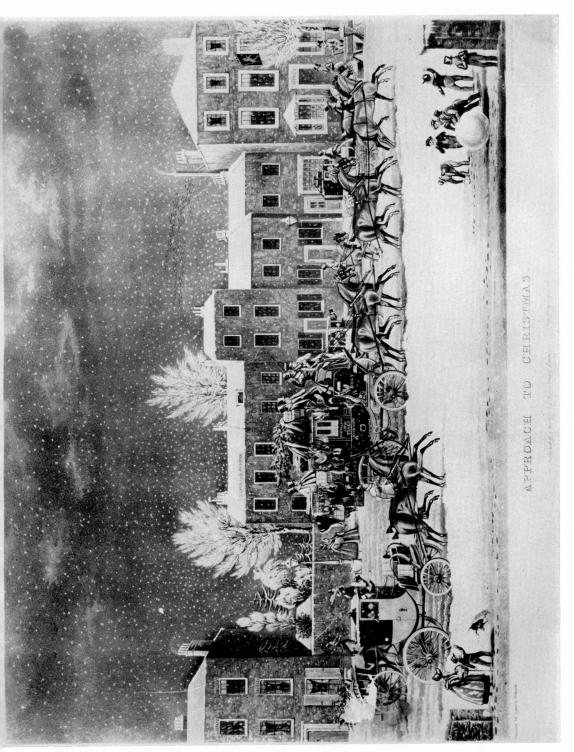

APPROACH TO CHRISTMAS

102. G. Hunt: *Approach to Christmas*, after J. Pollard; coloured aquatint

103: D. Wolstenholme Jnr: *Whitewell near Welwyn*, after D. Wolstenholme Snr., from *Hertfordshire Village Scenery*; coloured aquatint

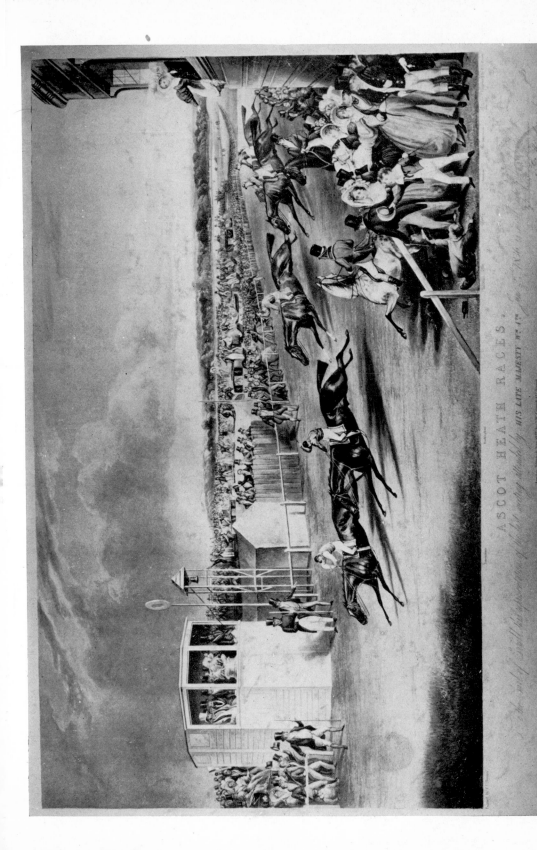

104. R. G. Reeve: *Ascot Heath Races*, after F. C. Turner; coloured aquatint

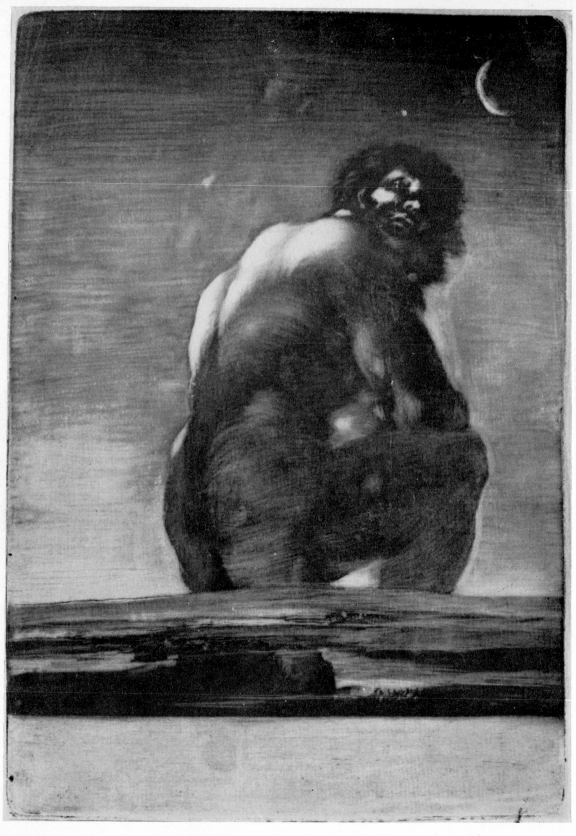

105. Francisco Goya: *El Coloso* (*The Giant*)